BOWMAN LIBRAR P9-CKD-962

Dutch Painting in the Seventeenth Century

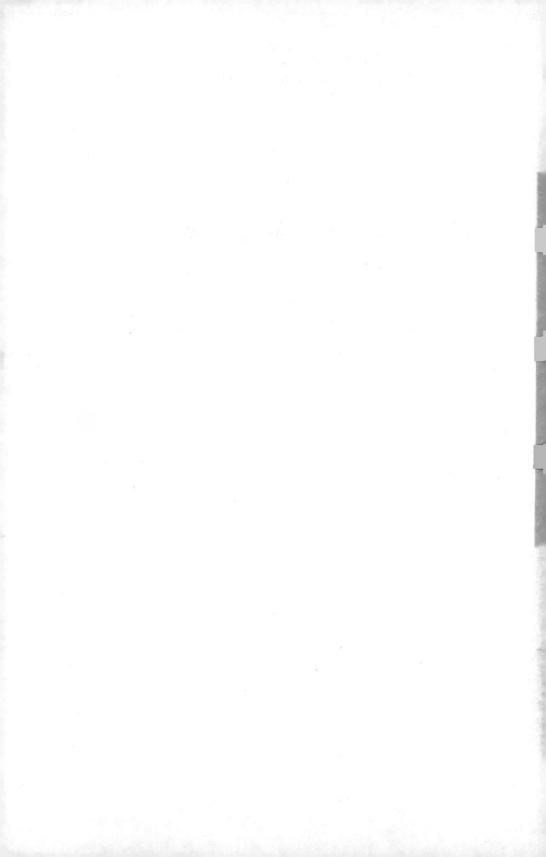

Madlyn Millner Kahr

DUTCH PAINTING

in the Seventeenth Century

ICON EDITIONS

Harper & Row, Publishers

NEW YORK, HAGERSTOWN, SAN FRANCISCO, LONDON

ACKNOWLEDGMENT

It was my good fortune to be introduced to the study of Dutch painting by a great scholar and teacher, Professor Julius S. Held. For his contributions to this book specifically and to my work in general, I am deeply grateful.

DUTCH PAINTING IN THE SEVENTEENTH CENTURY. Copyright © 1978 by Madlyn Millner Kahr. All rights reserved. Printed in the United States of America. No part of this book may be used or reproduced in any manner whatsoever without written permission except in the case of brief quotations emobodied in critical articles and reviews. For information address Harper & Row, Publishers, Inc., 10 East 53rd Street, New York, N.Y. 10022. Published simultaneously in Canada by Fitzhenry & Whiteside Limited, Toronto.

This edition reprinted 1982 with corrections.

Designed by Suzanne Haldane

Library of Congress Cataloging in Publication Data

Kahr, Madlyn Millner. Dutch painting in the seventeenth century. (Icon editions) Bibliography: p. Includes index. I. Painting, Dutch. 2. Painting—Modern—17th–18th centuries—Netherlands. I. Title. ND646.K26 1978 759.9492 78-377 ISBN 0-06-433576-3 78 79 80 81 82 10 9 8 7 6 5 4 3 2 1 ISBN 0-06-43087-0 pbk 10 9 8 7 6 5 4 To the memory of Rose L. Vine Millner and Frank Millner

Contents

	Introduction: The Humanization of Art	ix
I /	The Birth of a Nation	I
2 /	Dutch Culture and Art	8
	The Support for Art in the Dutch Republic	8
	The Heritage of Dutch Art	20
3 /	Utrecht: From Mannerism to Caravaggism	28
4 /	Haarlem: Strides Toward Naturalism	44
	Goltzius' Role	44
	Early Seventeenth-Century Landscape in Haarlem	48
	Haarlem Scenes of Social Life	59
5 /	Frans Hals and the Portrait Tradition	67
6 /	Rembrandt	89
	Early Life and Education	89
	A Master in Leiden, 1625–31	91
	Flourishing in Amsterdam, 1632–42	104
	Personal Problems, Artistic Progress: 1642-50	123

viii	CONTENTS
Renewed Force and Fecundity: 1650–59	130
The Final Years: 1660–69	143
7 / The Rembrandt School	155
8 / Scenes of Social Life	170
9 / Still-Life	189
10 / Landscape and Seascape	204
From Mannerism to Early Realism	204
The Poetry of Observed Nature	205
The Monumental or Structural Phase	211
Italianate Landscapes	226
Seascapes	232
The Exotic Colonial World	238
11 / Architectural Subjects: Church Interiors and Town W	iews 240
Church Interiors	240
Town Views	250
12 / Vermeer and the Delft School	258
Carel Fabritius and Pieter de Hooch	258
Johannes Vermeer of Delft	268
Epilogue: The End of the Golden Age	299
Notes	301
Selected Bibliography	306
List of Illustrations	311
Index	317

Introduction The Humanization of Art

FOR THE DUTCH in the seventeenth century, art functioned as a social cement, reinforcing the shared beliefs and aspirations that helped to unite and shape the evolving nation. Innovations in painting responded to new communal concerns. In the works of most artists in the first half of the century, both content and style reflected the taste not of the wealthy and sophisticated, but of people in moderate circumstances. For this art public, international fashion could be largely ignored. This allowed the full development of native artistic species.

The many Dutch paintings that show pictures on the walls of ordinary dwellings give vivid evidence that it was customary for people on various social and economic levels to decorate their houses with paintings made in their own time or somewhat earlier. Written records of the time confirm this widespread investment in contemporary art. To meet the demand, an extraordinary number of artists provided an outpouring of paintings astounding not only in number, but also in quality and variety. Lacking the age-old domination—and support—of courtly and religious patronage, the Dutch painters were free to explore new pictorial territory. Painting mainly for the local market rather than on order, they provided for all tastes.

Most significant of the new developments that ensued was an unprecedented humanization of art. Works by a large number of painters reflected the common experiences of life in all their diversity. In concrete terms they embraced the typical, the ordinary in human concerns. The role of art in furthering mutual understanding of the various relationships in which each individual took his place—family, occupational, geographic, national—was particularly important in the changing social, economic, political, and intellectual environment in which the Dutch found themselves from the late sixteenth century on. The adaptability of the artists proved to match the fluidity of the situation. Paintings from various periods in the course of the seventeenth century provide a guide to the alterations in self-perception and social consciousness as well as to the persisting preoccupations.

Many artists became specialists in one specific kind of subject matter, such as landscape, portrait, still-life, or scenes of daily life, or even in subspecialties within these areas—for example, townscapes or tavern scenes. All of these types of subjects were brought to new heights of achievement through their efforts. The popular acceptance of works by serious living artists helps to explain, at least in part, how it happened that the newly independent Dutch Republic—a small nation, seldom free from war or the threat of war, periodically torn by political and religious conflict—gave rise to one of the most splendid schools of painting the Western world has known.

Dutch painting was not dominated by a single great figure (as, for instance, Flemish art was given its international significance by Peter Paul Rubens). Along with such giants as Rembrandt, Ruisdael, Hals, and Vermeer, there were clusters of highly gifted artists and whole squadrons of able, 'well-trained, and productive painters. The styles and subjects of these painters were diverse, yet there are traits that the phrase "Dutch painting" rightly presents to our mind's eye. Primary among them, probably, is intense concreteness. The paintings look to us like a family album of Dutch life. Grandmother poses stiffly for her portrait. Father faces the world with dynamism. Mother peels apples or makes lace while the children play beside her. Groups chat sociably in the light-flooded whitewashed interior of a church. Men and women carouse in taverns, gamble, write letters, converse. Life seems to go on before our eyes, without inhibition. The people, the meadows and woods, the cities and villages are here in living color.

This impression of solid realism lies behind the often repeated notion that Dutch painters simply recorded what they happened to see. It is true that there were Dutch painters who represented with scrupulous exactness the color, form, and texture of visible things. In this they followed the tradition of precise particularity that the Early Netherlandish painters of the fifteenth century had handed down to them. The bent for the philosophy of Nominalism, the recognition of the specific rather than the general as the basic reality, may have played a part in this intentness on the particular object. But what made the pictures aesthetically satisfying was the intervention in each case of a cultivated artistic personality. The organiza-

Introduction

tion of the objects in still-lifes, no less than the choice of viewpoints in landscapes, was determined by artistic goals. All kinds of liberties were taken. Some of the most naturalistic bouquets of flowers, for instance, could not have existed in real life, for the blooms depicted were never available all at one time. Compositional devices make the vaults of churches appear even loftier than they are in fact. Landscapes are approached—as indeed they must be by artists of all times—with preconceptions of what a landscape painting or etching should look like. The painters scrutinized the natural world, and they also drew on existing art of the most varied kinds. They studied prints, drawings, and texts, as well as paintings, to learn technique and theory. Their naturalism was restrained by calculated limits.

The emphasis on human and natural subjects in Dutch art of this period was also a response to the relative lack of interest in religious paintings in this Protestant land, where churches were not decorated with paintings and there was little call for devotional images. Along with the grandiose courtly baroque style, the pathos of religious art of the Counter-Reformation was excluded from the mainstream here. Religious concerns were by no means lacking, but now the voice of religion began to speak in human accents. The Dutch pictorial world, which looks like everyday reality, is in fact the vehicle for religious and moral preoccupations. In humanizing art the painters transferred to secular themes certain fundamental values that were understood and shared by their communities. In some paintings, particularly by Rembrandt and his school, traditional biblical subjects are treated like scenes from daily life. In other works, apparently naturalistic still-lifes, for instance, that are enticing in their sensuous appeal, there are often references to the vanity of earthly gratifications. Disguised symbolism, including pictures on the walls in painted rooms, often gives clues to emblematic content that seems to be in conflict with the overt situation depicted. A gravity of intention is present in the hilarious celebrations of Jan Steen, as it is in Rembrandt's tragic shadows and in the exquisite balance of Vermeer. The use of satire to improve society lends weight to frothy scenes of social life.

These seeming contradictions reflect a very human ambivalence. To Calvinists, the pleasures of the world must be weighed against guilt and the prospect of punishment for sins. At the same time, devotion to the physical world as God's creation may, by old tradition, dignify even the humblest of images. Ostensibly neutral subjects in terms of emotions, such as still-lifes and landscapes, may be larded with didactic content, while, on the other hand, religious themes are not always recognizable as such in their humanized versions. Human needs, strivings, and fantasies enter into this art in ways not seen before and even now so unfamiliar that they are often overlooked. As the ultimate expression of the Dutch hu-

xi

manization of art stands Rembrandt's acceptance of humanity in all its imperfection.

This book is concerned mainly with the most fruitful years, roughly the first three-quarters of the seventeenth century. It was in this period that the innovations took place and the characteristic works were created that we have in mind when we speak of the Golden Age of Dutch painting. In order to understand the circumstances that made seventeenth-century Dutch painting possible, we start with a consideration of the origin and nature of the new nation to which it belonged. The local artistic traditions that lay behind it, as well as both earlier and contemporary foreign art on which it also drew, help to define the place of this school in the history of art.

There is no simple formula that would be adequate to take into account the multiple facets of this unprecedented body of paintings. Some of the developments stand out in boldest relief when seen from the viewpoint of one of the great art centers; the leading ones were Utrecht, Haarlem, Leiden, Amsterdam, and Delft. Other features are best clarified on the basis of comparisons limited to a single type of subject matter. In other cases, particular aspects of Dutch painting group themselves naturally around the personality of a great master. Our focus, then, will shift, ranging from close-ups to panoramic views, as the material under scrutiny demands.

The organization of this book is thus determined by the nature of the art we are dealing with. The selection and arrangement of the material have been governed by three main considerations: first, while avoiding overwhelming numbers of names and facts, to acquaint the reader with the stylistic developments, subject categories, schools, artists, and specific works on which the fame of Dutch painting in the seventeenth century is justly based; second, to provide the essential definitions and information in clear and useful sequence; and, third, to place in context some of the stimulating questions inherent in this fascinating subject.

Dutch Painting in the Seventeenth Century

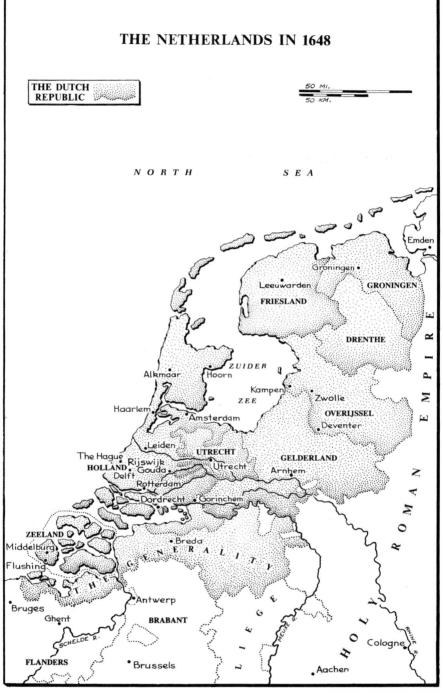

MAP BY THEODORE R. MILLER

1/ The Birth of a Nation

The DUTCH REPUBLIC made so powerful and individualized a mark on the world in the seventeenth century that—as the Dutch themselves might have put it—it seemed to have been fashioned by divine decree to fill a special role in God's world. The new nation's unprecedented political and social patterns, relative toleration of religious and other differences, striking economic strength, and great flow of art give the impression of a stable and unified society. In fact the genesis of the nation had been chancy and convoluted, and the United Provinces continued to be decentralized and relatively heterogeneous as an independent state.

Toward the end of the fourteenth century the dukes of Burgundy acquired, by marriage and conquest, realms in the Low Countries. Fourteen separate Netherlandish provinces thus were subject to the Great Duchy of Burgundy when it came into Hapsburg hands in 1477 as the inheritance of Mary of Burgundy, wife of the Emperor Maximilian of Austria. Maximilian and Mary's grandson, who was to become the Emperor Charles V, was born in 1500 in the southern Netherlands, in Ghent. In 1517 he arrived in Spain to claim the crowns of Castile and Aragon. Two years later he became the successor to his grandfather. Among the territories that Charles V added to the empire were three more provinces in the Low Countries. In his reign the Netherlands made progress toward unification under the Hapsburg Empire. Brussels was the administrative center, while Antwerp led in economic and artistic matters. When Charles V abdicated in 1555, he divided the domain he had fought so long to enlarge, giving the Netherlands, along with Spain, to his son, who was to reign as Philip II.

Spain was already suffering serious economic difficulties, and, partly in order to extract more money from the Netherlands, Philip sought to strengthen the central authority over the seventeen provinces, each of which had essentially governed itself in the past. The imposition of religious orthodoxy would at the same time be fostered by autocratic Spanish rule. Stirrings of rebellion soon responded to Philip's intrusions on the traditional privileges. The nobles, the princes of the Church, and the towns all had reasons to oppose the centralized government. The movement for liberation from the Spanish crown did not start as a struggle of Protestants against Catholics. The Spanish pushed it in that direction by being most merciless against the heretics.

As early as the 1560s, William of Nassau, prince of Orange (later known as "the Silent"), tried to organize all seventeen provinces of the Netherlands in resistance to Spain. Born in the Rhineland, the home of his parents, the Count and Countess of Nassau-Dillenburg, William had started life as a Catholic. When he was a year old, his parents became devout Protestants. At the age of eleven, in 1544, William inherited the great estates, mainly in Brabant, and the titles of his cousin, the prince of Orange, becoming sovereign of the tiny independent principality of Orange in southern France. Thereafter he lived in the Spanish Netherlands as a wealthy nobleman, a courtier, and a Catholic. He became a trusted friend of Charles V and his sister, Mary, the Dowager Queen of Hungary, who was Regent of the Netherlands. At the age of sixteen he met Philip II, who was personally less favorably disposed toward him. Still, in 1564 William became stadholder (Governor) of the northern provinces of Holland, Zeeland, and Utrecht under the Spanish crown.

It was an ironic twist of fate that brought this luxury-loving adherent of the Spanish monarchy into the vanguard of the struggle for liberation from Spain. Philip II, less conciliatory than his father, sent the Duke of Alba to put down the rebellion in the Netherlands by force of arms. Added to the harshness of the military repression, economic measures were instituted to lay the burden of the cost of the war on the Netherlands through an excise tax. This aroused the merchant class to join the opposition against Spain. Thousands fled, among them William himself.

William became a Calvinist convert in 1573 and led troops in an unsuccessful attack on Alba's forces. While aiming to expel the king's army, William continued to recognize the king as the legitimate sovereign. Unsuccessful on land, the rebels resorted to freebooting at sea. The "Sea Beggars," through wily maneuvers, were able to capture the ports of The Brill and Flushing in 1572, thus protecting Holland and Zeeland from invasion by sea. Haarlem, Leiden, and other cities withstood long, dreadful sieges. Desperate measures of defense, including destroying the dikes and flooding the land, ruined large areas, especially in the southern provinces.

In 1579, the Treaty of Arras organized Antwerp, Ghent, Bruges, and other southern cities, as well as some northern towns and territories. Two weeks later, the Union of Utrecht, a loose alliance designed solely to prosecute the war against Spain, laid the groundwork for the unity of five of the seven northern provinces, Holland, Zeeland, Utrecht, Gelderland, and Friesland, to which Overijssel and Groningen were later to be added. In 1581 a declaration that Philip II had forfeited his sovereign power was made in the name of the Union of Utrecht. This defined the split between the northern and the southern Netherlands. The borders between the two, however, continued to fluctuate in the course of military events. The separation that ensued was not between different ethnic or linguistic groups, nor was it based on disagreement about religion. It was not planned by William of Orange; on the contrary, it was counter to his intentions. There were, however, certain sociological features in the north that supported the drive for independence, especially a dominant middle class of increasing strength. In the south, the nobility continued to prevail, and they were less firm in pressing to break the bonds with Spain.

The seven northern provinces were protected by the barriers of the great rivers, which provided natural lines of defense against invasion. The extraordinary ability of William of Orange was also an important factor in the success of the rebellion. He was a brilliant political and military leader, courageous, intelligent, willing to place his considerable fortune at the service of the cause. He gained the support of all factions. His principle of toleration aimed at the perhaps unattainable goal of conciliating the hostile religious interests. It was a great loss to the movement for unity and independence when in 1584, at Delft, he was assassinated. His son, Prince Maurice, who succeeded him, was also an excellent general.

In 1585 Spain took Antwerp, sealing the fate of the southern Netherlands. France and England, both enemies of Spain, entered into alliances with the Dutch. The defeat of the Spanish Armada in 1588, a disaster for Spain, improved the position of Dutch sea power. Shortly before his death in 1598, Philip II detached the Netherlands from Spain, giving them to his daughter, Isabella Clara Eugenia, as a dowry on her marriage to her cousin, the Archduke Albert of Austria, who since 1596 had been the king's stadholder of the Netherlands. The United Provinces refused reintegration under their administration. It had become known that secret clauses in the act of cession by the Spanish crown would have made the proffered independence of the Netherlands illusory. The religious differences had by now become irreconcilable, and certainly the economic advantages of freedom from Spain were not to be renounced voluntarily. A truce with Spain in 1609 marked to all practical purposes the birth of the Dutch Republic. It was headed by a stadholder who was appointed by the States of the Provinces, Prince Maurice of Orange. Sharing authority with him was the *landsadvocaat* of Holland, Johan van Oldenbarnevelt. Maurice was supported by the ardently Calvinist faction, including many in the working class, while Oldenbarnevelt represented the interests of the "regent" class, the merchant rulers of the cities. The clashing interests of these two groups made for an uneasy cooperation which in the course of time frequently was broken by open conflict. The House of Orange owed its strength to its military leadership, and it therefore preferred to prosecute and prolong the war. The fanatical Calvinists, who wished to continue the war with Spain for religious reasons, were natural allies of the Orangist faction. For the increasingly dominant prosperous middle class, whose goal was profitable trade, peace was preferable.

The United Provinces did not start with the major part of either the population or the assets of the Netherlands. In 1555, it is estimated, their population was only about one and a half million. They were not rich in natural resources. In fact they had to import both food and raw materials for industry and commerce. Even timber for ships had to be brought from Norway or the Baltic. They had, however, geographical advantages. Their location made them natural middlemen between Northern Europe and the Mediterranean peoples, and the abundance of good harbors facilitated the development of maritime trade. Canals made travel and transport within the Dutch Republic cheap and easy. To the picture of the Dutch struggling to wrest and defend their land from the sea must be added the image of the felicitous contributions of water to the national welfare, from the protection provided by the broad rivers that prevented invasion by the Spanish forces to the prosperity based in great part on seafaring. Antwerp, which earlier had been by far the busiest port of the Netherlands, was closed to trade in 1585 by the Dutch blockade. Amsterdam inherited the role of major seaport. The Dutch people had the fortitude and the skills needed to capitalize fully on their advantages. They became the most proficient of shipbuilders, chart makers, and navigators. Dutch preeminence in trade rested on these skills and on a knack for serviceable organization.

In 1602 the States General chartered the Dutch East India Company, thus combining competing groups in a single monopolistic structure, set up with concessions to local interests. The Dutch West India Company was similarly established in 1621 for trade with America and Africa. While the carrying of grain from the Baltic remained the staple trade, riches from the far reaches of the earth were funneled through the port of Amsterdam. At the same time, imports provided the basis for thriving industrial development. Leiden grew as a manufacturing center. Haarlem prospered through its specialty of cloth finishing. It was also famous for brewing. By the fifteenth century Holland, Zeeland, and Utrecht had already become largely urban, and urbanization proceeded to an exceptional degree in the late sixteenth century. Amsterdam, which around 1572 had a population of about 30,000, by the beginning of the seventeenth century had grown to about 105,000 inhabitants. Leiden at this time was a city of almost 45,000, and Haarlem, third in size, almost 40,000.

From the time of the truce of 1609 the opportunities for trade increased, and the cities continued to grow. Refugees from the southern Netherlands added to the influx, as did Jews from Spain and Portugal and immigrants from many other countries. They contributed to the economic activity and the variegated culture of the cities of the United Provinces. By 1648 Amsterdam had become one of the larger cities of Europe, with a population of about 150,000. Leiden, Rotterdam, Haarlem, Delft, Dordrecht, Utrecht, and Middelburg were also thriving centers. Several of these cities gave rise to important local schools of painting.

In the government of the country, the urban patricians were dominant. The states general of the province of Holland, for example, had one seat for the nobility and twelve for the towns. The families of the so-called regent class-wealthy merchants and bankers-in effect were able to hand down positions of power from one generation to the next. Holland, by far the largest and wealthiest of the seven provinces, paid more than half the military costs and wielded the control that is tied to the purse strings, though officially all decisions had to be unanimous. The States General of the United Provinces dealt with foreign affairs, with a stadholder to carry out their decisions. On internal matters the individual provinces retained autonomy. This decentralization allowed for variety in all spheres of life. Even in religion, differences were tolerated. Catholics and Jews, as well as numerous Protestant sects, lived under certain restrictions but with more freedom than was available to religious minorities elsewhere in Europe. Even Catholic churches could exist if they were discreetly concealed. Cultural diversity was fostered by the lack of an authoritative central government. In some ways this was healthy and productive, though backward in relation to the dominant European political forces of the time, which tended toward the nation-state and strong central power. The coexistence of conflicting interests within the United Provinces had bitter fruit as well. Sectarian differences among the Calvinists were caught up in political struggles, sometimes with tragic results. Among the most dramatic was the execution of the aged Oldenbarnevelt in 1619, after many years of service.

At the end of the truce, in 1621, war with Spain was resumed, but it

1. Gerard ter Borch, The Swearing of the Oath of Ratification of the Treaty of Münster, May 15, 1648.

did not seriously interfere with the progress of the Dutch. Most of the troops were mercenaries recruited abroad, mainly in Germany and French Flanders, and the fighting was on the borders and outside Dutch territory.

It was not until 1648, with the Peace of Münster, that Spain officially recognized the independence of the Dutch Republic. Fittingly, a Dutch painter, Gerard ter Borch, was present to make a visual record of the ceremony sealing the peace pact (1). His painting shows six Dutch representatives raising their right hands as they swear; they number six because one province had not yet ratified, one representative was absent on account of illness and two were accredited from Holland. Spain had two representatives. In this small picture each participant is shown in a faithful portrait, and even the casket that contained the document is carefully depicted. This straightforward documentary record of the historic event makes a striking contrast with the grandiose and imaginative approach of the great Flemish master, Peter Paul Rubens, in his Conclusion of the Peace, from the series of paintings he made for Marie de' Medici between 1622 and 1625. This kind of contrast with the brilliance and splendor of courtly, Catholic painting in the baroque style has led many observers to believe that Dutch art was simple realism. The

The Birth of a Nation

seventeenth-century Dutch painters did indeed hand down to posterity a remarkably detailed visual record of their country, its people, and their way of life, but to consider their works as simple mirror images of what nature placed before their eyes would be to underestimate their selective discretion and their artistry in organizing their material in even their most naturalistic works. It would also grossly undervalue the richness of content of their pictures.

The impression of good cheer and tranquillity that permeates Dutch painting is also not a reflection of the actual state of affairs either domestically or internationally. Internal conflicts did not cease, nor was there an end to the need for defense against hostile nations after the conclusion of peace with Spain. Competition for the shipping trade led to war with England from 1652 to 1654 and again from 1665 to 1667. The fleet of the Netherlands, under the great Admiral Michiel de Ruyter, was successful in holding off the English aggressors. The French attacked in 1667-68. In the disastrous year of 1672 war with the English broke out for a third time, and the French again invaded the Republic, advancing as far as Utrecht. In this year there also took place perhaps the most degrading event in the history of the Dutch: Johan de Witt, the grand pensionary of Holland, who had been the chief executive of the country since 1653 while there was no stadholder, was torn limb from limb by a mob in The Hague, along with his brother, Cornelis. They were the victims of Orangist sympathizers. William III of Orange then became stadholder. Five years later he married Mary Stuart, and in 1689 they became King and Oueen of England in the Glorious Revolution. By this time the great days of Dutch art and Dutch economic expansion were in the past.

7

2/ Dutch Culture and Art

THE SUPPORT FOR ART IN THE DUTCH REPUBLIC

T S A P P E A L to all the people may have been the major impetus toward the humanization of art that brought into being a new vocabulary of images in Dutch painting in the seventeenth century. Painting was to reflect common human experience. The main currents of this art shunned the grandiose, the fantastic, and the supernatural. It generously embraced the thoughts and feelings that mean something to everyone. Protestantism doubtless played a part in shaping this down-toearth quality, but Catholic Dutch artists also contributed to the trend, which seems to have been national rather than sectarian.

The United Provinces, an independent nation to all practical purposes from the beginning of the twelve-year truce with Spain in 1609, went its own way in cultural matters as well as in politics and religion.¹ Most of the population was urban. The people were exceptionally literate; reading ability was important here, as in all Protestant countries, so that the individual could peruse the Bible. Publishing flourished. Religion and strong moral commitment were central to Dutch literature. It has been said that the works of the didactic poet Jacob Cats were in every Dutch home, alongside the Bible. Instructive aims also found expression in emblem books, which reached the height of their popularity in the Netherlands (both north and south) in the seventeenth century, having developed from Italian sixteenth-century iconological literature.² An emblem, strictly speaking, combines a caption and a picture whose connection is not obvious but is made clear by verses or prose texts, often quotations from classical literature or the Bible. Generally the meaning of the emblem is a moral, and the game of its decipherment was designed to make morality more attractive. Emblematic meanings as well as motifs derived from illustrations in emblem books frequently appear in Dutch pictures. Even where the subject appears to have no connection with character improvement, moralizing messages are present in many paintings and prints. Ingenious ways were found to include such teachings in still-lifes, portraits, and narrative subjects. The scenes of debauchery and other compositions that depict groups of figures in interior settings, commonly thought of as genre, are often satirical. They correspond in tone to the popular farces of Bredero. The didactic intention seems to have been one of the sources that fed the stream of Dutch painting in the seventeenth century. Demand for moralizing pictures may have contributed to the increase in the supply, though we cannot be sure that the buyers were motivated by moral strivings. The Calvinist view of all worldly life as evil coexisted with appreciation for "God's world." This paradox opened the way to nearly all kinds of subject matter.

Persons in all walks of life bought paintings and hung them. Reports of this fact were written at the time, for example, by two frequently quoted English travelers. Peter Mundy, who was in Amsterdam in 1640, commented on the love of paintings he observed.

"As For the art off Painting and the affection off the people to Pictures, I thincke none other goe beeyond them, there having bin in this Country Many excellent Men in thatt Facullty, some att presentt, as Rimbrantt, etts, All in generall striving to adorne their houses, especially the outer or street roome, with costly peeces, Butchers and bakers not much inferiour in their shoppes, which are-Fairely sett Forth, yea many tymes blacksmithes, Coblers, etts., will have some picture or other by their Forge and in their stalle."³

The famous diarist John Evelyn was at the Rotterdam fair in the following year, and he wrote that even farmers' houses were full of paintings. "The Occasion of this store of pictures and their Cheapnesse," he explained, "proceed from their want of land."⁴ His assumption that paintings were in demand as investments may have been well founded, but of course there were innumerable other ways to employ money, even though there was little opportunity to become land-rich in the Netherlands. The wild speculation in tulips shows how far the Dutch could go in searching out financial risks. As with flowers, so with paintings, a predilection for them must be assumed, without which the reliable demand necessary for attractive investment would have been lacking. The modest court at The Hague never provided great patronage, nor did the Dutch Reformed Church. It was mainly the middle levels of society that provided the market for pictures. What made this possible was the fact that the benefits of prosperity were enjoyed by an unprecedentedly broad segment of the population. A considerable proportion of the inhabitants of Dutch towns had more than sufficient income to provide for their fundamental needs. Many chose to spend their surplus on furnishings for their homes, including pictures. This led to a great demand for paintings, but almost exclusively for paintings at low prices. Since they were to be hung in the rooms of ordinary Dutch houses, most of them were small.

The pictures on the walls depicted in interior scenes are fascinating documents from several points of view. Some of them are miniature copies of known paintings. They are commonly meaningful in the context of the subject matter of the picture in which they appear. At the same time, they are represented as objectively observed parts of the realistic scenes in which they are included, and they reflect shifts in fashion. Changes in the styles of frames, for instance, can be observed in the pictures on the walls as the century advances, from the simple black frames of the early period to the elaborate carved and gilded frames of the later years, when ornateness and elegance were in fashion for paintings as well as for furnishings and costumes.

The diversity of Dutch seventeenth-century paintings was fostered by the fact that instead of painting to the order of the wealthy and powerful, painters were—for the first time in the history of Western art—producing wares commercially. Individual buyers of different backgrounds and various tastes were receptive to pictures of all kinds of subject matter and a wide range of styles. Large numbers of paintings were sold. But it seems that even larger numbers were put on sale than the market could readily absorb. Prices were generally low, and painters did not grow rich. The competition was so sharp that few could prosper. A number of accomplished painters had to earn their living by other means. To regulate the competition, control the standards, and establish rules governing the training of students, the artists relied on the Guild of St. Luke, named for St. Luke the Evangelist, the patron saint of painters.

The guild organization had survived from medieval times. The guild of St. Luke was comparable in every way to the guilds to which shoemakers, carpenters, and other craftsmen belonged. In some towns, in fact, such craftsmen as embroiderers or wood carvers belonged to the same guild as the painters. Each town had its own guild, each with its own rules. Generally they prohibited nonmembers from selling their work, so that it was important for an artist to be accepted as a member of the local guild if he moved from one town to another. (Guild rosters provide us with significant dates—in some cases the only precise dates—in the lives of painters.) The rules might prohibit the sale of paintings for a specified number of years by any artist who had sold his works at auction. They established the number of students permitted to each artist; students' fees were a source of livelihood to the head of the studio. The guilds regulated the terms of apprenticeship, and it seems likely that the relative uniformity in training undergone by Dutch artists contributed to the generally high level of quality that distinguishes seventeenth-century Dutch paintings.

Boys customarily became apprentices at the age of ten or twelve, through the signing of a detailed contract by the father of the apprentice, who paid specified fees, and the master to whose studio the boy was to be attached. He would live in the household of the master. (It seems doubtful that any girls became apprentices under this system, though some female seventeenth-century Dutch painters are well-known. It would undoubtedly have been easier for daughters of painters, who could have been taught by their fathers, to become artists than for girls who lacked this advantage.) The artistic training started with the copying of drawings and prints. Next, the student would be set to drawing from plaster casts, some of which were fragments of human figures, including in some cases antique examples. Theoretical studies, such as works on perspective and anatomy, were also included in the program; well-known treatises on these subjects were available in Dutch translation. Drawing from the live model was generally the next step. Only after sufficient skill in drawing had been attained was the student permitted to paint, at first copying pictures, either works painted by the master or works of other artists provided by him, and later painting from the live model.

While the master was obliged to teach his apprentice, the boy was required to serve the master in specified ways. He ground pigments, stretched canvases, put paints on the palette and, as he advanced in ability, might paint areas of lesser importance, for instance draperies, in the master's paintings. Usually after four to six years of training, the apprentice could apply for membership in the guild and submit a painting, which, if it was approved, would qualify him to become a master. Only then could he establish his own studio, in which he could take pupils, and sell his pictures under his own name and for his own profit.⁵

The modest circumstances in which artists worked are shown in a painting made in the 1660s by Adriaen van Ostade (2). The cloth stretched under the ceiling of the humble studio was to keep dust from the paints. An apprentice grinding pigments, like the youth on the right in the background here, is a feature of numerous pictures of studio interiors, of which we know many from this period. The person on the left in the background is putting colors on a palette. Pictures of studio interiors also show us students drawing figures after casts and lay figures (wooden manikins with joints that can be arranged in more or less natural poses), which were usual studio accessories at the time. Mirrors also appear as standard workshop equipment.

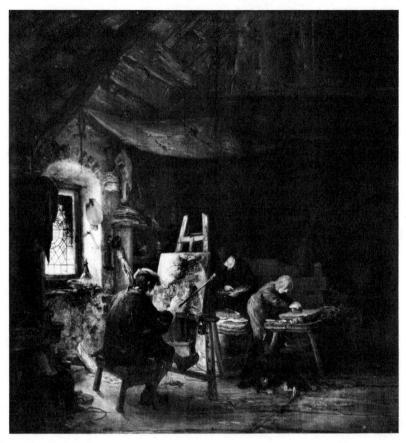

2. Adriaen van Ostade, A Painter's Studio.

Another depiction of a studio in which a painter is at work, probably dating from late in the same decade, the famous painting by Johannes Vermeer of Delft correctly known as *The Art of Painting* (3), is often called *The Painter's Studio*. Its allegorical meaning claims higher status for the painter by associating painting with the liberal arts. (It is typical of Dutch seventeenth-century painting to use apparently realistic subject matter to convey various kinds of messages.) Italy had taken the lead in efforts by artists to dissociate themselves from the guild and instead establish academies, which would substantiate the higher quality of education and intellectual endeavor required for art, in contrast with craftwork. The first Dutch art academy was established in The Hague in 1655. Called Pictura, it admitted both painters and sculptors. Its rules were based on the familiar guild regulations.⁶

Examination of the natural world, in which Dutch painters excelled,

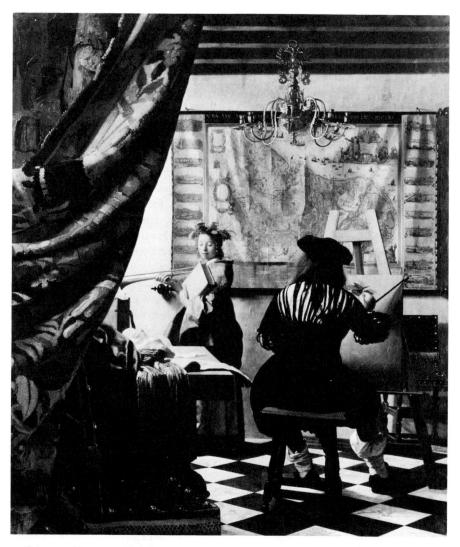

3. Johannes Vermeer, The Art of Painting.

was the focus of scientific interest as well in the seventeenth century. Pure science was valued for its own sake and also for the impact of its technological applications on the Dutch economy. The Netherlands took the lead in several aspects of "natural science."7 The distinguished mathematician Simon Stevin, born in Bruges in 1548, had come to Leiden to serve as tutor to Prince Maurice, the son and successor of William the Silent. Prince William had founded a chair of mathematics and engineering for Stevin at the new University of Leiden. A pioneer in the decimal system and in the investigation of hydromechanical problems, Stevin was also famous for his work in ballistics and fortification. His book De Havenvinding, immediately translated into French and into English as The Haven-Finding Art, was an important contribution to navigation. Among their innovations in marine technology, the Dutch could boast the invention of a new type of merchant ship, the fluit ("flute" or "flyboat" to the English), which became the symbol of their maritime supremacy. The Dutch also excelled in cartography. Lenses, essential tools of the age of observation, were ground for their own use by many scientists in the Netherlands. It is not certain whether any artists were directly in touch with scientific developments, but it seems likely that at the very least the interest in science, and particularly optics, may have fostered a zest for both observation and experimentation on the part of the painters.

Drawings, often made to be used as the basis for widely circulated prints, fulfilled the function of reportage for the people of the time. They give us clues as to what was then considered newsworthy. Hendrick Goltzius' drawing of a Beached Whale, 8 for instance, is one of a number of such drawings by various artists that were the basis for prints that spread the news of dramatic events (4). It depicts the dead whale that was washed ashore near Berkheij, between Scheveningen and Katwijk, in February 1598. People are shown climbing on the carcass, marveling at its size. Goltzius took care with his depiction not only of the whale and its observers, but also of the coastal landscape, dappled by the shadows of clouds, and of sailboats in the sea. This is an early example of the realistic depiction of landscape that was to be advanced by Dutch painters in the seventeenth century. The drawing would seem to reflect the interest in the observation of natural phenomena that was related to the developing scientific trends. Numerous drawings, prints, and paintings document this interest. But there was another use for it as well, as becomes clear when one reads the long inscription on the engraving that Jacob Matham made after Goltzius' drawing, dated 1598, which describes the whale as a "wonderwork of God." (4) We cannot be sure, of course, that praise of God's creation was in the mind of the artist when he undertook the drawing, which appears to be merely an objective portrayal of the natural world.9 What is clear is that depictions of nature could be, and were,

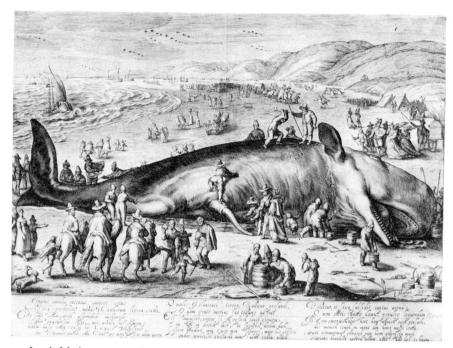

4. Jacob Matham, engraving after Hendrick Goltzius, The Beached Whale.

used to foster religious meditation. It may be that such considerations enriched the great school of Dutch landscape painting to a degree that has not been fully recognized. While the market for traditional religious subjects was limited, religious sentiment found its way into pictures that appear to be purely secular. This development was consistent with the stand of Calvin on representational art. He wrote that only what can be seen should be portrayed. Luther had not been explicit on this point; he said nothing about art in churches, but he took great interest in selecting the illustrations for his Bible.

In fact, the tradition of religious painting in the northern Netherlands had been broken; little earlier monumental religious art had survived since the time of the iconoclastic destruction in 1566, when fanatical Protestants had looted churches and destroyed images. But there were, of course, numerous printed Bible illustrations, as well as prints after paintings by artists in other parts of Europe, that provided models for religious iconography. It should be borne in mind, too, that while overtly religious subjects played a lesser role in Dutch painting than they did elsewhere, they were not so thin a strain as has sometimes been alleged. Not only Rembrandt and his school, but numerous other artists in various Dutch towns painted Old Testament and New Testament subjects. Many types of subject matter that played a major role in painting in Catholic lands after the Council of Trent, however—portrayals of saints and miracles, pictures related to the cult of the Virgin, devotional images—were ruled out among the Dutch Calvinists. *Sola Scriptura* was the dictum that was followed; only what appeared in the Bible was to be considered canonical. Aside from biblical subject matter, however, Dutch artists expressed reverence for all the world as reflecting the Divine Order. They translated religious feeling into human terms. Some Dutch painters, notably the Catholic artists of the Utrecht school, continued to paint traditional religious themes.

Among other paintings that appear to be straight reportage, many views of the towns of the Netherlands were preserved for posterity in paintings. Pieter Saenredam's painting of *The Old Town Hall of Amster*dam (5), inscribed 1657, was painted long after that Gothic monument had burned down in 1651. (Rembrandt made a drawing, of the ruins in 1652 [6].) Saenredam's painting was based on a drawing dated 1641. It is clear from this example and also from many of his fine paintings of

5. Pieter Saenredam, The Old Town Hall of Amsterdam.

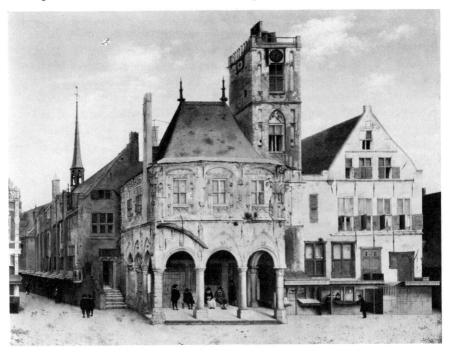

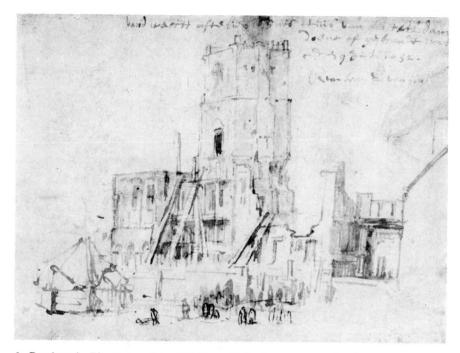

6. Rembrandt, The Ruins of the Old Town Hall of Amsterdam, drawing.

church interiors that he did not hesitate to make alterations for artistic purposes in composing the paintings.

Numerous other artists also left wonderfully vital pictures of the world they lived in. Jacob van Rusidael's *The Quay at Amsterdam* (7) gives us a view of buildings, ships in port, activities, and costumes that document the main square in Amsterdam and its inhabitants in about 1670. *The Interior Court of the Amsterdam Exchange*, by Emanuel de Witte (8), painted in 1653, is one of a number of depictions of this busy scene by various artists. The Amsterdam Bourse was the chief money market of western Europe in the middle of the seventeenth century. In pictures of it there are usually some men in exotic costumes among the groups standing in the courtyard and conversing, as on the left in this scene. This too is a record of fact, for merchants and traders came from distant places to trade in Amsterdam, and their customs and attire were recorded by the local painters. Thus we may assume that the variety and color of life in seventeenth-century Holland contributed to the variety and perhaps also to the quantity of paintings produced.

Cultural variety was also increased by the presence of refugees from a number of countries. Merchants, workers in the cloth trade, craftsmen, and some painters came from Antwerp and from other parts of the south-

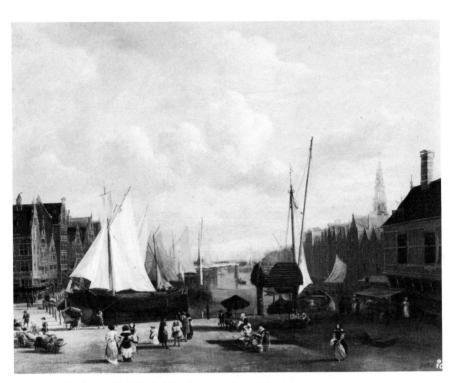

7. Jacob van Ruisdael, The Quay at Amsterdam.

ern Netherlands. Many arrived because they chose to live in a Protestant land, but some Catholics came as well, which suggests that economic motivation also played a part in the influx. As is well-known, Jews fleeing the Inquisition in Spain and Portugal found refuge in Amsterdam, as did Central European Jews, and Rembrandt depicted their appearance and activities.

Intellectual life was enriched also by immigrants who came to the Dutch Republic mainly because it offered freedom of thought and conscience. This attracted some of the most independent thinkers of the era. The French philosopher René Descartes (9) lived mainly in Holland for almost thirty years, not as a refugee from persecution but in order to work in peace in a sympathetic environment. He himself remarked that among the Dutch there was always a receptive audience for new ideas. His most distinguished disciple, Baruch Spinoza (1632–77), was a member of the Sephardic Jewish community of Amsterdam. Spinoza earned his poor living by grinding and polishing optical lenses. A third great philosopher, John Locke, arrived in Holland in 1683 as a refugee and worked there productively for five years.

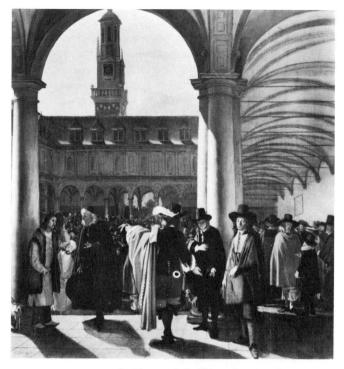

8. Emanuel de Witte, Interior Court of the Amsterdam Exchange.

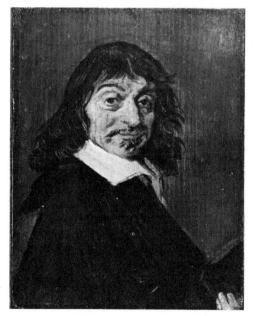

9. Frans Hals, Portrait of Descartes.

The diversity of the population enriched Dutch art. Even the different social classes provided varied subject matter for paintings through their diverse activities and interests. Dutch society was not egalitarian. The new economic opportunities, however, laid the groundwork for changes in rank in society. Social prestige was based not on hereditary status, as elsewhere, but on wealth. Thus there was unusual fluidity in the social scale. It is true, though, that before long a new wealthy middle class became dominant. Leading political and social roles became virtually hereditary in the powerful regent families who ruled the towns. On the other hand, men of various social classes had the opportunity to mingle in certain organizations that helped to weld a strong social structure. The civic guard groups, which had originally existed to serve a military function, became essentially recreational organizations, with some ceremonial intellectual responsibilities. More in their interests were the rederijkerkamers (chambers of rhetoricians), which specialized in literary activities, including plays and poetry competitions, usually based on historical and mythological subjects. There were such clubs in various towns in both the northern and the southern Netherlands. Both doelen (civic guards) and rederijkers commissioned important group portraits to be hung in their meeting rooms. The governing boards of professional and charitable institutions also supported art in this way.

THE HERITAGE OF DUTCH ART

A number of distinguishing characteristics help to define the art of the United Provinces as it grew to its full stature in the seventeenth century. In general terms, this school of painting is noted for its reflection of the close scrutiny of forms observed in the natural world. This is to be seen most obviously in the realistic landscape depictions, which differ sharply from the style of landscape paintings that had previously prevailed. A concern with phenomena of light was carried to a high degree of expressive force by Dutch painters. Also noteworthy is the unprecedented breadth of variety of subject matter, including a wide range of types of scenes from everyday life generally known as "genre." The independent still-life was endowed with new kinds of content and new vitality. Portraiture, too, provided the possibility for novel achievements, with especially interesting innovations in group portraiture. Earthy humor, often with satirical overtones, was another specialty of Dutch artists.¹⁰ These developments did not start in the seventeenth century from ground zero. They were anticipated by both earlier local traditions and foreign art.

Most of the subject-matter interests and stylistic achievements usually credited to seventeenth-century Dutch art were foreshadowed in paintings that originated in the fifteenth century in the same geographic area. At

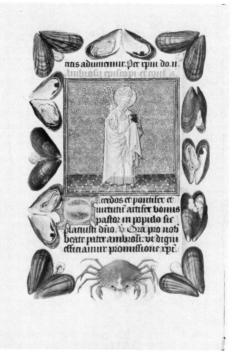

10. Hours of Catherine of Cleves, St. Ambrose with Mussel and Crab border.

this time in the northern Netherlands there was a religious movement that can be seen as a precursor to Protestantism. The *Devotio moderna* fostered individual spiritual devotion, independent of the church hierarchy. Taking human nature into account, it liberalized the religious life. The emphasis on the direct contact with Scripture led to personal interpretations and the production of many manuscripts. By the 1430s a great school of miniature painting had developed in Utrecht.

It is striking that in a single illuminated manuscript dating from about 1435, a masterpiece known as the *Book of Hours of Catherine of Cleves*, can be seen many of the features that we associate with seventeenth-century Dutch painting.¹¹ Some of the most impressive advances appear in relatively minor parts of the illuminations, such as borders or ornamental elements at the bottom of the page. The miniature featuring St. Ambrose is surrounded by a border that reflects the most careful observation of individual shellfish (10). Each of the eleven mussels is different from all the others. Contrasts of color and texture are meticulously rendered. This border did not, however, represent mere ornamentation or a capricious choice on the part of the artist. The eleven mussels represent the eleven faithful disciples, while the crab stands for the twelfth of the original disciples, Judas the betrayer.

Likewise for more than one reason, shellfish and their empty shells continued to appear in paintings through the seventeenth century. Surely they were attractive subjects for purely visual reasons. In addition, they were objects of scientific interest, an interest that was industriously cultivated by the Dutch, who pursued science and natural history not only for their inherent value but also for their possible contributions toward the practical goals of the ambitious maritime nation.

References to exploration and exotic places were implied in such paintings as Balthasar van der Ast's still-life, *Fruit and Flowers* (147), which shows shells from different countries. In his paintings with only a few shells, the shells always were from at least two different continents. It is likely that these facts—and the precise origins of the shells—were known to those who bought and hung such paintings. Shells from far places were among the items included in collections of interesting, beautiful, and exotic objects that were prized features of the homes of well-todo Dutch people who had some intellectual interests. Such collections, which were widely fashionable in Europe, customarily included art objects as well as souvenirs of antiquity and specimens of the wonders of nature.

Shells were also used with symbolic intent in still-lifes, in which empty shells, accompanied by other depleted and partially consumed elements, refer to the transience of earthly pleasures, a moralizing point that was repeatedly emphasized in Dutch art. The *Girl Salting Oysters* (143), painted with exquisite finish by Jan Steen in about 1660, employs the oysters in a different way, with erotic implications.

Fish, always important as food as well as for trade in the Netherlands, make up the border of a page in the Book of Hours of Catherine of Cleves in which St. Lawrence is the central subject. The patron of the poor, he holds a purse that represents his bestowal of alms. "Big fish eat little fish" was a popular proverb in the fifteenth and sixteenth centuries, referring to the poor being devoured by the rich. These elegant fish, the iridescence of their scales indicated with silver paint, thus are both aesthetically pleasing and symbolic of meaning beyond the obvious. Fish continued to play a part in Dutch painting in the seventeenth century. The typical Breakfast Still-Life of 1629 by Willem Claesz. Heda shows herring along with other humble items of food (149). Later in the century, as still-life compositions became more elaborate and concerned with costly objects, fish still found a place and sometimes were even starred, as in Abraham van Beyeren's opulent Fish Still-Life (152). Somewhat later, between 1661 and 1663, Emanuel de Witte painted Adriana van Heusden and Her Daughter at the New Fishmarket in Amsterdam (11), giving equal attention to the charming portraits, the rhythmic forms of the

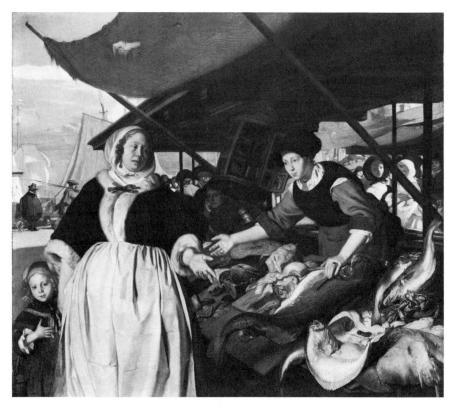

11. Emanuel de Witte, Adriana_van Heusden and her Daughter at the New Fish Market in Amsterdam.

stock of different varieties of fish, and the evidence of a bright, windy day at the water's edge.

De Witte's market scene that brings together the individualized human figures, the still-life elements, and the indication of the setting at a particular moment of observed light brilliantly exemplifies the achievement of Dutch seventeenth-century painters. Such subjects reflect sixteenth-century prototypes, particularly paintings and prints by Pieter Aertsen and his nephew and pupil, Joachim Beuckelaer.¹²

The depiction of naturalistic landscape might be considered a subcaption under the heading of the interest in all natural forms, but because it was developed so remarkably in Holland in the seventeenth century, it is worthy of attention in its own right. The *Book of Hours of Catherine of Cleves* provides a striking forerunner, an impressive landscape with aerial perspective successfully suggesting recession in space, based on observation.¹³ There were also fifteenth-century Dutch easel paintings in which

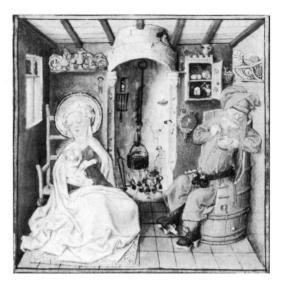

12. Hours of Catherine of Cleves, The Holy Family at Supper.

landscape was a major factor, for example, *Saint John the Baptist Meditating in the Wilderness* (Berlin, Dahlem Museum), painted in about 1485 or 1490 by the Dutch painter Geertgen, known as Geertgen tot Sint Jans, who was born in Leiden.¹⁴

Another outstanding aspect of Dutch seventeenth-century painting, the domestic scene in an interior setting, also had fifteenth-century ancestors. The Holy Family at Supper from the *Book of Hours of Catherine of Cleves* (12) is touchingly humanizing in its approach to an exalted religious subject and thus clearly represents an antecedent to treatments of this sort of subject two centuries later. It is close in spirit to *The Holy Family with Painted Frame and Curtain* (97), which Rembrandt painted in 1646. In Rembrandt's conception, as in the miniature from the *Book of Hours*, the Holy Family in their humble dwelling are engaged in common human activities; everyone can identify with them. This kind of intimate domestic interior becomes entirely secularized at the hands of a number of Dutch artists throughout the seventeenth century. The tenderness and family feeling in many cases continue to carry with them a sense of holiness. The deep concern for basic human relations expressed in these paintings is one of the essentials of Dutch painting.

Interior scenes were used in the seventeenth century to show all kinds of activities, and a great variety of interiors were depicted, among them the interiors of churches. This too was something unusual in the history of art. But again a miniature from the *Book of Hours of Catherine of Cleves*, The Pentecost (M-p. 52), shows that the church interior already existed in Dutch painting in the fifteenth century. There are also famous examples of church interiors painted by Jan van Eyck in the early fifteenth century. These were the pioneering examples in easel paintings of this type of composition. Geertgen tot Sint Jans depicted The Holy Kinship in a church in about 1485-90 (Amsterdam, Rijksmuseum). These are the ancestors, so to speak, of the kind of church interiors painted in the seventeenth century by Pieter Jansz Saenredam and others, who in a sense secularized the image. It remains a church, but it is not the setting of a devotional subject. When Jan van Eyck painted the interior of a church, the Madonna or, in another case, an Annunciation was within it. In seventeenth-century Dutch church interiors there are figures, but they represent ordinary people carrying on their everyday activities. Thus even the church interior is humanized. The buildings themselves, which are the primary interest, are shown in relation to their social uses. Some of the paintings are more or less accurate depictions of specific existing architecture, while others are more fanciful, sometimes combining elements from different churches.

One of the recognized achievements of seventeenth-century Dutch painting is the resourceful expansion of the expressive possibilities of light. This too was heralded in the fifteenth century, as is evident in *The Nativity at Night* (13) by Geertgen tot Sint Jans, in which the foreground figures are illuminated by the radiance emanating from the Christ Child.

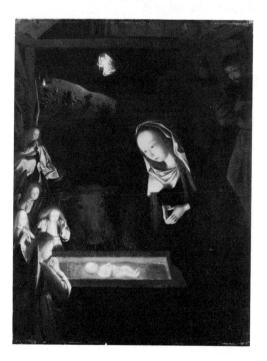

13. Geertgen tot Sint Jans, *The Nativity at Night.*

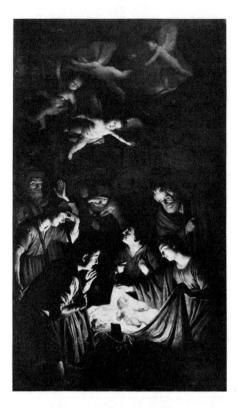

14. Gerrit van Honthorst, *The Adoration* of the Shepherds.

The angel in the background glows with supernatural light, and the shepherds to whom he is announcing the birth of the Saviour are seen in the light of their bonfire. The concern with light sources within the picture went on into the seventeenth century, when it was particularly noteworthy among Caravaggist painters. In The Adoration of the Shepherds (14) by Gerrit van Honthorst, one of the leading painters from Utrecht in the early seventeenth century, there are similar luministic effects. The interest in nocturnal scenes was not confined to Dutch artists; it found distinctive expression also in Northern Italian painting in the sixteenth century and in Rome in the seventeenth. The earliest examples were Dutch, however, and outstanding seventeenth-century Dutch artists continued the tradition of painting nocturnes. Among them was Rembrandt. Going far beyond the interest in the technical aspects of representing illumination within the picture, he showed his mastery of chiaroscuro as an emotional force in his early drawings and etchings as well as paintings. In The Presentation of Jesus in the Temple (15), painted in 1631, Rembrandt used light as a symbol of revelation. Of all artists he was the most eloquent interpreter of both light and the lack of light. The entirely different quality of light in the paintings of Johannes Vermeer is no less admired.

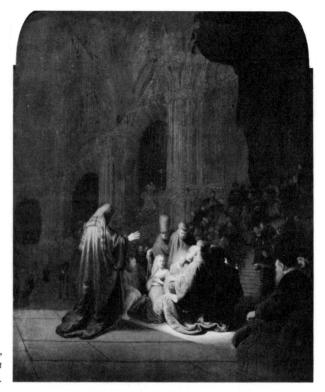

15. Rembrandt, *The Presentation* of Jesus in the Temple.

Portraiture was another area in which fifteenth-century Netherlandish innovative masters—Jan van Eyck, Petrus Christus, Robert Campin, and Roger van der Weyden among them—set a superb standard that might well have provided inspiration for later painters. In the special field of group portraiture, in which the seventeenth-century Dutch were peerless, it was again Geertgen who was the pioneer. In another painting dealing with the patron saint of the order in which he was a lay brother, *The Story* of the Remains of John the Baptist (Vienna, Gemäldegalerie), portraits of three groups of men associated with the order are included. The independent group portrait became a Dutch tradition in the sixteenth century, before coming to its full flowering in the seventeenth.

It does not in the least detract from the achievements of the Dutch painters to note their indebtedness to their predecessors. Indeed, comparisons with the earlier works serve to emphasize the originality and independence of vision of the seventeenth-century artists. From the historical viewpoint, however, it is important to recognize the evident precedents. Similarly, the acquaintance of the Dutch painters with works by foreign artists also helps us to understand their place in the history of art, as we shall see in relation to specific paintings.

3/ Utrecht: from Mannerism to Caravaggism

TRECHT IS THE NAME of a province, one of the seven provinces that formed the independent nation called the United Provinces or the Dutch Republic. It is also the name of the major city in this province, which was one of the few great Dutch painting centers outside the province of Holland. Utrecht was a bishopric from the eighth century and had long been an important Catholic center, and it remained a Catholic enclave in the midst of the officially Calvinist nation that the independent Netherlands became.

The Mannerist style in painting, which was dominant internationally by the latter part of the sixteenth century, prevailed in all of the prominent Dutch centers of painting at the beginning of the seventeenth century.¹ Dutch Mannerism of this period is interesting to us mainly as the style that was being abandoned at the onset of the great strides forward in Dutch art, having had its highest point at about the time of the Union of Utrecht in 1579. The artists in the generation active around 1580 were generally Mannerist painters. The roots of the Mannerist movement go back to the great High Renaissance masters, Michelangelo and Raphael, and their followers. The Mannerist style continued into the seventeenth century in Italy as well as in the Netherlands.

Typical of the jaded and derivative nature of late Dutch Mannerism are the works of the Utrecht painter Joachim Wttewael, who remained a Mannerist throughout his career. Wttewael, who lived from 1566 to 1638, was in Italy from 1586 to 1588. He lived in Padua and was familiar with Venetian painting as well as with Tuscan Mannerist painting. On his

Utrecht

return to the Netherlands he traveled by way of France, where he could have seen paintings in a highly evolved Mannerist style developed by the School of Fontainebleau, under the leadership of Rosso Fiorentino and, after his death, of Primaticcio. By 1592 Wttewael had returned and settled in Utrecht, where he painted mythological and religious subjects, as well as kitchen scenes, in the sharp colors and complex compositions that characterized the Mannerist style of his entire production.

Wttewael's painting of *Diana and Actaeon* (16), signed and dated 1607, is an example of the Mannerist proclivity for nude figures in crowds, often in stressful or even impossible poses, which sometimes look like classical *contrapposto* carried to absurd lengths. Frequently the figures are arranged in pairs so that the action of one counters that of his companion. Mythological subjects lent themselves well to this kind of treatment, but Mannerist artists did not hesitate to deal with religious subjects in a similar manner. Wttewael's elongated figures with small heads follow the usual Mannerist scheme of proportions. Male figures tend to be overmuscular; they are exaggerations of Michelangelesque nudes in both muscular development and pose. There is no concern for the convincing representation of space. Such features as trees and draperies take

16. Joachim Wttewael, Diana and Actaeon.

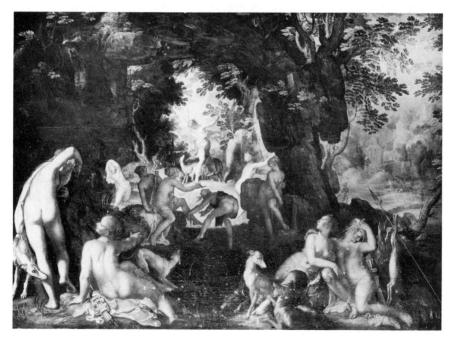

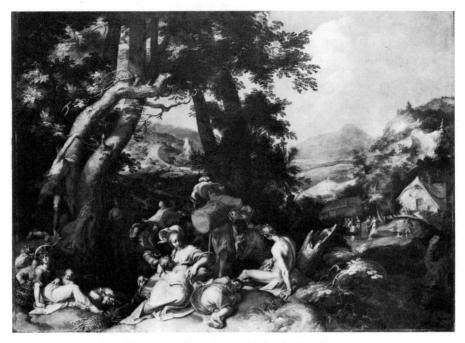

17. Abraham Bloemaert, Preaching of John the Baptist.

the form of extravagantly decorative arabesques. There is also a Mannerist taste in colors: unusual, overrefined colors, with emphasis on the effects of changeable taffetas and other attention-claiming fabrics and ornaments. The Mannerists might be called a school of artificialists as opposed to naturalists. To mirror not nature, but their own conceptions was their goal. In many cases it is not easy to discern what the subject of a Mannerist painting is, for the chief characters in the narrative may be almost lost to sight in the overpopulous scene, in which they are not given a prominent or central position.

The main line of development of Dutch painting in the early seventeenth century was directly contrary to the Mannerist style. The advanced artists looked not inward, but to the outer world for their imagery. Artists like Wttewael who persisted in the Mannerist mode became oldfashioned. Some of his contemporaries changed with the times. One such was Abraham Bloemaert.

Born in the town of Gorinchem in 1564, Abraham Bloemaert started with works in the Mannerist style, but in the course of his long career he adapted to the successive new trends in painting as he came into contact with them. He was a pupil first of the Mannerist painter Cornelis van Haarlem and afterward, in Utrecht, of Joos de Beer. In about 1580 he went to Paris, where he worked with the Antwerp-born Mannerist painter

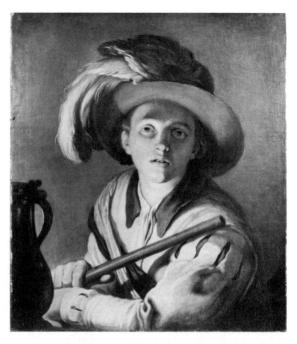

18. Abraham Bloemaert, Flute Player.

Hieronymus Francken. Bloemaert would very likely have had the opportunity to see the famous Mannerist paintings in Fontainebleau. From about 1591 to 1593 he lived in Amsterdam, and from about 1593 on, in Utrecht, where he died in 1651.

The facial and figural types in Bloemaert's *Preaching of John the Baptist* (17), painted in about 1600, are closely related to Antwerp Mannerist works. Though this is a subject that does not require nudity, bare skin is prominently displayed. The preaching saint is almost hidden in shadows under the large twisted tree at the left. The landscape too is Mannerist in style, with unlikely crags, eccentric branches, and decorative patterns of leaves, reflecting the artist's imagination rather than observation of nature. The buildings are more picturesque than realistic. Later Bloemaert's landscapes as well as his figures were to become much closer to natural forms based on visual experience, and his compositions were to become clearer and more stable.

Bloemaert was important as a teacher. He taught, among others, Cornelis Poelenburgh, Jan Both, and Jan Baptist Weenix, who later went to Rome and were among the most accomplished of the group known as Romanist landscape painters. He also taught some of the painters who were to become known as the Utrecht Caravaggists: Honthorst, Terbrugghen, and van Bijlert. Though he himself never went to Italy, these

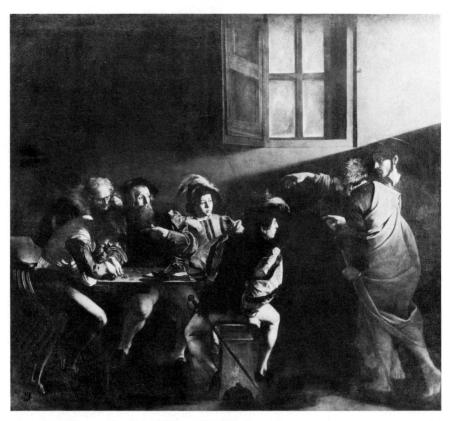

19. Caravaggio, The Calling of St. Matthew.

former students of his went to Rome, where they were strongly influenced by the Caravaggist school of painting, and when they came back to Utrecht they familiarized him with the new style.² As a result Bloemaert also painted some pictures that clearly show Caravaggist influence. Caravaggist in subject matter as well as in style is Bloemaert's *Flute Player* (18), which is signed and dated 1621, by which time both Terbrugghen and Honthorst had returned to Utrecht.

Hendrick Terbrugghen was born in 1588 of a wealthy Catholic family, who moved to Utrecht when he was a baby.³ His earliest training was in the studio of Abraham Bloemaert in Utrecht. When he had completed his studies with Bloemaert, he went to Italy, spending time in both Rome and Naples. Arnold Houbraken, whose book *De Groote Schouburgh* was published in 1718–21, says that Terbrugghen went to Italy in 1604. He is thought to have spent about ten years there. He was back in Utrecht by 1614 and became a master in the guild in 1616–17. He married in Utrecht in 1616 and apparently remained there until his death in 1629. He was the

Utrecht

earliest Utrecht painter to go to Italy and to return to Utrecht with the Caravaggist style. He is also the only one of them who could have met Caravaggio, who had to flee from Rome in 1606, having murdered a man, and who died in 1610 without having returned to Rome. But of course all of these artists would have seen works by Caravaggio in Rome and also could have known Italian followers of Caravaggio and seen their works. Meeting with Caravaggio himself was not essential to the development of a mode that reflects some of the stylistic features that proved so influential.

We do not know any works that Terbrugghen painted in Italy or immediately afterward. During his brief career he painted some religious subjects and numerous genre pictures. His two versions of *The Calling of St. Matthew* show the marked progress that he made during the few years that separate them. They also give evidence of Terbrugghen's familiarity with Caravaggio's painting of this subject (19) which was painted between 1597 and about 1601 for the Contarelli Chapel in the Church of San Luigi dei Francesi in Rome. Terbrugghen's version of *The Calling of St. Matthew* in the Le Havre Museum bears every mark of an early effort. It has been assigned a date of about 1617. Terbrugghen's later version of *The Calling of St. Matthew* (20) is a revision of the earlier work. Ap-

20. Hendrick Terbrugghen, The Calling of St. Matthew, 1621.

33

parently the artist was dissatisfied with the earlier version and felt that he could improve it. In the 1621 painting he brought the figures closer to the picture plane. In contrast with his previous version, which followed rather faithfully Caravaggio's open, spread composition, Terbrugghen's figures now form a compact mass. This is typical of his mature works; he prefers a closed compositional arrangement, whether of a single figure or a group of several, filling the picture space with solid weight and volume. In cutting the figures down to three-quarter length, he eliminated the foreground details. He also simplified the background.

Terbrugghen reversed Caravaggio's composition, putting Christ and his companion on the left, but he retained Caravaggio's repoussoir figure in the foreground. The function of the *repoussoir* is literally to push back. He establishes the foreground plane, thereby giving a sense of the distance between us and the other figures, whom we understand to be on a deeper plane in space. Repoussoir figures appear frequently in Dutch painting; they function as a major force in establishing the spatial depth that is characteristic of painting in the seventeenth century. Also borrowed from Caravaggio is the typical Terbrugghen device of including a figure in profile against the light. Caravaggio was famous-or infamous-for depicting ordinary people even in religious subjects, but compared with Terbrugghen's northern candor, Caravaggio's figures look handsome and idealized. Terbrugghen's modeling is smooth and firm, with exquisite reflected lights in the shadowed parts. His colors, much less robust than Caravaggio's, tend to be subtle, modulated hues, such as lavenderish gray and silvery blue, with delicate variations of tone in the folds of the materials. His unusual color harmonies are one of the aspects of his style that make his paintings immediately identifiable. The silhouetting of figures against a light ground was a brilliant innovation that was adopted by later artists, including Carel Fabritius and Johannes Vermeer.

A Shepherd Playing a Recorder (21) demonstrates Terbrugghen's particular affinity for the single-figure genre subject, especially the solitary musician or singer, which was very popular among the painters who followed in the footsteps of Caravaggio, both the Italian artists and those from other countries. One of the things that differentiates Terbrugghen's pictures of this kind from other artists' is the self-contained quality, the sense of removal from the hurly-burly of the world, the complete indifference to the environment, that characterizes his figures. His recorder player is circumscribed in a closed, contained composition.

In contrast, Caravaggio's early pictures in which he dealt with similar subjects tend to bring the observer into the action through the gaze and gesture of the figures depicted. Terbrugghen's strong modeling and the unification of the picture through light, the use of half-length or three-

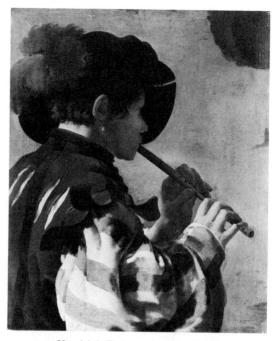

21. Hendrick Terbrugghen, A Shepherd Playing a Recorder.

quarter-length figures close to the picture plane, the indication of a very shallow area of space, all are features that he shares with Caravaggio and his followers. (Some of the characteristics that we associate with Caravaggio's name were not, in fact, invented by him. Because he was the outstanding master of this revolutionary trend in painting in Rome at the turn of the seventeenth century and because his powerful influence attracted followers who spread this style internationally, we speak of this important stylistic trend in seventeenth-century painting as Caravaggesque and of the painters who adhered to it as Caravaggists.)

In composing *The Liberation of St. Peter* (22), Terbrugghen limited himself to two half-length figures shown close to the picture plane, unified by sharply focused light, in the Caravaggesque way. Though they are fully modeled and convincingly three-dimensional, they do not occupy deep space. This painting, which appears to be a late work, depicts the imprisoned St. Peter at the moment when "the angel of the Lord came upon him, and a light shined in the prison: and he smote Peter on the side, and raised him up, saying 'Arise up quickly,' and his chains fell off from his hands'' (Acts 12:7). St. Peter's hands project into the fore-ground space as he holds them up before him prayerfully. The angel, touching St. Peter's shoulder gently, speaks into his ear and points up-

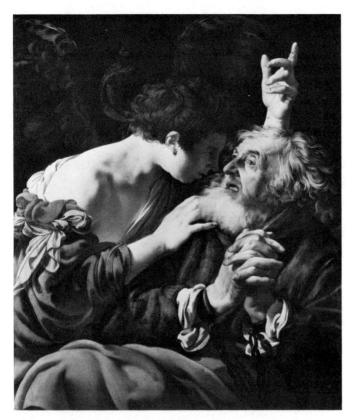

22. Hendrick Terbrugghen, The Liberation of St. Peter.

ward with a common human gesture to indicate that he is a messenger from God. The amazed old man and the matter-of-fact young angel are closely knit compositionally, so that the two figures form a unity. Filling almost the entire picture space, they constitute a contained pyramidal composition, with the upraised hand of the angel as the apex. Terbrugghen's personal and yet, in more general terms, northern interpretation of Caravaggio's naturalism makes it clear that Caravaggio's appeal to the Dutch artists rested in part at least on their interest in the depiction of ordinary people and observed objects, which Caravaggio had incorporated into a new mode in art.

A Terbrugghen painting of 1625 shows a subject that was popular in the seventeenth century, both in Italy in North of the Alps, *St. Sebastian Attended by St. Irene* (23). Earlier art had usually shown St. Sebastian standing, tied to a tree, being shot at by archers and wounded by a number of arrows. (This was not, strictly speaking, the martyrdom of St. Sebastian, because he survived, only to be martyred later by being beaten

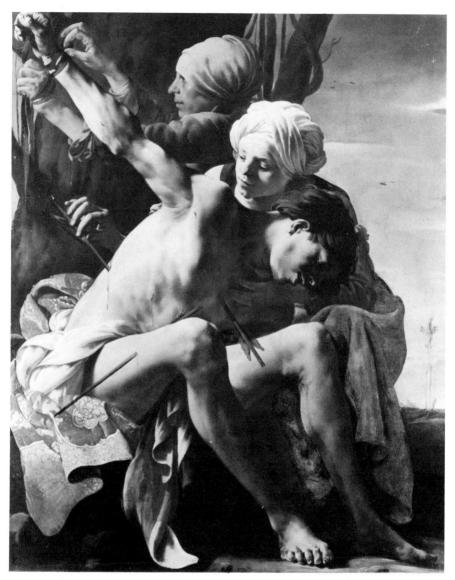

23. Hendrick Terbrugghen, St. Sebastian Attended by St. Irene.

with clubs.) According to St. Sebastian's legend, a Roman matron, Irene, and her maid or helper came to his aid. This picture shows the moment when the holy women are untying St. Sebastian and tending his wounds. Again Terbrugghen includes only the minimum necessary to make the episode clear, economizing on space in his characteristic way. He does not skimp on the plasticity of the life-size figures, but brings them together in a compact, unified grouping. Together they form diagonals that go not only across the face of the picture but into the depth of the picture space. Differences in lighting establish the locations of the three figures at different planes in depth. The arrow at the left almost penetrates our space. There is minimal involvement with the desolate landscape; this is Terbrugghen's only painting with a landscape setting.

The rawboned figure and face of the saint are typical of Terbrugghen, who seems to have been constitutionally averse to idealization. He visualized the saint as a simple Dutch young man. His bony structure is emphasized, stressing the irregularities of the features. Again, the face of the saint is turned away from us, so that the features are in shadow. The reflected lights in the shadowed parts are realized with great subtlety. The surface is a smooth, even plane, which implies the removal of the personality of the artist, to a certain degree, from the painting. The air of reserve is fostered also by the fact that in this painting—as in others by Terbrugghen—no figure looks toward us or in any way involves us in the event depicted.

Gerrit van Honthorst was, to his contemporaries, the most successful of the Utrecht Caravaggists. A good deal of information about Honthorst is provided by the German painter and writer on art, Joachim von Sandrart, who was a pupil of Honthorst's in Utrecht in 1627, some years after Honthorst's return from Rome, and remained his assistant for a time. Sandrart reported that Honthorst was reserved and melancholic; on the evidence of the paintings one would think that these characteristics might rather be associated with Terbrugghen.

Honthorst was born in Utrecht on November 14, 1590. He was thus two years younger than Terbrugghen, and he too was a pupil of Bloemaert. Around 1609 or 1610, at the end of his period as a student, he went to Rome, where he became known as "Gherardo delle Notte" ("Gerard of the Nights") as his nocturnal scenes made him famous. He carried out important commissions for paintings for churches and palaces. He lived in the palace of the great Roman collector, the Marchese Vicenzo Giustiniani, and some of his pictures were in this famous collection for a long time, which provides useful early documentation of these works. Cardinal Scipione Borghese, nephew of Pope Paul V, also commissioned paintings by him. We know that Honthorst copied pictures by Caravaggio. A drawing he made in 1616 after Caravaggio's *Crucifixion*

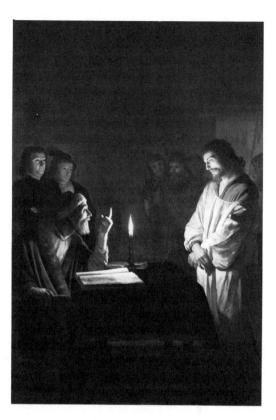

24. Gerrit van Honthorst, Christ Before the High Priest.

of St. Peter still exists; it is Honthorst's earliest known dated drawing.

Honthorst's painting of *Christ Before the High Priest* (24) was one of the Giustiniani commissions, probably painted in 1617. The candle, the central focus, casts light on the figures in proportion to their proximity to it. The face and arm of the seated High Priest and the pages of his open book are brilliantly illuminated, as are the face, hands, and white garment of Christ. The nearer onlookers are clearly delineated, while the more distant ones almost merge with the shadows. Pikes are seen through the doorway in the background at the right side, against which the dark outlines of Christ's contours are silhouetted. This monumental altarpiece, with its grave dignity and communicativeness, must be reckoned as an outstanding work of this period in the history of art.

In *The Adoration of the Shepherds* (14), whose coloristic warmth shows Venetian affinities, Honthorst introduced a striking seventeenth-century naturalism in the light effects, as compared with its forerunner from the fifteenth century (13). Honthorst's shepherds find it necessary to shield their eyes against the divine radiance of the Christ Child.

Typically Caravaggesque in its composition is Honthorst's Samson and Delilah (25), with three half-length figures at the foremost plane. Again a lighted candle is the focal element, and the flesh tones are redtinged where the candlelight plays on them. Delilah delicately snips Samson's locks with scissors that are absurdly small in relation to the damage they are doing. The maid's gesture for silence is directed toward the Philistine soldiers who must be presumed to be waiting in hiding until Samson's haircut deprives him of his strength. This picture was probably painted in about 1619, which is the time of origin of a painting of this subject by Guercino, which apparently served as Honthorst's model. That Honthorst was still in Italy in 1619 is proved by a signed drawing bearing that date and the inscription "in Roma."

In 1620 Honthorst returned to Utrecht. He became a master in the Guild of St. Luke there in 1622. His prominence is indicated by the report that he had twenty-four pupils, each paying a fee of one hundred florins. There was no essential change in his style immediately after his return to Utrecht. Mostly he painted night scenes in interior settings with a light source either wholly in evidence or concealed by one of the fig-

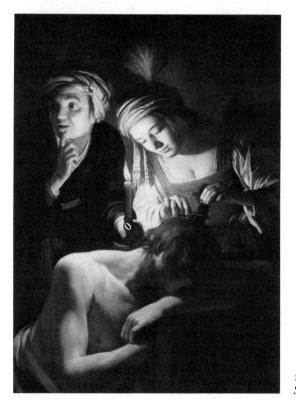

25. Gerrit van Honthorst, Samson and Delilah.

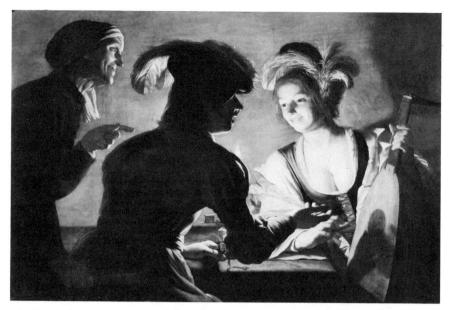

26. Gerrit van Honthorst, The Procuress.

ures. Usually they were tavern or brothel scenes with two or three participants, a popular Caravaggist type of composition that referred more or less explicitly to the Parable of the Prodigal Son who "squandered his property in loose living" (Luke 15:13). Honthorst had already painted such subjects while in Italy, including a Merry Company (Florence, Uffizi) that was commissioned by the Grand Duke of Tuscany. These pictures often contrast a dark male repoussoir figure, seen against the light, with a brightly illuminated woman, as in The Procuress, dated 1625 (26). The ruddiness of the skin tones, heightened by nearby candlelight, is characteristic of Honthorst's style of his Caravaggesque years. The old procuress at the left grins approvingly as the young man, who grasps his money bag with his left hand, offers a coin to the smiling young woman. The young woman holds a lute, a commonly understood symbol for harmony in the sense of agreement. Music had long been associated with amorousness in art, and a lute player was often included in "Merry Company" or "Prodigal Son" compositions.

In 1627 Rubens visited Honthorst during a trip to the northern Netherlands, and the following year Honthorst went to England, perhaps at the suggestion of Rubens or as a result of his recommendations to patrons there. For King Charles I, Honthorst painted a huge allegorical group portrait, probably intended for the Banqueting House in Whitehall but now exhibited in Hampton Court Palace, representing *Mercury Present*- ing the Liberal Arts to Apollo and Diana in the persons of King Charles and Queen Henrietta Maria. The Duke of Buckingham was cast in the role of Mercury. Honthorst's Caravaggesque style was dissipated under the demands of this commission, which he executed in a bombastic manner. The picture was well received, however. Honthorst was not only generously paid, but was given costly presents. He also painted some portraits of individual courtiers in England.

In the 1630s Honthorst was kept busy with formal portraits and large decorative commissions, which lacked the vigor of the night pieces that had made him famous. In 1637 he became official court artist for Stadholder Frederick Hendrick in The Hague. Settling on a formula, he painted numerous commissioned portraits, dull, dry, and cold in color. He also produced big allegorical compositions for the castles of Ryswijck and Honselaersdyck and, in 1649–50, after the death of Frederick Hendrick's widow, Amalia van Solms. Honthorst died in 1656 in Utrecht, having spent there the years from 1652 until his death.

Dirck (or Theodor) van Baburen, a Dutch Caravaggist of lesser interest, was born in Utrecht in 1590 and died there in 1624, but oddly enough he was never a pupil of Bloemaert, who taught so many of the other painters of that period. He was a student of Paulus Moreelse in Utrecht. Like Terbrugghen and Honthorst, Baburen went to Rome and spent a long time there, from 1611 to about 1622. He too had important commissions in Rome and was much influenced by the style of Caravaggio. In a painting of The Entombment (Rome, San Pietro in Montorio), for instance, Baburen adhered quite closely to Caravaggio's composition in the Vatican, a dramatic and well-known painting. Baburen's figures tend to have squared-off skulls and awkwardly depicted facial features. They often have bright red noses that made them look like country bumpkins. We see this sometimes in Terbrugghen too. Baburen is more awkward and at the same time closer to Caravaggio than the other Utrecht Caravaggists generally are. Only about twelve pictures can firmly be ascribed to him. One reason he interests us is that in 1622 he painted The Procuress (27), which was depicted by Vermeer in the background of two of his paintings, The Concert (210) and Lady Seated at the Virginals (220). As a painting within a painting at this period commonly contributed to the meaning of the whole, Vermeer's use of The Procuress may be understood as a clue that the seemingly polite scenes that he depicted were related to the theme of prostitution or licentiousness.

The subject matter of the brothel, so frequent in works by the Utrecht Caravaggists, had appeared in earlier Netherlandish art. Prints and paintings by Lucas van Leyden, for example, dealt with such scenes. In the course of the seventeenth century, some Dutch artists depicted uncouth

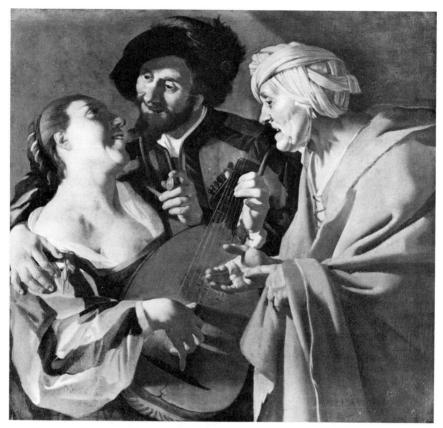

27. Dirck van Baburen, The Procuress.

peasant scenes in taverns, in which all kinds of lascivious acts take place, in addition to other behavior that would have been considered reprehensible, such as smoking, drinking, and gambling. Other painters, such as Gerard ter Borch and Johannes Vermeer, were more subtle. In their pictures the erotic content is disguised; the individuals shown appear to be elegant, proper, and even aristocratic. There are veiled references, however, that associate these works with the continuing thread of eroticism that can be traced through the sequence of Dutch seventeenth-century painting. There seems to have been a steady market for pictures of such subjects; this is perhaps a measure of the Dutch people's ambivalence toward sensuous pleasures.⁴

4/ Haarlem: Strides Toward Naturalism

GOLTZIUS' ROLE

N UTRECHT, as we saw, there was a renunciation of the late Mannerist style that prevailed in the last decades of the sixteenth century. As the seventeenth century advanced, Mannerist artificiality was generally abandoned in favor of naturalism, clarity, and calm. A similar movement away from the Mannerist aesthetic took place in Haarlem, where in the early years of the seventeenth century there were remarkably innovative artists who based their works on observation. Their interests were different from those of the Utrecht school, however, and they extended the range of subject matter to areas not explored in painting previously. This dramatic advance followed an exceptionally fruitful Mannerist period.¹

One of the leaders among the Haarlem Mannerists was Carel van Mander, who was born in western Flanders in 1548. He spent the years from 1573 to 1577 in Italy. From 1583 to 1603 van Mander lived in Haarlem, where his Mannerist tendencies were moderated. When he died in 1606, few of his drawings and paintings were found in his house, his biographer wrote, "because he tired very easily from looking at his own work, he could not stand to have it near him." The *Adoration of the Shepherds* (28) is a fair example of his style in 1598. It is a feeble version of this traditional subject, with the familiar device of the Christ Child as the source of light.²

Today van Mander's contributions to the history of art are considered to lie more in his writings than in his paintings. His book, *Het Schilder-Boeck* ("The Painter's Book"), which was published in 1604 in Haarlem,

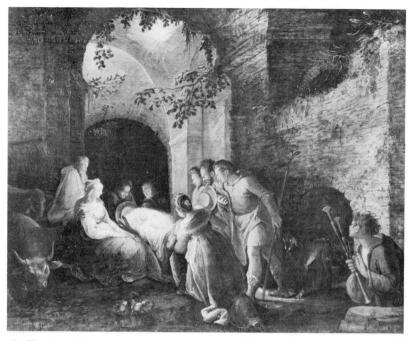

28. Karel van Mander, Adoration of the Shepherds.

included, besides biographies of artists, "The Fundamentals of the Noble and Free Art of Painting." This versified version of the Mannerist art theory that prevailed in Italy in the late sixteenth century reflected the views of such authors as G. P. Lomazzo and Federigo Zuccaro, who stressed that the artist's goal was not to mirror nature, but to communicate his idea (*disegno interno*), which surpasses nature, and who exalted "history" painting above other kinds of subject matter. At the same time, van Mander spread the word that "one called Carracci" had painted a gallery in fresco whose "beauty cannot be expressed," and that Caravaggio also "does wonderful things." These references to the post-Mannerist trends in painting in Rome may well have spurred some Dutch painters to go to Italy and, once there, to seek out the works of the innovative painters, particularly Caravaggio and his followers. These paintings pointed a way out of the Mannerist thicket, on the road toward naturalism.

There had still been receptivity to Mannerism among artists in Haarlem when van Mander arrived there in 1583. His book tells that he brought drawings by Bartholomeus Spranger from Italy and taught "the Italian style" to Hendrick Goltzius and Cornelis Cornelisz. van Haarlem.⁴ Spranger's painting *Venus and Adonis* (29) shows the suave Man-

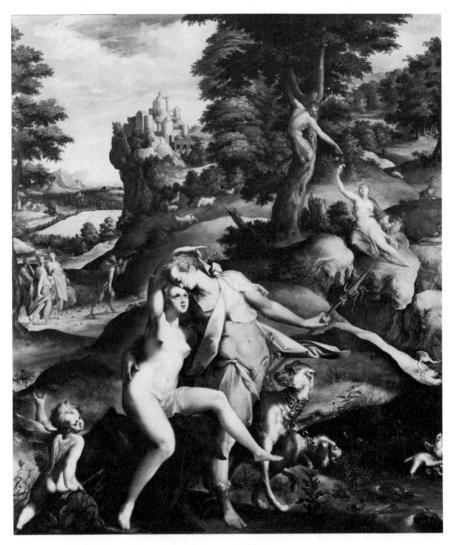

^{29.} Bartholomeus Spranger, Venus and Adonis.

nerist elegance that made him fashionable. Typical of Mannerist taste are the elongated figures with small heads, the distortion not only of figures but of space itself, and the exotic mixed colors, such as orange-pinks and lavenders. Spranger, born in Antwerp in 1546, had traveled through France and worked under distinguished patronage in Italy and for the court of Rudolph II in Vienna and Prague, where he died in 1611. He often borrowed poses from Italian Mannerist painters, including Perino del Vaga, Bandinelli, Salviati, and Bronzino. His adaptation of the cur-

30. Hendrick Goltzius, engraving after Bartholomeus Spranger, The Marriage of Cupid and Psyche.

rent style in Italy proved to be attractive to artists north of the Alps, who came to know his works mainly through drawings and prints.

Hendrick Goltzius, for whom van Mander expressed great admiration, seems to have been the central figure in a group of painters active in Haarlem until his death there in 1617. His originality and his genius as a graphic artist might well have stimulated his associates. Despite the fact that his right hand was maimed, having been injured in a fire when he was a child, Goltzius had superb technical virtuosity. He was praised for his ability to imitate convincingly the styles of great masters of graphic art of both the previous century and his own time. Besides engravings, Goltzius designed excellent chiaroscuro woodcuts. He was also famous for his pen drawings, in some of which he used a swelling line that imitates the engraved line. The painters in his circle apparently soon responded to Goltzius' first engravings after works by Spranger, which were available by 1585. Around the same time, prints of his own design reflected Spranger's style. The engraving The Marriage of Cupid and Psyche (30), by Goltzius after Spranger, is dated 1587. It exemplifies the predilection for nudes and the elaborate, involved kind of multifigural composition by Spranger that Goltzius helped to popularize among Dutch artists.

Goltzius was born near the town of Venlo in 1558. He came to Haarlem in 1577 to work with Dirck Volkertsz. Coornhert, a well-known printmaker, who had previously been his teacher in Xanten. Goltzius was closely associated with van Mander and Cornelis in Haarlem until he left in 1590 to go to Italy by way of Germany. In Rome he made many drawings after antique statues and Renaissance sculptures. According to van Mander, he was also impressed by the paintings of Raphael, Correggio, Titian, and Veronese. When he returned to Haarlem late in 1591, his style had been changed by these experiences.

There is reason to believe that Goltzius was the key figure in the striking advances toward naturalism in painting in Haarlem. It is possible that his presence there attracted other gifted artists. The artistic ferment in Haarlem tapered off after his death on January 1, 1617. The naturalistic shore scene he drew as the setting for his *Beached Whale* (4) is but one of many pieces of evidence of the respect for the observation of nature that distinguished his work before the end of the sixteenth century. During the first two decades of the seventeenth century, naturalistic landscapes, interior domestic scenes, and scenes of social life in both indoor and outdoor settings—reality-oriented types of compositions that were to become highlights of Dutch painting—received their early impetus in Haarlem.

EARLY SEVENTEENTH-CENTURY LANDSCAPE IN HAARLEM

In the early years of the seventeenth century in Haarlem a new, realistic approach to the depiction of the independent landscape became evident, first in drawings and prints, not long afterward in paintings.⁵ The interest in the close observation of nature that is apparent in some Netherlandish paintings of the fifteenth century was in abeyance in the sixteenth. When religious scenes required landscape settings, the sixteenth-century painters in the Netherlands consulted their imaginations or the works of earlier artists rather than nature. They generally adhered to certain conventions of composition and color, with a predominantly brown foreground plane, green in the middle ground, and blue characterizing the distant plane. The fantastic landscape views that became standard types were anticipated in paintings by Joachim Patinir, who became a member of the Antwerp guild in 1515 and lived until about 1524. Patinir pioneered in introducing naturalistic details into the conventional stratified compositions. His landscape paintings, which were usually dominated by high crags framing decorative panoramas, were enlivened by observed natural forms. Most of his works include small religious or mythological scenes in these dramatic landscape settings, but in some cases there is no narrative content. Patinir has been widely credited, therefore, with painting the earliest independent landscapes; the Landscape with Cliffs and Bay (Rotterdam) is such a picture. The numerous series of prints based more or less closely-on landscape drawings by the great Pieter Bruegel the Elder played an important part in the dissemination of this approach to landscapes. The drawings Bruegel had made of the Alps on his way to

Haarlem

Italy in 1553–54, mingled with aspects of his native Flemish landscape of dunes, meadows, and villages, served as raw material for engravers spanning more than half a century.

This Flemish tradition of aggrandized mountain landscapes into which some naturalistic features were inserted was carried on into the seventeenth century by Joos de Momper the Younger, who was born in Antwerp in 1564 and died there in 1635. After becoming a member of the Antwerp guild in 1581, he made extensive trips in Switzerland and Italy, so that he certainly had the opportunity to observe real mountains. But he depicted mountainous landscapes according to the fixed formula, generally with brown mountains on one side in the foreground, a greenishocher middle ground on the other side, and a blue valley fringed with peaks in the distance.

A link between the Antwerp landscape tradition and Dutch painting was provided by Gillis van Coninxloo, born in Antwerp in 1544, who left the southern Netherlands as a religious refugee in 1585, spent some years in the German town of Frankenthal, along with some other Flemish artists, and lived in Amsterdam from 1595 until his death in 1606. He was the teacher of Hercules Seghers and possibly of other Dutch landscapists. His works were characteristic of the Flemish Mannerist landscape style: panoramic views, with mountains and river valleys, in the tradition of Patinir and Bruegel (31). Separate planes of brown, green, and cool blue provide differentiation between foreground, middle ground, and background. The sharp contours of the foliage have a tapestrylike, decorative quality. Light and shadow create lively accents.

This imaginative and romantic Flemish landscape tradition found eloquent exponents among Dutch seventeenth-century painters, foremost among them two great individualists: Hercules Seghers and Rembrandt. Hercules Seghers' paintings are extremely rare, and little is known about his life. He was probably born in Haarlem in about 1590; he became a master in the guild there in 1612. During Coninxloo's last years, in Amsterdam, Seghers was apparently his pupil, as his last tuition payment was still due when Coninxloo died. Seghers seems to have lived in poor circumstances, mainly in Amsterdam. At the age of twenty-two he married a woman of forty, if contemporary reports are to be believed. He was said to have been melancholy and to have become an alcholic. No more is heard of him after about 1635. But he was not without admirers in the seventeenth century. Rembrandt owned eight of his paintings.

Seghers' Landscape in the Meuse Valley (32), dating from about 1625–27, is in the low horizontal format that he favored. Unlike most other Dutch landscapists, in his earlier paintings he provided little space for the sky. The rich textural quality, the prevalence of warm ocher and sienna tones, and the subtle play of light are characteristic of Seghers'

31. Gillis van Coninxloo, Landscape with Venus and Adonis.

32. Hercules Seghers, Landscape in the Meuse Valley.

33. Hercules Seghers, View of Amersfoort, etching.

paintings. As with the Flemish tradition that he must have learned from his teacher, Coninxloo, the cliffs at the right establish a foreground plane beyond which the vista stretches interminably. Seghers made the traditional format over into something that was his own, unified by overall patterns of color and texture, with mysterious, moody overtones. Similar panoramic views were the subjects of some of his most impressive etchings.

An original and highly gifted painter, Seghers was equally outstanding as a graphic artist. The chronological relation of his graphic works to his paintings is not clear, but it may be that Seghers, like his colleagues in Haarlem, made his experiments in etchings, such as the panoramic *View of Amersfoort* (33). Seghers appears to have been the first artist to use the aquatint technique. This would be in keeping with the feeling for texture that his paintings reveal, for aquatint can add a rich textural note to the etched plate. The *Great Landscape with a Wooden Rail* (34) has a quality of equal tension over the whole surface quite unlike the contrasted positive and negative areas that are usual in compositions by other print

34. Hercules Seghers, Great Landscape with a Wooden Rail, etching.

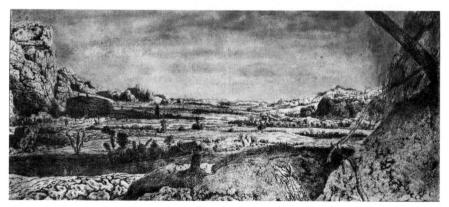

35. Hercules Seghers, *The Larch*, etching.

36. Hendrick Goltzius, Landscape with a Farmyard, drawing.

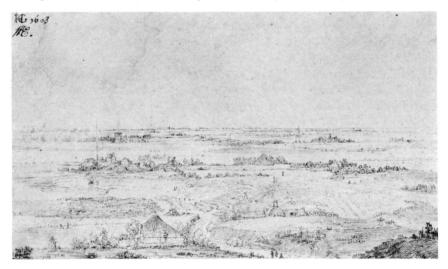

Haarlem

designers. In contrast, *The Larch* (35) shows a centrally placed spreading tree that stretches to fill the picture space with its drooping branches. Seghers varied his prints by making impressions using inks of various colors on different colored grounds, so that each impression is a new and different work of art. Sometimes he added color by hand after the printing. Both the motifs he selected and his technical innovations enlarged the range of printmaking.

While Seghers was inventing his individualistic variations, progressive landscape artists in Haarlem and Amsterdam had for some time been making studies from nature that foreshadowed developments that were to be seen later in paintings. That great innovator Hendrick Goltzius was making drawings of views around Haarlem as early as 1603 (36). These were scenes from life studied with loving care, in striking contrast with Goltzius' own landscape drawings from his Mannerist phase.

Landscape drawings closely based on the observation of nature were also produced in the first decade of the seventeenth century by the Amsterdam artist Claes Jansz. Visscher. A drawing inscribed "Outside Haarlem on the Road to Leiden, 1607" (37) places him among the earliest of the Dutch naturalistic landscapists. This was one of a series of twelve drawings Visscher made for etchings. He must surely have been aware of the similar activities of the Haarlem artists.

Esaias van de Velde, who became a member of the Haarlem guild in the same year as Seghers, 1612, was born in Amsterdam in 1590 and moved from Haarlem to The Hague in 1618. During his residence in Haarlem, from 1610 to 1618, he made a series of eight etchings of scenes studied from life. The drawing of Spaerwou (38) was made in preparation for one of these etchings. The freshness of observation and the economy and freedom of execution of this little landscape clear away like a brisk breeze the overripe scent of the old Mannerist landscape style. In his early painted landscapes, he was less daring. In about 1612 he painted a set of landscapes representing the seasons, which in compositional type recall Coninxloo. Each contains a small-scale biblical scene-altogether an old-fashioned idea, even in the early years of the seventeenth century. In his painting dated 1614, Village in Winter (39), he shows important advances toward freedom of composition. The frozen canal leads straight into the distance, cut by the horizontal of a bridge that is echoed by the far horizon. Bare trees and houses on either bank provide horizontal and vertical elements; diagonal forces receive little stress. Even the figures near the foreground are disposed in a horizontal configuration, and their shapes tend to be squared-off and upright. Thus van de Velde showed himself to be a remarkably early pioneer in the development of naturalistic Dutch landscape painting in general and, in particular, of the winter scene that constitutes one of the most ingratiating subjects associated with

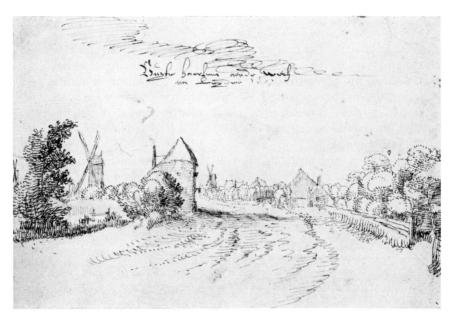

37. Claes Jansz. Visscher, Outside Haarlem on the Road to Leiden, drawing.

38. Esaias van de Velde, Spaerwou, drawing.

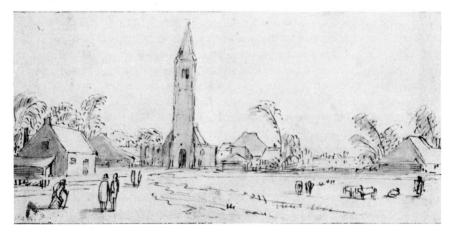

39. Esaias van de Velde, Village in Winter.

seventeenth-century Dutch art. In a number of paintings during the next few years, he presented naturalistic images of many aspects of the Dutch scene in town, village, and countryside. He usually included figures that would have reminded his fellow-countrymen of pleasurable activities, such as rabbit hunting, skating, and walking in the woods.

The View of Zierikzee (40) of 1618 is perhaps Esaias van de Velde's most original composition. The profile of the town is seen on the far bank of the canal, jutting into the sky, while in the foreground is a bit of the near bank, on which three figures, silhouetted against the light-reflecting surface of the water, intently go about their labors. The foreground figures, along with the many naturalistic details recorded throughout the picture, are subordinated to the composition as a whole. The masterly integration of all elements produces an impression of stability and a mood of enduring peace. It has been noted that this small masterpiece foreshadows Vermeer's great *View of Delft* (192) not only in composition, but in its memorable emotional communication.

In the 1620s Esaias van de Velde made a series of drawings of the flat Dutch landscape that were even more assured and fluent than his earlier

40. Esaias van de Velde, View of Zierikzee.

drawings. In these he succeeded in conveying an impression of the changes effected by the atmosphere in the appearance of increasingly distant objects, a remarkable accomplishment with the limited resources of the medium of drawing. His *Winter Landscape* of 1623 (London, National Gallery) is one of the early paintings in the monochromatic style that was to dominate in Dutch painting of various kinds of subject matter in the late 1620s and 1630s. The suppression of local color in favor of a gamut of ochers or grays lent a new unity to the entire picture field. In the 1620s van de Velde also added new kinds of figurative content to his landscape settings: scenes of dramatic action, particularly battles and pillaging.

Hendrick Avercamp, working not in Haarlem but in the remote small town of Kampen, on the east side of the Zuider Zee, deserves attention as another of the active landscape painters of the early years of the seventeenth century. His works, dated as early as 1608, though somewhat provincial, are immediately recognizable for their originality and charm. Known as *De Stomme van Kampen* ("The Deaf-Mute from Kampen"), Avercamp lived from 1585 to 1634. His career was not marked by any discernible regular development. For many admirers of Dutch painting he provided the definitive image of the Dutch winter, with cold gray skies, all-pervasive frostiness, and crowds of people of all ages enjoying the sport that became available only when the canals froze (in our day, and

Haarlem

probably in the seventeenth century too, not a frequent occurrence). Contrasting sharply with the general whiteness, in their costumes of intense colors and black, they skate, alone or in pairs, play *kolf*, give their babies and old folks rides in sleds, and present a picture of cheerful gregariousness. The fashions of the times, as well as the activities, came under the scrutiny of Avercamp. Some of his paintings, like the *Large Winter Scene* (41), had high horizons and featured the bare trees of winter and snow-topped buildings. Others had low horizons and expertly represented the aerial perspective effect of the distant horizon in the wintry atmosphere. The patches of bright or dark color representing the individual figures retain their independence one from another, so that a resemblance to the tradition of Pieter Bruegel gives an old-fashioned look to these otherwise rather modern early-seventeenth-century works.

Remarkably advanced landscape compositions were also coming quite early in the century from the hand of Willem Buytewech, who was born in about 1591 or 1592 in Rotterdam and was presumably trained there.⁶ He became a member of the Haarlem guild in 1612, the same year as Esaias van de Velde and Hercules Seghers. Hendrick Goltzius was still active at that time, as were Cornelis Cornelisz. van Haarlem, Frans Hals, Esaias van de Velde and his cousin Jan (1593–1641, who also made landscape prints), among others. Known as *Geestige Willem* ("Clever William"), Buytewech must have been a stimulating addition to this gifted group. Though only twenty-two known paintings by him survive, they—

41. Hendrick Avercamp, Large Winter Scene.

along with a number of etchings—give sufficient evidence of his contribution to the Haarlem school of painting. He remained in that city only until 1617 (the year in which Goltzius died), when he returned to Rotterdam, where he died in 1624. During the final years in Rotterdam he continued his relations with the Haarlem artists, and he also had connections with artists and publishers in The Hague, Amsterdam, and Leiden. He was among the landscape innovators in Haarlem who also produced a new type of genre scene that later became common in other centers of Dutch painting.

Only a few years after Esaias van de Velde's strikingly novel realistic landscape drawings and etchings appeared, in 1616, nine landscape etchings by Buytewech were published with a title in The Hague. There were three editions of this series of prints, which indicates that there was a considerable demand for them. They were revolutionary in their simplicity and dignity. Several of them were austere studies of the verticality of the individual tree, contrasted with the horizontal effect of the fencelike rank of trees, seen parallel with the picture plane, and the distant horizontal where earth meets sky. Such was the *Grove at the Pond* (42). Buytewech introduced the double-diagonal composition that was to become

42. Willem Buytewech, Grove at the Pond, etching.

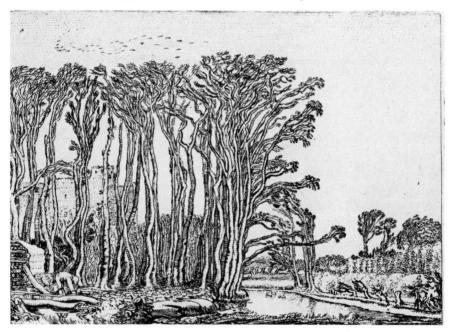

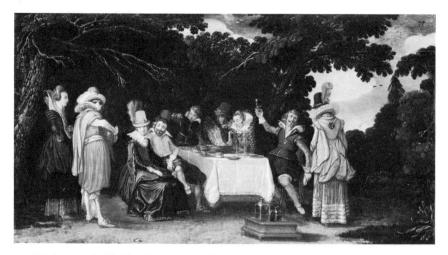

43. Esaias van de Velde, Banquet Outdoors.

one of the standard formats in the following decades. The path or road opening head-on in the foreground and receding into the far distance was another device that was to be repeated in many fine landscape paintings in the years to follow.

Both the personal touch that is revealed in the nature of Buytewech's etched line and the strength and originality of the compositions of these small prints would surely have attracted the attention of other artists. Buytewech's compositional innovations are echoed in paintings much later in the century. He must be accounted one of the pioneers in Dutch seventeenth-century landscape advances, though he made no landscape *paintings* so far as we know. While a realistic landscape may have been painted as early as 1611 by Adam van Breen in The Hague, the drawings and prints designed in Haarlem probably provided the immediate stimulus to artists both in Haarlem and elsewhere who were to carry forward the specifically Dutch landscape tradition.

HAARLEM SCENES OF SOCIAJ LIFE

The artists of Haarlem were among the leaders and guides of seventeenthcentury Dutch painters not only in the depiction of landscape, but also in a very different kind of subject matter, the representation of social life in which groups of figures are shown in a realistically rendered interior or exterior setting. The earliest dated painting of this kind that we know is Esaias van de Velde's *Feast in the Open Air*, dated 1614 (The Hague, Mauritshuis). His *Banquet Outdoors* (43), signed and dated 1615, is a similar subject, with elaborately dressed men and women, shown fulllength, gathered around a table under the trees. Standing figures provide strong vertical framing on both left and right, while the wine cooler in the foreground and the end of the table give countervailing horizontal accents.

The behavior of the men is far from decorous; this is the kind of scene that has plausibly been associated with the Parable of the Prodigal Son who wastes his possessions on carousing and erotic excesses. This subject had been explicitly dealt with in sixteenth-century paintings and prints. As is often the case in pictures with this kind of content, music accompanies the dissipation; the man standing at the left is playing a lute. The peacock pie on the table and the costly wine vessels also indicate wastefulness. From emblem books and didactic literature of the period we know that the Dutch were especially concerned with the moral issue of indulgence in sensual pleasures. The large number of paintings of people enjoying such pleasures, however, suggests that renunciation of the satisfactions of the senses was by no means universal. If doing such things was considered reprehensible, owning pictures that showed others doing them was seemingly more acceptable.

Willem Buytewech, like Esaias van de Velde a pioneer in realistic landscape depiction, also explored new ground in scenes of social gatherings of this kind, known to the Dutch as "Merry Company." Though the Merry Company scenes of Esaias van de Velde and Buytewech have something in common with the Caravaggist tavern and brothel subjects that were well-known by the second decade of the seventeenth century, they are entirely different in other respects. The figures of the Caravaggists were usually life-size but only half or three-quarter length, while the Haarlem compositions were on a small scale, but with full-length figures. Caravaggio and his followers generally ignored the background in such scenes, while Buytewech gave the setting the most careful consideration, both for compositional purposes and in order to endow a multitude of objects with convincing realism. The Caravaggist style depended on sharply focused light to bring out the relief of the figures and unify the composition, while the Haarlem artists bathed their figures and settings in even light, with bright, sometimes gaudy colors, quite different from the modulated tones and dramatic chiaroscuro of the Caravaggists.

There might, however, have been transitional works in Haarlem that provided a link between Caravaggism and the innovations introduced by Esaias van de Velde and Buytewech. A drawing monogramed and dated 1607 by Hendrick Goltzuis, *The Musical Trio* (44), suggests such a link. A table separates us from three figures in three-quarter length, elegantly dressed and gracefully grouped, a composition very similar to many that are familiar to us in paintings by both Italian and Dutch Caravaggists.

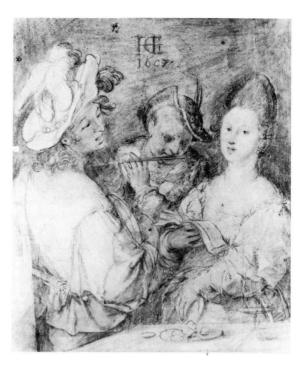

44. Hendrick Goltzius, *The Musical Trio*, drawing.

The even lighting differs from the strong Caravaggist illumination. It appears that Goltzius was a seminal force in this kind of subject matter and composition, as in other developments in Dutch painting. As Goltzius himself had returned from Italy to Holland late in 1591, before Caravaggio had developed the style that we associate with his name, it must be assumed that Goltzius became aware of Caravaggist works after his return to Haarlem, as van Mander did. The drawing of 1607 also antedated by a number of years the earliest return of a Caravaggist painter to Utrecht from Italy. It gives striking evidence of the alertness of Goltzius to new developments in art and his adaptability to change.

Buytewech made his mark mainly with paintings of a new type of genre subject. In geometrically constructed, stable settings, groups of figures are depicted with painstaking care to indicate every detail of their fashionable costumes. Their types and groupings, as well as numerous accessories included in the compositions, suggest that the paintings may have been intended as illustrations of scenes from plays. Of the *Fashionable Courtship* (45), of about 1616–17, in which some elements may have emblematic meanings, it has been suggested that the figures are portraits of members of a family whose coat of arms appears on the left.

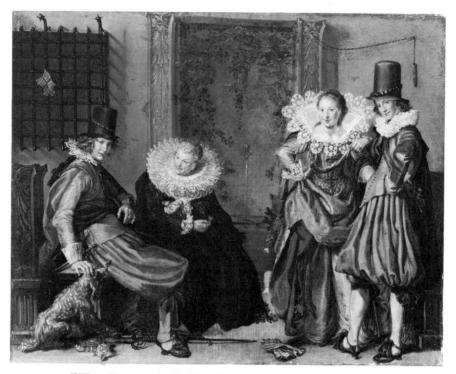

45. Willem Buytewech, Fashionable Courtship.

Since the figures are standard Buytewech types, however, it seems unlikely that portraiture is involved here. It seems reasonable to seek a literary source for a scene such as this, in which neither the individuals nor the objects represented seem to be taken from the ordinary activities of everyday life. Buytewech was certainly familiar with plays by contemporary Dutch playwrights, as he designed title pages and illustrations for at least two collections of plays, and an explanation of this picture on the basis of passages from a play by Bredero has been proposed. This interpretation would account for some but not all of the details. Another possible explanation lies in the fact that such a group in an outdoor setting calls to mind the tradition of the Medieval "Love Garden," a type of subject that was to be associated a bit later in the seventeenth century with the name of the great Flemish painter Peter Paul Rubens.

Buytewech's *Merry Company in an Interior* (Rotterdam, Boymansvan Beuningen Museum), one of the earliest examples of such a group depicted in a fully developed interior setting, seems to represent the vices of fashionable young men. In both indoor and outdoor settings Buytewech organized his figures in a shallow space with compositional emphasis on horizontal and vertical elements that provide balance and stability. His drawings of domestic interiors also are marked by this kind of calculated composition, based on the framework provided by the architectural members of the setting. Dated 1617, the drawing *Interior with a Family by the Hearth* (46) looks like an obvious example of the famous Dutch realism, a "snapshot" of a simple household. But the composition was planned to the last detail, and the result is an expression of serenity that did not come about by chance. (He made another drawing with an almost identical setting, but with changes in some of the details.) Each piece of household equipment is depicted with a degree of accuracy that presupposes the scrutiny of *that particular* pot or bellows. One woman is crocheting, while the other makes lace, and their tools are clearly indicated. A child sleeps in the cradle. Another is in the bed. Quiet and calm pervade the lived-in room. This exploration of women's work added a new territory to the universe of art.⁷

Sources of light were always of interest to Buytewech, and in this drawing he gave keen attention to the fire in the fireplace and the oil lamp burning at the left of the hearth and to the effect of the light that they shed. Drawings of this kind by Buytewech were the antecedents in both composition and emotional tone of many pictures of family groups in homelike settings by such later seventeenth-century painters as Pieter de Hooch and Gabriel Metsu.

46. Willem Buytewech, Interior with a Family by the Hearth, drawing.

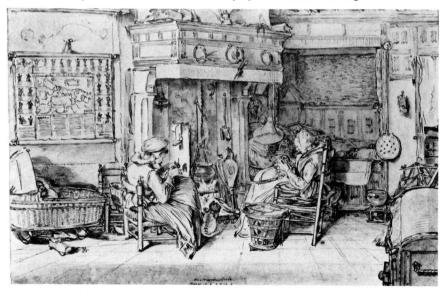

47. Frans Hals, A Young Man and His Sweetheart ("Jonker Ramp").

The place in the Merry Company movement of the great Haarlem portraitist Frans Hals is hard to define precisely. His *Shrovetide Revellers* (New York, Metropolitan Museum of Art) is generally thought to date from about 1615, but since there is no early genre work by Hals that can be firmly dated, this date is far from certain. Judging from the interests of Buytewech and Frans Hals as indicated in their works, it seems not unlikely that Buytewech was the innovator in painting pleasure-seeking

Haarlem

groups in interior settings. The only other composition by Frans Hals that is comparable to this, *A Young Man* ("Yonker Ramp") *and His Sweetheart* (47) is signed and dated 1623. It shows life-sized figures in threequarter length. A tavern interior is indicated on the right side, but the figures bear no relation to this background. Indeed, Lucas van Leyden's woodcut of *The Prodigal Son in a Tavern* dated 1519 is closer to Buytewech's compositions than the paintings by Hals are. This woodcut and other sixteenth-century prototypes would certainly have been available to Buytewech.

Dirck Hals (1591-1656), the younger brother of Frans, specialized in small-scale Merry Companies in indoor and outdoor settings. In A Lunch in the Country (Amsterdam, Rijksmuseum) Dirck Hals included a woman and a dog that he had borrowed from Buytewech. Indeed, Dirck Hals's compositions and style generally owe more to Buytewech than to Frans Hals. He painted small pictures of dressy figures in elegant poses who were engaged in the typical Merry Company activities of eating, drinking, making music, and flirting. They are usually arranged rather symmetrically in a shallow but clearly defined space, as for instance in the Party Scene, signed and dated 1626, in the National Gallery in London. Unlike Buytewech, Dirck Hals did not include details that suggest literary content. He was not attracted to fine detail, and even the faces of many of his characters are painted rather coarsely, lacking both underlying form and characterization. Later in his career he painted a number of softly colored interior scenes with a small group of figures, such as Children with a Cat (Williamstown, Massachusetts, Clark Art Institute), which belong to the numerous and much appreciated class of Dutch paintings of quiet domestic interiors.

Domestic scenes were favored subjects also of the versatile artist Judith Levster, who was born in Haarlem in 1609, the daughter of a brewer. When she was nineteen, her family lived for a time in a town near Utrecht; it seems likely that she studied with a Utrecht Caravaggist at this time. She made a specialty of night scenes with visible sources of light, in the manner of Honthorst. Her painting The Rejected Offer (48), which is signed with the initials JLS and a star (a pun on her name, which means lodestar) and dated 1631, is among her outstanding early works. Her subtle manipulation of light contributes to the psychological intensity of this rare depiction of a woman who does not welcome the man's advances. Keeping her eyes on her sewing, she ignores the importuning hand on her shoulder as well as the proffered coins.8 Having moved back to Haarlem in 1629, Leyster became a member of the guild there in 1633. Her free brush stroke and the lively expressions of her figures reflect her Haarlem heritage and particularly the style of Frans Hals, some of whose paintings she apparently copied. In 1636 Leyster married the painter Jan

48. Judith Leyster, The Rejected Offer.

Miense Molenaer (c. 1609-68), and from the time of her marriage she seems to have painted very little. She died in 1660.

Haarlem later became a leading center in the production of actionfilled peasant tavern scenes, which were hospitable to all varieties of uncouth behavior. The Flemish-born painter Adriaen Brouwer, who was in Haarlem by 1626, seems to have been instrumental in spurring this development (see figures 135 and 136). Portrait painting in Haarlem was dominated by the vibrant artistry of Frans Hals (chapter 5).

5/ Frans Hals and the Portrait Tradition

RANS HALS, who spent his long, productive years in Haarlem, was presumably born in the southern Netherlands, in Antwerp. His parents were Flemish, and it is assumed that they moved to the north as Protestant refugees after the fall of Antwerp to the Spanish forces in 1585. The baptismal record of Frans's brother Dirck in 1591 is the first record of the presence of the Hals family in Haarlem. The date of Frans Hals's birth remains unknown. He became a member of the Haarlem guild in 1610, and his earliest dated picture, the Portrait of Jacobus Zaffius (Haarlem, Frans Halsmuseum), is inscribed 1611. If he followed the normal course, he would not have been more than twenty years old when he joined the guild and became an independent master, and thus he would have been born not earlier than 1590. But no document has been found that would fix his birth date and give grounds for revising the traditional assumption that he was born between 1581 and 1585.¹ If Hals was in fact born at such an early date, what was he doing until 1610? No painting, drawing, print, or written document gives a clue to the answer to this question. Indeed, not a single drawing, oil sketch, or print by Hals is known-and this compounds the enigma of his early history and method of working. Carel van Mander, who moved a short distance away from Haarlem in 1603 and died in 1606, may have been his teacher, though van Mander did not mention Hals in his Schilder-Boeck, published in 1604. The biography of van Mander, which was written by an unidentified author and included in the second edition of Het Schilder-Boeck, in 1618, mentions that Frans Hals was a student of van Mander. No known

work by Hals gives any indication of dependence on the Mannerist style or theories of van Mander.

Portraiture was to be the main concern of Hals throughout his career. Even in those of his paintings that are customarily thought of as genre, portraiture is never entirely excluded. Hals's life-size figures in half length both in the early Shrovetide Revellers, and in his Young Man and His Sweetheart (47) of 1623, reflect the already widespread paintings of such subjects by painters of the so-called Caravaggist trend. They do not pertain to the new type of scenes of social life that were being produced by Esaias van de Velde, Willem Buytewech, and his own younger brother, Dirck Hals, a type that was to be reflected later in the century in numerous works by a succession of admirable artists. In both of these relatively early paintings by Frans Hals, the space is filled-one might even say overfilled-with people whose robustious gaiety can almost be heard as well as seen. Round apple cheeks and other spherical shapes contribute to the effect of solidity and weight and a crowding of the available space. A diagonal from upper left to lower right is the main compositional axis in both pictures. Hals did change his approach to color between the painting of the earlier picture and the one dated 1623, however. Whereas the Shrovetide Revellers is bright in color and sharp in contrasts, the colors of the young couple are more modulated and harmonious, as if seen in a silvery light. Both pictures contain details that can be interpreted emblematically. At least two among the Shrovetide Revellers are stock theatrical characters, and it is possible that both of these pictures illustrate scenes from dramatic literature or stage performances. A stage setting is suggested by the interior background in much smaller scale and the curtain that separates the foreground figures from this setting in the painting, bearing the date 1623, of the smiling young man (known as "Yonker Ramp" on the basis of an identification now known to be mistaken) with a grinning young woman at his side.

In both subject and style *The Boy with a Flute* (49) of about 1625 is closely akin to Utrecht Caravaggist works of about this time. Hals's personal manner is evident, however, particularly in the lively irregularity of outline that characterizes many of his compositions. The jutting forms of the plume and the four fingers of the hand make separate incursions on the space. The active effect is all the more impressive if one compares this picture with Terbrugghen's contained, concentrated rendering of the same kind of subject (21). Terbrugghen's boy turns away from us, totally absorbed in his own activity. The young flutist of Hals, in contrast, faces straight out of the picture. Though he is looking down and to his right and does not meet our gaze (as most figures by Hals do), he is exposed to confrontation. Hals's energetic brush stroke also contrasts strikingly with the smooth, impersonal surface of Terbrugghen's painting.

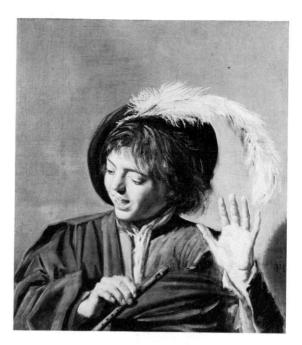

49. Frans Hals, Boy with a Flute.

Especially in his early paintings, Hals was something of a specialist in the depiction of cheerful moments. Even his commissioned portraits frequently communicate infectious gaiety and high spirits. This is a powerful part of Hals's appeal. In most cases the immediacy of the picture depends not only on a responsive facial expression, but also on the vitality of the colors and the vigor of the brush stroke, which seem to transmit momentary visual experience. In some cases, the instability or impermanence of the poses also contributes to the vivacity of Hals's paintings. One has the impression of seeing dynamic individuals at a particular instant in their lives.

The picture known since the middle of the nineteenth century as *The Laughing Cavalier* (50), inscribed with the date 1624 and the age of the man portrayed—twenty-six years—is perplexing. This title is obviously a misnomer; the man is certainly not laughing. His expression is provocative, not mirthful. It is not clear whether the picture was intended as a portrait, perhaps an allegorical portrait, or whether it fits better into the category of genre. The details of the embroidered sleeves, which Hals went to great pains to depict exactly, have symbolic meanings. The bees and the flames, for instance, may be related to an amorous emblem.

Among Hals's large output of paintings are a number that are difficult to classify, including various paintings of children (which may represent the Five Senses), musicians, and unforgettable characters such as the

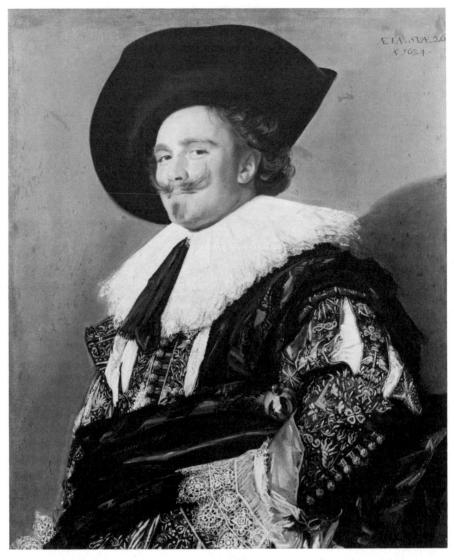

50. Frans Hals, The Laughing Cavalier.

Frans Hals and the Portrait

famous Malle Babbe (Berlin-Dahlem Museum). He painted a few religious subjects, which also seem to be portraitlike, judging from the two pictures of Evangelists that were rediscovered in the Odessa Museum in 1959. Frans Hals tended to blur the lines between portraits and other kinds of subject matter. To achieve the effect of individuality and vitality that was his strongest suit throughout his career, he took liberties even in formal portraits, which ordinarily tend to be bound by tradition. Individuals who wish to have their portraits painted may be expected to prefer likeness to vivacity and conventional modes to novelty, for the goal of any portrait is, in a sense, to place the sitter in history. Dutch painters produced portraits in unprecedented numbers in the seventeenth century; the new affluent middle class provided a broader-based patronage than ever before. The Dutch burgher was not immune to the universal desire to display evidence of social and economic status. Portraits were one sure way to do this. Innumerable families commissioned them-a single portrait, or matched portraits of man and wife, or the whole family group. Almost every Dutch artist painted some portraits, and some specialized in them. Portrait painting had long been recognized as a source of enduring fame for the artist as well as for the sitter. Leon Battista Alberti wrote in his treatise Della pittura in 1435 (first published in Basel in 1540; beginning of Book II): "Painting contains a divine force which not only makes absent men present as friendship is said to do (Cicero, De amicitia, vii, 23), but moreover makes the dead seem almost alive. Even after many centuries they are recognized with great pleasure and with great admiration for the painter. . . . Thus the face of a man who is already dead certainly lives a long life through painting." In the sixteenth and seventeenth centuries. Alberti was one of the most revered of the Renaissance writers on art. His recognition that a portrait may serve both to immortalize the sitter and to bring renown to the artist would undoubtedly have been endorsed by the Dutch.

Even more than painters of other kinds of subject matter, portraitists have been constrained by the requirement that they produce a likeness. Dutch portrait paintings up to the time of Hals clearly show the effects of this overriding aim. Dry paintings with clear, careful contours were coming from the brushes of the leading portraitists in Holland when Hals entered the field. Both individual and group portraits by Jan Anthonisz. van Ravesteyn of the Hague, who lived from about 1570 to 1657, exemplify the traditional style and formats. Similar conventional portraits were turned out, literally by the hundreds, in the studio of Michiel van Miereveld, who was born in Delft in 1567 and worked for some time in The Hague, specializing in portraits of the princes of the House of Orange and other famous statesmen. He ran a kind of wholesale portrait shop; he is credited with something like ten thousand portraits, many of which must,

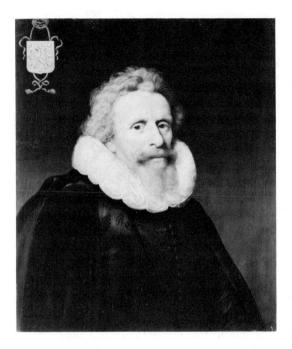

51. Michiel van Miereveld, *Jacob van Dalen*.

of course, have been done by his assistants. At the time of his death in 1641 there were numerous copies inventoried among the contents of his workshop. As was usual in portrait workshops, the master might do an original portrait of a leading figure of the time and then any number of copies would be made by other workers in the studio. Most of the paintings that came from Miereveld's workshop were mediocre, but there were some of high quality that must have been based on life studies. An example of a respectable late work by this successful portraitist is the 1639 portrait of *Jacob van Dalen* (51).

Though he was not averse to the use of traditional formats and poses, Frans Hals brought to his portraits a liveliness and dash that made them stand out amidst their competitors. He painted a number of pairs of portraits, but only two that are known today in which two figures appear in a joint portrait. One of these is a portrait of a married couple (52), which has frequently been misidentified as a portrait of Frans Hals and his wife. This it certainly is not. It has been convincingly identified as a marriage portrait of a well-known Dutch merchant, Isaac Abrahamsz. Massa, and his wife, Beatrix van der Laen, who were married on April 26, 1622.² That date would conform well with the style of the double portrait. Hals painted portraits of Massa in 1626 and in 1635, and his image in the marriage portrait is readily identifiable in relation to those portraits. There are numerous emblematic elements in this picture. Marriage portraits have traditionally been enriched in meaning by symbolic elements, from the time of Jan van Eyck's *Arnolfini Wedding Portrait* of 1434. The peacock visible in the garden setting of Hals's picture is the attribute of Juno, the goddess of marriage. Peacocks also are associated with the idea of immortality. The thistle and the ivy are both related to the concept of fidelity. The garden, with its fountain and strolling couples, reflects the tradition of gardens of love in medieval art, a type of subject that was carried into the seventeenth century most notably by Peter Paul Rubens. This great Flemish master's self-portrait with his first wife, Isabella Brant, anticipated Hals's marriage portrait of Massa and his wife.

In Hals's picture there is a failure in integration of figures and background. In the depiction of the love garden in the background and the building in it there is no sense of real light falling on a real outdoor scene and a substantial edifice. It is not possible to relate any part of this landscape setting, including the architecture, to the style of Hals himself. It is highly probable that someone else painted the background, which would

52. Frans Hals, Isaac Abrahamsz. Massa and His Wife.

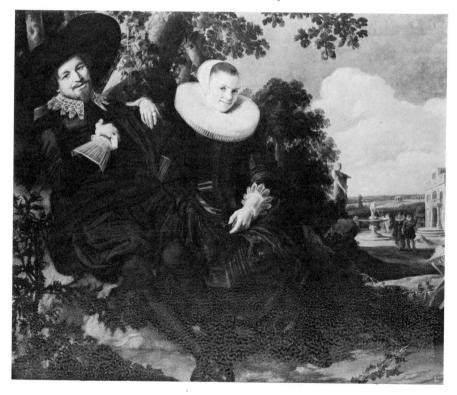

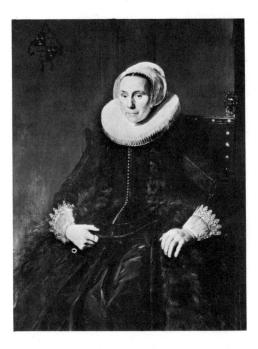

53. Frans Hals, *Cornelia Vooght Claesdochter*.

not have been unusual at the time. It frequently happened that more than one artist worked on a picture in the seventeenth century. Sometimes a specialist in landscape would do the landscape and a specialist in figures would do the figures. In this case the style of the execution of the landscape is dull and immaterial compared with the lively brush strokes and individualized characterizations of the forthright Massa and his smiling young wife.

There was a change in style that was general in Dutch painting around the 1630s, when paintings were limited in range of color, more restrained, more unified, not as lively and bright. It happened that the style of clothing became more somber at this time. The black costume that became fashionable would in itself have tended to make portraits look darker and more severe and closer to monochromatic. This can be seen in the portrait Hals painted in 1631 of *Cornelia Vooght Claesdochter* (53). There is a companion painting of her husband, Nicolaes van der Meer. Hals arranged the two figures so that they are related to each other compositionally. Each of the portraits includes the escutcheon of the sitter's family in a corner, an indication of the family pride served by portraiture among the middle-class Dutch.

Frans Hals inscribed the date 1650 on three portraits; this was the latest date he provided, though he seems to have continued to paint portraits practically until he died in 1666. His brush stroke was to become ever more bold and free in the course of his long career. His stylistic development can be clearly demonstrated in his series of group portraits. He painted six large life-size portraits of militia groups, three of regents, and four of family groups. These were important commissions. The civic guard and regent group portraits were to be hung publicly in the headquarters of the organizations. They provided artists with opportunities—rare in seventeenth-century Dutch art—to paint large works intended for public display.

Group portraits were painted by many Dutch portrait painters.³ There was a long tradition in Haarlem itself, with outstanding compositions by Goltzius and Cornelis van Haarlem, to which Hals was indebted for specific motifs and compositional formats. The earliest Hals portrait of a civic guard group, which is dated 1616, is highly accomplished. It portrays a Banquet of the Officers of the St. George Militia Company (54). Hals knew these men well, as he was a member of this organization during the years in which they served as officers, 1612 to 1615. The civic guards or militia companies, which earlier had assumed military responsibilities, by this time were ceremonial and social. This is the first painting on which Hals put a date after the portrait of Zaffius, which was dated 1611. The grouping and the general composition are foreshadowed in a painting by Cornelis van Haarlem of 1599. The grouping of the figures is a challenge to a painter when this many people are to be depicted together. To show them as engaged in a common activity is difficult because each one must be shown clearly. Though Hals organized the

54. Frans Hals, Banquet of the Officers of the St. George Militia Company, 1616.

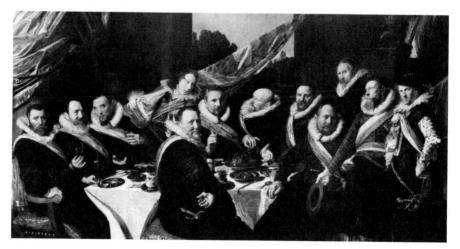

55. Frans Hals, Banquet of the Officers of the St. George Militia Company, c. 1626/7.

group as if they are all enjoying their banquet, they are not all focused on any specific activity, but look in various directions. Most of them are looking out of the picture toward us. The ensign carries the banner, and this is a help to Hals in establishing a strong diagonal line of composition. That diagonal is underlined by a parallel diagonal implied by the series of heads. One of the things that makes the civic guard group portraits colorful is the red, white, and light blue sashes, which Hals also puts to good use as repeated diagonal notes. The carefully detailed treatment of the damask tablecloth and the numerous objects on the table show a tighter, more cautious treatment than was to be seen in his later works.

As Hals went on dealing with the problems of group portraiture, he sought ways of organizing his figures so that there was more sense of a common activity uniting them. His next picture of a civic guard group again shows a *Banquet of the Officers of the St. George Militia Company* (55), this time in 1626 or 1627. The officers at this time are not the same men as those portrayed in the 1616 picture, and the way in which they are organized is also somewhat different. In this, the only signed civic guard piece that Hals did, he attempted to make the individual figures interesting by having a number of them turn toward us and engage us in their actions. The central man in the foreground who faces us and meets our glance is indicating by his gesture that his glass is ready for refilling. His

companion at the right makes a traditional rhetorical gesture as if he is addressing us as he extends his hand to the foremost plane of the picture. Hals used diagonals again in an attempt to organize the composition in a concrete way despite the fact that the various gazes go in different directions and the grouping of the figures sets up an irregular rhythm. The style is freer than that of the earlier picture; the brushwork is more open, more dramatic, and the sparkle of highlights enlivens the entire surface. But the general tenor of his intention here is very similar to what it was earlier.

In about 1627 Hals also painted a banquet of the officers of the second of the Haarlem civic guard companies, the St. Hadrian company, which was called "The New Company." It was surely a sign of Hals's success that around the same time both of the Haarlem militia companies commissioned him to record their officers on canvas for posterity. It was traditional to hang these group portraits of the officers in their meeting room, in which large paintings could be accommodated. However, it may be that the figures were not painted in full length, but were kept to a three-quarters format, because the pictures were hung above a chair rail and the ceiling was not high enough for full-length, life-size figures.

In 1633 Hals was commissioned to paint a group portrait by an Amsterdam civic guard company. This must have been quite a feather in his cap; there were Amsterdam painters of high repute to whom the commission could have been entrusted. The picture, known as The Meagre Company, or The Corporalship of Captain Reynier Reael and Lieutenant Cornelis Michielsz. Blaeuw, is dated 1637, because it was not completed until that time; in fact, Hals himself never finished it. There was correspondence about this commission that sheds some light on Hals's independence and also on his way of working. The Amsterdam group were annoved with him for not finishing the work as he had promised to do. They wanted him to come to Amsterdam to finish it. He refused; he said, if you will come to Haarlem, I promise that the sittings will be short. Of course it was self-serving to tell them that the sittings would not take very long, so we cannot be sure that it was simple fact when he gave this assurance. However, they did not come to Haarlem and he did not go to Amsterdam. The picture, which is now in the Rijksmuseum in Amsterdam, was completed by an Amsterdam painter named Pieter Codde (1599-1678), who is known mainly for simple interior scenes of soldiers in their guardrooms and domestic interior subjects, tavern scenes and the like. It has been supposed that this is the only full-length civic guard group portrait by Hals because it was in the Amsterdam tradition to make them full length. It may be that it was full length simply because the meeting place of this company provided sufficient space for a full-length group portrait. When Codde worked on this picture he apparently re-

56. Frans Hals, The St. George Militia Company, c. 1639.

painted all over it to some extent to try to bring the style into accord. It is clear that the left side was brought close to completion by Hals, whereas much more of the right side does not show his brush stroke but is obviously by another hand.

In about 1639 Hals again painted *The St. George Militia Company* (56). He reverted to the old-fashioned simple lineup of figures side by side. It may be that there had been complaints about not being sufficiently visible by some of the men who were in the background in his other group portraits and that he therefore placed all the important figures in equally prominent positions in this picture. The figures in the second rank, in the background, are not officers; among them is Frans Hals himself, second from the left in the upper row of figures. This is his only unquestionable self-portrait known to us. He had been a member of this civic guard group for a number of years.

Hals painted three portraits of regent groups, the governing boards of charitable organizations. The earliest of them, dating from about 1641, portrays the *Regents of St. Elizabeth's Hospital in Haarlem* (57). By the 1640s fewer group portraits were commissioned by civic guards. More often artists were asked to portray the more sober (in every sense) groups of people who were brought together by their interest in something quite different from the convivial civic guard activities. The middle-class Dutch now preferred to be shown to their contemporaries and to posterity as philanthropists. Hospitals, almshouses, orphanages, and schools were supported by the regent class; the Dutch met the needs of their poor with exceptional generosity. Like donors everywhere, they enjoyed the recognition that came with portraits hung in the great hall of the institution concerned.

Frans Hals and the Portrait

In composition this picture depends on a group portrait painted in 1638 by the successful Amsterdam portraitist Thomas de Keyser, which we know from an engraving. Again Hals proved not to be averse to using an existing composition by another artist. But he added a sparkle and a painterly individuality that were his own. He succeeded in conveying the feeling that each one of his figures represents an interesting personality.

In the small, sketchlike portrait of Descartes (9), surely the most spirited image we have of the great French philosopher, we see Hals's response to a leading intellectual of his time.⁴ He appears to have been no less inspired by the aged men and women in the two late group portraits, which probably date from 1664, two years before his death. His modern admirers consider him to have been at his best in these works, painted in his late seventies or eighties. One of these pictures portrays the *Male Regents* (58) and the other the *Female Regents of the Old Men's Home* (59). In both cases the individuals are depicted seated and looking out toward us, not engaged in conversation or action. Hals did not concern himself with the problems of unifying or animating the groups, but instead he portrayed each individual in the most closely observed way, yet with the greatest freedom of paint application (60). The liveliness of the paint surface contributes to a sense of motion and change.

Judging from his surviving works, Frans Hals was limited in his interests and subject matter, limited in his formal invention, but brilliant in his

57. Frans Hals, Regents of St. Elizabeth's Hospital.

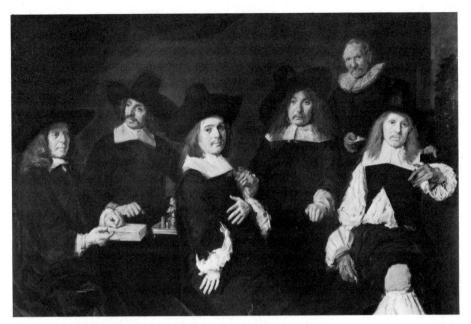

58. Frans Hals, Male Regents of the Old Men's Home.

60. Detail of 59.

59. Frans Hals, Female Regents of the Old Men's Home.

61. Thomas de Keyser, Constantijn Huygens and His Clerk.

brushwork. He was able to combine solidity of form with a scintillating surface, in portraits of striking individuality. This has brought him ardent appreciation during the past century and makes him a great favorite today. He was appreciated in his own day as well. He had important portrait commissions through his long career and was probably well paid for them. Yet there is a tradition that he was poverty-stricken through most of his life. It is hard to evaluate the records that seem to indicate this. The

fact that Hals was in debt may indicate simply that he was a poor manager, or that he was a slow payer, or extravagant in his expenditures, or a variety of other possibilities. That he was in good standing socially is indicated by his membership in the civic guards and also by the fact that from 1616 to 1625 he belonged to a rhetoricians' society. De Wiingastraenken ("The Vine Tendril"). Until a very old age he continued to work effectively and productively. After his death his reputation declined, and it was not restored until the late nineteenth century, when his style appealed especially to those who appreciated Impressionist painting. It should be noted, however, that Hals's technique was essentially different from that of the Impressionist painters. Hals built up the forms with large areas of tone, and only afterward added the lively, unmodulated brush strokes which, according to Houbraken, Hals himself called "the handwriting of the master."⁵ Some of the followers of Hals were able to imitate superficially the effect of his free brush strokes, but they failed to equal his convincing indication of the underlying forms.

While Frans Hals was employed as a portraitist even to the end of his life, other styles in portraiture became more fashionable, and there were other artists who in his later years were more in demand than he. Though there was a reliable market for portraits, competition must always have been intense in this good line of trade. A vast amount of hack work was produced, as well as much sensitive and highly skilled portraiture.

In Amsterdam there was an outstanding portraitist named Thomas de Keyser, who lived from 1596 or 1597 to 1667. He was the son of Hendrick de Keyser, an important architect and sculptor. The style of Thomas de Keyser gives a good idea of the best in portraiture at the time when Rembrandt came to Amsterdam, where he settled in 1632, already recognized as a gifted portraitist. De Keyser's portrait of *Constantijn Huygens and his Clerk* (61) is monogrammed and dated 1627. This impressive picture is rather small, well under life-size, a format typical of de Keyser. Huygens was one of the outstanding figures of the period, a well-known man of letters, who was secretary to Stadholder Frederick Hendrick and remained one of the major advisers to the House of Orange for a period of sixty-two years, from 1625 until his death in 1687, an enormously long tenure as one of the chief figures in the government of the United Provinces.

De Keyser was a perceptive portraitist, and the portrait of Constantijn Huygens gives a good indication of how he achieved his aim of indicating the personality and position in life of the person who was his sitter. We see Huygens seated at his desk, being approached by his clerk with a message. Behind him is an impressive tapestry which was probably one of his prized possessions, depicted with considerable care. On the wall above the large mantel hangs a painting of a ship in rough seas. On the desk, a musical instrument gives further evidence of Huygens' devotion to the arts, while two globes, one terrestrial and one celestial, refer to his scientific pursuits. Constantijn Huygens was the father of the great scientist Christian Huygens and was interested in all aspects of science. He is working on a large chart or architectural plan, and there are books and a pen and ink, indicating his activity as a writer. His boots and spurs mark his knighthood, conferred by James I five years earlier.

Huygens and his clerk are depicted in a realistic way in an action that they might ordinarily have participated in. This is an advance over the kind of portrait in which the sitter just sits; it is an effort to show him in his own setting, in a characteristic activity that brings some sense of his life and human relations. Characterizations of this kind, milieu portraits, were specialties of some outstanding Dutch painters, including Rembrandt. They had distinguished sixteenth-century forerunners, particularly Holbein. De Keyser was also famous for small equestrian portraits, which likewise tell something about the social status and way of life of those portrayed.

By the middle of the seventeenth century a taste for elegance and luxury dominated the portrait market as well as other aspects of life, such as clothing and interior decoration. Many patrons now preferred portrait painters whose style was polished and aristocratic to the free and lively Hals or the profoundly expressive Rembrandt. One of those most favored was Bartholomeus van der Helst. He was born in Haarlem in 1613 and was thus of a later generation than Hals, who became a member of the guild in Haarlem in 1610. By 1636 van der Helst had settled in Amsterdam, where there was a larger market in art than there was in Haarlem. He died in Amsterdam in 1670, only four years after the death of Hals and one year after Rembrandt's death. His glossy, highly finished style seemed appropriate to patrons who had arrived and wished to make this known, as was the case increasingly as the century went on. People were interested in looking affluent; they wore more colorful and elaborate clothes than had been the fashion earlier. Most of them chose portraitists who would do full justice to the costly fabrics and ornaments that advertised their economic well-being and their sophisticated tastes.

Van der Helst was the natural choice to paint what was perhaps the most festive of all civic guard banquets, the *Banquet of the St. Jorisdoelen in Celebration of the Peace of Münster* (62), held on June 18, 1648. This feast took place in the large hall of the headquarters of the Amsterdam Militia Company of St. George. The painting recording the event is a huge one, full of life-size, full-length figures loosely arranged around the banquet table, in much the same way that Frans Hals had organized his earlier civic guard group portraits. There is more variety and elaboration in van der Helst's picture than was ever to be seen in a

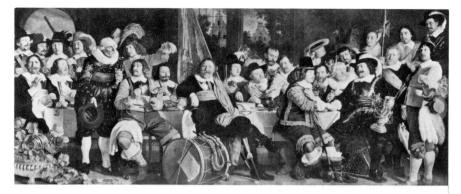

62. Bartholomeus van der Helst, The Celebration of the Peace of Münster, June 18, 1648, at the Headquarters of the St. George Civic Guard.

work by Hals, however, and the painting style is slicker. Van der Helst too was capable of creating an image of a lively event and, at the same time, an ensemble of portraits of impressive individuality. His forms are firmly modeled, his colors intense and rich. To the drum in the foreground is attached a piece of paper bearing a poem by the well-known poet Jan Vos in praise of the peace, adding to the documentary value of this remarkable record of the joyous reception of the news that the independence of the United Provinces was officially recognized.

Van der Helst's highly salable talent for showing the richness of costumes and the self-satisfaction of their wearers is also demonstrated by his portrait of *Daniel Bernard* (63), dated 1669, which shows why a prosperous businessman would have had good reason to choose van der Helst as his portraitist. Larger than life-size, resplendent in his rust-colored velvet beret and robe, with a lavish white scarf with rust and gold stripes, his left hand prominently displaying a diamond ring, Bernard looks up from the account book on which he has been working, as he turns to meet our gaze. A Turkish carpet of the type associated with Holbein portraits covers his work table. The tools of his trade are at hand; this is a milieu portrait of a prominent Dutch type, the self-assured product of the successful mercantile economy of the Dutch Republic, as depicted by an artist eminently suited to the task.

Gerard ter Borch, skilled at recording the charming and elegant, was a sensitive portraitist. Born in Zwolle in 1617, he was among the few outstanding Dutch painters who did not live in a major art center. He worked mainly in the town of Deventer, where he is recorded as being present in 1651 and where he died in 1681. He was a prodigy, a member of a gifted family of painters, and his art was by no means provincial. According to Houbraken, he traveled widely in the Netherlands, Italy, England, France, Spain, and Germany, and in Madrid he painted a portrait of

63. Bartholomeus van der Helst, *Daniel Bernard*.

Philip IV. From Philip's great court painter, Velázquez, he apparently derived the idea of placing the full-length, standing figure in space without regard to setting, avoiding even so much as a definite indication of a floor or horizon line. Only the modulation of the background colors and values and their relation to the painted figure establish the environment of space and air in which the figure exists.

Ter Borch's portrait of *Helena van der Schalcke as a Child* (64) was probably painted around 1644, when ter Borch painted portraits of her parents. This little masterpiece exemplifies the artist's effectiveness with an economical format and a direct approach. The centrally placed figure of the little girl appears as a stable, pyramidal form, utterly self-sufficient compositionally, without the help of furniture, architectural elements, or any accessories that would help to place her in space. The atmospheric implication of space gives the diminutive figure monumental solidity. Helena's face, rather old and wise for her years, and her intense gaze contribute to the unforgettable impact of the portrait. It is easy to see why ter Borch was commissioned to paint numerous portraits of full-length standing figures in the small format of which he was the master, in addition to the graceful genre scenes for which he is also famous.

A group portrait by Gerard ter Borch, small but including seventyseven individuals, is unique in its documentary nature: *The Swearing of*

64. Gerard ter Borch, Helena van der Schalcke as a Child.

the Oath of Ratification of the Treaty of Münster, May 15, 1648 (1). This is the event that we see celebrated in Bartholomeus van der Helst's Celebration of the Peace of Münster [62].) The peace ratified in the city of Münster, Westphalia, marked the end of eighty years of struggle for independence from Spain. Ter Borch went to Münster to seek portrait commissions from the distinguished persons gathered there for the occasion and to record the event itself. He included his self-portrait, standing at the extreme left, behind a man resting his hand on a chair. Ter Borch took

some liberties with the arrangement of the figures, but, as we know from a contemporary written description, he was careful to be accurate about the persons, the setting, and even the accessories involved in the ceremony. On the left, six delegates from the provinces of the Netherlands raise their hands to take the oath, while on the right two representatives of the Spanish crown place their hands on the Bible held by a chaplain. Even the red box with gold braid that contained the copy of the treaty that was to go to the United Provinces was faithfully depicted; it is now in the National Archives in The Hague. A high price, six thousand guilders, was asked for this painting. Apparently there was no buyer, as it remained in the possession of ter Borch's family. Ter Borch was highly esteemed by his contemporaries. He was prominent in civic life, serving as a member of the town council. A virtuoso painter of silks and velvets, he was more than a skilled reporter. He was an original creative personality, and his works were copied by painters in Amsterdam, Haarlem, and The Hague.

Dutch painting in the seventeenth century, abundantly endowed with gifted portraitists, was graced by one who was incomparable. For many people all over the world, the thought of portraiture brings to mind first the work of Rembrandt. It hardly seems reasonable to conclude a chapter on the Dutch portrait tradition without mentioning him. From the beginning of his career to his last days, Rembrandt made portraits of women, men, and children, singly or in groups, with awesome sensitivity. His portraits convince us that he combined depth of insight with unparalleled means of communicating his understanding of character. In drawings and prints, as well as in paintings, he seemed to present the mental and spiritual as well as the physical essence of the individual. In addition to commissioned portraits, he made many informal portraits of his closest associates, allegorical portraits, and group portraits of unprecedented dynamism. Above all, his long series of self-portraits brings us into close contact with this humane man and supreme artist. The following chapter, devoted to Rembrandt, includes discussion of a sampling of his varied types of portraits.

6/ Rembrandt

EARLY LIFE AND EDUCATION

MONGTHE MANY admirable Dutch painters of the seventeenth century, one stands out like the moon amidst the stars: Rembrandt. His output of paintings, prints, and drawings was prodigious in both quality and quantity.¹ An extraordinarily broad range of subjects claimed his interest, and he excelled in all of them. Nothing human was alien to him.

Rembrandt seems to have had accessible to him deep wells of human experience. His mysterious capacity to communicate his insights directly to the hearts of other people has made him one of the most widely loved artists of the Western world. From an early age he was so thoroughly the master of his craft that he could use his brush—or pen, or chalk, or etcher's needle—freely for expressive purposes. The manipulation of light and shadow was one of his major emotive resources; this was a token of his genius throughout his career. He also had a gift for using the undisguised nature of his materials to evoke spiritual and emotional resonance.

It would be a mistake to believe that Rembrandt relied solely on intuition, however, for he had at his command knowledge and intellectual powers that enabled him to devise original interpretations of numerous themes. His frame of reference included works of art of the most diverse types, from monumental paintings of the High Renaissance to contemporary Mughal miniatures, all of which were absorbed and transformed into products that were uniquely his. Training, practice, thinking, feeling—all nourished his art, which yet, in essence, remains inexplicable.

Rembrandt was born in Leiden on July 15, 1606, the eighth of at least

nine children of the miller Harmen Gerritsz. van Rijn and his wife, Neeltgen Willemsdochter van Zuidbroeck, who was the daughter of a baker. The family mill was on the bank of the Rhine River, hence the surname van Rijn ("of the Rhine"). His full name was Rembrandt Harmenszoon van Rijn; as is customary, "Harmenszoon" (Harmen's son) is generally contracted to "Harmensz."

The old city of Leiden, prominent in the manufacture of cloth, grew and prospered through the seventeenth century, becoming one of the major industrial cities of Europe by the time of Rembrandt's death in 1669. Refugees from the south gave new impetus to industry and trade. As elsewhere, however, industrialization brought problems. There were many poor people, some of whom were reduced to beggary. Like many other aspects of the life he observed, beggars were among the subjects that Rembrandt immortalized. His own parents were reasonably well-todo, and they sent him at the age of seven to the Latin School, where he continued his studies until he was fourteen. This was more education than was accorded to the average young person of the period, and it seems to imply professional and perhaps also social ambitions on the part of his parents. Students at the Latin School read history and literature in Latin and performed plays in Latin, gaining a cultural outlook that would prove to be useful to an artist in the seventeenth century, when paintings of "history subjects," meaning content based on literary texts, were still considered by theorists to be of a higher order than works with other kinds of subject matter. It seems unlikely, however, that the painter's craft was foreseen as Rembrandt's future during his early eduation, for he was enrolled in the university on May 20, 1620.

The University of Leiden had been established in the preceding century, when the people of the city, given the opportunity to choose their own reward for withstanding a long and painful siege by the Spanish forces, asked for the right to found a university. By Rembrandt's time Leiden had become one of the major intellectual centers of Europe, attracting distinguished scholars from other countries as well as from the United Provinces. The university's register shows under the date "20 Mai 1620" the entry: "*Rembrandus Hermanni Leydensis studiosus litterarum annor 14 apud parentes*" ("Rembrandt son of Harmen of Leiden, student of letters, aged 14, living with his parents"). There are no further records of his presence at the university. He seems to have left within a few months and to have begun the study of art.

Rembrandt is said to have had an unidentified teacher before he became the pupil of a Leiden painter who specialized in architectural subjects and views of Hell, Jacob Isaacsz. van Swanenburgh (c. 1571–1638), with whom he spent three years. Even Rembrandt's earliest known works

Rembrandt

bear no resemblance to the style or subject matter of this mediocre painter. After this, in 1623 or 1624, the young artist was sent to Amsterdam to study with Pieter Lastman. His six months with Lastman made a lasting impression; there are early paintings that follow Lastman closely in the choice of history subjects and in style, and even much later, well after Lastman's death in 1633, Rembrandt continued to borrow motifs from his paintings.

Pieter Lastman was born in Amsterdam in 1583. His early works were Mannerist in style, generally similar to the Mannerist works of Hendrick Goltzius and Cornelis Cornelisz, van Haarlem, Lastman went to Italy, however, and after his return to Amsterdam in about 1605 his painting style showed striking changes. He specialized in narrative subjects from the Bible, mythology, and Roman history, and his chief aim seems to have been to give a clear impression of a dramatic moment. Usually he dealt with numerous figures in landscape settings. Lastman, like other artists who worked in Rome at about this time, learned from the German-born painter Adam Elsheimer (1579–1610), whose landscape style had an important impact on seventeenth-century Dutch landscape painting. Lastman's firmly modeled figures of his mature years were more normal in their proportions and more expressive in their gestures than had been the case in the Mannerist paintings. His colors were intense, his compositions-when he was at his best-clearly organized. These features are evident in his painting of 1617, Christ and the Woman of Canaan (65).

Lastman was one of a group of painters who have been known to modern art historians as "Pre-Rembrandtists"; they might more appropriately be called "clear narrative painters," which stresses their rejection of Mannerist goals and their success in developing a new style appropriate to their new aims. Lastman himself, of course, is of interest to us chiefly because of his influence on Rembrandt. As it happens, he was also the most accomplished of the clear narrative painters, among whom were Claes Moeyaert and the brothers Jan and Jacob Pynas. Houbraken, who reported that the Pynas brothers went to Italy with Lastman, also stated that Rembrandt studied for a few months with Jacob Pynas after his period in Lastman's studio.

A MASTER IN LEIDEN, 1625-31

By 1625 Rembrandt had returned to Leiden from his studies in Amsterdam with Pieter Lastman, and he was working as an independent master. His earliest dated painting, signed with the initial "R" and dated 1625, is

65. Pieter Lastman, Christ and the Woman of Canaan.

The Stoning of St. Stephen (66), which shows his debt to the style of Lastman.² The immediate model for this painting, however, is a picture not by Lastman, but by Adam Elsheimer. This too is a depiction of The Stoning of St. Stephen (67); it is a tiny panel, loaded with events, figures, and swirling motion. The clothing of Elsheimer's St. Stephen is reflected in Rembrandt's, but the pose of Rembrandt's figure has been altered to give the first martyr a more active role. Although the heavenly vision that consoled St. Stephen is visible in Elsheimer's painting, the young saint does not seem to be in contact with it. In Rembrandt's painting the vision is not explicitly present, but the saint's upward gaze gives an impression of his communion with the divine as he kneels at the mercy of his tormentors. As compared with the diffuse light in Elsheimer's painting, large masses of light and dark function as the major principle of organization of Rembrandt's composition. Rembrandt's figural types, intense local colors, and dynamic facial expressions and poses all reflect the style of Lastman. The eccentric buildings are also similar to types of architecture seen in paintings by Lastman. The church-like structures that rise behind the ruins suggest the triumph of Christianity over the pagan and Jewish religions.

Saints seldom appear in seventeenth-century Dutch painting. Protestants, of course, rejected the cult of saints. The Bible was the sole source

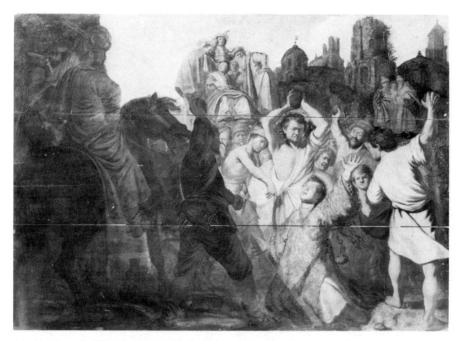

66. Rembrandt, The Stoning of St. Stephen.

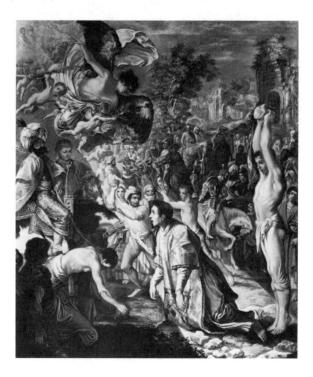

67. Adam Elsheimer, *The Stoning of St. Stephen.*

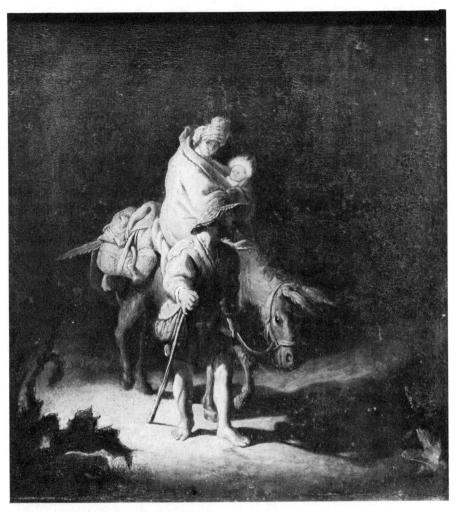

68. Rembrandt, The Flight into Egypt.

of truth to Luther and Calvin and their followers, and therefore most Dutch religious paintings of the seventeenth century are based on biblical texts. As the story of St. Stephen is in the Bible, in the Acts of the Apostles, it provided one of the few acceptable choices for a Protestant artist who wished to try his hand at a scene of martyrdom, a subject that gave artists in Catholic countries the opportunity to create some of their most dramatic baroque works.

The Flight into Eygpt (68), dating from 1627, is an early example of Rembrandt's mastery of the expressive use of illumination. In this he may again have derived inspiration from Adam Elsheimer. Elsheimer's Flight

into Eygpt (69), dating from about 1609, is remarkable for its light effects: the moon and its reflection in the pond, the fire and the illumination it spreads on the figures around it, and the Holy Family with their lamp, barely emerging from the darkness, but with intense, ruddy color where the lamplight touches them. And then there are the stars glittering in the night sky; Elsheimer is said to have been the first painter who showed the constellations as they actually look-a token of the scientific interests of his time. This landscape is a fine example of Elsheimer's work, with its solidity and its convincing recession. The plasticity of the forms, the indications of the structure of the trees, the diagonal leading into depth, and the luminous effects that he depicted with such imaginative enterprise and with such aesthetic impact-all these features make it clear why other painters were impressed by Elsheimer. Rembrandt, along with other artists, knew Elsheimer's works through superb engravings after them made by Hendrick Goudt of Utrecht (1585–1648), who succeeded in translating to the graphic medium Elsheimer's dramatic chiaroscuro (70).

Rembrandt depicted *The Flight into Egypt* in graphic works at various times during his career. This early, small painting foreshadows his lifelong approach to stories from Scripture as human experiences. Familiar

69. Adam Elsheimer, The Flight into Egypt.

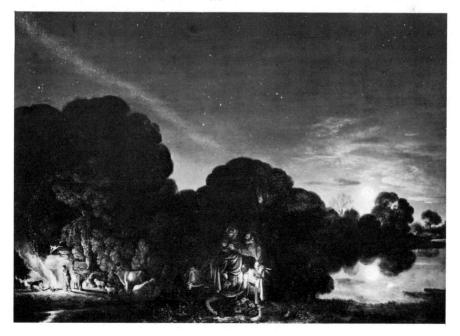

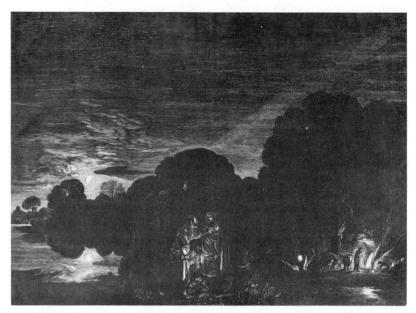

70. Hendrick Goudt, engraving after Adam Elsheimer, The Flight into Egypt.

with the Christian story and its iconographic tradition, we recognize the Holy Family on their way to safety in Egypt. If we did not relate the picture to the New Testament, we might see in it the perilous plight of any refugee family wandering at night, carrying with them all their worldly possessions. The lighted path before them may indicate spiritual guidance. Without overemphasizing details, Rembrandt took a number of measures to identify this particular family. Since Joseph is a carpenter, a saw and a bit and brace are among the donkey's burdens. Joseph carries a pouch holding the meager material wealth of the family. They are poor; he is barefoot. He fills the traditional role of the father as leader and protector of the group. The mother cares for the child, calmly and patiently, warmed by the divine light emanating from the child. The solidarity of the family is strong; compositionally they are a single unit. Thistles in the lower left corner function as repoussoir, recalling Lastman's practice of placing plants similarly to serve this purpose. For this prominent spot Rembrandt chose clearly defined thistles, surely not by chance. The thistle is a hub of meaningful associations. In this context, it may refer to the crown of thorns, representing the Passion of Christ, foreseen even from his earliest days. It may also symbolize the thorny path ahead, all the difficulties that stand in the way of the Holy Family. As to what symbolism-if any-Rembrandt had in mind, we can only conjecture. Most impressive in this early painting is the emotional mood that is established

primarily by the control of light and dark. Rembrandt was only twentyone when he painted this personal and deeply moving interpretation of a traditional subject.

A Self-Portrait (71) of about this time, a drawing in pen and ink with wash, shows the remarkably free and sure hand of the young artist in a study stressing strong illumination. The wash laid on to add the bold dark notes brings a conviction of solid form to the economical composition. It is an investigation of a facial expression of emotion, one of a number of such studies that Rembrandt made in the 1620s, often using himself as model. His Self-Portrait (72) painted around 1628 or 29 displays the assurance with which he handled oil paints in a portrait study at this early time. Seen against a light ground, the image is highlighted with bold impasto patches. Incisions in the wet paint with the tip of the brush handle mark the hair. The arbitrary shadowing of the eyes gives the self-portrait a romantic air for all its apparent naturalism. What Rembrandt learned from the drawings, etchings, and paintings in which he explored the problem of the communication of emotions and character, he applied to figures in narrative paintings, in which imparting the feelings of the individuals was a major concern. These exercises must also have contributed to what has always been considered one of his greatest and rarest gifts,

71. Rembrandt, Self-Portrait, drawing.

72. Rembrandt, Self-Portrait

the ability to give the impression of revealing character in his portraits.

The codification of human expressions was a widespread interest of painters in the seventeenth century. They sought to arrive at a standard image to show surprise or fear, joy or sorrow, on a human countenance. Mainly this enterprise was aimed at organizing the material in such a way that it could be taught and learned as part of the curriculum of the academies in which artists hoped to establish the status of painting as a learned profession rather than a craft. For his part, Rembrandt avoided fixed patterns, never ceasing to work directly from life.

Rembrandt's ability to convey a highly dramatic moment was impressive early in his career. His painting of *Samson and Delilah* (73) of 1628 is an outstanding example of this. It is a small yet tremendous depiction of a moment of peril, achieved with restraint and economy of means. Rembrandt's friend and companion in his years in Leiden, Jan Lievens, also painted *Samson and Delilah* (74), dealing with the same moment in the story, the moment in which Delilah has cut Samson's hair and is calling the Philistine soldiers to come and take him into captivity. Lievens was a prodigy. Although he was a year younger than Rembrandt, born in 1607, he had worked in Lastman's studio considerably earlier, starting at the age of ten, from 1617 to 1619. Constantijn Huygens, whose autobiographical notes in Latin, written between 1629 and 1631,³ contain the earliest written reference to Rembrandt that we know, praised both of these gifted young artists: "The miller's son, Rembrandt, and the embroiderer's son, Lievens, are already on a par with the most famous painters

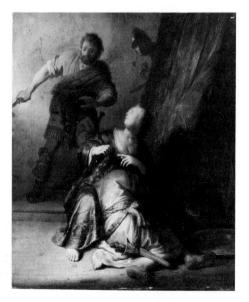

73. Rembrandt, Samson and Delilah.

74. Jan Lievens, Samson and Delilah.

and will soon surpass them." Rembrandt, he went on to say, is superior to Lievens in judgment and in the representation of lively emotional expression, but Lievens has greater grandeur of invention and boldness than Rembrandt.

The contrast between these two conceptions of Samson and Delilah gives a good indication of the difference between the two artists at this early point in their careers. They presumably were painted close to the same time. Rembrandt put his figures in a shadowy, mysterious space. The curtains of the bed on the right, behind the two figures, give a gloomy, cavelike quality. The Philistine soldier behind them looks frightened and surprised. His expression conforms to the story, for twice before Delilah had attempted to turn Samson over to the Philistines, but each time he had misled her as to the source of his strength. When she thought she had deprived him of his strength, and he had been tied up by the Philistines, he broke the bonds with which they had bound him. The soldier thus has reason to fear that on this third try Delilah may have failed again. But, according to the Old Testament story, this time Samson had been cajoled into telling the woman the true source of his strength, which was his long hair. She cut his hair while he slept, and he was taken captive, was blinded, and came to a tragic end. All of that is foreshadowed, in a literal sense, in Rembrandt's small composition. Lievens, on the other hand, presented a much more obvious illustration of the story, in a composition of a type that had already been produced quite widely by the followers of Caravaggio, grouping close to the picture plane a small number of life-size figures who fill almost all of the picture space and are strongly modeled by the sharp light that falls on them. The

75. Rembrandt, Judas Returning the Pieces of Silver.

76. Detail of 75.

expressions and gestures of Lievens' figures are exaggerated, and the total effect is grotesque rather than tragic.

Constantijn Huygens praised Rembrandt for "his superior ability to convey expression of emotion in a small, carefully worked-out picture." As evidence of this, Huygens mentioned Rembrandt's painting *Judas Returning the Pieces of Silver* (75 and 76), which is inscribed with a monogram and the date 1629.⁴ The monogram, the adjoined letters RHL, is frequently found on works of Rembrandt's Leiden period and rarely on works that originated later than 1632. It is a contraction of his identification as it appeared in his registration in the University on May 20, 1620: *Rembrandus Hermanni Leydensis*.

"This painting," Huygens wrote, "can stand comparison with any Italian or ancient picture; in it the beardless son of a Dutch miller has surpassed Protogenes, Apelles, and Parrhasius." Of course neither Huygens nor anyone else in his time knew what paintings by these lengendary artists from antiquity actually looked like.⁵ Comparison with them had simply become the common currency of praise for contemporary painters. Still, it shows the very high esteem in which Huygens, who was something of a connoisseur, held Rembrandt's work at this early period in his career. It was the depiction of the grief and remose of Judas, the kneeling figure at the right, that he found especially praiseworthy. This picture,

77. Rembrandt, *"Rembrandt's Mother."*

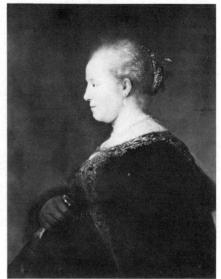

78. Rembrandt, "Rembrandt's Sister Lysbeth."

too, is marked by the dramatic juxtaposition of light and darkness. The spatial organization, in a grandiose, fanciful interior setting, is not entirely clear. This is typical of Rembrandt's architectural settings. The dark areas are broadly painted, while the decorative details, such as the elaborate embroidery of the costumes and the ornate shield hanging on the wall, are depicted minutely. Even the thirty coins thrown on the floor are all clearly shown and countable, a degree of literalness that would be out of character with the artistic perceptions of the more mature Rembrandt of the periods that were to follow.

At this time, however, he was already engaged in depicting biblical events in original ways that showed his drive to explore the potentialities of his medium, as well as his thoughtful interpretations of the meanings of the stories. He painted *The Presentation of Jesus in the Temple* in 1627 or 1628 and again in 1631 (15). The painting of 1631 is an admirable example of his works of the Leiden period, delicate and subtle in color. It is organized around the group illuminated by the radiance of the divine light. The moment depicted is that when the righteous and devout old Simeon, who had been led into the temple by the Holy Spirit, took up the child Jesus in his arms, saying "Mine eyes have seen thy salvation which thou has prepared in the presence of all peoples, a light for revelation to the Gentiles, and for glory to thy people Israel" (Luke 2: 30–32). Rembrandt made the light of revelation visible. The strange, invented archi-

tecture bears no relation to any possible building; it serves to suggest the remoteness in time and location of the event portrayed. The rich costumes, like the magnificence of the temple, owe their grandeur to the opulent imagination of the artist.

As Huygens made clear, the skills Rembrandt brought to his paintings of historical subjects gained him favorable attention from the contemporary audience for art within a few years after he had embarked on his career as an independent master. At the same time, he was also becoming expert as a portraitist. He often used himself as a model and also repeatedly painted, drew, and etched portraits of a few individuals who have traditionally been identified as "Rembrandt's Father," "Rembrandt's Mother"(77) "Rembrandt's Sister Lysbeth" (78) and "Rembrandt's Brother Adriaen." One sister and two brothers of Rembrandt's are known to have survived to adulthood, but there is no firm evidence as to the appearance of any of them. Indeed, several different physiognomies have been honored with each of these imaginative titles. The only well-founded identification of a parent or sibling in a work by Rembrandt is the *Portrait of His Father* (79), a drawing in sanguine and wash proba-

79 Rembrandt, Portrait of His Father, drawing.

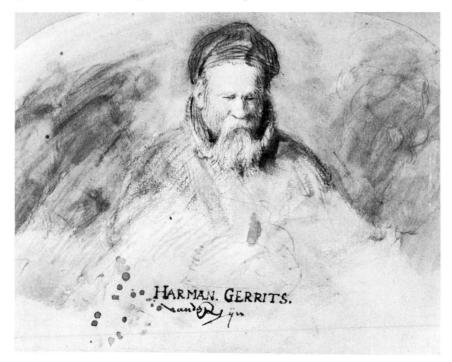

bly made not long before the father's death in April 1630 at the age of seventy. The inscription of his father's name may be in Rembrandt's own hand.⁶ One significant piece of information provided by this portrait is that Rembrandt's father was apparently blind, at least late in his life. This may have played a part in stimulating the painter's concern with blindness, of which there is evidence in works spanning almost his entire career.⁷ It is not surprising that the visual artist, whose chief function in life depends on seeing, would find blindness a particular source of anxiety and emotional involvement.

Rembrandt's reputation had quickly spread beyond the bounds of his native city. By 1631 he was receiving commissions to paint portraits of members of prosperous Amsterdam families-the seal of approval and key to financial success for an aspiring Dutch artist. Rembrandt's portrait of the Amsterdam merchant Nicolaes Ruts (80), monogrammed and dated 1631, must have been among his earliest Amsterdam commissions, though possibly commissioned and painted while he still resided in Leiden. It is an excellent example of his portrait style at this early time. The figure dominates the space masterfully, in a pyramidal composition that provides a stable base. Wealth and well-being radiate from this man, with his alert, forceful expression and his ample, fur-lined cloak. Patrons had reason to be pleased with portraits such as this one, which handsomely convey both individuality and membership in a particular social class. One of Rembrandt's notable strengths, in portraits as in other subjects, was his use of light as a compositional as well as an expressive force. The relief of the figure depends not only on the shadowed parts of the figure itself but on the subtle variations of light and shadow in the background. At this time Rembrandt painted details with care; with utmost delicacy he rendered the hairiness of the fur and the folds of the ruff. He never relied on the kind of stereotyped pattern of a ruff that comes from the hands of most other artists. On the contrary, he exploits the ruff as an opportunity for a sensitive study of translucency and transparency. We are convinced that he observed that ruff in that light. On the light side he ventures to lose the arabesques of the folds; he simplifies, providing just enough detail to give the implication of the continuing pattern, but no more.

FLOURISHING IN AMSTERDAM, I 632-42

A document reveals that as early as June 20, 1631, Rembrandt lent one thousand florins to an Amsterdam art dealer and painter named Hendrick van Uylenburgh. By July 26, 1632, he was living in Uylenburgh's house in Amsterdam. A large group portrait dated 1632 marks the transition be-

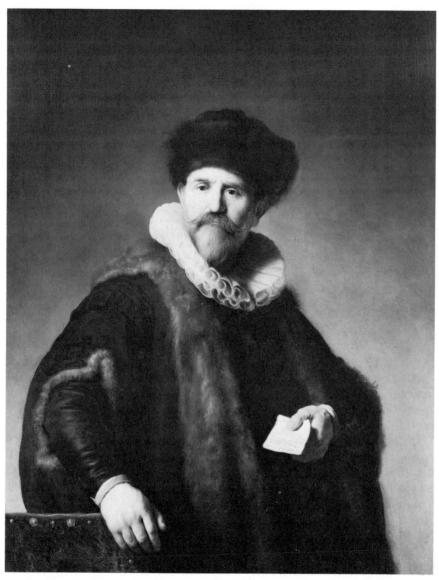

80. Rembrandt, Nicolaes Ruts.

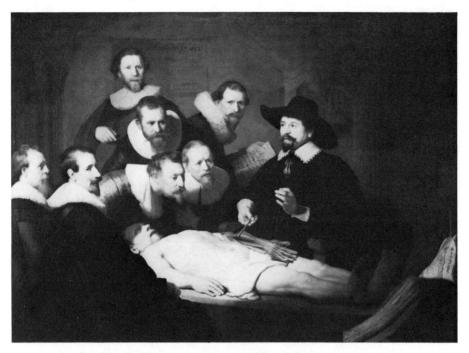

81. Rembrandt, The Anatomy Lesson of Dr. Tulp.

tween Rembrandt's Leiden years and his career in Amsterdam: *The Anatomy Lesson of Dr. Tulp* (81).⁸ This important commission for a painting to be hung in the quarters of the Surgeons' Guild in Amsterdam may have played a part in encouraging Rembrandt to move to the great port city to seek his fortune. He settled there sometime between March 1631 and July 26, 1632. It is reasonable to suppose that he painted the *Anatomy Lesson* in Amsterdam.

Both Leiden and Amsterdam had anatomical theaters in which public demonstrations occasionally took place. Doubtless morbid curiosity as well as scientific interest helped to attract audiences that numbered as many as two or three hundred. By law, only the bodies of condemned and executed criminals could be the subjects of such performances. What Rembrandt depicted was not a public anatomy demonstration of this kind. The identities of the persons present, listed on the paper held by the man beside Dr. Tulp's right shoulder, reveal that it was also not a traditional group portrait of the officers of the Surgeons' Guild, for most of them were not officers of the guild in 1632. It seems, therefore, that the group portrait was privately commissioned and that Rembrandt arranged the figures in a setting of his own invention. The viewpoint from which the

corpse is seen is not consistent with the perspective of the figures, and the representation of space is unclear. Both compositional considerations and the inconsistencies of brushwork and lighting give evidence that two of the figures, the one on the far left and the topmost one, were not included in the original composition. There is no space for the one on the left, and the upper one weakens the composition, which without these figures would comprise a compact semicircular group centered on the cadaver.

The innovative impact of The Anatomy Lesson of Dr. Tulp far outweighed its weaknesses. Its special strength lies in the extraordinary unification of the group by means of light and through the focusing of the attention of all present on the activity that, for pictorial purposes, brings them together, the demonstration of the anatomy of the left arm and hand. Portraits of groups of members of the Surgeons' Guild, like those of other groups, from their start in the sixteenth century and on into the seventeenth, traditionally showed figures lined up in more or less even ranks, giving equal space to each figure. Without shirking his responsibility to characterize each individual, Rembrandt subordinated them all to a comprehensive scheme. Dr. Nicolaes Tulp, who was a leading figure in Amsterdam's intellectual and social life, is differentiated from the others by the fact that only he wears a hat, indicating his superior status, and by the shell niche behind his head, a traditional indication of respect. The gestures of his hands also command attention. The large folio volume at the feet of the green-tinged corpse represents an anatomy textbook; in the composition it serves as repoussoir.

With *The Anatomy Lesson of Dr. Tulp*, Rembrandt at a single leap outdistanced the leading Amsterdam painters of group portraits at the time of his arrival there, Thomas de Keyser (1596/97-1667) and Nicolaes Eliasz., known as Pickenoy (1590/91-1654/56), who were both accomplished artists. Soon many wealthy residents of the city selected him to paint their likenesses. No fewer than forty-six commissioned portraits by Rembrandt from the years 1632 and 1633 survive. Most of them are depictions of a single individual in bust, half, or three-quarter length, some are full length, and some are of two persons. A number of them are pairs of portraits of husband and wife.

Among the acquaintances Rembrandt made while he lived in the household of Hendrick van Uylenburgh was Hendrick's orphaned young cousin, Saskia van Uylenburgh, who came from the city of Leeuwarden, capital of Friesland, where her father had been burgomaster. On the small silverpoint drawing *Saskia in a Straw Hat* (82), he wrote: "This is a portrait of my wife, in her twenty-first year, the third day after our betrothal—the eighth of June 1633." With dashing immediacy Rembrandt brought Saskia to life as she sat leaning her head on her left hand. His touch was free, yet delicate; the light coming through the brim of her

82. Rembrandt, Saskia in a Straw Hat, drawing.

straw hat dapples her forehead with a subtlety that could have resulted only from close observation. She holds a flower, a tradition in betrothal and marriage portraits.

On June 22, 1634, Rembrandt and Saskia were married. In 1635, 1638, and 1640 children were born to them. All of them died in infancy. Only their son Titus, baptized on September 22, 1641, lived to adulthood. Saskia herself died on June 14, 1642, before she reached the age of thirty. Saskia's relatives were wealthier and socially more elevated than Rembrandt's family, and Rembrandt enjoyed his most expansive way of life during their years together. Saskia appears often in his works.

During the year of their marriage Rembrandt painted *Saskia as Flora* (83), an appropriate personification for a beloved young woman, as the goddess Flora is associated with love.⁹ Allegorical portraits were by no means unusual in the seventeenth century, and Flora seems to have been a special favorite with Rembrandt, perhaps because of the beautiful example set by Titian. Besides showing Saskia as Flora in two paintings, he also painted her successor in his life, Hendrickje Stoffels, in the guise of

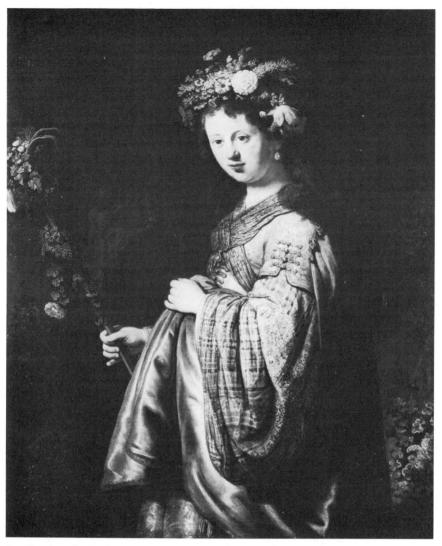

83. Rembrandt, Saskia as Flora.

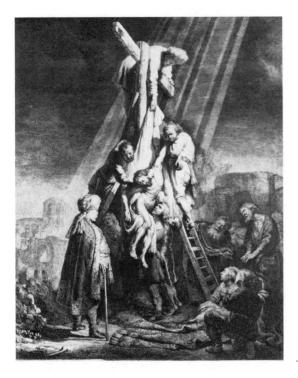

84. Rembrandt, *The Descent* from the Cross, etching.

Flora. The painting of 1634 is extraordinarily lovely. Saskia wears a costume of soft green and gold silk. Her hair is garlanded with colorful flowers, and in her right hand a staff entwined with flowers is held at an angle that echoes the inclination of her head. Her skin has a glow that outshines the rich costume. At this period Rembrandt's work shows a delight in the intricate details of damask and embroidery, of flowers and jewels.

Through the good offices of Constantijn Huygens, Rembrandt received an important commission to paint scenes of the Passion of Christ for the Stadholder, Frederick Hendrick. Seven letters in Rembrandt's hand have survived to our time, and they all are addressed to Huygens and concern this commission.¹⁰ In the first of them, to which the date 1636 was added, perhaps by Huygens, Rembrandt writes that he is "very diligently engaged in completing as quickly as possible the three Passion pictures which His Excellency himself commissioned me to do: an Entombment, a Resurrection, and an Ascension of Christ. These are companion pictures to Christ's Elevation and Descent from the Cross." This is understood to mean that the *Raising of the Cross* and *Descent from the Cross* were not commissioned, but had been bought from Rembrandt after he had painted them some time before 1636. The five paintings, matching in format, are all now in Munich, uniformly framed in the black frames encircled with gold wreaths that were described in an inventory in 1667. An etching dated 1633 of *The Descent from the Cross* (84), with the composition of the painting reversed, proves that this painting was finished by that date. *The Descent from the Cross* is frankly indebted to Rubens' great composition of that subject in the Cathedral of Antwerp, painted in 1613. Rembrandt would have known Rubens' composition through the engraving by Lucas Vorsterman, and he would probably have been aware that both Huygens and Frederick Hendrick favored the works of the Flemish master. It was not until 1639 that Rembrandt was ready to deliver the remaining three paintings. And, as his formal and deferential letters indicate, he was paid neither promptly nor the full price that he asked.

As "a token of appreciation," Rembrandt proposed to send Huygens "a piece 10 feet long and 8 feet high, which will be worthy of my lord's house." Apparently Huygens demurred, for Rembrandt added a postscript to a letter he wrote on January 27, 1639, saying that he was sending the canvas against Huygens' wishes and adding: "My lord hang this in a strong light so that one can stand at a distance from it; then it will sparkle at its best." It has generally been assumed that the gift to Huygens was the large painting of *The Blinding of Samson* (85), which is inscribed with the date 1636.¹¹ Indeed, Rembrandt had mentioned in the first of the surviving letters, which was written in 1636, his intention of sending Huygens "something of my latest work," and it may well be that it was this just-completed painting that he had in mind, though he did not send it until three years later.

The Blinding of Samson is a scene of raw horror. The fact that the figures are life-size makes the agonized contractions of Samson's hands and foot and the spurting of his blood almost intolerably real. Light strikes sharply on the armor of the soldiers on the right. Every line of the pikeman on the left describes hostility. And in the center, at the apex of the compositional triangle, Delilah looks back with an expression of mingled revulsion and triumph, as she rushes toward the light, which Samson will never see again. Most deeply disturbing is the fact that Rembrandt gave the perfidious Delilah, perhaps the most villainous woman in all of literature, the features of his wife, Saskia.

The emotional power with which Rembrandt invested Samson's gruesome ordeal is a direct expression of the concern with blindness that preoccupied him throughout his career. To the artist, to whom vision was the essence of life, blindness represented the ultimate deprivation. Darkness and light here play their most penetrating roles. They establish the basic pattern of the essentially baroque composition, within which surging masses and dominating diagonals intensify the drama. This was Rem-

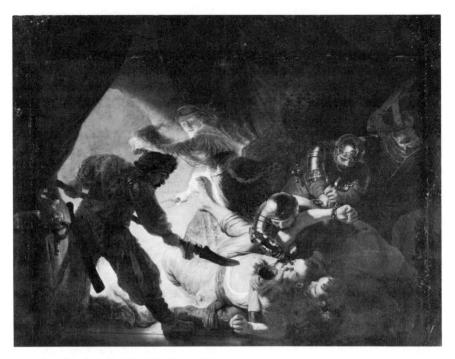

85. Rembrandt, The Blinding of Samson.

brandt's most complete and most successful incursion into the field of baroque style, the fashionable style of the European courts. *The Blinding of Samson* proved his ability to shine in comparison with Rubens or any other baroque painter.

A far more favorable view of woman is expressed in Rembrandt's $Dana\ddot{e}$ (86).¹² The legendary princess Danaë was imprisoned by her father to keep her from all contact with men, after the oracle had informed him that he would be killed by his grandson. Jove came to her in the form of a shower of gold, and she became the mother of Perseus, through whom the prophecy was fulfilled. The beautiful Danaë receiving the golden shower was the subject of some splendid paintings before the time of Rembrandt. Correggio made her one of his most appealing female nudes, and Titian painted her at least twice. Rembrandt was not the specialist in sensuous nudes that these two masters were, but he made of Danaë a more human figure, whose smile and gesture of welcome show her readiness both to receive and to give love—a rare conception of woman in Western art of any period.

This painting is inscribed with the date 1636 but was reworked later, perhaps as late as the early 1650s. The baroque curtains, the elaborate bed ornamented with a gilded Cupid who weeps at Danaë's enforced

chastity, the table and the slippers Danaë has kicked off at the bedside, all are in Rembrandt's minutely detailed style of the 1630s, and the composition as a whole has the baroque quality that marked his works of that period. Danaë's figure and that of the old woman who pushes back the bed curtains are painted quite differently, with the greater breadth and freedom that he developed by the 1640s or early 1650s. While earlier artists had shown either drops of gold or—in most cases—golden coins falling into Danaë's lap, Rembrandt retained the naturalism of the scene and eliminated any hint that Danaë's love was bought and paid for by having only light indicate the presence of Jove. He made Cupid, too, a plausible, though unusual, part of the realistic scene rather than a live visitor from the world of mythology.

In 1639 Rembrandt delivered the final two paintings in the Passion series to the Stadholder Frederick Hendrick. On the first of May of that year he moved into a large house on St. Anthonie-Breestraat, which he had bought four months earlier. He had reached a high point in his ca-

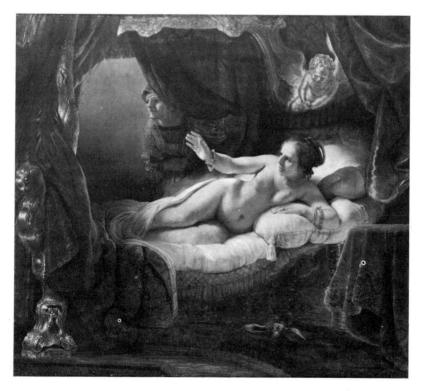

87. Rembrandt, Self-Portrait Leaning on a Stone Sill, etching.

88. Rembrandt, drawing after Raphael's *Portrait of Baldassare Castiglione*.

reer. How did he look at this time? His etched *Self-Portrait Leaning on a Stone Sill*, dated 1639 (87), gives evidence of his secure well-being. It also gives specific information about the way in which he adapted works by earlier masters, for this etching is clearly related to a drawing he had

89. Rembrandt, Self-Portrait, Leaning on a Sill.

made after Raphael's *Portrait of Baldassare Castiglione* (88). As he wrote on the sheet on which he made the quick sketch, Rembrandt saw the painting by Raphael at an important auction of works of art on April 9, 1639, in Amsterdam, where it sold for 3,500 guilders. The buyer was Alfonso López, an art collector and dealer of Spanish origin, who was already the owner of another picture that Rembrandt used in composing his *Self-Portrait Leaning on a Stone Sill*, Titian's *Portrait of a Man* (London, National Gallery, which has mistakenly been known as *Portrait of Ariosto*). Rembrandt's pose and costume reflect the portrait by Raphael, while the highlighted full sleeve and the sill on which it rests were derived from Titian. The use of the balustrade or sill not only gives a reasonable excuse for cutting off the figure at half length, but at the same time provides a note of stability, something that was to become more and more prominent in Rembrandt's works in the 1640s. In his painted *Self-Portrait Leaning on a Sill* (89), dated 1640, he went even further in the

direction of formal stability. He altered the beret to a more level line, in contrast with its sheer dynamic diagonal tilt in the etching, and he darkened the background, the wall of the sill, the sleeve, and the hat, so as not to divert attention from the face.

The German painter Joachim von Sandrart, who had been a pupil of Honthorst's in Utrecht in 1627, was also present at the auction of Lucas van Uffelen's collection in Amsterdam on April 9, 1639. He was, in fact, the underbidder on the Raphael portrait. He could not have been unaware that there were opportunities to see some fine examples of Italian Renaissance art in Amsterdam. Yet in Volume I of his book on art and artists, Teutsche Academie, published in 1675, he laid the groundwork for the legend that Rembrandt was not only ignorant, but disdainful of Italian art and theory. "Thanks to his natural gifts, unsparing industry and continuous practice, he lacked nothing but that he had not visited Italy and other places where the Antique and the theory of art may be studied, a defect all the more serious since he could but read simple Netherlandish and hence profit but little from books. In consequence he remained ever faithful to the convention adopted by him, and did not hesitate to oppose and contradict our rules of art-such as anatomy and the proportions of the human body-perspective and the usefulness of classical statues, Raphael's drawing and judicious pictorial disposition, and the academies which are so particularly necessary for our profession. In doing so, he alleged that one should be guided only by Nature and by no other rules "13

It is true that, unlike many artists of his time, Rembrandt never visited Italy. Constantijn Huygens reported in his autobiographical notes that when he asked the two young Leiden artists whom he so thoroughly admired, Rembrandt and Lievens, why they did not visit Italy, they replied that they were too busy with their own work, and, besides, they could see enough Italian art in Holland. A certain number of Italian paintings could indeed be seen at auctions or in collections in Amsterdam. Some of the most influential art that inspired artists in Italy, however—especially the art and architecture of antiquity and the great Renaissance fresco cycles as well as those of the early seventeenth century—was not portable. Nevertheless, such works could cast their spell abroad by way of imitations and copies. We know from the inventory of Rembrandt's possessions made in 1656 that he owned a large collection of drawings and prints and some casts after the antique. These were the forms in which works of art were usually disseminated.

In addition, Rembrandt was made aware of recent developments in art by his teachers, who had been to Italy. Echoes of Caravaggism appear frequently in his works. His acquaintance with the works Elsheimer made in Rome during the first decade of the seventeenth century can be docu-

mented, as for instance in *The Stoning of St. Stephen* (66). In the 1630s, during his most baroque period, he made frank references in his works to the style and compositions of Rubens, whose artistic personality had been formed in Italy during his eight years there, from 1600 to 1608. And in both the etched and painted versions of his *Self-Portrait Leaning on a Stone Sill*, when he was a successful artist of thirty-four, Rembrandt invoked the aid of two of the greatest painters of the Italian sixteenth century, Raphael and Titian. Throughout his career he used these and other discernible sources in earlier art as raw material that he transformed and made his own.¹⁴ Sandrart's comments on Rembrandt were far from the facts.

The notion that Rembrandt insisted on basing his art on nature alone is contradicted in many ways by his works. Not only did he make numerous frank references to works by other artists, but he also drew freely on the riches of his own imagination, as we have seen in his biblical subjects. Nowhere is the triumph of fantasy over observation more complete than in the landscapes he painted in the second half of the 1630s, for example, the *Landscape with an Obelisk* (90) of about 1638. This type of

90. Rembrandt, Landscape with an Obelisk.

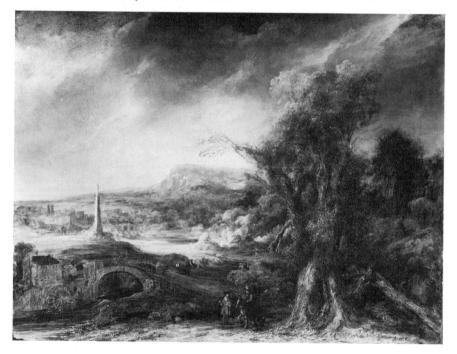

117

landscape composition harks back to the sixteenth-century Flemish tradition of fantastic landscapes. Rembrandt may well have been directly inspired by works by Hercules Seghers. In Rembrandt's hands this type of composition took on an exquisite romanticism. The play of light and shade, which unifies the composition, hints of drama. The colors in his imaginary landscapes were soft and harmonious; beyond the dark reddishbrown foreground, pale greens and golden tones blend earth and sky. The paint surface has a lively texture, with movement implied by details of line and form. Often the space in these small landscape paintings is unified by views through arches, bridges, and the like. In this particular example, the distant obelisk stands out boldly against the far-off fields, making a miniature echo of the tall vertical of the aged tree in the right foreground. Does the fact that the obelisk is so clearly placed to attract our attention indicate that it has special significance? Obelisks were, in fact, not foreign to the countryside as Rembrandt knew it. There were between ten and twenty obelisks near Amsterdam in the seventeenth century; they were used as boundary markers. The obelisk might rather have been intended, in this fanciful context, as a reminder of antiquity or as a more general symbol of the nostalgia that is a common ingredient of romanticism, like the ruins in some of his other landscapes of this period.

The imaginary mode of most of Rembrandt's landscape paintings and landscape backgrounds in figurative subjects seems to indicate that he turned his back on the natural scene. But after he moved, on May I, 1639, into the large house on the St. Anthonie-Breestraat, where he was to live until the end of the 1650s, he began to spend more time in the nearby countryside observing landscapes, which he drew and etched profusely in the following two decades. His etching of *c*. 1640, *View of Amsterdam from the Northwest* (91), presented a compositional type introduced by the Haarlem artists Goltzius (36) and Seghers (33) that was to be crucial for the development of panoramic landscape painting.¹⁵ Open-ended on both sides, with a distant view of the horizon pricked by windmills and the towers of the city (which are identifiable), this print implies in a tiny space the broad, unobstructed expanse of the flat Dutch land.

To Rembrandt "nature" surely meant not only the trees and fields and waterways that he could see around him, but—preeminently—humankind and all that pertains to it. In his landscape etchings and paintings he customarily placed small figures, engaged in a wide range of activities, that fit into the scene as unobtrusively as other natural forms. Ceaselessly he drew figures from life, apparently enjoying an instantaneous connection between eye and hand. The drawing of *Two Women Teaching a Child to Walk*, in red chalk on rough grayish paper (92), is an instance of the magic of his line. With this simple medium he creates form and space,

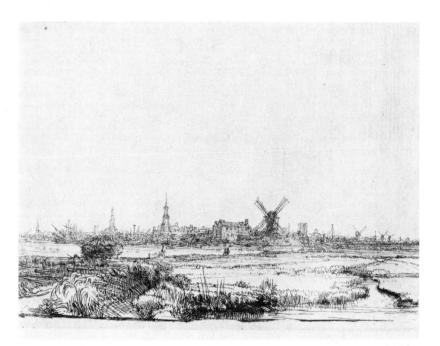

- 91. Rembrandt, View of Amsterdam from the Northwest, etching.
- 92. Rembrandt, Two Women Teaching a Child to Walk, drawing.

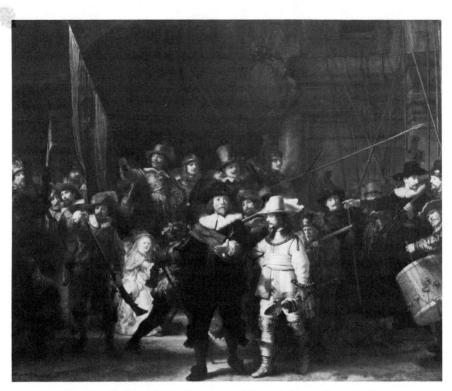

93. Rembrandt, The Militia Company of Captain Frans Banning Cocq ("The Night Watch").

action and emotional expression, while composing the group perfectly in the allotted area. A momentary, ordinary event in life is transmuted into an immortal work of art. This everyday scene speaks eloquently of Rembrandt's feeling for the family and the succession of the generations. The grandmother hovers protectively over the child, while the mother encouragingly points the way forward. They have provided the baby with a bumper hat that will protect his head against the hard knocks that may befall him.

In some types of subject matter, the baroque unrest and drama that marked Rembrandt's style of the middle 1630s continued as the next decade began. Nowhere is it more in evidence than in *The Militia Company* of Captain Frans Banning Cocq (93). The title *The Night Watch*, which was in use by 1800, has become indelibly attached to this painting, though it is certainly not a night scene. This group portrait was commissioned in 1639 for the decoration of a new great hall in the headquarters of the Kloveniersdoelen (company of arquebusiers). It was completed in 1642. Such a large group portrait of life-size figures, designed for public

display, was an important commission for any Dutch artist. In this case it was particularly challenging because between 1638 and 1645 a number of other painters were also working on major group portraits for this room, among them Flinck, Backer, Nicolaes Eliasz., Sandrart, and van der Helst. Rembrandt outshone them all and, in a sense, even outdid himself, producing a group portrait in the guise of a history painting. The myth that this painting was not well received and that its failure led to the decline of Rembrandt's career and his ultimate neglect and destitution is utterly without foundation.¹⁶

Efforts have been made to associate The Night Watch with a specific occasion or with a literary source, but the arguments propounded up to now have been flawed. It seems likely that Rembrandt invented a happening as a rationale for his dynamic conception. Possibly a theatrical production he had seen played a part in shaping his composition. A seventeenth-century civic guard group portrait commemorating a particular event would in any case not have been unique. What is unique in The Night Watch is the drive and energy of the activity that brings the group together, the lively realism that animates the surging crowd, and the drama of brilliant sunlight and shadow. Essential to all of these effects is the exceptional depth of space represented. The crowd is deployed in a broad and deep foreground area, with an architectural background lending unity and stability. Architecture was in fact to play an increasingly prominent part in Rembrandt's compositions, including commissioned portraits, from this time on. This was in keeping with the general tendency in Dutch painting toward the middle of the century to aim for more stable compositions by stressing horizontal and vertical elements, a tendency that is often spoken of as "classical."¹⁷

Captain Frans Banning Cocq, a stalwart life-size figure wearing black with a red sash and white ruff, marches out directly toward us, with his arm outstretched before him, pointing out the way. The shadow of his extended hand falls on his lieutenant, dressed in yellow, who marches at his side. The lieutenant holds a halberd whose foreshortening, like that of the arm of the captain, gives an optical impression of spatial depth. Three of the men behind this central pair are engaged in exercises from the manual of arms, one at the left loading his caliver, another, at the right of the lieutenant, blowing powder from the lock, and a third, between the two officers, firing his weapon. There are eighteen names inscribed on the cartouche (a later addition) on the right side of the archway. Sixteen of those portrayed paid about one hundred guilders each, more or less depending on their place in the picture. At least ten additional figures were included for reasons that are not understood. Especially beguiling are the figures of three children. The little girl with the fowl hanging at her belt, seen in brilliant illumination, has given rise to various speculations, but

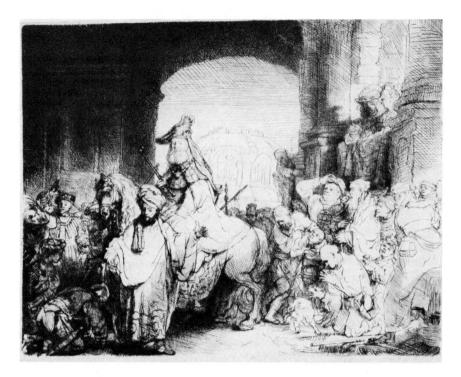

94. Rembrandt, The Triumph of Mordecai, etching.

no interpretation has yet been found that would be in accord with the implications of the picture as a whole.

In its present state *The Night Watch* is Rembrandt's largest surviving picture. It was cropped significantly on the left and on the bottom and more narrowly on the right when it was moved from the civic guard headquarters to the less spacious War Council Room in the Town Hall in 1715. As a copy painted in 1660 for Captain Banning Cocq shows, there were originally three additional figures at the left, and the captain was in the center of the composition, with more space in front of him. In its original format the picture was even more striking than in its present state, in which it has been widely acclaimed as one of the great paintings of all time.

In the etching *The Triumph of Mordecai* (94), which probably dates from about the same time as *The Night Watch*, that is, about 1641 or 1642, Rembrandt similarly combined the theme of a procession with a crowd of onlookers. The archway in the background and the figure of Haman in the foreground show the strong formal parallels between this etching and the vastly larger painting.¹⁸

The Old Testament theme of Mordecai's success in saving his people

by thwarting the plot of Haman, the chief minister of King Ahasuerus, may have been intended as a reference to the success of the Dutch struggle for independence. Over a period of many years, Rembrandt repeatedly illustrated episodes from the Book of Esther in drawings, prints, and paintings. The etching of *The Triumph of Mordecai* shows the moment at which Haman, at the king's orders, is announcing to the populace: "Thus shall it be done to the man whom the king delighteth to honor," in tribute to Mordecai, who wears the royal apparel and crown and rides on the king's own horse. Knowing what came afterward in Rembrandt's life, we can see this print as a symbol of his years of "riding high" in Amsterdam, prosperous and successful. This triumphant period was soon to end, as personal and professional problems beset Rembrandt in the 1640s. Only his creativity never let him down.

PERSONAL PROBLEMS, ARTISTIC PROGRESS: 1642-50

While the story that *The Night Watch* was a failure that led to Rembrandt's ruin is modern romantic fiction, it is true that after the early 1640s there was decreased demand for him as a portraitist. This reflected a shift in taste, with preference for elegance and display of status and wealth. A more polished style was better suited to this fashion in portraiture and, for that matter, to other kinds of subjects as well, in the eyes of many patrons. Still, there were other collectors—those, perhaps, who were less concerned with conforming to the latest fashion—who continued to value the works of the famous painter Rembrandt. Even into the 1660s he received important portrait commissions, and he never lacked a market for his drawings and prints, as well as paintings. His creativity did not falter. He worked productively and grew until the end of his life. Personal problems did, however, assail him.

His mother died in 1640. His life changed markedly with Saskia's death on June 14, 1642. Rembrandt was left with the infant Titus, who had been baptized on September 22 of the previous year. Geertge Dircx, a trumpeter's widow, became his housekeeper, probably mainly to care for Titus. Rembrandt's personal involvement with her proved to be unfortunate for both of them. Geertge sued him for breach of promise. He in turn took an active part in having her committed to an institution in 1650. It was in an affidavit made in 1649 on Rembrandt's behalf in the litigation against Geertge that the name of Hendrickje Stoffels first appeared, so far as we know, in connection with Rembrandt. Hendrickje was to remain his steadfast helpmate until her death in July 1663. Rembrandt never married her, probably for financial reasons. According to Saskia's will, if Rembrandt remarried he would have been required to pay

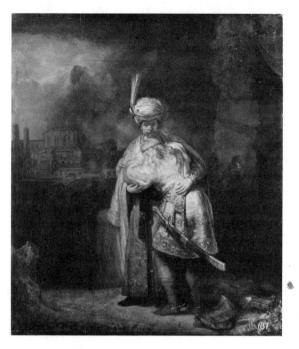

95. Rembrandt, *The Parting* of David and Jonathan.

Saskia's sister the half of her estate that he had inherited. He was in financial difficulties. Though his income from the sale of his works and the fees of students was substantial, it seems that his expenditures were excessive. His money was spent lavishly on his collection of art, antiquities, and curiosities of all kinds.

These problems may have contributed to the more somber and introspective quality that increasingly characterized his work in the course of the 1640s. Renouncing the dramatic moments that had often inspired his brush and pen previously, he dealt more often now with personal relationships in which inner experience was more significant than outward action. *The Parting of David and Jonathan* (95), signed and dated 1642, seems to be illuminated by the tender warmth of the friendship it commemorates. The embracing figures, in their rich, light-colored costumes, stand out against the shadowy landscape, with elaborate fantastic architecture representing Saul's palace in the distance. The vertical strength of the ruined wall at the right emphasizes the vertical stresses of the costumes of the merged figures. As compared with earlier works, the modeling of these figures is accomplished by broad brush strokes, and the contours are more broken.

The ministry of Christ, which occupied Rembrandt's thoughts often during this period, is perhaps most impressively exemplified by the

famous etching called *The Hundred Guilder Print* (96), which may have been conceived as early as the beginning of the 1640s and completed toward the end of the decade. The plate gives evidence that Rembrandt made numerous changes as he meditated on his interpretation of *Christ Healing the Sick*, the more descriptive title by which the etching is properly known. This print illustrates several passages from chapter 19 of the Gospel According to Saint Matthew. The symbolic significance of light and darkness is at the heart of the message: Those who have faith in Jesus proceed from darkness to illumination. This is the principle on which the composition is organized formally as well as in meaning. Christ stands like a pillar of strength, towering over the throng and dominating the space. He is radiant against a looming black form that suggests the shadow of the cross. The composition holds together firmly, despite the contrasts in technique.

The full range of values, from unalloyed whites through the gamut of grays to deep, velvety blacks, is proof of Rembrandt's unparalleled mastery as a print maker. He combined etching with drypoint and burin work to achieve the richly pictorial quality. From the Pharisees on the left, depicted freely and sketchily, to the highly finished, strongly modeled elements on the right, the groups of figures are interwoven in a system of

96. Rembrandt, Christ Healing the Sick ("The Hundred Guilder Print"), etching.

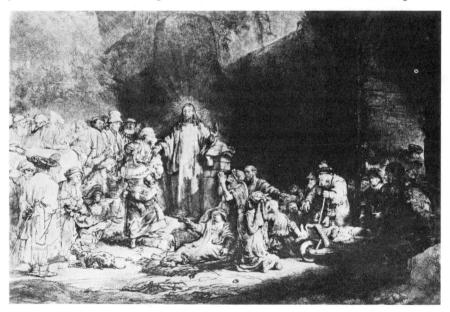

diagonals, focusing on Christ. In pose and gesture the figure of Christ bears a marked resemblance to Captain Frans Banning Cocq in *The Night Watch* and Haman in *The Triumph of Mordecai*. The compositional similarities between *The Hundred Guilder Print* and those two works provide visual evidence supporting the assumption that all three were conceived in the same period of Rembrandt's activity. The shadow cast by Christ's outstretched right hand and the striking shadow of the praying woman silhouetted on Christ's robe have the same linking effect as that produced by the shadow of Captain Banning Cocq's hand darkening the bright surface of his lieutenant's jacket. Such shadows also stress the three-dimensionality of the forms whose obstruction of the light creates the shadows. At the same time, they make us aware of the space that intervenes between the object and its shadow. Thus through firm organization and numerous skillful devices Rembrandt brought order to this complex pictorial problem, with its countless sensitively observed details.

Included in the crowd on the right side are varied costumes, physiognomies, and physical conditions that tell with sympathy of the "great multitudes" that followed Christ to the coasts of Judea. The camel and the laden donkey attest to the length of their travels. The camel also calls to mind the words of Jesus: "It is easier for a camel to go through the eye of a needle than for a rich man to enter into the kingdom of God" (Matthew 19:24). Other apparently minor elements also add their contributions to the meaning. The shell seen in a brightly lighted spot near the center of the foreground, for instance, is a symbol of pilgrimage. On the left side are the arguing Pharisees and also the rich young man, who sits with head on hand as he ponders. The disciple who staves off the women who approach with their children is the object of Christ's remonstrance: "Suffer little children, and forbid them not, to come unto me: for of such is the kingdom of heaven." With this large print, so rich in meaning, Rembrandt demonstrated with mature assurance the expressive potentialities of the medium. This is but one of the many works that contribute to Rembrandt's reputation as the greatest graphic artist of all time.

Though his range of subject matter was broad, there were some subjects to which Rembrandt returned again and again. He made no fewer than nine portrayals of the Holy Family and an equal number of depictions of the Flight into Egypt in paintings, drawings, and etchings. He imbued these subjects with a profound sense of the human values implicit in the Christian story. *The Holy Family with Painted Frame and Curtain* (97), painted in 1646, is one of the most accessible of all versions of this subject. Merely to compare this interpretation with any traditional depiction of the Madonna and Child is to see at a glance the revolutionary achievement of the Dutch humanization of art. Of the humanization of religious themes, Rembrandt was the prime exponent. He represents

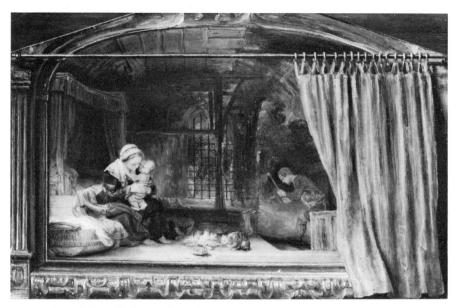

97. Rembrandt, The Holy Family with Painted Frame and Curtain.

sanctity not by a regal, remote, aloof image of ideal beauty, but by an ordinary, familiar mother fondling her infant. This intimate conception of the revered figures brings them so close to us that we can identify with them, while at the same time it enhances the essential human relationships that structure family life and underlie all social functioning.

The wicker cradle at the left serves as *repoussoir*, leading our gaze into the humble room, where the mother sits, clasping her baby to her breast as she warms her bare feet at the open fire. The fire is central, reminding us of the crucial role that fire historically has played in the maintenance of human life, making the hearth the symbol of the home. As in many a simple dwelling, the cat huddles beside the fire, eyeing the bowl of food that is warming nearby. The breadwinner, a carpenter, has left the fireside to work at his craft. But, as would have been usual in the seventeenth century, he works where he lives, and so he is seen in the shadowed area at the right of the picture. So Rembrandt encompasses, in this small and apparently casual composition, reverent associations to the elemental necessities of life. Deeply meaningful associations such as these—whether consciously acknowledged or not—fill Rembrandt's depictions of the Holy Family with emotional currency valid for nonbelievers as for devout Christians.

The red curtain contributes to the color harmony of the painting, heightening the effect of the child's red garment on the left and the related tones of the fire and the earthenware bowl in the center, which are the most saturated hues in the interior scene. The curtain also adds to the space illusion, by establishing a foreground plane. The feigned frame, curtain rod, and curtain add a new dimension of reality, mediating between the pictured world of the Holy Family and the everyday world in which we live. In meaning as well as in formal terms the drawn-back curtain serves multiple functions. Opening to our contemplation a spiritual realm immanent in human experience, it may refer to revelation in a religious sense. It also suggests the precious nature of the scene that it is designed to protect. This modest, apparently realistic painting represents, in short, the epitome of Rembrandt's artistic economy. As a diamond concentrates light, *The Holy Family with Painted Frame and Curtain* sharply focuses a theme that is dispersed throughout Rembrandt's works: The divine resides in human life and glorifies common humanity.

In the same year, 1646, Rembrandt's naturalism came to the fore in a painted landscape that is so sketchlike and direct that it is tempting to suppose that it was painted on the scene, from life. There is no solid evidence, however, that any Dutch seventeenth-century artist painted landscapes anywhere but in the studio, though a number of paintings show them drawing landscapes in the open. Rembrandt's *Winter Landscape* (98) is a very small panel, painted wet-in-wet, and differs strikingly from

98. Rembrandt, Winter Landscape.

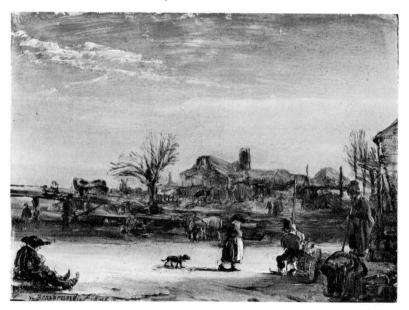

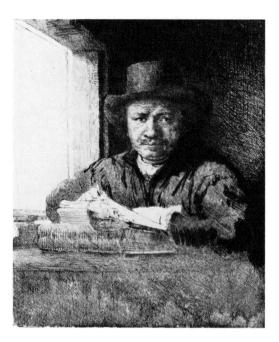

99. Rembrandt, Self-Portrait Drawing at a Window, etching.

his other, fantastic landscape paintings in its evocation of a specific time, place, and condition of weather.

The Self-Portrait Drawing at a Window (99), dated 1648 in the second state, is Rembrandt's first etched self-portrait after the Self-Portrait Leaning on a Stone Sill (87) of 1639. It chronicles the changes nine years wrought in the man and his style. No longer does the artist pose as a dandy, nor does he refer to the great painters of the Italian Renaissance. His hair has been cut short, his beard shaved off, and he wears the simplest of clothing. Instead of the baroque emphasis on the body's occupation of spatial depth through a position perpendicular to the picture plane, with the head turned to look over the shoulder, in the 1648 composition he is seen frontally, with a brimmed hat squarely on his head replacing the dashing sweep of the beret in the earlier etching. The window, with its emphatic verticals, is the visible source of the light that defines the forms, and it is sharply contrasted with the black shadows. The intensity of Rembrandt's gaze gives a convincing impression that he adhered closely to the image of himself that he studied in a mirror. He used himself in this case as model for a milieu portrait of the artist at work, aged forty-two, in strong maturity, free from all pretension.

It is tempting to imagine that he sat at a window in just this way and, with the ease that accompanies complete mastery, made drawings such as

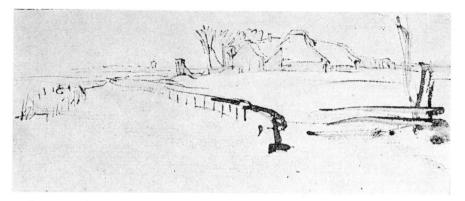

100. Rembrandt, Winter Landscape, drawing.

A Winter Landscape (100)—though surely this scene was not visible from his own house in Amsterdam. This supremely economical impression of fields and farmhouse deep in snow was probably drawn at about the end of the 1640s.

RENEWED FORCE AND FECUNDITY: 1650-59

In the great period of the 1650s Rembrandt produced paintings, drawings, and etchings prolifically. Both his powers of invention and his technical mastery reached new heights, in the judgment of modern connoisseurs. Characteristic of his painting style at the beginning of this decade is A Young Girl at a Window (101), which is signed and dated 1651. The stability of the figure, posed in uncompromising frontality, is underlined by the horizontal and vertical of the architectural features. The rich colors are applied in unmodulated blocks of paint. The costume is light red with a chemise of warm white, and the girl's flesh tones are ruddy, her hair reddish-all in brilliant contrast to the surrounding darkness. Impressive for its color, composition, and luscious paint surface, the Young Girl at a Window is appealing for its humanity as well as its formal splendor. The contemplative young woman is given her due as an individual. So insightful is the portrait that our acquaintance with her seems more than skin deep. Should this be considered a genre painting, or primarily a portrait, or simply a study of a model dressed in a costume made up of studio props? As with so many of Rembrandt's paintings, it is impossible to be sure. He was independent of conventional modes. It may even be that he had in mind a text from the Bible or some other literary source.

Rembrandt's affinity for the contemplative moment is nowhere more

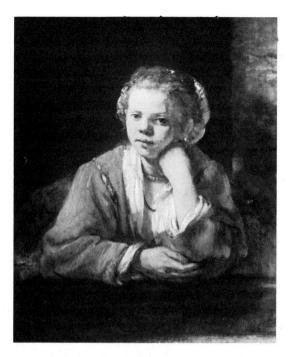

101. Rembrandt, A Young Girl at a Window.

fully realized than in his Aristotle with the Bust of Homer (102). In 1653 he signed and dated this painting, which had been commissioned by a Sicilian nobleman who was an avid art collector, Antonio Ruffo. Ruffo paid a high price for it and was so pleased with it that he ordered two more paintings by Rembrandt. These were to represent Homer and Alexander the Great, both of whom appear in the Aristotle, Homer in the form of a bust, on the base of which Rembrandt inscribed his signature and the date, and Alexander (very likely) on the portrait medallion suspended from the massive chain worn by Aristotle. Such a chain bearing a portrait of the donor, a token of honor in the Renaissance, was presented to some eminent court painters, including Titian, Rubens, and van Dyck, by royal patrons. The blind Homer, who represents the inner vision, the source of spiritual knowledge, is depicted as a copy of a Hellenistic bust of which Rembrandt probably owned a cast. Thus the revered poet is made the focus of a tribute to the art of antiquity. The contrast between Aristotle's right hand, seen in full light, raised to touch the head of Homer and his left hand, in shadow, lowered to touch the chain, suggests a choice between the life of art and the life of action. The right hand, light, and *elevation* are all metaphors for the better of two alternatives, as compared with the left, darkness, and an inferior position. Julius S. Held has interpreted the picture as representing a preference for enduring values rather than transitory rewards.19

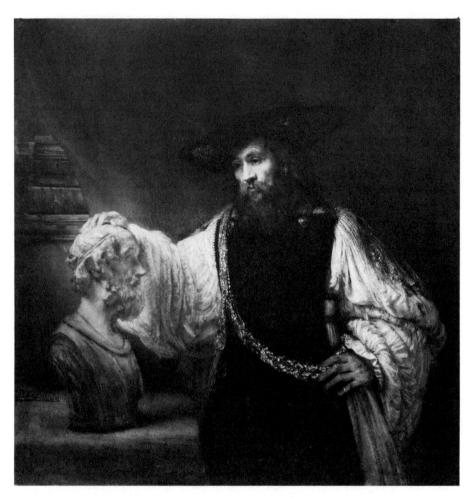

102. Rembrandt, Aristotle with the Bust of Homer.

The almost square format of the *Aristotle*, with the space so well filled by a three-quarter-length figure, is reminiscent of the compositional type of a number of Titian's portraits. The color scheme too is Titianesque: red table cover, black "apron" and hat, expansive pleated sleeves of warmly tinted white. Even the physiognomic type of Aristotle (of whom we have no authentic portrait) resembles some of Titian's bearded sitters. Rembrandt's free touch and rich paint surface also call to mind his great Venetian predecessor. The dazzling virtuosity of the painting of the chain is matchlessly Rembrandt's, as is the poetic distribution of light.

A Woman Bathing in a Stream (103), dated 1654,²⁰ looks so spontaneous and natural in subject matter, so direct and sketchlike in style that it is easy to think of it as nothing more than an impression of a momentary visual experience. But a garment of rich gold brocade on the bank of the stream, behind the woman, suggests that some specific meaning is attached to this unique subject. Perhaps the picture represents one of the Old Testament bathing beauties, Bathsheba or Susanna, to both of whom Rembrandt devoted other works. It may be that Hendrickje served as model for the lovely wading woman, but this is by no means certain.

In 1654 Rembrandt also painted one of his rare female nudes, *Bathsheba* (104), whom he had depicted earlier as well. In this moving version, Bathsheba appears to be meditating on the tragedy that will result from King David's lust for her. The paint, laid down with firm, heavy strokes, builds the forms in flesh tones that glow against the darkness.

During the last fifteen years of his life, Rembrandt's thoughts often turned to the infancy and childhood of Christ, which provided subject matter for some of his most affecting etchings and drawings, as well as paintings. In about 1654 he made the etching *The Adoration of the Shepherds* (with the Lamp) (105), a touching tribute to humility. The country folk crowd into the barn to pay their respects to the Mother and Child, whom they find in a state no less humble than their own, as they rest on straw on the ground. The lamp produces a natural but halolike circle of light and flickeringly illuminates the people and animals. The crisp, sure etched strokes build forms and indicate the play of light in a manner uniquely Rembrandt's. By varying the inking and wiping of his plates and the choice of paper on which he printed the impressions, he could make of each sheet, particularly in a night scene such as this, an individual work of art.

In the following year, 1655, Rembrandt painted *Titus at his Desk* (106), which is probably his earliest existing portrait of his son. The pensive boy is placed in space between the firmly constructed desk and the recessive darkness of the background. The beauty of paint itself is surely a dominant interest in Rembrandt's paintings of this period. With the pal-

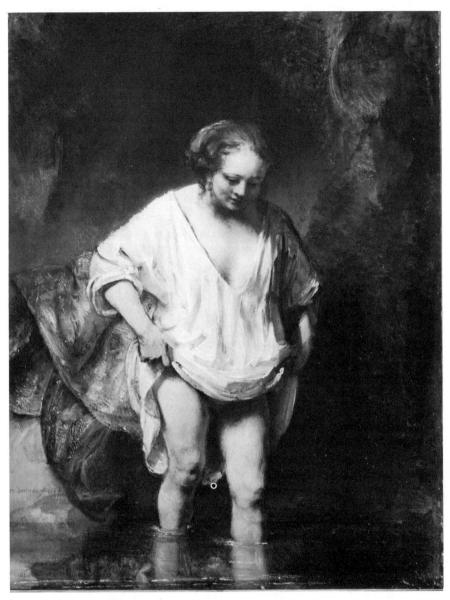

103. Rembrandt, A Woman Bathing in a Stream.

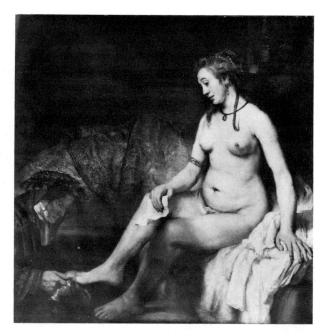

104. Rembrandt, *Bathsheba*.

105. Rembrandt; The Adoration of the Shepherds (with the Lamp), etching.

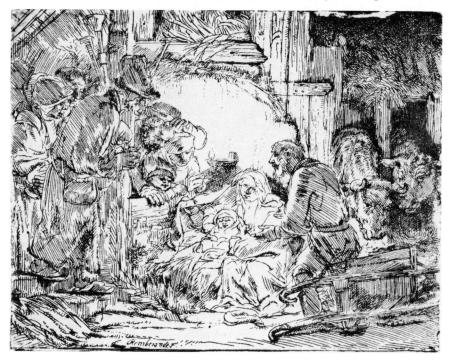

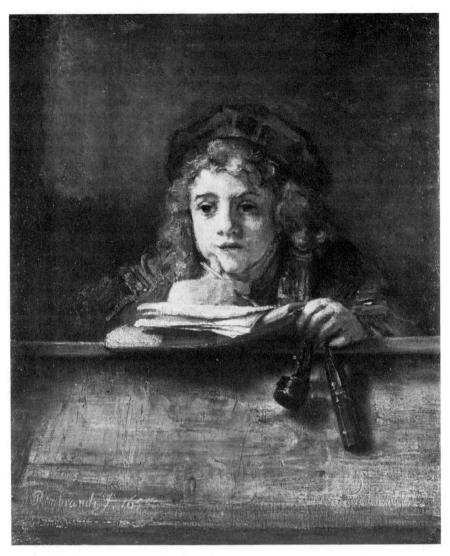

106. Rembrandt, Titus at his Desk.

ette knife he laid down rich swaths of pigment, establishing forms and textures convincingly, yet never concealing the actual nature of the material with which he worked.

Hendrickje at an Open Door (107) is similar in style. The figure is firmly anchored by the horizontal and vertical details of the setting. X-rays show that Rembrandt worked out the pose directly on the canvas, starting with a full-face view and hands together, which he altered so that

107. Rembrandt, Hendrickje at an Open Door.

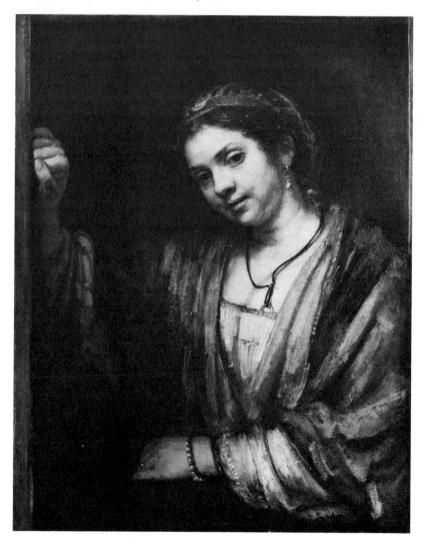

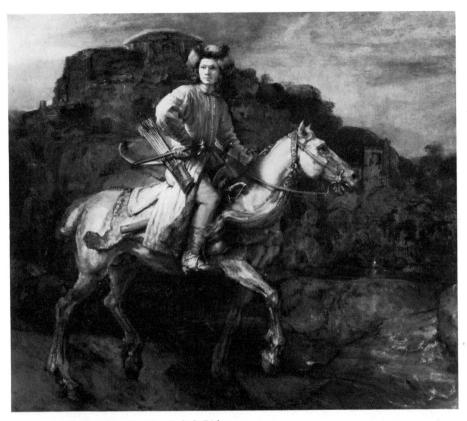

108. Rembrandt, The Polish Rider.

the arms emphasize the architectural framing, while the gracefully inclined head suggests a diagonal.

The Polish Rider (108), painted in the middle 1650s, unifies the figure of the young horseman and the romantic, fortress-crowned landscape in an evocation of the ever-renewed literary theme of the mission of the youthful hero. Whether the rider depicted was in fact Polish, and related to a specific event or text, or whether he represents the ideal of the Christian Knight in a more general sense, the painting conveys the beauty and hopefulness of a young man's response to the challenges of life.²¹ Though it is by no means a portrait of Titus, the feelings expressed may stem from Rembrandt's fatherly aspiration.

Rembrandt's concern with the family, with continuity represented by the successive generations, found expression in an Old Testament subject, *Jacob Blessing the Sons of Joseph* (109). This was signed in 1656, though parts may have been reworked in the following decade. The text (Genesis 48) does not call for the presence of Joseph's wife, the Egyptian

Rembrandt

Asenath, but Rembrandt saw fit to include her in the scene in which the aged Jacob extends his blessing to her sons. According to the Bible, Jacob placed his right hand on the head of Ephraim, the younger son. When Joseph tried to move his father's right hand to the head of his firstborn, Jacob refused, saying, "His younger brother shall be greater than he." The interpretation of this as a prophecy that Christianity would triumph over Judaism led to the inclusion of this scene in Christian art from medieval times.²² Differing in some ways from the long iconographic tradition in which it takes its place, Rembrandt's painting is a masterpiece of emotional expression. Restrained, economical—perhaps even unfinished—it conveys the personal response of each of the individuals to this solemn moment that they share (110). It is an outstanding example—among many—of Rembrandt's appreciation of the Bible as a treasury of human experience.

It may be that Rembrandt's meditation on the theme of family solidarity represented by the story of the aged Jacob's blessing of his grandchildren bore some relation to his personal situation. Rembrandt now, like Joseph, had a second child. Hendrickje's daughter, Cornelia, was baptized on October 30, 1654. Of the four babies born to Saskia between 1635 and 1641, only Titus had survived. Infant and child mortality in the seventeenth century gave ample reason for anxiety as to the prospects for a posterity. In the course of events, Cornelia was to be Rembrandt's only survivor.

Rembrandt's new family, however welcome to him, was not without problems. Both Rembrandt and Hendrickje had been summoned before the Council of the Reformed Church on June 25, 1654, because they were living together illicitly. A week later the records of the Council made no mention of Rembrandt, but stated that Hendrickje had not appeared. When she finally came before the Council she was reprimanded and suspended from communion. Apparently she was suitably repentant, and three months later Cornelia was baptized. The chief concern of the Council was that the child should be baptized. Whether some degree of social ostracism followed from Rembrandt's common-law marriage to Hendrickje cannot be documented. He was criticized for keeping low company, and this may have had to do with Hendrickje, who was illiterate and of humble origin as well as "living in sin."

Financial difficulties also hounded the household. In 1653 Rembrandt was pressed for overdue payments and interest on the debt on his house. He borrowed to pay off all but one thousand guilders. Unable to meet his obligations, in July 1656 he filed a petition for a *cessio bonorum*, an alternative to outright bankruptcy. It may be that he had speculated in art and lost money during the economic recession at the time of the first war with England, from 1652 to 1654, which ruined Dutch trade. An inven-

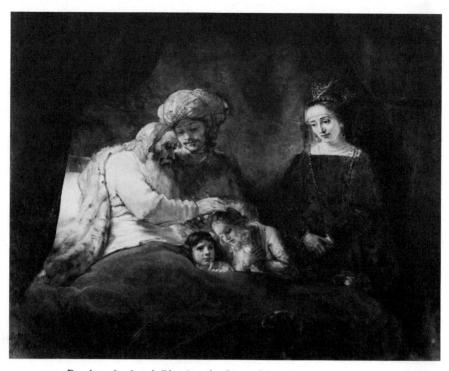

109. Rembrandt, Jacob Blessing the Sons of Joseph.

110. Detail of 109.

tory of all his possessions was made in preparation for the three auctions that were later held,²³ in the first of which his personal property was sold, in the second his house, and in the third his art collection. The prices were disappointingly low.

Rembrandt's career as a painter was by no means in eclipse. In 1656, for instance, he received a commission to paint a large group portrait, *The Anatomy Lesson of Dr. Joan Deyman*, which was damaged by a fire in the eighteenth century, so that only a fragment survives (Amsterdam, Rijksmuseum). That Rembrandt was far from a broken man is indicated by his *Self-Portrait at the Age of Fifty-two* (111). He sits as if regally enthroned, with the squared-off neckline and sash of his rich, theatrical costume emphasizing the blocklike solidity of the figure.

In 1659 Rembrandt dealt once again with a subject from the apocryphal Book of Tobit, the text of which provided subjects for as many as fifty-five of his drawings, etchings, and paintings.²⁴ (The Apocrypha were included in earlier Protestant Bibles, as well as in the States' Bible published in 1637 for the Dutch Reformed Church.) The small painting of

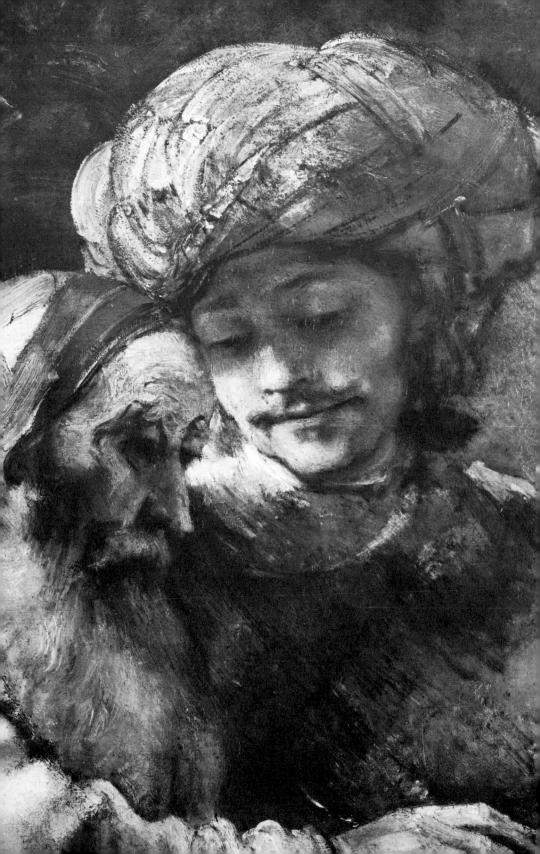

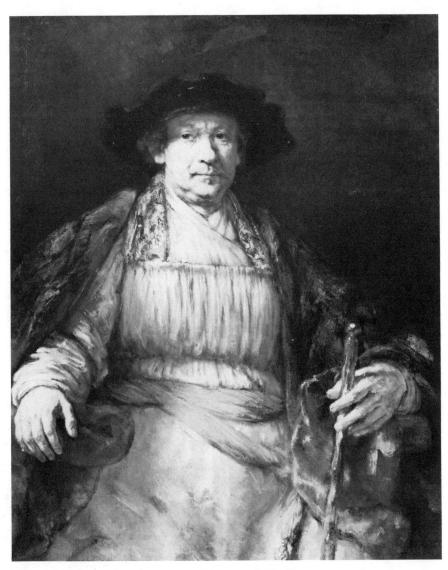

111. Rembrandt, Self-Portrait at the Age of Fifty-Two.

Rembrandt

Old Tobit and Anna Waiting for Their Son (112) is among the most moving of the series, as it shows the gloom and isolation of the two old people. Anna sits by the window, spinning, while blind Tobit warms himself by the fire. Both Rembrandt's concern with blindness and his interest in the father-son relationship probably attracted him to this story, in which the old father, blinded as a result of a pious deed, is cured by his son, with divine assistance. The simplicity of the composition and the loose, free brush strokes are characteristic of Rembrandt's late style.

THE FINAL YEARS: 1660-69

On December 15, 1660, Rembrandt signed an affidavit in which Titus and Hendrickje "agree to carry on a certain business started two years before, in paintings, pictures on paper, engravings, and woodcuts, the printings of these, curiosities, and all pertaining thereto, until six years after the death of" Rembrandt. In effect this notarized document made Rembrandt their employee.²⁵ Its purpose was to prevent his future earnings from going to his creditors. Hendrickje was "assisted by a guardian" and signed with an X. Three days later they moved to a smaller

112. Rembrandt, Old Tobit and Anna Waiting for Their Son.

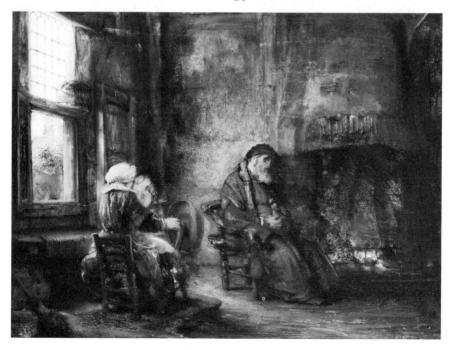

house on the Rozengracht. Rembrandt continued to have pupils and to paint, but he made few drawings and even fewer etchings thereafter.

The large painting of *The Apostle Peter Denying Christ* (113), which he signed and dated in 1660, is evidence of his continuing creative force. In this scene, one might say, light speaks for itself. The burning candle that the maidservant holds is mostly concealed by her right hand; the light it casts draws the forms out of the darkness. It reveals the coarseness of the soldiers at the left and the metallic harshness of their armor, as well as the maidservant's questioning expression. The light ruthlessly exposes the Apostle at the moment of his faithlessness; his face expresses the tragedy of his dilemma. In the right background Christ, as he is being led away, turns to look at Peter. It is rare in Rembrandt's late works to find such a tension between foreground and background. No doubt he felt the

113. Rembrandt, The Apostle Peter Denying Christ.

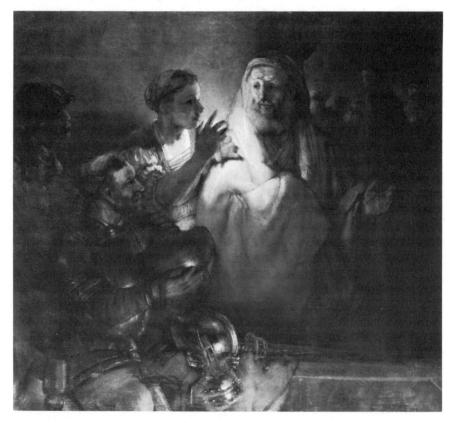

144

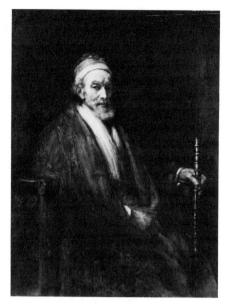

114. Rembrandt, Jacob Trip.

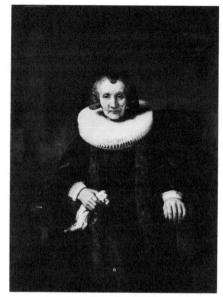

115. Rembrandt, Margaretha de Geer, Wife of Jacob Trip.

need to show the presence of Christ as a token of the promise of grace to every repentant sinner.

The extraordinary sympathy that Rembrandt always felt for the aged is apparent not only in narrative subjects but in commissioned portraits. The portraits of The Dordrecht Merchant Jacob Trip (114) and Margaretha de Geer (115), his wife, were probably painted not long before Trip died in May 1661. They were both members of prominent and wealthy families involved in the manufacture of armaments, among other interests. Eighty-five-year-old Jacob Trip is wrapped in a fur-lined cloak, while his wife wears old-fashioned attire, as might have been expected of a conservative woman of advanced years in those days. Though the artist did not beautify his subjects, he made beautiful paintings of them. His sensitive response to their individuality did not preclude unsparing candor. The free, open brush stroke of his late style and the subtlety of the flesh tones transcend the depredations of age that they define. The late drawing A Lion Lying Down (116) gives further evidence of the continued vigor of Rembrandt's eye and hand and his unabated curiosity about the natural world.

The new Town Hall of Amsterdam, which was officially opened in 1655, provided an important commission for Rembrandt.²⁶ It had been decided by the city fathers that the lunettes in the galleries surrounding

116. Rembrandt, A Lion Lying Down.

the great hall should be filled with paintings telling the story of the Batavians, who revolted against the Romans in A.D. 69, as described by Tacitus.²⁷ The Dutch considered the Batavians their forefathers and wished to stress the parallels between their own heroic fight for freedom and that of the Batavians. On November 28, 1659, a former pupil of Rembrandt's, Govaert Flinck, was given the commission for twelve paintings, eight of which were to depict events in the Batavian revolt. Less than three months after making full-size watercolor sketches on canvas, Flinck died suddenly. The commission was then divided among a number of artists. Rembrandt was to paint the first event, the initiation of the conspiracy. A local historian noted that he saw Rembrandt's painting in place in the Town Hall on July 21, 1662. But it was soon removed, for reasons that we do not know, and never replaced. Instead another, less able, former pupil of Rembrandt's, Juriaen Ovens, painted over Flinck's sketch; this is still to be seen in the spot for which it was designed.

Rembrandt's painting was originally sixteen feet square. At some time after it came back into his hands, he cut it down and painted in some alterations. We know his painting, called *The Conspiracy of Julius Civilis* or *The Oath of the Batavians*, through the surviving fragment (117). A pen and wash drawing (made on the back of a funeral notice dated October 25, 1661) gives us an idea of the composition as Rembrandt planned it (118). According to Tacitus, the meeting took place at night in a sacred grove. The drawing shows that Rembrandt placed it in a vast, vaulted interior through whose high, open arches tall trees are visible. Broad steps

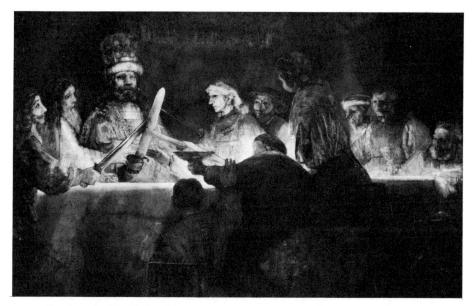

- 117. Rembrandt, The Oath of the Batavians.
- 118. Rembrandt, The Oath of the Batavians, drawing

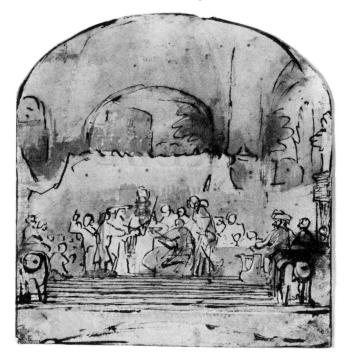

and a canopy or curtain emphasize the horizontal stability that is established by the table placed parallel to the picture plane.

The painting is huge in scale and broadly painted, to be seen from a distance. The source of light is hidden by the figures at the near side of the table, one of whom lifts the goblet of wine that signals the sealing of the pact. The oath is taken "in the style of the barbarians," by touching swords. The leader of the conspiracy, Julius Civilis (sometimes called Claudius Civilis, as he was apparently referred to in the seventeenth century), had lost an eye in combat. It was usual for artists to conceal such a defect through a profile pose, but Rembrandt shows Julius Civilis frontally, with his injury fully visible. A crown like a gigantic popover adds to his impressive stature. His sword, too, dominates the swords of his fellow conspirators.

The radiant colors of the illuminated areas, mainly flamelike reds and yellows, stand out with dramatic intensity against the dark surroundings. Light seems to dissolve the solid forms and to function as an element in itself. This is the apotheosis of Rembrandt's long exploration of the expressive powers of light and darkness. To us it seems a tragedy that only a fragment remains of the tremendous painting. We can see, however, that it might have been less pleasing to the arbiters of the decoration of the Town Hall, whose goal it was to establish the dignity of their government. The symbolic value of the decorative program was their first consideration; all the paintings and sculptures within the building and on the exterior served propaganda purposes. But style was important to them too. Judging from the works that they selected, they preferred the international baroque style associated with the courts of Italy and Flanders to Rembrandt's highly individual and less grandiose approach. Perhaps this explains why Rembrandt's largest painting was rejected. But this is only conjecture. It is not beyond the realm of possibility, for instance, that he had the painting taken down because he himself wished to make changes. which he never succeeded in doing to his own satisfaction. Or perhaps a failure to agree on price was responsible for the removal and ultimate dismemberment of the great picture.

That Rembrandt continued to be appreciated by at least some prominent persons is indicated by the fact that he was chosen to paint an important group portrait, *The Sampling Officials of the Cloth-Makers' Guild* (119), which he signed in 1662, to be hung in the headquarters of the cloth-makers.²⁸ Five officials of the guild are grouped around the table, which is shown in sharp foreshortening and seen from below. Their servant or clerk stands behind them, bareheaded; X-rays show that Rembrandt changed this man's position several times before he was satisfied with his place in the composition. The impression that all of the men look intently out of the picture, toward us, and that their poses are lively rather

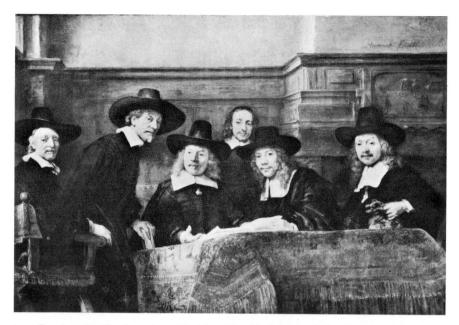

119. Rembrandt, *The Sampling Officials of the Cloth-Makers' Guild* (*De Staalmeesters*).

than fixed has given rise to an anecdotal interpretation. This notion, that a moment is depicted in which the officials are responding to members of an audience that they are facing, cannot be sustained. It is rather to be credited to the painter's compositional and technical skill that he was able to assemble the six portraits in such a way as to give the effect of tension actually experienced in a shared enterprise.

The responsibility of these men for good administration is signaled by the beacon depicted in the decoration of the paneled fireplace, on the right, a symbol of civic virtue known from emblems of the period. The warm brown wall and red table cover splendidly serve as foil for the austere black costumes and hats and the white collars and cuffs that frame the rich flesh tones. Again we are moved by the living individuality of these figures created by the penetrating eye and the assured brush of this great master, whose human sympathy is perhaps the most essential ingredient of the communication that speaks warmly after three centuries.

Hendrickje died in 1663. All we know about it is that on July 24 she was buried in the Westerkerk.

The painting traditionally known as *The Jewish Bride*, more appropriately titled *The Loving Couple* (120), is widely recognized as a peerless evocation of tender love. Rembrandt completed it around the middle of the 1660s. Whether the embracing man and woman represent biblical

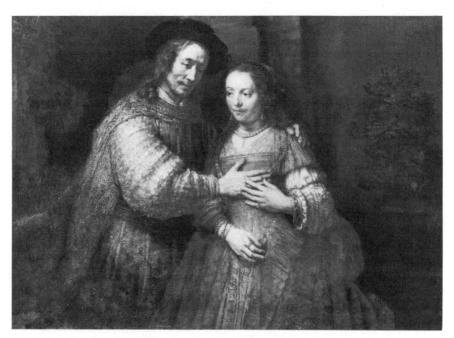

120. Rembrandt, The Loving Couple ("The Jewish Bride").

characters, historical figures, or contemporaries of the artist in the guise of characters from literature or history is uncertain. Their luxurious, fantastic costumes remove them from the realm of the usual commissioned portraits, and the intimacy of their pose would also be unexpected in a portrait of a couple in the middle of the 1660s. It is striking that though they are physically in intimate contact, their glances do not meet. Sad overtones to the expressions of both of them add a note of poignancy to the meeting, which somehow seems to foreshadow a parting. The glorious golds and reds of the costumes and the abundance of gleaming jewels make the dark outdoor setting mysterious, even threatening, by contrast.

Emotional implications that arouse a universal resonance are no less evident in a painting of about the same time, approximately 1665, that depicts an Old Testament subject, *The Downfall of Haman* (121). The facial expressions of all three figures are grave (122). They do not communicate with one another through either glance or gesture. Each seems withdrawn from the others, as if mobilizing his own inner resources to accept an inevitable tragedy. The background lost in shadow lends powerful support to the brooding, ominous emotional tone, while it gives no clue to a naturalistic setting. All of these features are characteristic of Rembrandt's paintings of his final decade.

Rembrandt

The aging Rembrandt could hardly have set himself a more exacting test of his mastery, noted from the time of his earliest works, in depicting emotions through facial expressions and postures. Here he availed himself of only three heads and two hands, in addition to three costumes, to tell his story. The text on which the picture is based is Esther 6:10, which tells that King Ahasuerus during a sleepless night had the book of chronicles read to him and was thus reminded that he had never rewarded the cousin of Queen Esther, Mordecai, for saving his life. In the morning he

121. Rembrandt, The Downfall of Haman.

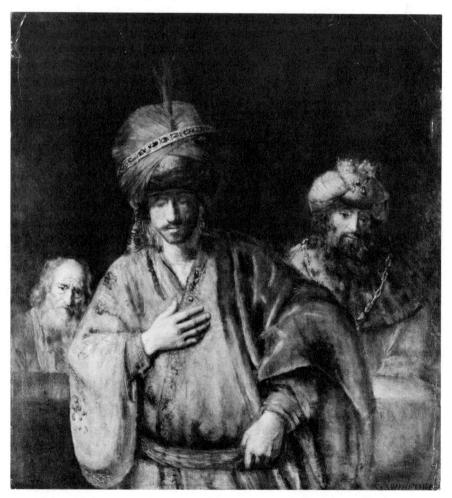

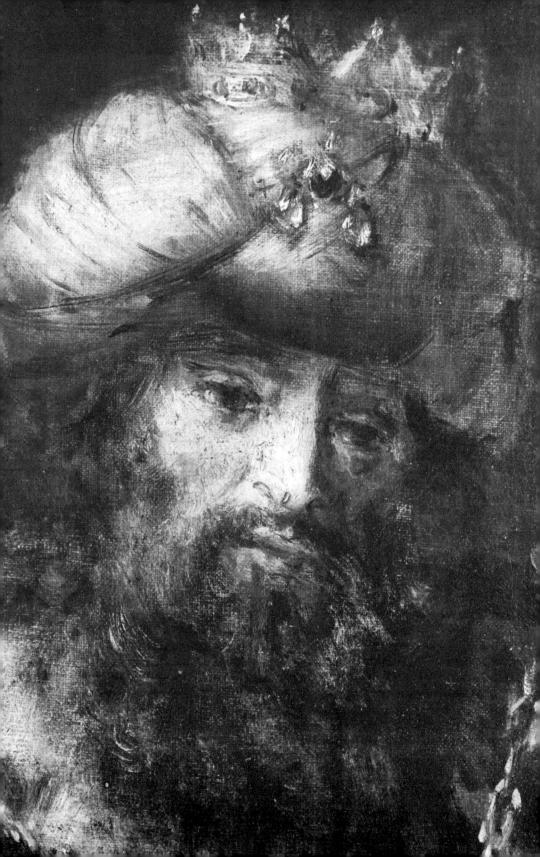

Rembrandt

122. Detail of 121: King Ahasuerus.

ordered his first minister, Haman, to honor Mordecai publicly. Thus Haman's plot to destroy Mordecai's people, the Jews, was thwarted. The painting shows the moment at which Haman leaves to do the king's bidding, realizing that he himself is doomed. Rembrandt's source seems to have been the *Jewish Antiquities* of Flavius Josephus, of which he owned a German edition with woodcuts by Tobias Stimmer, according to the inventory of 1656. This version is more explicit than the Bible about this incident. The old man on the left is the scribe or servant who read the chronicles to the king. Haman is the active participant at this moment in the narrative and is therefore central in the painting. The Book of Esther celebrates the triumph of a captive people with whom the Dutch, recently liberated from their bondage to the Spanish crown, liked to identify. It appealed to the sense of nationality and pride of race that supported their independence. In the course of his career Rembrandt depicted various episodes from this Old Testament story.

Rembrandt's works as he grew older showed his increasing detachment from the drama of events. He became more concerned with situations of inner crisis in which each person is solitary. It is the emotions involved that he strove to communicate. In *The Downfall of Haman* there is no hero, no villain. The painter's compassion casts on all alike the light that comforts while it reveals. This conception is built on faith that expiation may lead to redemption. Rembrandt's meditation on the central Christian belief in salvation through God's grace is shown by his various depictions of the return of the prodigal son, starting with an etching made in 1636. His feeling for this parable culminated in the great late painting (Leningrad, Hermitage) of the scene in which the father embraces his son who "was lost, and is found" (Luke 15:24, 32).

Rembrandt's portrayals of himself constitute one of the most beautiful and moving records of a human life known to us. In what was probably his final *Self-Portrait* (123), painted during the last year of his life,²⁹ his brush had not lost its magic, though he had suffered a dreadful blow. On February 10, 1668, Titus had been married to Magdalena van Loo and left his father's household to establish his own home; but he lived less than seven months longer. On September 7 he was buried in the Westerkerk. Rembrandt was godfather to Titus' posthumous daughter, Titia, at her baptism on March 22, 1669.

In his last self-portraits Rembrandt still appears as the clear-eyed observer, without fear or pretense. He seems to have adhered to the difficult precept that to live fully one must squarely examine things as they are. His understanding that the real world includes feelings led him more fully

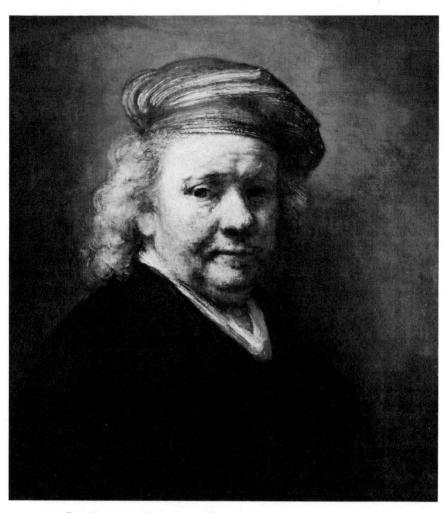

123. Rembrandt, Self-Portrait in His Last Year.

than any other artist to bring within the compass of Dutch naturalism the actuality of emotional life. Going beyond the observable, he left margins of mystery, room for the complex and the unexplained. Surely no one has imparted with greater economy of means—and purer aesthetic effect—the human condition.

On October 4, 1669, Rembrandt died. He was buried in the Westerkerk four days later. We still feel that in him we lost a warm, wise friend.

7/ The Rembrandt School

JAN LIEVENS is an artist who must be considered in connection with the Rembrandt "school," though he was never a pupil of Rembrandt's.¹ During Rembrandt's early years as an independent master in Leiden, the two were closely associated. It is possible that they shared a studio. Their names were so firmly linked at this time that in 1632, in an inventory of the collection of paintings of the stadholder in the Nordeinde Palace in The Hague, one picture was listed as "by Rembrandt or Lievens." This confusion is surprising, in view of the marked differences between their depictions of Samson and Delilah, both very likely painted in 1628 (73 and 74). Constantijn Huygens, who probably visited the two young artists in November 1628, while they were working together in Leiden, also stressed the contrasts between their achievements, though he admired them both.

Lievens was a year younger than Rembrandt but was more advanced in his art studies. Indeed, he was apparently precocious. He is said, improbably, to have had a two-year apprenticeship in Leiden and then to have gone to Amsterdam at the age of ten to study for two years with Pieter Lastman and to have worked on his own at Leiden thereafter. Rembrandt, on the other hand, spent six months in Amsterdam as Lastman's pupil in about 1624 and returned to Leiden to work as an independent master by 1625. In about 1628 or 1629 Lievens painted a portrait of *Constantijn Huygens* (124) that demonstrates his skill and sensitivity at that early time. In his early years Lievens also designed excellent etchings and woodcuts. That he was held in greater esteem than Rembrandt is

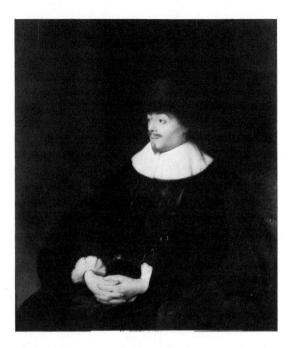

124. Jan Lievens, Constantijn Huygens.

suggested by the fact that J. J. Orlers, in the second edition of his description of the city of Leiden, published in 1641, devoted twice as much space to Lievens as to Rembrandt.

While still in Leiden, Lievens was a sympathetic painter of old men with soft, white beards. One such is the main figure in *Job in Misery* (125), dated 1631. This life-size figure represents Job at the depths of sorrow, bereavement, and degradation (Job 2:8–13). The light is strongly focused on the gaunt, stricken Job, an unforgettable image of grief. Even the position of his arms expresses the emptiness and defeat of one who has lost everything.

The promise that Lievens showed was not to be fulfilled, however. He left Holland in 1631. He is said to have spent three years in England, after which he settled in Antwerp, where he is known to have been from 1635 to 1644. The Flemish style in both portraits and landscapes influenced him even after he returned to the United Provinces in 1644, where he continued his career as a fashionable but uninspired portraitist. He died in 1674.

In 1628, at the age of twenty-two, Rembrandt already had a pupil, Gerrit Dou, who was born in Leiden in 1613. From 1625 to 1627 Dou had been a member of the glaziers' guild. He was the only pupil of Rembrandt's Leiden period who was to become a hugely successful painter in his own right. Orlers, in his history of Leiden, recorded that, after three years with Rembrandt, Dou "had grown into an eminent master, particularly skilled in small, subtle, and curious things." His paintings were considered marvels of skill. They were elaborate compositions, extremely detailed and very finely finished. They sold at high prices; the evidence of meticulous care and craftsmanship in painting has always appealed to a large public. Many painters became *fijnschilders* (fine painters) in emulation of Dou. Outstanding among his followers were

125. Jan Lievens, Job in Misery.

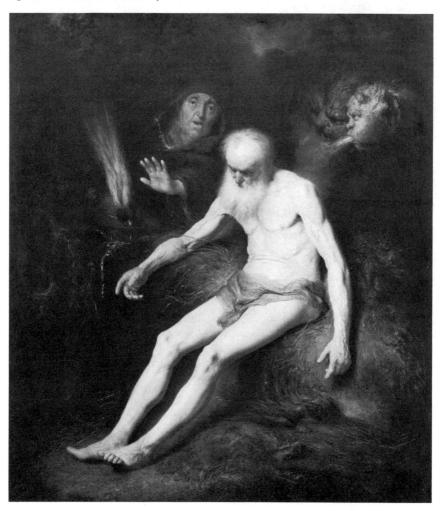

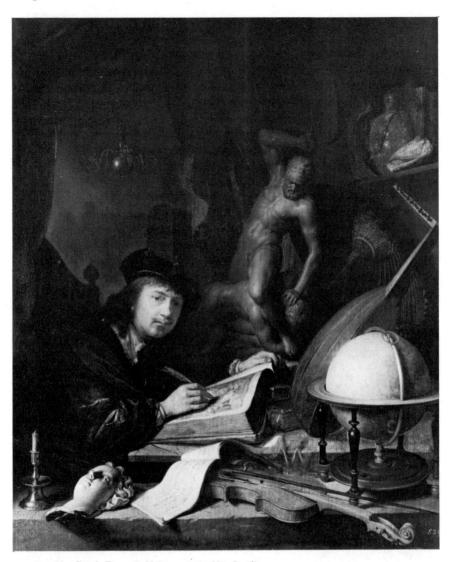

126. Gerrit Dou, Self-Portrait in His Studio.

Gabriel Metsu (1629–67), Frans van Mieris the Elder (1635–81), and Godfried Schalcken (1643–1706).

While Dou was still in Rembrandt's studio the resemblance of his style to his master's was strong. Like Rembrandt's paintings of the late 1620s, Dou's works were small and polished. There are a number of paintings that were once attributed to Rembrandt that are now accepted as works made by Dou in the years of his close association with Rembrandt.

The basis for distinguishing between the two artists in paintings of this type lies largely in the fact that Dou's paintings tend to be drier, more finicky, and less sensitive in the choice of colors and values than the comparable works by Rembrandt. Dou continued throughout his career to paint small-scale, detailed, shiny-surfaced pictures, while Rembrandt, in contrast, went on to encompass a rich series of creative developments in his style and treatment of varied subject matter.

Dou's *Self-Portrait in his Studio* (126), dated 1647, shows the artist drawing in a book, surrounded by attributes of the arts. This association of painting with the other arts is seen repeatedly in the seventeenth century. It was ammunition in the battle to elevate the status of painting from a craft to a liberal art. The sculpture behind the artist is of particular interest. It represents a reduced copy of Michelangelo's *Samson Killing Philistines*, which was planned to be executed larger than life-size as the companion of the *David*, to be placed at the entrance of the Palazzo Vecchio in Florence. The full-scale work was never made. Dou's painting proves that artists in Holland knew Michelangelo's composition from reduced versions such as this one. This is but one of thousands of small pieces of evidence that Dutch artists respected art of the past and used it in their work, contrary to the notion that they referred only to the natural world as they saw it.

Dou's paintings frequently showed figures in a window embrasure, as in *A Poulterer's Shop* (127). Placing the scene behind a sill and framing it removes it from us and has something of the effect of a picture within a picture. This motif was also used by Rembrandt and other Dutch painters. The relief under the sill, depicting children playing with a goat, appears in a number of Dou's paintings of similar format. It has classical forebears and was probably based on a relief that the Flemish sculptor François du Quesnoy made in Rome. Though they seem like reasonable stock in the shop, the poultry as well as the hare have erotic implications, as do the bird cages.² The emblematic significance added a piquant note to this meticulously observed representation, in which, with tiny brushes, the artist gave each detail of fur and feathers its due. This is probably one of Dou's late works. He remained in Leiden until his death in 1675, and the smooth, exquisitely detailed style for which he was noted was continued by his followers in the Leiden school of fine painting.

By the time Rembrandt moved to Amsterdam he was well known, and apparently students flocked to him.³ The German painter Joachim von Sandrart, who was in Amsterdam from 1637 to 1642, wrote: "Rembrandt's home in Amsterdam was crowded with countless young people from leading families who came there for instruction and education, each paying him an annual fee of one hundred guilders." The pupils copied Rembrandt's works, including his self-portraits, and while they were

127. Gerrit Dou, A Poulterer's Shop.

working directly with him they sometimes succeeded surprisingly well in imitating his style. He was probably responsible for the compositions of some paintings whose execution is clearly not by him but presumably by one of his students. He also retouched students' works, both drawings and paintings. Once the pupils had left Rembrandt's studio, most of them no longer followed Rembrandt's style. Many of them in the course of time adopted the florid, polished portrait style that was fashionable after the middle of the century.

Rembrandt was so widely famed and highly regarded as a teacher that his studio functioned as a graduate school for artists who had already

been trained. Among these were Jacob Backer (1608-51) and Govaert Flinck, both of whom had been painting students in Leeuwarden before coming to Amsterdam to spend some time with Rembrandt in the 1630s. Their works show unmistakable references to Rembrandt's style of this decade. Govaert Flinck was born in 1615 in Kleve (Cleves), on the lower Rhine, remote from the great Dutch centers of art.⁴ He studied with Lambert Jacobsz. in Leeuwarden, the leading city of Friesland and home town of Rembrandt's wife, Saskia. Some of Flinck's admirable early portraits (e.g., 128) are close to Rembrandt's style in commissioned portraits of the thirties, while those of a somewhat later date follow Rembrandt's development of the following decade. Houbraken says that many of Flinck's works were sold as Rembrandts. Isaac Blessing Jacob (129), which dates from 1638, bears strong resemblance to works by Rembrandt, even as to facial types. Flinck's colors, however, are more varied and intense, and he falls short of Rembrandt's ability to unify through light and shadow.

Flinck received important commissions and became a competitor with

128. Govaert Flinck, *Portrait of a Woman.*

129. Govaert Flinck, Isaac Blessing Jacob.

Rembrandt for portraits and other orders. He painted important group portraits as well as numerous portraits of families and individual portraits of some of the most distinguished persons of his time. In the forties he gradually abandoned Rembrandt's style in favor of a more fashionable, more elegant, and somewhat lighter approach. He never gave up the ambition to be a history painter, and his success in this field led to the most important commission in Amsterdam, when in 1659 he was chosen to paint historical subjects for the large lunettes in the galleries of the new Town Hall. His death shortly afterward prevented completion of this task.

Flinck was a very capable draftsman, as many of Rembrandt's students were. Their training in Rembrandt's studio clearly included drawing as well as painting, and there is considerable evidence that they copied his drawings. Some of them were so skillful in imitating his style that there is still difficulty in sorting out the hands responsible for some drawings.

Ferdinand Bol (1616–80), a wealthy young aristocrat according to Sandrart, probably came to study with Rembrandt in the early 1640s, a few years later than Backer and Flinck. Like most students, he followed the master's style of a few years earlier. His etchings and drawings of the early period are so close to Rembrandt's style of the 1630s in these media that in some cases they are difficult to distinguish. A bit later Bol reflected Rembrandt's portrait style of the 1640s, though without the incisive power of characterization, which could not be imitated. Between 1649 and 1669 Bol painted a number of pictures for public buildings in Amsterdam, chief among them the new Town Hall,⁵ and in other cities. His later works tended to be shallow and repetitious.

Of all the pupils of the early 1640s, Carel Fabritius was the most gifted. His career will be dealt with in chapters 11 and 12. His younger brother, Barent Fabritius (1624–73), may have been a Rembrandt student later, around 1650. Another interesting student during the late 1630s or early 1640s was Gerbrandt van den Eeckhout (1621–74) of whom Houbraken wrote that he was a good friend of Rembrandt's and continued in his manner even in his later years.

Works by the series of painters who studied with Rembrandt at various times reflect the different periods in his development to which they were exposed. Their paintings thus add to the scanty documentary evidence about his continuing activity as a teacher. Prominent among the pupils of his later years was Nicolaes Maes, who was from Dordrecht, where he was born in 1634. It is assumed that he went to Amsterdam in the late 1640s and that he was probably with Rembrandt toward the end of the 1640s or the beginning of the 1650s. He was back in Dordrecht before the end of 1653. In 1673 he returned to Amsterdam and remained there until his death in 1693. Christ Blessing Children (130) is now generally accepted as a work painted by Maes in the early 1650s-a date that credits him with precocity. This picture is a fascinating example of the problems of attribution in the Rembrandt school. In the eighteenth and nineteenth centuries it was attributed to Rembrandt himself. From 1880 on it was recognized as a school piece, and the names of a number of painters were proposed as its author. Among the more plausible of them were Gerbrandt van den Eeckhout, Juriaen Ovens, and Barent Fabritius. The subject, based on the text (found in Matthew 19 and elsewhere) "Suffer little children to come unto me," was a major theme in Rembrandt's great etching of the 1640s known as The Hundred Guilder Print (96).

The Interior with a Sleeping Maid and Her Mistress (131), also called The Idle Servant, is more typical of Maes in style and content. His reputation is based mainly on domestic interior scenes in small scale, many of them representing quiet moments shared by women and children. He made a purely secular interpretation, for example, of Rembrandt's Holy Family with Angels (1645; Leningrad, Hermitage). Maes's version, Mother Looking at her Child in a Cradle, painted in about 1655, is in the

Rijksmuseum in Amsterdam. Maes's colors are generally less modulated and less subtle than Rembrandt's, with large areas of local color, and his contours tend to be clear-cut, his paint surface smooth. The Sleeping Maid and Mistress also exemplifies something else about Maes that differentiates him markedly from Rembrandt. When Rembrandt includes cats in his Holy Family pictures, the cats seem to be a normal part of the life of the household, contributing to the sense of intimacy and humanity in those subjects. Maes, on the contrary, uses cats in his pictures in an anecdotal way. Here the cat is stealing food, enacting the dangerous effect of the maid's inattention to duty. A lazy servant was an established symbol for the vice of Sloth.⁶ The mood is jocular, however. The servant has fallen asleep with the dirty dishes on the floor before her, but her companion smiles as she points this out. The scene in the adjoining room identifies the setting as a tavern, and tavern scenes usually referred to reprehensible behavior and had moral implications. The elaborate still-life in the foreground is a distraction that would not be found in a painting of this nature by Rembrandt. It is highly finished, more in the manner of Dou in its explicitness.

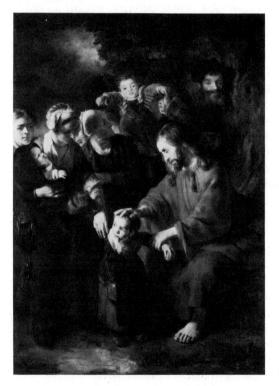

^{130.} Nicolaes Maes (?), Christ Blessing Children.

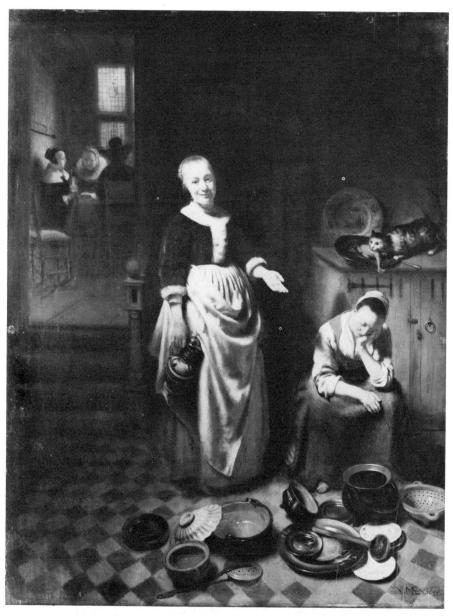

131. Nicolaes Maes, Interior with a Sleeping Maid and Her Mistress (The Idle Servant).

The composition of the *Sleeping Maid and Mistress* is historically interesting, because it is inscribed with the date 1655 and is the earliest known dated seventeenth-century picture of a scene from daily life in which there is a view into an adjoining room. This kind of composition became very popular in the later 1650s; it is particularly associated with Pieter de Hooch. It is not certain who originated the motif of the adjoining room seen through a doorway in the seventeenth century. This type of spatial extension goes back to Early Netherlandish painting, not in genre, of course, but in scenes with religious content.

From 1660 on Maes painted portraits almost exclusively. Their elegant, cool, smooth quality had nothing to do with Rembrandt. Houbraken undoubtedly expressed a view that was dominant in the late seventeenth and early eighteenth centuries when he wrote that Maes painted better portraits than anyone before or after him.

Though many may have considered him old-fashioned, even late in his life Rembrandt continued to have students. It was probably in about 1661 that Aert de Gelder entered his studio.⁷ By this time the guild rules in Amsterdam were relaxed; the apprenticeship of three years was no longer enforced, nor was a "masterwork" examination required. Aert (sometimes spelled "Arent") de Gelder, born in 1645, had first studied in his native town, Dordrecht, with another Rembrandt pupil, Samuel van Hoogstraten (1627-78). Hoogstraten had studied with Rembrandt earlier, along with Carel Fabritius. He is significant in the history of art because of his book, Inleyding tot de Hooge Schoole der Schilder-Konst, published in Rotterdam in 1678, and because of his explorations of illusionistic effects in painting.⁸ Hoogstraten's trompe l'oeil Still-Life (132) is a forerunner of a type of painting that was to become very popular in nineteenth-century American art.9 His Peepshow with Views of the Interior of a Dutch House (London, National Gallery) is one of several seventeenthcentury Dutch perspective boxes that have survived.

Aert de Gelder's first dated painting is from 1671. His works carried traces of Rembrandt's late style well into the eighteenth century, for he lived until 1727. The richness of his paint surface, free brush strokes, warm color, suppressed contours, and simplification of backgrounds are all features he learned from Rembrandt. He did many paintings of half-length figures in biblical scenes, a format perhaps suggested by late works of Rembrandt, such as *The Downfall of Haman* (121). Among them were a number based on the Book of Esther, an Old Testament text that also occupied Rembrandt at various times throughout his career.

Like most Dutch artists in the seventeenth century, Aert de Gelder painted comissioned portraits. Late in his life, in about 1722, he painted *Hermanus Boerhaave with his Wife and Daughter* (133). Boerhaave (1668–1738), an eminent physician, Professor of Medicine at the Univer-

132. Samuel van Hoogstraten, Still-Life.

133. Aert de Gelder, Hermanus Boerhaave with His Wife and Daughter.

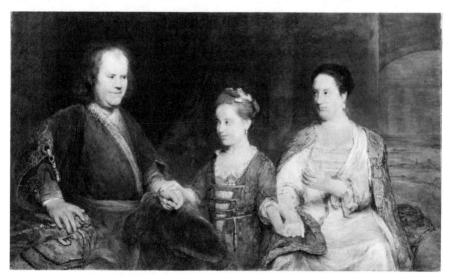

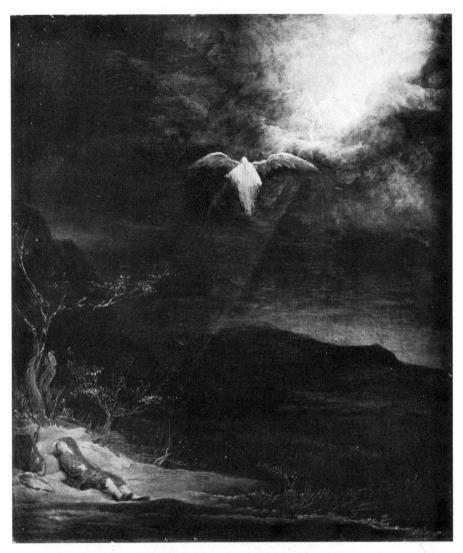

134. Aert de Gelder, Jacob's Dream.

sity of Leiden, remains famous in the history of medicine, one of the scientific fields in which the Dutch made noteworthy contributions in the seventeenth century. He was also a distinguished chemist, botanist, and mathematician. De Gelder, however, did not depict him as a proud or awesome figure, but in a pose of relaxed intimacy with his family. This direct and human approach is so different from the slick, pretentious mode of portraiture fashionable in the eighteenth century that it is obvious why de Gelder was virtually forgotten from the time of his death until the late nineteenth century. The emotional as well as the sensuous beauty of the Boerhaave portrait is now immensely appreciated. All linked by their hands, the family group are shown as belonging together and caring about one another. There is warm-hearted humor in the stressing of the daughter's strong resemblance to her mother through the identical posing of their heads. The brush stroke is very free and open, the colors light.

The expressive power of light and darkness is the thematic core of the visionary *Jacob's Dream* (134), Aert de Gelder's worthy tribute to his great teacher's unique style. Until 1914 this picture was attributed to Rembrandt; the signature "ADeGelder" became visible only in 1946, when the painting was cleaned. Jacob lies in the left foreground, very small, very isolated, under the vast night sky. Angels light up the heavens, not in the overwhelming baroque manner of proclaiming spiritual events, but as presences that can be sensed rather than seen. The whole landscape whispers of dream rather than waking experience. Warm light bathes Jacob—for this is a moment of illumination (Genesis 18:12).

8/ Scenes of Social Life

HE FRENCH WORD genre, which literally means "type" or "kind," is used in relation to art to designate subjects depicting ordinary human beings engaged in everyday activities. Genre paintings deal with neither identifiable individuals nor specific events. Their realm is the commonplace. Strictly speaking, genre scenes refer to nothing beyond what is immediately visible in them; that is to say, religious, mythological, literary, or philosophical references would exclude pictures from this category. It has been found, however, that numerous paintings that had long been considered as genre do in fact have ulterior meanings. Social gatherings, like other kinds of subject matter, were used by Dutch artists for didactic purposes. This makes genre an inappropriate designation for much of the seventeenth-century art to which it has conventionally been applied. It is clearer, in any case, to avoid the term genre and identify the paintings instead as belonging to more specific classes, such as "domestic interiors," "peasant tavern scenes," or other aspects of social life.

Various sorts of contemporary social scenes were favored by the painters of particular local schools. In Amsterdam by the second decade of the seventeenth century a group of painters had identified themselves with a subclass within the category of "scenes of low-life in an interior." They specialized in depicting off-duty soldiers in various group activities, including "barrack scenes," in which soldiers enjoy such recreations as drinking and gambling, and "tavern scenes" showing soldiers with women. "Tavern" seems to be equivalent to "brothel" in these and other seventeenth-century Dutch paintings. It is interesting to note that through the successive periods of war that tainted Dutch life in the seventeenth century, art was not employed to glorify military events on land. Some seascapes, mostly from later in the century, show naval battles, and admirals were grandly memorialized in elaborate tombs. But the army is not heroized. Soldiers are shown occasionally as plunderers, more often as mildly disreputable. This may be because the military forces were largely made up of mercenaries from other countries.

Willem Duyster, who lived only from about 1599 to 1635, was among the Amsterdam artists turning out small pictures of soldiers looting as well as more dignified social gatherings of fashionably dressed men and women in interior settings. Duyster's signed painting A Man and a Woman Playing Trick-Track, and Three Other Men (London, National Gallery), in which the costumes are datable between 1625 and 1630, exemplifies the firmly organized composition and the assured execution of which this artist was capable early in his short career. Dealing in a similar manner with subjects of this sort was Pieter Codde, who also painted portraits. Codde was born in Amsterdam in 1599 and died in 1678. In Utrecht, Jacob Duck (1600-1660) likewise painted such scenes of social life, as did Anthonie Palamedesz. (1601-73), also a portraitist, in Delft. The aspects of social life depicted by these artists were usually those that would have been identified as reprehensible in their day, such as gatherings of smokers, "pipe-drunk women," drinkers, gamblers, soldiers fighting over booty, and musical parties. Their artistic embodiment, however, was admirable. The play of light in shadowy interiors is one of the attractions of these compositions.

The Utrecht Caravaggists, as we saw in chapter 3, repeatedly dealt with brothel or procuress scenes, many of them involving soldiers. Unlike the paintings from other centers, the Utrecht compositions of life-size figures placed close to the picture plane usually gave only minimal attention to the surroundings in which the scenes were set.

Painters in Haarlem at roughly the same time, in the second decade of the seventeenth century, were pioneering in the depiction of social gatherings in interior settings, as well as in Merry Companies in the outdoors, as described in chapter 4. In the 1620s Haarlem became the center for the production of what have been known generally as "low-life" scenes. They dealt very frankly with indecorous behavior of various sorts, usually taking place in a humble interior setting or just outside a tavern, identified by the sign over the door. These rough-and-tumble subjects elicited the highest order of compositional skill and sensitive painting from the hands of a number of artists. Much of this paradoxical development was owed to a brilliant artist who was a leader in this field of painting, Adriaen Brouwer, who was born in 1605 or 1606 in Oudenarde, Flanders.¹

None of Brouwer's works painted before he left Flanders is known, nor is it certain when he arrived in Holland, but records show that he was in Amsterdam and Haarlem in 1625 and 1626. He may have been in Haarlem as much as two years earlier. In 1626 he was a member of the chamber of rhetoricians in Haarlem to which Frans Hals belonged, and it has been surmised that his free brushwork owes something to Hals. By 1631 or 1632 Brouwer was in Antwerp, where he became a member of the guild, and he seems to have remained there until he died in 1638. The contrast between crude subject matter on the one hand and subtle color, craftsmanlike composition, and painterly assurance on the other makes Brouwer's works extraordinarily pungent. The high esteem he enjoyed in his own time is indicated by the fact that Rubens owned seventeen of his paintings. Rembrandt's collection included a sketchbook by Brouwer, as well as six of his paintings.

The Flemish tradition best represented by Pieter Bruegel the Elder and his son Pieter the Younger is clearly reflected in the early works of Adriaen Brouwer, which show crowds of figures in lively action, painted in strong colors. It seems, however, that it was not long after his arrival in Holland that he adapted to his own uses the tonal style that prevailed in Haarlem at that period. Both because Brouwer incorporated Dutch traits in his style and because he in turn had very productive Dutch followers. he has a claim to a place in the history of Dutch painting, though he was born in Flanders, was presumably trained there, judging by his age when his presence in Holland is recorded, and ended his short career in Antwerp. What is more, Brouwer may be credited with directing attention to a rich vein of subject matter that was to be mined by a series of Dutch painters as well as by Flemish artists: scenes of peasant life, treated with a mixture of naturalism and irony. The paintings and prints of Pieter Bruegel the Elder had staked out this area in the sixteenth century, often with satirical and didactic purposes made evident through direct references to proverbs or traditional concepts such as "Virtues" and "Vices." No less an artist than Peter Paul Rubens gave seventeenth-century respectability to depictions of merry gatherings of country people.

The *Tavern Scene* (135) is an example of the turn that representations of peasant life took at the hands of Brouwer. Guzzling from the jug, regurgitating, drinking themselves into insensibility, these louts might well represent the vice *Gula*—gluttony, one of the series of Vices that were subjects of art from medieval times and, most relevantly, in the sixteenth century in prints by Pieter Bruegel the Elder. One of the merrymakers is smoking, also recognized as a vice in the seventeenth cen-

135. Adriaen Brouwer, Tavern Scene.

tury. The combination of smoking and drinking may be associations to the senses of smell and taste. Representations of the Five Senses, as of the Vices, were intended as reminders of the unworthiness of earthly pleasures, as numerous works of art as well as emblem books and didactic literature make clear. The fact that the individuals shown indulging in this vulgar behavior are countrymen or peasants (the Dutch references to such pictures call them *boers*, which simply means farmers) might appear to imply the inferiority of rustic people. They seem to be "country bump-

136. Adriaen Brouwer, Peasants Quarreling over Cards.

kins." In facial types and in physique they resemble figures invented by Bruegel. They are clearly members of the lower class. It might be thought that such pictures indicate disdain for the poor on the part of the middle class. As we shall soon see, however, representatives of the prosperous middle class and even the artist himself and his family are in many cases depicted in paintings that imply the same moral stance. As so often in Dutch paintings, Brouwer's *Tavern Scene* appears to be a simple slice of life, a recording of a chance gathering of rowdy drinking companions, but it is in fact a calculated composition and is designed to convey a specific moralistic meaning.

In *Peasants Quarreling over Cards* (136) Adriaen Brouwer shows his prowess as a landscape painter. The figural group in the foreground is a stable pyramidal composition, in contrast with the violent activity of the individual figures. As in the *Tavern Scene*, both gestures and facial expressions contribute to the animation. Exaggerated grimaces and physiognomies verging on caricature tell the story. The family of swine at the lower right participate in the excitement, while also calling attention to the bestial nature of their human companions. Again the crude subject matter is belied by the elegance of Brouwer's style. He dealt in an equally sensitive way with other subjects that today, at least, seem somewhat repellent, such as a dentist or a surgeon at work. This type of

theme, which was also popular in Flemish seventeenth-century painting, may have been inspired by Lucas van Leyden's engravings, *The Dentist* (B. 157), of 1523, which shows a woman picking a man's pocket while the dentist operates on him, and *The Surgeon*, dated 1524 (B. 156). Brouwer's brush stroke differs from the manner of Frans Hals, with less of a repeated pattern of paint application and more broken, more irregular strokes. Brouwer seems to have built up his forms with the separate strokes *alla prima*, whereas it is apparently true, as Frans Hals is quoted as having said himself, that Hals added his dashing strokes only after having painted in broader areas of local color. The color harmonies of Brouwer are generally more subtle than the more robust colors of Hals.

Paintings by Brouwer are relatively rare. Many imitations exist, however, from his own time and later. He also had a number of followers of some consequence, both Flemish and Dutch. One of the most productive, and most typically Dutch, was Adriaen van Ostade, who was born in Haarlem in 1610 and lived until 1685.² About eight hundred paintings and fifty etchings by him are known, as well as many drawings, some with watercolor. There evidently was no lack of customers for pictures of people making merry indoors or out, itinerant musicians entertaining travelers outside an inn, a teacher with his pupils in a schoolroom, and other subjects that seem to give accurate information about the Dutch social scene. His painting showing An Alchemist at Work (137), dated 1661, appears to be no less realistic. It illustrates the squalid surroundings of the family in which the father tries to transform base metal into gold instead of earning a living in a more reliable way. (The naturalistic note of the mother cleaning a baby's bottom was apparently offensive to an earlier owner, who had the baby transformed into a bundle on the woman's lap. This was in fact a meaningful part of the picture. The parallel between excrement and riches has appeared in art from medieval times.) Alchemy was indeed still practiced in Ostade's period, though widely recognized as a folly. The paper in the center of the foreground is inscribed with an apothegm from Plautus: "Oleum et operam perdis" ("You waste oil and work"). Moralistic overtones were not unusual in Adriaen van Ostade's works; he also painted scenes representing the Five Senses.

While Adriaen van Ostade's early works dealt mainly with groups of lowly people in their humble homes or taverns, in the course of time he moderated both the grotesqueness and the violent activities that Brouwer favored. His stylistic development followed the prevalent trends in Dutch art, with tonality in the 1630s, a tendency toward more spacious interiors in the 1640s and, by mid-century, calmer, less turbulent compositions, with renewed emphasis on local color. Perhaps under the influence of Rembrandt, he also showed, from the 1630s on, an interest in chiaro-

137. Adriaen van Ostade, An Alchemist at Work.

scuro. His later works are marked by a smooth, more elegant surface.

Ostade's picture of *A Painter's Studio* (2) painted in the 1660s, shows his interest in the effect of the daylight entering the window and the way in which it illuminates a limited area of the gloomy room. The painter is seated at his easel, which has been placed to receive the best possible light from the left. It is interesting to note that the subject he is painting is a landscape, painted not from life but from memory or possibly after his own earlier sketches or other works of art. The harmony of colors, skillful use of light and shadow to reveal form and space, and highly organized composition make an impressive pictorial whole of the unpretentious scene.

Adriaen van Ostade taught his gifted younger brother, Isaack, who was born in Haarlem in 1621, became a member of the guild there in 1643, and died only six years later. Isaack van Ostade painted landscapes in fairly large scale with many figures, such as travelers with their dogs and horses arriving at an inn, or skaters in icy winter landscapes, with gnarled branches of trees punctuating the gray sky. It is hard to know whether to call these pictures landscapes or to consider the figural groups the prime subjects. The same is true of the works of Issack's contemporary Philips Wouwerman, who was born in Haarlem in 1619 and lived until 1668. Wouwerman produced numerous elegantly painted small landscapes in which figures and horses are prominent. He was particularly skilled at painting horses in motion, with the ripple of muscles under their satiny surfaces. Indeed, he might appropriately be called "the master of the white horse," in honor of one of his favorite motifs (173).

Barrack room scenes were the subjects of the earliest known paintings by Gerard ter Borch, who was active in Haarlem by 1634.³ Outstanding as a portraitist (see chapter 5), ter Borch after the middle of the century painted many compositions showing a single figure or two or three figures in small scale, fashionably dressed and beautifully poised in well-appointed interior settings. With infinite care he depicted the satins and furs and jewels of the rich costumes that were fashionable in his time. In some cases there are clues, however, that indicate that the individuals represented are not as proper as they seem. In the painting long known as *The Fatherly Warning* (138), from about 1654, an apparently respectable officer is offering a coin to a young woman, thus indicating that she is a prostitute, her exquisite white satin dress and graceful bearing notwithstanding. A recent cleaning brought to light traces of the coin, which a squeamish former owner had obliterated.

A Woman Writing a Letter (139), painted in about 1655, shows Gerard ter Borch's capacity for perfection in small compass. The seemingly simple composition places the woman in space most artfully. We

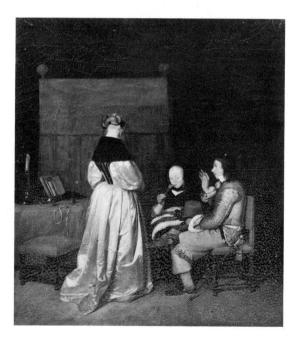

138. Gerard ter Borch, "The Fatherly Warning."

can almost feel the texture of the Turkish rug that establishes the foreground plane. The scale of its pattern and its woolly surface bring it very close to us and thereby have the effect of pushing the figure farther from us in a convincing spatial depth. The sinuous line of her neck and back are echoed by the tentlike bed curtains. The quill pen parallels the line implied by her foreshortened upper left arm, and at the same time it completes a pyramidal conformation in which the rug and the woman cooperate. The unification by means of color is also extraordinary. A harmony of reds, from the young woman's reddish-blond hair, her roseate flesh tones, her salmon red bodice, to the russet curtain behind her and the reds of the rug at the left foreground and the cushion on which she sits, at the right, constrasts with the cool greenish tones of the background and her skirt. The related colors of skirt and wall bring together the foreground and background, and between them-almost central to the painting from top to bottom, from side to side, and from front to back-is the blue ribbon that sets off the glorious pear-shaped pearl at her ear.

Ter Borch and other painters of the period depicted many times the subject of the letter writer. This subject has been associated with the fact that the far-flung mercantile empire of the Dutch sent men abroad for long periods, so that a painting of a woman writing a letter might have indicated that she was thinking of her absent husband or lover. Since some of the pictures, however, show a man, sometimes an officer, writing or dictating a letter, it seems possible that this subject, like so many others at this period, refers to an erotic arrangement. The fact that ter Borch's figures are in many cases shown in profile or rear view lends a note of reticence that effectively disguises any impulse toward the world outside the picture. Yet it is clear from other paintings that appear to be no less self-contained that ulterior meanings may lie behind such compositions and that they are frequently erotic.

Outspoken erotic subjects were by no means rare in Calvinist Holland. The Leiden painter Frans van Mieris the Elder, who was born eighteen years later than Gerard ter Borch, in 1635, but died in the same year as he did, 1681, was among those who did not always dissemble. As a pupil of Gerrit Dou, Mieris achieved a refined style that was highly valued by his contemporaries. He painted small narrative scenes and portraits, as well as such a subject as *The Brothel* (140). Though this frank representation of a house of prostitution might ostensibly have been designed as a warning against the behavior shown, it would doubtless appeal to prurient tastes. It may be that the careful composition and fine painting gave the coarse subject matter added spice. The man in the foreground, wearing a steel cuirass, is clearly identified as a soldier. By the time this was painted, Dutch art had for some fifty years derogated soldiers, and this was not the end of it. Soldiers could serve as whipping

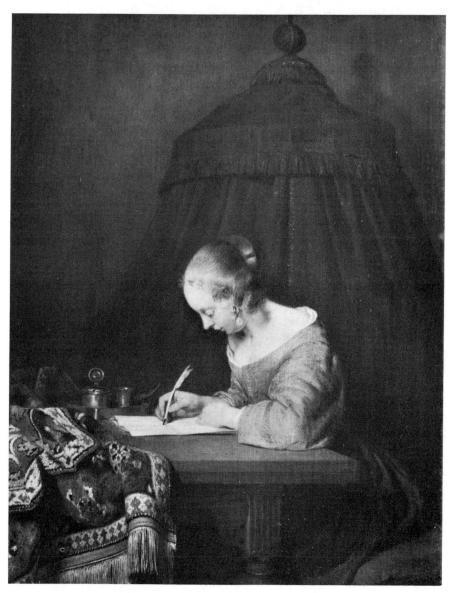

139. Gerard ter Borch, A Woman Writing a Letter.

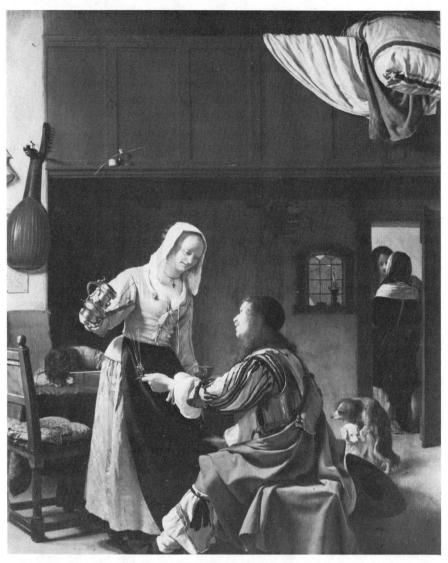

140. Frans van Mieris the Elder, The Brothel.

boys for the animal impulses that good burghers were constrained to deny.

Another Leiden-born painter, Jan Steen, about ten years older than Mieris, placed the Dutch middle-class family itself—indeed, often his own family—in the midst of the merrymaking and disreputable behavior that color our picture of Dutch social life.⁴ The son of a brewer, Steen was born in 1625 or 1626 and became a student at the University of Leiden in

Scenes of Social Life

1646. He studied painting in several cities. In Utrecht he was a pupil of the Leipzig-born Nicolaus Knupfer, in Haarlem of Adriaen van Ostade, and possibly, at The Hague, of Jan van Goyen, whose daughter he married there in 1649. His style reflects the robustiousness of the Haarlem school as well as the *fijnschilderij* (fine painting) of Leiden, where he settled in about 1645. Steen may have spent two or three years in Delft, where he leased a brewery from 1654 to 1657. After living some four years in a town near Leiden, Steen became a member of the Haarlem guild in 1661. In 1670 he was back in Leiden, where in addition to painting he operated a tavern until his death in 1679. His peregrinations and manifold obligations did not prevent him from producing some eight hundred paintings.

Jan Steen was a lifelong Catholic. The possibility of a successful career for a Catholic in Protestant Holland was by no means foreclosed. Some esteemed painters were Catholics all their lives, and some, Adriaen van Ostade among them, were converted to Catholicism, as was the great Dutch poet, Joost van den Vondel, who became a Catholic convert in 1640. Steen was and has remained particularly popular among the Dutch. Throughout his career he painted religious subjects, scenes from *rederijker* dramatic performances, figures in landscape settings, and the boisterous groups in interiors with which his name is most often associated. His style is sometimes exceedingly refined, sometimes broader and even coarse. These variations in style appear to be unrelated either to Steen's chronological development or to the different kinds of subjects with which he concerned himself.

The domestic scenes of Steen often include three generations and the family pets engaged in pleasurable activities in a cluttered, unkempt room. Steen himself frequently plays one of the leading roles in the lively action. In The Dissolute Household (141) he depicted himself with his usual merry grin as he sits near the center of the composition with his leg slung over the thigh of a seductive young woman who offers him a glass of wine. He holds a long clay pipe, which may refer to the sense of Smell. Behind them stand another couple, the man playing a violin. The dog and the monkey (Touch) are no more mischievous than the children. one of whom is picking the pocket of the woman who has fallen asleep with her head on the table. Pocket picking is a traditional reference to the sense of Touch. Food on the table as well as in the right foreground obviously represents the sense of Taste, as does the wine. Playing cards, a scoreboard, and oyster shells are among the objects strewn on the floor, all of them symbolizing vices. Through the partly open door at the right, a fire is seen burning on the hearth of the adjoining room. The neighbor peering out through a window of the adjacent house may, like the brilliant flames and the picture on the wall, be recognized as an allusion to

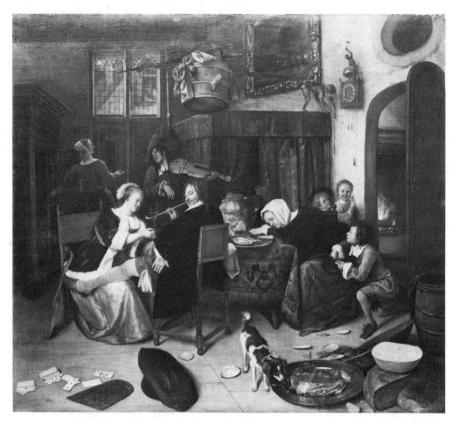

141. Jan Steen, The Dissolute Household.

the sense of sight. Fire is also associated with the vice of Lasciviousness. For Hearing, there are the musical instruments. The clock surmounted by a bell ringer would also be heard, while serving the additional purpose of calling to mind the swift passage of time and the transience of earthly pleasures. The painting might well be titled *The Five Senses*. It is typical of Steen to provide an overabundance of clues to this meaning. Any assumption that the Merry Companies painted by Jan Steen are objective reports on gatherings he might have witnessed in his tavern would be contradicted by the carefully assembled elements that communicate the moral of the story.

In *The Physician's Visit* (142) Jan Steen used different means to elucidate the alternate title, *The Lovesick Young Woman*. The knowing smile of the physician hints that he is not taking very seriously the illness of his patient. The nature of her ailment is betrayed by the painting on the wall, which shows Venus embracing Adonis, who soon will leave her despite her entreaties. And the child playing on the floor is a recognizable

Scenes of Social Life

kin to the Cupid with his quiver of arrows who accompanies and identifies the goddess of Love in innumerable Renaissance paintings. The dog (symbol probably of animal nature rather than fidelity in this context), resting quietly beside the young woman, has its parallel in Adonis' hunting dogs in the picture within the picture. This small domestic drama, blending earthy reality with both classical allusions and moralizing comment, is characteristic of Jan Steen and of a large and significant segment of Dutch painting. In some cases Steen inscribed his paintings with a motto or proverb to stress his didactic intention.

A Girl Salting Oysters (143) is a small jewel of a painting, displaying Steen's most delicate and polished style, close to the elegant manner of

142. Jan Steen, The Physician's Visit.

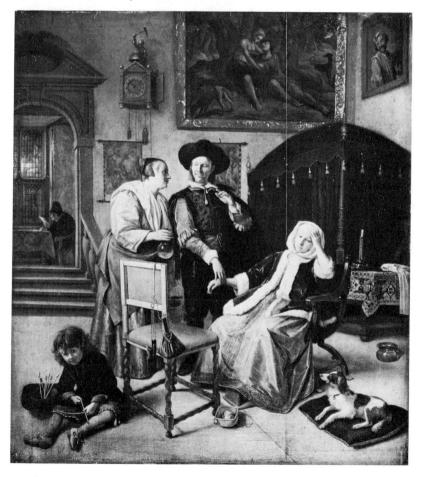

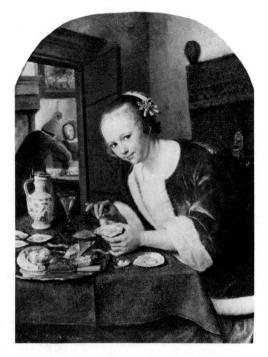

143. Jan Steen, Girl Salting Oysters.

Frans van Mieris the Elder. The arched top, the small scale, and the infinite care taken with every detail call to mind the works of Mieris' teacher, Gerrit Dou, the great master of Leiden "fine painting." As is also often the case with Dou, Steen's young woman makes direct eye contact with us. Her flirtatious expression suggests that it is for *you* that she is salting the oyster, well known as an aphrodisiac. These are indeed the most seductive of oysters, swimming lush and plump in their luminous shells. The composition, no less than the color harmony and the exquisite details, is most skillfully calculated. The charming young woman is framed between the verticals of door frame and bed curtains and the horizontal edge of the table, with the arched top echoing the curve of her head and shoulder. The still-life elements, including the oyster in the girl's hand, form an arrowhead that directs our gaze toward the figure in the adjoining room who provides a counterpoise to the foreground figure.

It is clear to be seen that the disorder of a "Jan Steen household" was not in the mind of the painter, whose control of his artistry was consummate. By inventing a kind of Bacchic revelry with a Dutch accent, he made fun of Calvinist prudence and morality. The actors in these rhapsodies of self-indulgence were solid Dutch families, including his own. His good-natured acceptance of human foibles obviated the need for

Scenes of Social Life

disguises, such as the cloak of mythology or biblical sanction, to which other painters had recourse. His thoroughly humanizing sensibility was Dutch to the core. He expressed the Dutch bent for naturalism, for portraiture, for love of home and family, and for didactic messages, sometimes camouflaged in varying degrees—all encompassed within the bounteous contents of his domestic scenes. Jan Steen's delight in the manifold possibilities both of life and of paint is as contagious today as it was in the seventeenth century.

A very different artistic personality reveals itself in the domestic interiors of Emanuel de Witte, who was born in Alkmaar between 1616 and 1618 and became a member of the guild there in 1636.⁵ In 1639 and 1640 he was in Rotterdam, and for most of the following decade he lived and worked in Delft, where he became a master in 1642. He settled in Amsterdam in 1652 and presumably remained there until his death in 1692. Portraits and narrative subjects were among his early works. After 1651 he devoted himself mainly to the church interiors for which he is famous (189 and 190), along with a few extraordinary domestic interiors and market scenes. Spaciousness and order are the keynotes of his style. The Interior with a Woman Playing the Virginals (144), which dates from about 1660, is composed mainly of a complex pattern of rectangles. Almost three centuries later, the Dutch painter Piet Mondrian was to deal with similar patterns in a nonrepresentational manner, limiting himself to black and touches of primary colors on white, recalling the dominant triad of black, white, and red that de Witte preferred.

Compared with the works of Steen and other contemporary painters of domestic scenes, de Witte's *Interior* is concerned more with spaces than with people. The main pictorial problem consists of a series of rooms seen through doorways, with walls parallel to the picture plane, so that a succession of strict horizontal and vertical elements provides a structure of architectural stability. Within the indicated rooms, furnishings and decorations provide additional horizontal and vertical notes. Perspective recession, along with marked decrease in size, produces an effect of considerable depth between the foreground plane and the facing window in the farthest room, through which we glimpse the world outside. Rectangular patches of sunlight superimpose a striking rhythm upon the geometrical pattern of the black-and-white marble floor. Red curtains and embrasures of the windows at the right are balanced by the red bed curtains and predominantly red carpet at the left, in keeping with the carefully controlled color scheme.

Though the geometrical relationships and the interplay of plane and solid make the predominant impression, the figures in the picture are by no means insignificant. They do more than simply provide the warmth of human life to animate the impact of the composition. They also tell a

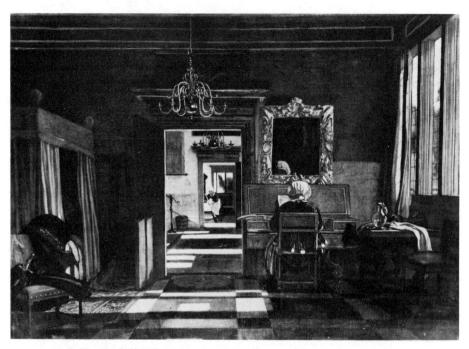

144. Emanuel de Witte, Interior with a Woman Playing the Virginals.

story. The woman at the virginals preserves her anonymity, though the back view we have of her is augmented by a reflection of her head in the mirror she faces. She is not playing for her own ears alone. In the bed, hardly to be discerned, there is a man. His presence is betrayed by his clothing and the sword—which identifies him as an officer—on the chair in the left foreground. Through the distant doorway can be seen a maid, tiny in scale in comparison with the woman at the virginals, but clearly visible as she sweeps the floor. Along with the pump and bucket in the intervening room, she stands for cleanliness—moral cleanliness—in a wicked world. "Cleanliness is next to godliness."

Emanuel de Witte's painting of *The Interior Court of the Amsterdam Exchange* (8), shows a social group of quite a different kind. Dutch businessmen and some foreigners in exotic costumes crowd the inner court of the financial center of Amsterdam, which played an important part in the economic life not only of the Dutch Republic but of all Europe. Other artists also made depictions of this scene, which was attractive as an architectural subject as well as for the activity of which it was the setting. The building, constructed between 1608 and 1611, was designed by the well-known architect and sculptor Hendrick de Keyser, who lived from 1563 to 1621. It was based on the London Exchange designed by Gresham, which had been built in 1566; recourse to an architectural model already forty years old is perhaps an index of the innate conservatism of financial institutions. Though it may well have been de Witte's ability in the depiction of architecture that made this seem an appropriate subject for him, it is not at all unlikely that the painting was commissioned by the man at the foreground on the right, for this figure clearly is a portrait.

Another painting in which de Witte combined portraiture with an activity of daily life in an actual city setting is *Adriana van Heusden and her Daughter at the New Fish Market in Amsterdam* (11). Painted between 1661 and 1663, this picture resumes a tradition most notably represented in the sixteenth century by Pieter Aertsen, who combined lavish kitchen or market scenes, sometimes featuring fish, with figures of persons going about their daily tasks. Aertsen's compositions became widely known through prints and provided inspiration for various seventeenthcentury artists. Portraiture, however, does not seem to have played a part in them; this was de Witte's innovation.

De Witte's characteristic color scheme is perfectly suited to this subject, with the great baroque curves of the different varieties of fish calling forth his most subtle range of grays and ochers and the red of the salmon, which is related to the red bodice and apron of the fishmonger. Red ribbons tying the little girl's black tippet and blond curls carry the red note to the left side of the composition. A glimpse of the harbor on a sunny day sets the scene at the New Fish Market, which opened early in 1661. In addition to its striking beauty, this picture has interest as a social document. The middle-class housewife wears a velvet jacket with border and cuffs of white fur, precisely like those worn by women in paintings of this period by such artists as ter Borch and Vermeer. For her marketing expedition, however, she appears in a freshly pressed silvery gray apron, the badge of her domestic duties, through which the black velvet and white fur borders of her jacket can be discerned. The market woman, who belongs to a lower class, wears more practical, less expensive attire. A black jerkin covers her red dress and white cape collar. Her apron is dark red, her cap black.

Market scenes as well as domestic interiors were also painted by numerous minor masters, "small masters" by virtue both of the fact that their paintings are generally small and modest rather than large and ambitious and also of their being by any standard of evaluation inferior to the top level of the greatest masters of the period. The small paintings of Gabriel Metsu are typical. Metsu, who was born in Leiden in 1629 and is known to have spent the last decade of his life in Amsterdam, where he died in 1667, tended to be derivative and uneven, but at his best was capable of creating vivacious and ingratiating pictures. His *Self-Portrait*

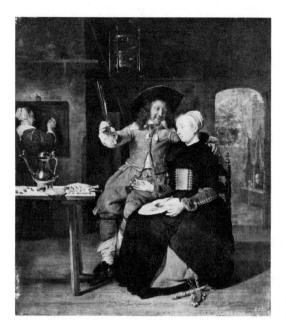

145. Gabriel Metsu, Self-Portrait with His Wife in a Moralizing Tavern Scene.

with His Wife in a Moralizing Tavern Scene (145), which is signed and dated 1661, reflects a composition by Rembrandt of a similar subject (Self-Portrait with Saskia in a Moralizing Tavern Scene, Dresden). The account board indicates that there will be a reckoning of each person's sensual indulgences at the time of final judgment. Rembrandt's painting, which was begun in the middle 1630s and was later cut down in size, is 161 x 131 cm., while Metsu's is 35.5×30.5 cm. This comparison gives some idea of the shrinkage of this Leiden specialty, the domestic interior scene that can easily be mistaken for simple genre, though in fact it frequently involves moral implications and portraiture, in the case of these two pictures, self-portraiture.

Though the social behavior shown in such pictures may be deliberately exaggerated for satirical or didactic effect, we derive considerable information from them about Dutch life in the seventeenth century. Fashions in home furnishings and attire become more elaborate in the course of time.⁶ Differences between social classes and differences in attitudes toward them are made evident in the paintings. Social stratification increases as the century advances. Wealth and its accompanying social and political prominence do not exempt anyone from moral judgment. As people became increasingly purse-proud, they seem to have been no less ready to consider the virtue of abnegation as a moral principle. That man is mortal and will be judged was a preoccupation of the generation of Steen and Metsu as it was of the generation of Rembrandt.

9/ Still-Life

The term "still-life" strictly speaking refers to the depiction of objects that lack the capacity for self-governed motion.¹ Pictures are included in the category of still-life in common usage, however, even when live animals or humans appear in them, in those cases in which such elements are clearly subordinate to the main subject matter, which usually comprises flowers and other natural entities, food of various sorts, books, musical instruments, tools and utensils, and decorative objects. The English term "still-life" is derived from the Dutch *stilleven*, which came into use in the middle of the seventeenth century. Before that time—and also afterward—the Dutch commonly referred to a painting as "fruit piece," "flower piece," "breakfast," "banquet," or the like.

In recent years two divergent theories about the origin of independent still-life painting have contested for acceptance. Charles Sterling argued that still-life painting as it appeared in the sixteenth century and flowered in the seventeenth had as its direct ancestors ancient Roman illusionistic frescoes and mosaics. This antique tradition, he asserted, was carried on in the Quattrocento in *trompe l'oeil* compositions in Italian marquetry, which were the immediate antecedents of painted still-lifes. *Trompe l'oeil* ("deceive the eye") works are designed to convince the onlooker that what he sees is not a work of art representing objects, but the objects themselves.² This type of enterprise came to its highest development in fifteenth-century Italy, where whole rooms had their walls covered with *trompe l'oeil* marquetry panels. These consisted of mosaics of inlaid

wood of different colors, made to look like shelves with objects on them, cupboard doors partially open to reveal the contents, and other such features that would have been appropriate furnishings of a study. The *intarsia*, as such panels were called, were composed of small pieces of various naturally colored woods arranged to give the impression of three-dimensionality by appearing to show the shadowed and the lighted sides of objects, as well as their specific locations in space.

The other point of view as to the origin of still-life painting, which Ingvar Bergström champions, relates still-life subjects in Dutch seventeenth-century painting to local tradition. From the early fifteenth century on, Netherlandish religious pictures had still-life elements in them. Erwin Panofsky, whose many gifts included one for usable phraseology, devised the phrase "disguised symbolism" to refer to the function of those objects which, though they appear to be ordinary parts of the naturalistic setting, in fact carry symbolic meaning related to the religious content of the composition. The symbolic value of a flower, a chandelier, a book, or a bottle lends new interest in the representation of such still-life features as these in the context of religious subjects. Indeed, Panofsky stated, all physical objects may be understood as "corporeal metaphors of things spiritual," in the words of St. Thomas Aquinas.³ The spiritual interpretation of material objects is to some extent applicable to art of the seventeenth as well as to paintings of the fifteenth century.

As to the development of the independent still-life as such, Bergström points to evidence that as early as the fifteenth century "certain artists were attempting to separate the customary symbols from the religious scene and to give them an independent existence as a symbolical stilllife." In sixteenth-century Flemish Mannerist painting, religious subjects were shown in very small scale in the background in numerous compositions in which still-life elements flowed over the foreground in great abundance. In what seems a natural step, eventually the religious scene in the background was omitted, and the independent still-life emerged.

Bergström and Sterling are in agreement that literary references to still-life depictions by artists in antiquity stimulated production of such subjects in the Netherlands, as elsewhere. Extraordinary interest in the individual object on the part of the Dutch was evident in paintings from the early fifteenth century on, and it seems likely that this affinity for the specific contributed to the preeminence of Dutch artists in the field of stilllife. At the same time, the Dutch bent for emblems and moralizing literature must have provided added impetus for the production of still-life paintings, for symbolic meanings continued to adhere to many types of objects long after they were freed from the traditional religious contexts and incorporated in secular scenes of daily life or in independent still-life compositions.

Still-Life

Flowers were frequently among the agents of disguised symbolism in fifteenth-century Netherlandish altarpieces. Doubtless they were also among the most readily understood. The short life of the flower is a reminder of the transience of all earthly things. Some particular varieties had additional, specific meanings. The "Madonna lily," for example, is probably the most widely recognized symbol of the purity of the Virgin Mary. Besides their symbolic uses, flowers offer the possibility of enriching a painting in color and compositional grace, which must have added to their appeal to both painters and patrons. In addition, the Dutch love of flowers surely played a part in the appreciation for flower subjects in paintings. Even today, flowers are much in evidence on the Dutch scene. Vast markets filled with blooms give some idea of the place of flowers and bulbs in the economy of the Netherlands. Street corners glow with the brilliant hues of flowers, for sale at moderate prices. People in modest circumstances buy splendid cut flowers and embellish their houses with them. The modern taste for flowers is, however, restrained as compared with that of the seventeenth century, when there was an unprecedented craze for tulips. Tulips had been brought from Turkey in the middle of the sixteenth century, and before long there was intense competition in the Netherlands in developing new varieties. The rare types sold at higher and higher prices. There was a speculative frenzy that reached its apex in the middle of the 1630s. In 1637 the market broke. It fell to one onehundredth of the previous record high, in reaction to the enormous inflation in prices that had taken place.

Paintings of flowers, too, sold at high prices. When we see flowers painted with unstinting care for the individuality of the various types, we can assume that these distinctions were valued by the art public of the period. The leading painters of early flower and fruit pieces were of Flemish origin. They introduced into Dutch painting—mainly in Middelburg, Utrecht, and Amsterdam—this new type of subject matter, which had recently appeared in Antwerp. Some specialized in depictions of flowers alone, some in fruit alone, and some in combinations of the two. Fruits, like flowers, were familiar symbols in Early Netherlandish religious paintings.

One of the great specialists in early flower paintings was Ambrosius Bosschaert the Elder, who was born in Antwerp in 1573. His family moved to Middelburg, in the northern Netherlands, as religious refugees. His father was a painter. Bosschaert was mentioned as a member of the Guild of St. Luke in Middelburg in 1593. From 1616 to 1618 he was a member of the Utrecht guild. Later he lived in Breda, a Dutch town near the border of the southern Netherlands. About twenty-five paintings by him are known, dating from 1607 to the year of his death, 1621. The Large Bouquet (146) shows the symmetry around a central axis that is

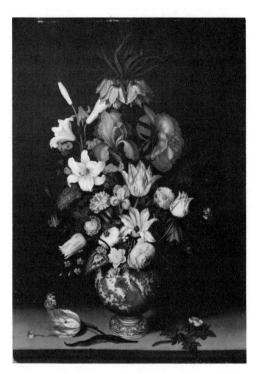

146. Ambrosius Bosschaert, the Elder, *Large Bouquet in a Gilt-Mounted Wan Li Vase*.

typical of the compositions of Bosschaert and other flower painters of his period. In some cases Bosschaert placed the vase of flowers in a niche or window embrasure, thus adding to both the architectural stability and the three-dimensional effect of the composition. His colors are generally light and vivid.

Bouquets painted by Bosschaert (and by his contemporaries) generally include flowers that bloomed at various times of the year. It is clear that the artists made studies of the individual flowers at different times and combined them only on the canvas. In compositions of this period it was usual to spread the flowers, with little overlap, so that each bloom can be seen and enjoyed in its own right. In still-life compositions of other kinds of objects as well, early in the seventeenth century, there was a tendency to separate the objects on the canvas or panel and show each one with sharp contours and clear delineation. Bosschaert's paintings in particular have a graceful, calligraphic quality, especially in the depictions of stems and foliage. He studied the flowers, and also the insects and shells he included, as painstakingly as if they were specimens for scientific research. The fact that some particular shells and flowers appear repeatedly in different paintings shows that the artist had the individual studies in the studio and could make various combinations of them in successive compositions. There were at the time collectors and connoisseurs of natural history specimens such as shells who might well have commissioned paintings showing the exotic varieties they valued most highly. Similarly, flower breeders and fanciers might have wished to have their favorite rare types immortalized in paintings. Seventeenth-century paintings of collectors' cabinets, an Antwerp specialty, often showed vases of flowers, along with shells, coins, books, scientific instruments, and works of art. Old inventories show that the well-to-do Dutch prided themselves on similar collections.

Ambrosius Bosschaert the Elder had a number of pupils, including his three sons, who carried on his type of still-life composition and his style. His brother-in-law, Balthasar van der Ast, who was born in 1593 or 1594, probably in Middelburg, and became a member of the guild in Utrecht in 1619, also specialized in flower and fruit pieces, often featuring shells. The shells represented the fascinating world beyond the seas; in some compositions there were examples from every continent. In contrast with the symmetry and uniform attention to each detail that characterize Bosschaert's works, van der Ast's paintings show a great advance in organization, with compositional emphases and the subordination of details. In *Fruit and Flowers* (147), the large bowl of fruit, placed to the right of center, is encircled by a garland, one might say, composed of the fruits, shells, insects, and other creatures at the near edge of the table, the

147. Balthasar van der Ast, Fruit and Flowers.

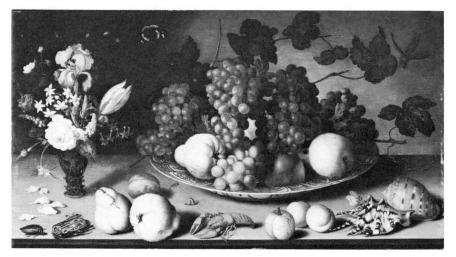

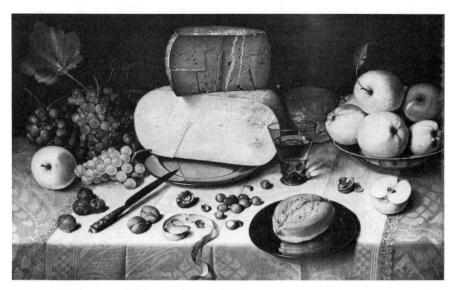

148. Floris van Dijck, Breakfast Still-Life.

vase and bouquet of flowers at the left, and the silhouetted vine leaves. The background is lighter at the right, the better to exploit the elaborate shapes of leaves and bunches of grapes. The bouquet of flowers itself is less symmetrical and frontal than was usual in the earlier flower pieces. The bright local colors are somewhat modulated, in accord with the trend toward tonality that began to dominate Dutch painting in general in the late 1620s. The greater variety of objects, including live insects, butterflies, and birds with brilliant plumage, as well as shellfish, in van der Ast's paintings also differentiates them from works by artists of the previous generation. Most of his dated paintings originated in the 1620s, though he lived until 1657, having spent his last twenty-five years in Delft.

Fruit and Flowers also communicates overtones of symbolism that were common in Dutch still-life paintings. The fallen petals and the damaged fruit call attention to the brevity of life and the transience of earthly satisfactions, and thus suggest the desirability of turning our minds to the life eternal that is the main concern of Christian doctrine. Many different kinds of symbols were used to convey this message, which the Dutch of the seventeenth century, alerted by literature and sermons and their shared religious tenets, would have understood immediately.

Among the types of still-lifes Dutch painters produced early in the seventeenth century were what they called "breakfasts." Not only Haarlem and Amsterdam painters, but also some non-Dutch artists, particularly a group living in Frankfurt-am-Main, were among those who painted "early breakfast pieces." These pictures often include bowls of fruit, but they differ from the early fruit and flower pieces in that they present objects that are perceived as food rather than as ornaments or as natural history specimens. They are arranged in such a way that we relate them to eating, an association that is supported in many cases by the utensils and cutlery that accompany the foods. Often, in fact, it appears as if someone is or has been eating the simple meal.

The early breakfast piece, which was introduced possibly toward the end of the sixteenth century and certainly by the beginning of the seventeenth, gave equal emphasis to all the objects. Humble tableware, mainly of pewter and pottery, and commonplace food and drink, such as apples, bread, and cheese, and glasses of beer, were major constituents of these compositions. As in the *Breakfast Still-Life* (148) of 1613 by Floris van Dijck, a Haarlem painter who lived from 1575 to 1651, they usually showed the table from a high viewpoint. A large tabletop fills most of the picture space. On it the brightly colored objects are spread out so that each one is seen separately, with a minimum of overlapping.

In the course of time, compositions with a lower viewpoint began to prevail, with the objects drawn up more or less in rows. In the *Breakfast Still-Life* (149) dated 1629 by Willem Claesz. Heda (1599–1680/82),

149. Willem Claesz. Heda, Breakfast Still-Life.

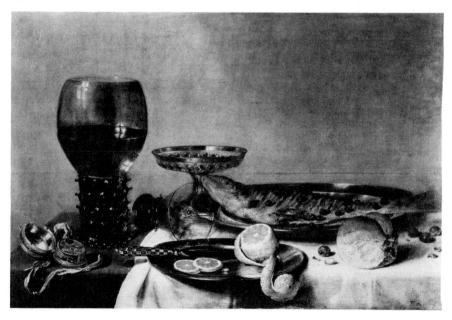

though there is still considerable attention to the individual objects, they are related compositionally in an effective way, by means of intersecting diagonals. The colors likewise are more harmonious than in the earlier breakfast pieces. The even distribution of light contributes to the distinctness of each element and the sense of an accumulation of separate items. In virtually all compositions of this type, as in the early fruit and flower pieces, the table is parallel to the picture plane, with its forward edge very far forward. Table covers, depicted with striking clarity, serve to emphasize the cubic solidity of the table and its proximity to our eyes. Objects projecting over the edge of the table—often a plate and a long spiral of lemon peel—seem to bring the images even closer to us. This spatial illusionism was to be continued in the later breakfast pieces as well as in the lavish still-life subjects of the second half of the century.

Willem Claesz. Heda was one of the two leading still-life painters in Haarlem in the advance toward more unified compositions, tending toward the monochrome, that occurred in the 1620s and 1630s, paralleling the similar development in landscapes and scenes of social life. His outstanding contemporary was Pieter Claesz. It is not certain which of them was the innovator. Both were very productive. At the same time, Jan Jansz. den Uyl (1595/96–1640) painted in Amsterdam in a closely related mode. The surviving works of Pieter Claesz. give the clearest evidence of the course of stylistic changes, as more of his early paintings are known to us.

Pieter Claesz. was born in 1597 or 1598 in Westphalia of Dutch parents. In 1617 he was married in Haarlem, at which time he was described as a painter, and he died in that city in 1661. His earliest known dated work, inscribed with his monogram and the date 1621 (West Monkton, England, Coll. E. C. Francis; repro. Bergström, fig. 100), is in the style of the early breakfast piece, with fruits, wine, and utensils in strong colors lined up and studied individually. Within two years he had begun to unify both composition and colors and to experiment with distinctive representations of different textures. Before 1630 he had found his mature style, a style imbued with calm, moderation, and harmony. His renunciation of the lively contours and bright colors of the earlier style lent itself well to *vanitas* still-life subjects, which direct attention to the vanity of earthly satisfactions in the face of death.

Vanitas still-lifes began to appear around 1620. It may be that the interest in such subjects coincided with the end of the Twelve-Years Truce, in 1621, with the fears of death that always accompany war. The ravages of the plague may also have helped to turn the attention of the Dutch away from earthly things and toward thoughts of the final judgment and the ensuing rewards or punishments. In 1624–25 the plague killed 9,897 and in six months during 1635, 14,582 in Leiden alone. This may have

Still-Life

predisposed Leiden to become the center of *vanitas* still-life painting. The central figure in this movement may have been David Bailly, who was born in Leiden in 1584 and died there in about 1657. The fact that the University of Leiden was a center of Dutch Calvinism may also have contributed to the concentration on anti-worldly subjects in this city. In 1625 Jacob Cats, the popular didactic poet, became a Governor of the University. His prominence may have helped to popularize the moralizing tone in art.

Most of the paintings of Pieter Claesz. were not frank *vanitas* subjects, but rather were in the category the Dutch call "*Ontbijtje*," or "Breakfast." It is not unlikely that such pictures were intended to exert subtle moral exhortation, as their simplicity and austerity may be understood to extol a temperate life. The virtuosity of Claesz. in representing contrasting textures and especially reflective qualities in great variety provides visual riches that are all the more appealing in their unassertiveness. We can enjoy the honest plainness of the pictures without being deprived of the sensuous charm of which oil paints are capable. It is easy to see in the works of this great artist the painterly qualities that were to inspire the French painter Chardin in the following century.

The Still-Life with Skull (150), painted in 1630 by Pieter Claesz., is

150. Pieter Claesz., Still-Life with Skull.

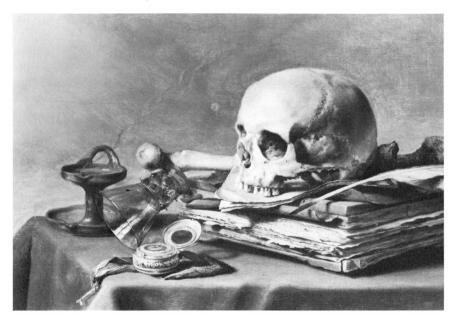

made up entirely of reminders of transience, all painted with a sensuous elegance that belies the grimness of the moral. There is a concentration of light on the ivory-like skull, the undeniable evidence that man is mortal. The watch that indicates the flight of time, the smoking oil lamp, and the overturned empty glass are all well-known symbols of the brevity of life on earth. Books, like all other material things, are subject to destruction, and pride in learning is one of the false values of humankind, as we learn from emblem books.

The clear organization is characteristic of the compositions of Claesz. and his contemporaries. The unification through light and color that plays a large part in the appeal of the *Still-Life with Skull* is also typical of the best works of the tonal period. The sage green table cover blends with the warm background and the grays and ochers and greenish and brownish tones of the objects on the table. The blue ribbon to which the watchkey is attached is effective in drawing our attention to the basic diagonal force of the design. Claesz.'s brushwork is vigorous and varied, making the most of the contrasting textures of the carefully selected elements in his painting.

Toward the end of the 1630s the still-lifes of Pieter Claesz. and his contemporaries tended to include more elaborate objects in more complex arrangements. Richer colors, too, began to prevail. From 1640 to the middle of the century and onward, a taste for luxury evident in Dutch painting in general had a striking impact on still-life subjects, and the masters of the tonal period adapted to the new fashion. The "banquet piece" replaced the "breakfast piece" in popular favor. After 1640 the most appreciated still-life painter was Jan Davidsz. de Heem, who had an affinity for compositions overflowing with fruits and costly decorative objects, in the Flemish tradition. De Heem, his studio assistants, and his pupils and followers produced paintings in impressive numbers, meeting the demand for these highly decorative works in both the northern and the southern Netherlands.

Jan Davidsz. de Heem was born in 1606 in Utrecht, where he spent his childhood. He moved to Leiden, where from 1625 to 1629 he painted "monochrome" *vanitas* subjects, in keeping with the prevailing mode there at that time. In 1636 he became a member of the guild at Antwerp, and in 1637 he was granted citizenship in that city. Late in his life, from 1669 to 1672, he again spent some years in Utrecht, following which he returned to Antwerp, where he died in 1683 or 1684. Thus in his person he provided a link between the Dutch Republic and the Spanish Netherlands, and the style of his work similarly showed features that were native to both sides of the border. From the Dutch tradition he derived the intense individualization of the objects depicted. He drew on Flemish art for the lavish compositional formats of his mature works. In contrast with

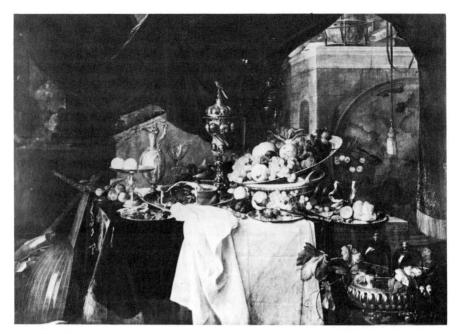

151. Jan Davidsz. de Heem, Still-Life.

the more modest assemblages represented in earlier still-life subjects, the embarrassment of riches de Heem crowded onto his canvas, as in the *Still-Life* (151) of 1640, show a pride in possessions and a display of wealth that speak clearly of different social aspirations. The down-to-earth, relatively egalitarian picture buyers of the early years of the century have given way to collectors who flaunt their economic and social superiority.

Some of de Heem's paintings have an added note of grandeur in the form of monumental classical columns and sweeping draperies in their backgrounds. Landscape vignettes are also sometimes visible in the distant background. Fruits, flowers, vegetables, and elaborate silver, glass, and china utensils are represented in highly finished detail. Musical instruments, shells, nuts, shellfish, and costly textiles add their various notes of color and texture to the superabundance of his feasts for the eye. Items of symbolic import familiar from *vanitas* paintings are sometimes included, and it may be that the large compositions representing objects calculated to appeal to all the senses may have been intended, as paintings referring to the Five Senses traditionally were, to allude discreetly to the moral danger inherent in material pleasures, even while they glorified these sources of sensuous gratification.

De Heem produced, in addition to the large compositions so rich in

varied elements, numerous smaller pictures. His hanging garlands and bouquets in radiant colors glowing against dark grounds are especially noteworthy. As in his own day, he is still greatly admired for the amazing effect of verisimilitude he achieved through consistent lighting and exquisite craftsmanship. It is very likely that the actual arrangements that he painted were never set up, but that he worked, as the early flower painters did, by way of studies of separate objects—some perhaps imaginary, some based on prints—that he composed on the canvas. Numerous painters, both Dutch and Flemish, showed their admiration by imitating him, well into the eighteenth century.

Many paintings survive by another great Dutch still-life painter, the strikingly individual stylist Abraham van Beyeren. Yet he appears to have been little known in his lifetime and in financial difficulties much of the time. Born in The Hague in 1620 or 1621, van Beyeren seems to have had a restless life, residing for a time in Leiden, then back in The Hague, on to Delft, once more in The Hague, in Amsterdam, Alkmaar, and finally Overschie, where he died in 1690. Few of his paintings are dated, and his development is not entirely clear.

Some of van Beyeren's most elegant paintings depict tables laden

152. Abraham van Beyeren, Fish Still-Life.

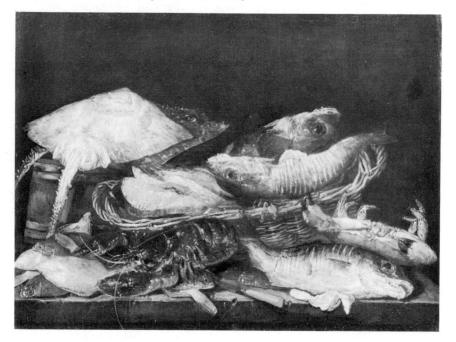

200

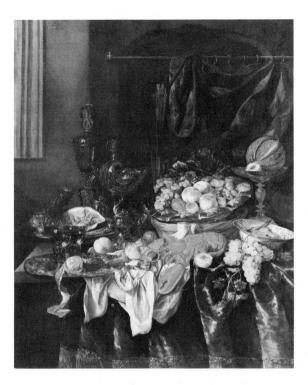

153. Abraham van Beyeren, *Still-Life*.

with several varieties of fish (152), a subject in which other Dutch painters also specialized. He painted some seascapes, but mainly devoted himself to diverse types of still-lifes, including fruit and flower pieces, dead birds, and *vanitas* subjects. Most appreciated now are his so-called "banquet pieces," which combine fruits, fish, lobsters, and elaborate accessories. An excellent example is the large *Still-Life* (153), in which the rich harmonies of his color and composition effectively unify the numerous and varied elements. The dramatic sweep and grandeur of such a picture associates it with the style of the high baroque. The baroque emphasis on diagonals into depth is the organizing principle of the composition. Spatial depth is also illusionistically increased in both the foreground and the background, in the foreground by way of a series of objects that project over the edge of the table, in the background by way of an arched opening in the wall, partly concealed by a silk curtain.

Van Beyeren revels in the sumptuous colors of melon and peach, of ham, salmon, and lobster boiled to brilliant red, but he organizes these, along with the sensitive greens and rich, dark background tones so that they all sing in harmony. The dark purple velvet table cover, which appears in a number of his pictures, sets the keynote. Its palpable texture is realized in the loose, painterly style with which van Beyeren brought to life so many different surfaces and structures. He was never intimidated by detail, but captured-easily, it appears-the fine-grained network of the melon's skin, just as he did the elaborately wrought silver plate and the grainy lemon peel, with a free, paint-laden brush. Close to the foreground, within reach of the lobster's claws, lies a pocket watch, the irrefutable reminder that time moves on, and all these alluring things, both natural and man-made, are of short duration. Renunciation hardly seems the natural, or even possible, reaction to this warning against the delight we take in van Beyeren's painting or in the objects it represents. Rather we might be tempted to respond in the spirit of carpe diem-seize the day, enjoy these pleasures while you may. Would the seventeenth-century Dutch have reacted differently? Perhaps they would in theory, if not in practice, for, even as ostentation increased in the later still-life subjects, the watch, the empty glass, and other indications of transience continued to be included. It may be that this helped to mitigate the psychic conflict good Calvinists would have suffered when the material possessions they amassed and enjoyed distracted them from concern with their spiritual welfare.

That there was an interest in rare and costly objects, especially those reflecting human skill and taste, is shown by the *pronk* or "ostentatious" still-lifes that were produced in considerable numbers from the 1640s on, at the same time as the lavish banquet pieces by Jan Davidsz. de Heem and his school and the exquisite works by Abraham van Beyeren. The Dutch metropolis, Amsterdam, was the natural home of this kind of tribute to the works of man. The great master in this field was Willem Kalf. Born to a wealthy middle-class family in Rotterdam in 1619, Kalf lived in Paris from 1642 to 1646, residing afterward at Hoorn and, from 1653 until his death in 1693, in Amsterdam. Among his most ingratiating pictures are peasant kitchens in small scale, with heaps of vegetables and utensils of various materials in the foreground. He also painted some landscapes and game pieces (which began to appear around 1640), but his fame rests mainly on his *pronk* still-lifes.

Kalf's mature works, after his return from Paris, generally depict a limited number of sumptuous objects closely grouped together on a tabletop that in many cases is partly covered by a crumpled Oriental carpet (154). A porcelain bowl or silver plate containing a few pieces of fruit is usually at one side in the foreground, with a higher silver jug or glass beside or slightly behind it, and a still higher object placed farther back. A watch is sometimes included, and very often the long spiral peel of a lemon hangs down over the near edge of the table. Some of the individual objects appear in more than one of his paintings, and at least one of the elaborate silver jugs has been shown to be based on an engraving. Thus it appears that Kalf, like other still-life painters, invented his compositions

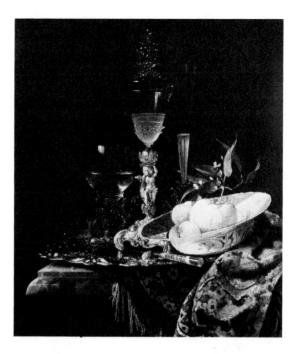

154. Willem Kalf, Still-Life

and did not copy them from actual arrangements. This makes the unification through light and shadow all the more impressive. His color harmonies of warm reds and yellows contrasted with the cool tones of silver, glass, and porcelain are very personal, and his brush stroke is lively. The details of the highly ornamented objects are boldly stated, never finicky. In his mastery of *chiaroscuro* he presumably owed something to Rembrandt.

The rich harvest of still-life paintings shows unmistakably that even before their nation was officially independent, the Dutch were delighting in the material well-being that had come their way. Neither the rigors of their Calvinist faith nor their generally middle-class goals prevented them from acknowledging, in their art, aristocratic strivings. They provided themselves lavishly with images of the appurtenances of wealth and cultivated tastes. Yet they seem to have felt some ambivalence about the pride in possessions thus revealed, for they never ceased to incorporate discreet indications of a moralizing intention. We do not really love all these luxuries of earthly life, they kept reminding themselves or each other; we still know what is truly important, and that is the life eternal. To convey this message is the task of the references to transience, decay, and death. For the same purpose, the still-lifes sometimes included symbols of resurrection, such as sprays of ivy, and the wheat and wine of the Eucharist, disguised by being intermingled with the other objects, but surely understood by those to whom they were addressed.

10/ Landscape and Seascape

FROM MANNERISM TO EARLY REALISM

ANDSCAPE was one of the types of subject matter in which great progress was made in Haarlem in the second decade of the seventeenth century.¹ The advanced artists there turned their backs on the traditional Flemish Mannerist, schematized landscape representation and started to look around them and to record what they saw, first in drawings and prints, soon afterward in paintings. They organized what they saw and invented new combinations of motifs, but even in their carefully structured compositions they continued to be guided by their observations of nature. At the same time, the Flemish landscape tradition did continue to influence some Dutch painters. Hercules Seghers (32) was one outstanding landscapist who, even when he adapted elements from observed nature in his landscapes, still adhered to some extent to the Flemish pattern of organization in successive planes identified by preconceived colors. Rembrandt, whose etchings and drawings (91; 100) were directly based on the scrutiny of actual scenes, continued in most of his landscape paintings to rely mainly on fantasy (90).

Esaias van de Velde (38-40) represents the other tendency, the new naturalistic Dutch outlook on landscape. He developed some of the formats that were taken up by artists through the century. The problem of showing depth convincingly had been solved during the first two decades of the century. Formats developed then and often adapted later, such as the pattern of double diagonals, can be understood as means of organizing the image on the picture plane rather than devices serving primarily to indicate the depth of space that is represented.²

THE POETRY OF OBSERVED NATURE

Haarlem continued to be a leading center of landscape painting through the century. One of the artists who played a major part in the slightly later developments was Pieter de Molijn, who was born in London in 1595 and in 1616 became a member of the guild in Haarlem, where he worked for most of his life. His early works were Mannerist in style, influenced by Bloemaert, but before long he followed in the path of the Haarlem naturalistic landscapists. His *Sandy Road* (155), painted in 1626, was "one of the cornerstones of Dutch landscape painting."³ It is built of large areas of light and shadows, unified by diagonals into the distance. This small but impressive painting is well on the way to the tonality that within a decade was to become the prominent advanced style in Dutch landscape.

Another leading realistic landscape painter was Jan van Goyen, born in Leiden, Rembrandt's home town, in 1596, ten years before Rembrandt was born.⁴ In 1617 van Goyen spent a year in Haarlem studying with Esaias van de Velde. This was apparently the crucial part of his training, although he is said to have had six teachers altogether in the course of his schooling as an artist. He started with a style and subjects very similar to Esaias van de Velde's. In fact, very early paintings by Jan van Goyen

155. Pieter de Molijn, Sandy Road.

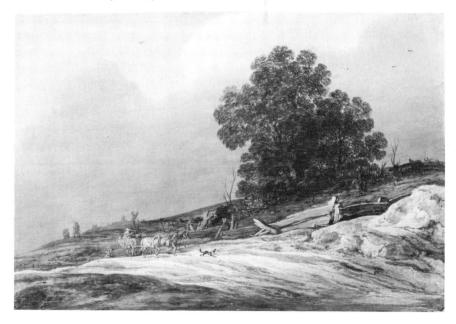

156. Jan van Goyen, Landscape with Two Oaks.

are hard to differentiate from paintings by Esaias. In his early works there are intense local colors and sharp contrasts of light and dark.

In the 1630s Jan van Goyen, who settled in the Hague in 1631, was one of the painters who developed what is called the tonal style. The climax of the tonal period ranged from about 1633 to about 1644, and van Goyen was one of the major landscape painters of this period. He traveled a good deal, and his sketchbooks that have survived, dating from about 1620-25, show how he worked freely from life during his travels, recording views in various parts of the Netherlands. The unification of space and light in his drawings is remarkable for this early time. He inscribed the location and the date on many sketches, so that his routes can be followed. Many of the paintings he based on such sketches are also signed and dated, making him one of the few painters whose production we can follow almost year by year. The Landscape with Two Oaks (156), monogramed and dated 1641, is one of his most famous paintings. It is a heroizing of the two old trees, truncated but persisting in putting forth leaves, and still dominating the landscape and towering over mere humans. The compositional pattern of a large, weighty motif on one side

Landscape and Seascape

with an open vista on the other was a favorite with van Goyen. A harmony of a limited range of colors, tending toward the monochromatic, marks it as from his tonal period.

The River Scene near a Village (157), signed and dated 1645, shows more contrasts in colors and values. The River Landscape (158) of 1649 is a composition of a type that van Goyen painted numerous times: a spit of land in the foreground, and fishermen putting out their nets from a boat that provides a horizontal note in the broad expanse of smooth water; a church dominating the town that, along with masts and sails, intrudes on the sky which occupies three-quarters of the composition. Van Goyen was a master of atmospheric perspective, based on changes in light in the distance and on the fact that objects are less clearly contoured as their distance from the observer increases. His observations of the infinite variations possible in the appearance of water are also remarkably sensitive. Another feature of van Goyen's style that enriches his paintings is a kind of calligraphic effect. He painted wet-in-wet, leaving little wavelike ridges of paint, which are especially apparent if the picture is seen in a

157. Jan van Goyen, River Scene Near a Village.

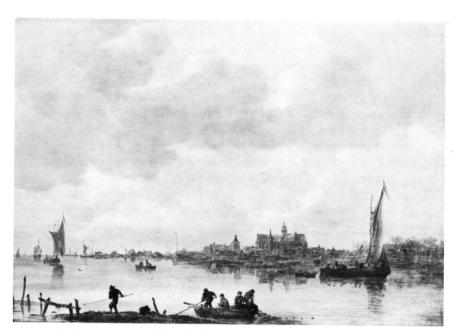

158. Jan van Goyen, River Landscape.

glancing light or from a side view. This gives an overall effect of texture that enlivens the surface. Van Goyen's paintings, even from the tonal phase, are not truly monochrome; that is, they are painted not simply in values of one color, but in a limited range of colors. Mainly there are golden ochers, with some siennas and other earth browns, and sometimes soft greens, silvery blues, and grays. Frequently the ocher colors dominate, as they do in the *Landscape with Two Oaks*. Some of his tonal paintings have a cool, silvery cast. After the tonal period he began to increase the range of colors and the contrasts in values.

Van Goyen was one of the early masters of the vast sky that is associated with Dutch landscape. Devoting a large proportion of the picture space to the sky accentuates the flatness of the land. One is very aware of the sky in the Netherlands; it is constantly changing. The clouds move, and the light changes as the location of the clouds in relation to the sun is altered. This, of course, affects the light and shadows on the earth, which shift with every variation in the wind-swept sky.

At the same time that van Goyen was painting, Salomon van Ruysdael was working in Haarlem in a similar style. Born between 1600 and 1603 in Gooiland (a district to the east of Amsterdam) and sometimes called Salomon de Gooyer, he lived until about 1670. He was a member of the Haarlem guild in 1623, a good ten years later than the gifted group

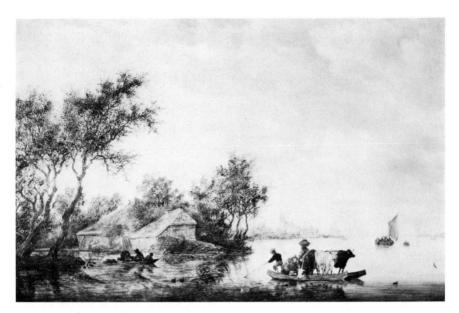

159. Salomon van Ruysdael, The Ferry.

who joined the Haarlem guild around 1610–12. We do not know who his teacher was; his early work shows the influence of Esaias van de Velde. His earliest surviving dated work is from 1626. In the thirties his style became much like van Goyen's. Later he developed greater force and diverged more from the style of van Goyen, but it is sometimes hard to distinguish between them in paintings of the early period. Ruysdael's touch was on the whole more delicate than van Goyen's; one distinction that is apparent is that Ruysdael's leaves are feathery, whereas van Goyen's are generally more blunt, with thicker paint. Ruysdael had a gift for creating a mood of serenity, a lyrical sense of the gentle light and the moist atmosphere that envelop the people and the man-made and natural forms. His compositions, however, are often less firmly unified than van Goyen's.

The Ferry (159), dated 1653, is a type of river scene that Salomon van Ruysdael painted many times. There is more detail in the foreground and more emphasis on the colors than in his early works. The ferry, carrying both people and cattle, provides a strong horizontal statement in the foreground, and the backs of the cattle, along with the line of the spit of land where the buildings in the centerground stand, add another horizontal. This stress on stability is characteristic of Dutch paintings of all kinds of subjects around the middle of the century.

Aert van der Neer is one of the most poetic of the landscape painters

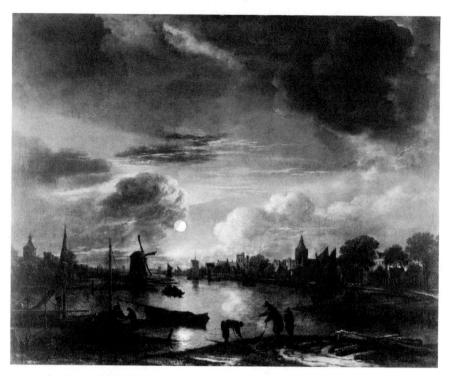

160. Aert van der Neer, Canal Scene by Moonlight.

roughly contemporary with Jan van Goyen and Salomon van Ruysdael. He was born in about 1603 or 1604 and died in 1677. He painted in Amsterdam, where he owned a tavern. He was a specialist in nocturnal landscapes, generally small, with a unique quality of luminosity. In the *Canal Scene by Moonlight* (160), the reflection of the moon on the water and the clouds exemplifies his romantic contribution to Dutch landscape painting. He painted a number of pictures of conflagrations in towns that also gave him the opportunity to deal with strange and fascinating light effects. There was a scientific interest in light in the seventeenth century, and the artists were, in some cases at least, aware of this. Their study of the possibilities of light in different situations is one of the interests that may have led to some of the experiments in landscape painting. Aert van der Neer, however, gives not a scientific but an emotional effect with his nocturnal studies.

THE MONUMENTAL OR STRUCTURAL PHASE

Artists of the following generation, born around 1620, created landscape paintings of unprecedented power. Their works are marked by strong and broadly organized colors and by compositional formats with emphasis on firm structure. Like their predecessors, they virtually always included human beings in their compositions. They saw the natural world as dominating but not hostile to human life. Roads, dwellings, travelers, mills, domestic animals, and other signs of human habitation relate most of these compositions, with all their grandeur, to the human scale.

Philips Koninck was known in his own day for portraits and for history and genre paintings, but today we value him chiefly for his landscapes, which give the panoramic view the utmost scope. He was born in 1619 in Amsterdam. In 1639 he was the pupil of his brother Jacob in Rotterdam, and around 1642 he settled in Amsterdam, where, according to Houbraken, he was a pupil of Rembrandt. His drawing style as well as some features of his paintings give evidence of Rembrandt's influence. His most impressive works are landscapes offering views that are not bounded in any way on either side. They give the impression of an expanse of land without limit, as we see the flat, low horizon from an elevated viewpoint. Typical of his style is the large Panoramic Landscape of 1649 (161), in which neither trees nor buildings link the earth to the sky. This adds to the dominant effect of the horizon. The rich greens and earth tones have a textured quality reminiscent of Seghers. Koninck's expressive use of large areas of shadow contrasted with the sunlit parts of the landscape shows indebtedness to Rembrandt's landscapes. The delicacy of Koninck's skies is uniquely his. There are a number of dated pictures by him, inscribed with dates from 1647 to 1676, but his chronology and development are not clear. He lived until 1688.

The painter considered by many to be the greatest of Dutch landscapists, Jacob Isaacksz. van Ruisdael, was born in Haarlem in 1628 or 1629 and became a member of the guild there in 1648. His father, Isaack, was a framemaker and painter, but no works by him are known. Salomon van Ruysdael was Jacob's uncle and evidently influenced the style of his nephew's earlier works (Jacob Isaacksz. van Ruisdael never spelled his name with a y). Jacob van Ruisdael painted landscape subjects of extraordinary variety. He is the great master of the mysterious depths of the forest and of the heroic tree or cluster of trees. In addition, he painted winter scenes, panoramic views, seascapes, and town views (7). A number of his landscapes were based on northern motifs, with steep, rocky mountainsides, rushing torrents, and evergreen trees, dramatic scenes not to be found in the placid Dutch topography. He apparently derived some of these motifs from drawings and paintings by Allaert van

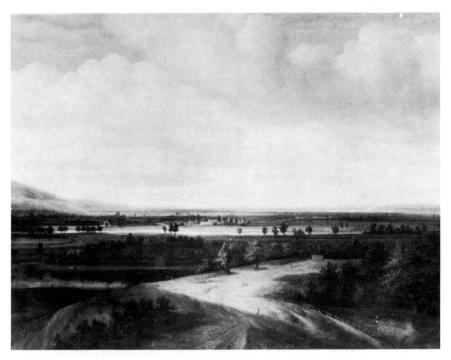

161. Philips Koninck, Panoramic Landscape.

Everdingen (1621-75), who had brought them back from Sweden, where he had gone early in the 1640s for a protracted visit with a patron.

Ruisdael's Rocky Landscape (162) combines a number of his favorite motifs. The fallen tree in the right foreground, jaggedly broken from its stump, forms a bond between the bank on which it grew and the body of water that fill the full width of the foreground. Feeding this still pond and giving it a ruff of white foam is a waterfall emanating from a cleft in the rocky cliffs. Thick woods cover the summit of the hill on the right. Dwellings are perched on the edge of the precipice, and near one of the houses are the minute figures of a man and a woman. The most prominent single feature is the tree that spreads its leaves against the sky to the left of center. The delicate, feathery effect of the foliage calls to mind the style of Jacob's uncle, Salomon van Ruysdael. As usual with Ruisdael, the trunks of the trees have marked individuality. They seem to have reached verticality only after a struggle. Beside the leafy tree are the vestiges of another from which life has long since departed. The lower land to the left is heavily wooded, and again, like an echo, foliage asserts itself against the sky. A hill closes the distant vista. Ruisdael organized these varied elements around a diagonal from upper right to lower left, a

Landscape and Seascape

compositional pattern he favored, which was one of the formats that had been perfected by the early realist landscape painters who preceded him. The right side, solidly filled, intense in color and rich in contours as well as masses, contrasts with the left half, with its open vista dominated by the light colors of the cloudy sky.

Like other artists in the structural or monumental phase of landscape painting, Jacob van Ruisdael employed color schemes more intense than those of the masters of the tonal landscape, with sharper contrasts in values adding boldness and strength to the composition. Even the skies of Ruisdael's mature works are massive; the clouds seem to be three-dimensional, weighty, and sometimes ominous.

One of Jacob van Ruisdael's famous subjects is *The Jewish Cemetery* (163), which dates probably from close to 1660. This is one of the rare landscape paintings of the seventeenth century in which the overriding intention was clearly symbolic. The actual place that is represented is an old cemetery at Ouderkerk, near Amsterdam. The tombs that Ruisdael depicted were to be seen there, but there were of course no ruins like

162. Jacob van Ruisdael, Rocky Landscape.

163. Jacob van Ruisdael, The Jewish Cemetery.

those seen in the background, no waterfall, and no hilly area. It is clear that Ruisdael selected elements from the visible scene and added invented motifs to suit his purpose. In a sense, then, this is a fantasy landscape. Yet it is based on the observation of nature. The prominent tree probably was based on a drawing of an actual tree that Ruisdael studied from nature. He chose the colors for their melancholy quality, just as he devised the rocky elements that look fractured, old, and timeworn. The broken, dead tree in the foreground and the ruins in the background are also among the motifs that lend themselves to the overall idea of *vanitas*, of the impermanence of everything earthly. This is a subject frequently seen in Dutch still-life paintings, but it is rare to have a landscape painting that can be so clearly read as having the same moralizing intention, that of directing people's thoughts to eternal spiritual values.

The monumentalization of a single element is strikingly exemplified in *The Mill at Wijk bij Duurstede* (164), which Ruisdael painted probably between 1665 and 1670. This was during his great period; from the time he moved to Amsterdam in 1656 until the early 1670s, he painted many of his outstanding works. After the middle of the 1670s there was a weakening in his style. In this picture the color and broad areas of light and dark unify the composition. The great mill seen against the sky dominates the scene. The lines of the wings of the windmill are echoed by a lozenge pattern in the sky, a geometrical organization of the clouds. Everything in this painting is highly organized. The tall masts, for example, are related to the clouds above and to the posts below. A zigzag pattern of strong diagonals directs our attention into and through the picture, from the foreground at the left of center to the paling at the lower right, which leads our eyes to the point of land in the middle ground and from there to an ascending diagonal provided by the cloud formations and the wings of the windmill. While giving a clear impression of the flora in the foreground, Ruisdael never overstresses such details to the detriment of the total effect. The overall composition of this picture is so powerful that all details are subordinated to it without a struggle.

The windmill, so noticeable a feature of the Dutch landscape and so important in its practical uses, is a suitable monument to Dutch tenacity and ingenuity. Jacob van Ruisdael was not the first great Dutch artist to make a windmill the focal feature of a masterpiece. His painting adapted

164. Jacob van Ruisdael, The Mill at Wijk bij Duurstede.

165. Jacob van Ruisdael, Extensive Landscape with a Ruined Castle and a Village Church.

to the artistic goals of the monumental phase of landscape painting a composition by Jan van Goyen, whose *Windmill by a River* of 1642 (London, National Gallery) provided the compositional pattern in the tonal period. In Ruisdael's hands a similar scene became a more dramatic and powerful picture. Like van Goyen, Ruisdael also built compositions around an imposing tree or group of trees.

Ruisdael's *Extensive Landscape with a Ruined Castle and a Village Church* (165), an imaginary view, probably dating from the later 1660s, recalls the panoramic landscapes of Philips Koninck. There is a seemingly endless view over the flat countryside, open on both sides, and with very few intrusions from earth to sky. Prominent in the foreground, with a vivid reflection in the water, are ruins which lend a sense that man lived here in generations past and departed, and yet again the peasants are here in the land with their animals, so that it is still a part of the natural world that supports human life. The windmill visible in the brilliantly lighted central area in the distance is also, like the church towers, evidence of the everyday life that continues to go on within this land, where sheaves of wheat lined up in the lush fields on the left imply the bounty of nature and the fruitful labor of those who work the land.

The nostalgic charm of the ruins and the swans swimming in the moat

add a romantic note to the naturalistic scene. The active pattern of the clouds and the sharp contrasts between sunny areas on the earth and those darkened by the intervention of clouds give a brilliantly observed impression of the variable weather of Holland, where the sunlight shifts or is lost from moment to moment. No landscapist anywhere has been better able to paint wind and weather than Jacob van Ruisdael at his best. In the painting of the *staffage* he had the help of another artist. While Ruisdael himself painted the swans and the small figure of a man amidst the ruins, the peasants and domestic animals in the left foreground have been attributed to Adriaen van de Velde, himself a painter of delightful landscapes.

In *Wheatfields* (166), which Ruisdael painted in about 1670, the depth of view is emphasized by the sharp decrease in the width of the road seen head-on, centrally in the foreground, where it exceeds the width of the picture space. The foreshortened road seems to lead us straight into the distance. *Wheatfields* majestically exemplifies the qualities by which we define the great monumental or structural phase of Dutch landscape painting: breadth, balance, serenity, strength and harmony of color. It is

166. Jacob van Ruisdael, Wheatfields.

167. Meindert Hobbema, A Stormy Landscape.

clearly with good reason that Ruisdael is considered the supreme master in this field. Besides his varied landscape, seascape, and townscape paintings, he made admirable drawings and etchings of great compositional power and emotional force. Etchings by him are known from as early as 1645.

A gifted pupil, whose works were similar to Ruisdael's in many ways, was Meindert Hobbema. He was probably born in Amsterdam, though that is not entirely certain, in 1638, and lived there until 1709. Hobbema's subject matter was less varied than Ruisdael's. He preferred forest scenes lightened by a pond or road, watermills, and farmhouses in flat landscapes with expansive groups of trees with open contours and feathery texture. His touch is more fluid than Ruisdael's, his mood generally more serene. His skies are luminous, less massy than Ruisdael's, but still contributing to compositional patterns. His colors tend to be somewhat lighter and more cheerful, his foliage more air-borne. He was a master at indicating the penetration of light within the shadowed areas. By means of dappled light or open spaces within the forests, Hobbema avoided the closed-in, myterious, and somewhat ominous quality of Ruisdael's forests. There are Ruisdael-like motifs, however, in many of Hobbema's paintings, and in some cases he directly imitated works by Ruisdael.

Hobbema's finest works date from the 1660s. A Stormy Landscape (167) is a typical Hobbema composition, with a cluster of trees dominating the right side and an open vista on the left, the two sides joined in a surface pattern of diagonals that meet at the apex of the highest tree. The shadowed earth and dark greens of the foliage on the right contrast strongly with the sun-brightened left side, with the reflections in the water which play a vital part in bringing the light of the sky down to the earth. Houses are nestled amidst groves of trees, and people walk, converse, and fish in Hobbema's hospitable natural world, where air and space, sunshine and water set the stage.

Buildings in ruins not only can add to a landscape a note of regret for times gone by and man's ambitious enterprises destroyed, but they can also enlarge the range of colors appropriate to the naturalistic landscape. Both Ruisdael and Hobbema often availed themselves of the warm tones of weathered stone or brick, which provided a handsome contrast with the prevailing greens and browns of the landscape. Hobbema's Ruins of Brederode Castle of 1671 (168), unlike the ruins in Ruisdael's Cemetery (163), depicts the remains of an actual building and its moat, which are still to be seen about three miles north of Haarlem. The painting can, indeed, be considered a memorial to the old landed nobility. This castle was the seat of the Brederodes, a family of ancient lineage, prominent in Holland's history until the death of the last of the line in 1653. The soft rosy reds of the castle and the sun-gilded grass before it gave a delightful warmth to the scene. Again the crowns of the trees and forms of the clouds cooperate to make a triangular pattern. Along with this upwardpointed triangle, the foreground elements are related to one another so as to complete a lozenge shape that pulls the whole composition together on the picture plane, countering the various movements into depth. The treatment of the water, with subtle reflections of sky and the surrounding objects, is typical of Hobbema. The figures in the foreground and the overly conspicuous ducks appear to have been painted by another artist (or artists).

Hobbema painted little after he reached the age of thirty. At that time he married a housemaid of the burgomaster and received an official city post as wine gauger. Twenty years later, however, he produced a great work: *The Avenue, Middelharnis* (169). Earlier he had experimented with compositions in which a sharply foreshortened road or a stream seen broadly in the immediate foreground leads the eye straight into the scene. These direct paths into the depth would typically curve away in the middle ground. In *The Avenue, Middelharnis*, dated 1689, the rutted road leads boldly to the far background, and the tall trees bordering it on either

168. Meindert Hobbema, Ruins of Brederode Castle.

side emphasize the perspective recession. The symmetry of the composition, the luminous sky and rich color scheme, the stability of forms and subtlety of facture make this masterpiece an ideal representative of the structural or monumental phase of Dutch landscape painting. Among landscapes being produced at this late date, Hobbema's *Avenue* was alone in its perfection.

Meanwhile, other landscapists had developed personal interests and styles of outstanding merit. Aelbert Cuyp, a member of Ruisdael's generation, was born in 1620 in Dordrecht and lived until 1691. He was the son of a well-known painter, Jacob Gerritsz. Cuyp (1594–1652), who specialized in portraiture. Early in his career Aelbert Cuyp painted more or less monochrome landscapes somewhat similar to those of van Goyen, but generally more yellowish in color. He seems to have seen the world through sunny glasses, so that a golden tone pervades his works. He never went to Italy but was influenced by artists who did, particularly by Jan Both, who had returned from Italy to Utrecht by the time Cuyp was entering upon his career. The warm light of the southern landscapes recorded by the Dutch Italianate landscape painters tinged Cuyp's paintings with a golden glow. It may be that optical studies of the effect of

169. Meindert Hobbema, The Avenue, Middelharnis.

moisture in the air on appearances also contributed to Cuyp's special sensitivity to mists at different times of day.

A Herdsman with Five Cows by a River (170) shows Cuyp's golden haze where the land and water meet the sky. The atmospheric perspective is subtly rendered, seeming to arise naturally from the moist atmosphere of the water-rich Netherlands. The serene, still quality is characteristic of Cuyp. In this picture, which he painted probably in the middle 1650s, Cuyp gave prominence to cattle, as he frequently did. He placed the cows in such a way as to create a stable, almost architectural effect. The backs of the cows form a straight line, and the arrangement suggests a rectangular solid. The foreshortened boat with fishermen in the foreground on the left draws our attention to the series of sailboats that carry our eyes to the far horizon.

The luminous expanse of sky and water is the essential subject of *Dordrecht: Sunrise* (171). Both the activities of the figures in the foreground and the distant silhouette of Dordrecht, with the Groote Kerk recognizable across the River Merwede—representing observed reality—are subordinate to the masterly rendering of light and atmosphere, which blends truth with poetry.

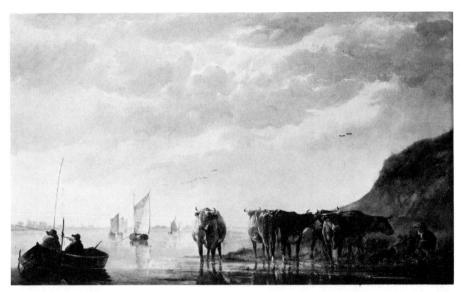

170. Aelbert Cuyp, A Herdsman with Five Cows by a River.

171. Aelbert Cuyp, Dordrecht: Sunrise.

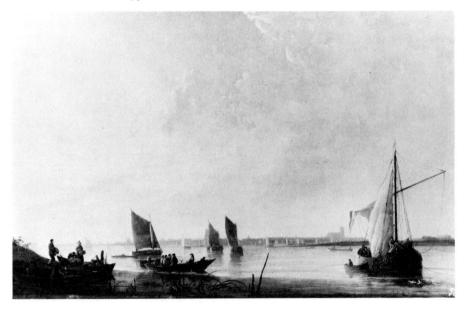

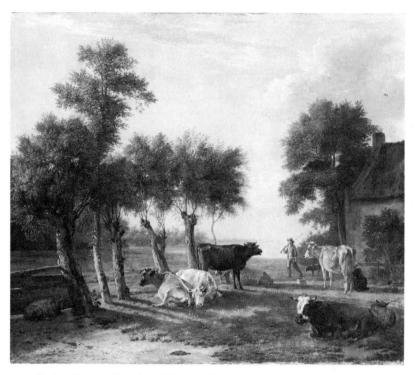

172. Paulus Potter, Cows in a Meadow Near a Farm.

Paulus Potter, who lived from 1625 to 1654, was among the landscape painters with a primary interest in domestic animals. Landscape paintings from the time of calendar pages in medieval manuscripts had included domestic animals. They were usually simply accessories in landscape scenes. In works by Cuyp and some other painters of monumental landscapes, animals took on a more important role, both as subject matter and in terms of their function in the composition. With Potter the animals are the main point. Potter's Cows in a Meadow near a Farm (172), signed and dated 1653, is a study of cows and sheep in their natural habitat. The animals have been arranged as the focus of the composition, and the individual appearance of each one has been studied with the same sensitive attention as that which a portraitist would be expected to devote to each sitter in a group portrait. The herdsman and the milkmaid are subordinate to the imposing animals. And the evening landscape, with its long shadows, is but a setting for the noble cows. Many other Dutch artists similarly made clear in their paintings the interdependence of human beings and domestic animals and the harmonious life they shared on the land

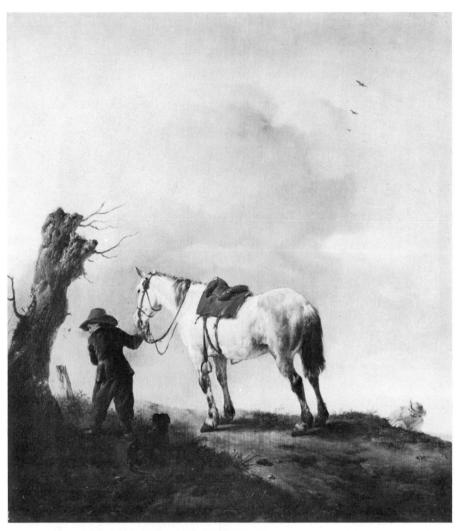

173. Philips Wouwerman, The White Horse.

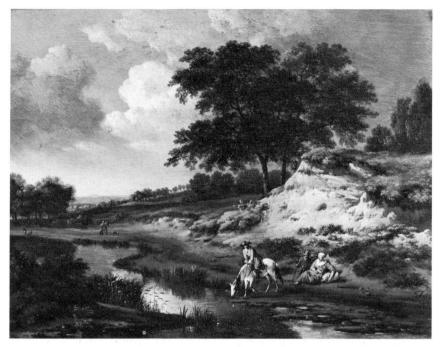

- 174. Jan Wijnants, Dune Landscape with a Horse Drinking.
- 175. Adriaen van de Velde, The Beach at Scheveningen.

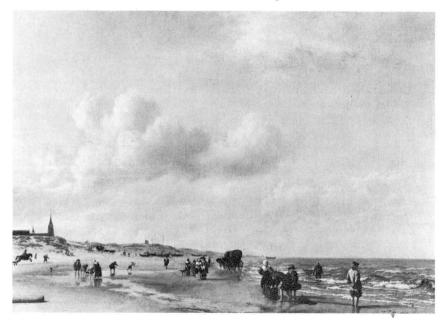

Philips Wouwerman, who painted a vast number of scenes involving horses—battles, travelers, blacksmith shops—also made the horse as such the subject of some of his most impressive compositions. He understood both the dynamism and the elegance of horses. The highly successful Wouwerman, much appreciated in his own time and in France in the eighteenth century, was born in Haarlem in 1619 and became a member of the guild there in 1640. His small genre scenes are set in skillfully organized landscape settings. In *The White Horse* (173), the landscape is secondary to the monumental horse, so brilliantly observed as to both structure and surface. The artist's understanding of the outdoor illumination and his arrangement of the carefully selected forms entitle him to consideration among the Dutch artists who contributed to the new breadth of landscape painting in the seventeenth century. He died in 1668.

Among the many able painters who followed after the great masters of the monumental phase of landscape, Jan Wijnants was one who made fresh, delightful depictions of the dune landscape in the environs of Haarlem available to art lovers near and far. Wijnants was probably born in Haarlem in about 1630. He moved to Amsterdam in 1660 and lived there until his death in 1684. In the *Dune Landscape with a Horse Drinking* (174) a meandering stream makes its way from the right foreground to the left middle ground, where it is met by the lower point of a diagonal descending from the upper right. The light on sand and water and the active clouds create a lively effect. Once again, the landscape is a humane one in which people and their domestic animals are at home. (The foreground figures are by another artist, probably Johannes Lingelbach [1622-74].)

Similar subjects, "intimate landscapes," were treated with comparable skill by Adriaen van de Velde (1636–72), a pupil of Wijnants in Haarlem in the early 1650s. His sparkling *Beach at Scheveningen* (175) has the authentic air of the outdoors that we associate with Impressionist landscapes.

ITALIANATE LANDSCAPE

A number of Dutch landscape painters who were born approximately between 1595 and 1600 went to Italy, which was the magnet for painters in the early seventeenth century. Rome in particular was the center of the new developments in art, artists everywhere were well aware of this, and many were interested in visiting Italy and seeing what was to be seen there, both contemporary art and the art and architecture of antiquity and the Renaissance.

Among the artists who led the movement of the seventeenth-century Dutch painters of landscape into Italy was Cornelis Poelenburgh, who

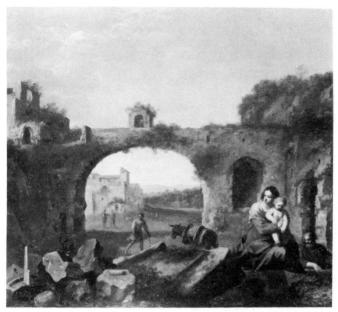

176. Cornelis Poelenburgh, Rest on the Flight into Egypt.

was born in Utrecht probably about 1595. He was a student of Abraham Bloemaert, who taught some of the Utrecht Caravaggists as well.⁵ Utrecht, as a center of Catholic life in the Protestant Netherlands, had particularly close relations with Rome; Utrecht artists had gravitated toward Rome early in the century and in some cases spent a number of years there. Poelenburgh was in Italy from 1617 to possibly 1622 or later. In Rome he made copies of works by Elsheimer. On returning to Utrecht he became a leader among the painters there. In 1637 he went to London and painted for Charles I. The Italianate landscapists were out of fashion in the latter nineteenth century, and for a long time their paintings were considered a minor form of art. They have been more or less resuscitated in the appreciation of connoisseurs in more recent years. In their own time they were highly esteemed. Poelenburgh had many followers. He lived and worked mainly in Utrecht from the time of his return from Italy until he died in 1667. His landscape compositions were largely imaginative, with an arcadian quality. In many cases they were inhabited by mythological or biblical characters rather than contemporary people. His pictures, usually small in size and scale, have a highly finished surface that was much appreciated by his contemporaries. During the third decade of the seventeenth century he was perhaps the most influential Utrecht artist; his works made Italian landscape motifs available to many of the Dutch artists who did not go to Italy.

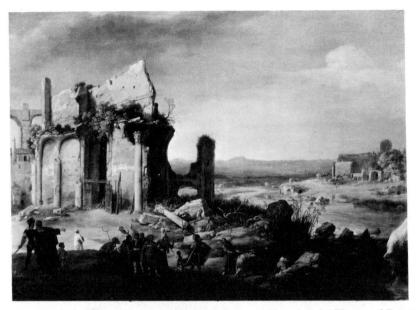

177. Bartholomeus Breenbergh, Moses and Aaron Changing the Waters of Egypt into Blood.

Poelenburgh's *Rest on the Flight into Egypt* (176) places the Holy Family in a sunny landscape dominated by remnants of ancient Roman architecture. Ruined and overgrown by the thrusting force of nature, these memorials to the glory of a lost but unforgotten culture bring to mind the Christian view that with the birth of Christ the old era ended and a new and more resplendent one began that drew sustenance from bygone times. Like other landscape painters of this period in Italy, Poelenburgh was impressed by the warm southern light. The unification of Italian landscape views through atmosphere and light was a feature for which Claude Lorrain became famous; this achievement was much appreciated by painters of the time and was reflected in many of their works.

Bartholomeus Breenbergh, who was born in about 1599 in Deventer, was also a pupil of Abraham Bloemaert in Utrecht and was in Rome for about a decade, beginning in 1619. Elsheimer's influence on him is evident. In 1633 Breenbergh was living in Amsterdam; he died there in 1657. His landscape harboring the Old Testament subject *Moses and Aaron Changing the Waters of Egypt into Blood* (177), like the Poelenburgh landscape illustrated, gives major prominence to Roman ruins, before which the exotically clad small figures enact their parts in the narrative. Some of these motifs were undoubtedly based on observation, but the composition as a whole is invented rather than naturalistic. Breenbergh's beautiful drawings made in the Roman Campagna, with their dramatic contrasts of light and shadow, suggest that he may have been the

pioneer in such landscape drawings, anticipating the famous drawings of Claude.

Another contemporary of Poelenburgh's who arrived in Rome a few years later, around 1625, was Pieter van Laer, who was born in Haarlem in about 1592. He took the lead in painting scenes of Roman street life. A cripple, he was known by the nickname *Bamboccio* ("Ugly Puppet"), and pictures of the kinds of scenes with which he became associated were called *bambocciate*. In Roman outdoor settings he depicted everyday events involving transients, street vendors, musicians, beggars, brawlers. Van Laer was influenced by the strong light effects favored by the Caravaggist painters, with the resultant plasticity of figures, as well as the interest in ordinary people so vividly brought into the sphere of painting by Caravaggio and his followers. His style was in turn reflected in the works of a number of Dutch painters who specialized in genre scenes involving street vendors, groups outside inns, and other aspects of the social life of the urban and rural populace.

Jan Both was a leading member of the second generation, the most active and most important period, of Italianate landscape painting. The painters of this group were those who were born around 1615 to 1630. Jan Both's birth date was probably about 1618. He too was from Utrecht and was a pupil of Abraham Bloemaert. He was in Rome by 1638, perhaps earlier. During his stay in Italy he visited Venice. He was back in Utrecht by 1641 and died there in 1652. Sandrart admiringly noted that in his paintings one can recognize the specific hour of the day and qualities of the particular fields, mountains, and trees that he depicted. In the manner of Claude, Jan Both effectively unified his pictures through light. After he returned to Holland he continued to paint Italian scenes which he composed from sketches that he had made while in Italy. In fact he painted almost exclusively landscapes based on Italian scenes, sometimes including religious or mythological subjects in small scale. More often peasants, travelers, or ordinary townspeople added animation to his paintings. In the Rocky Landscape with Oxcart (178), the way in which the distance becomes lost in the golden haze is typical of Both. The foreground is clearly depicted, and the figures are painstakingly painted.

Both, like Poelenburgh, had many followers, outstanding among them being Claes Berchem, son of the still-life painter Pieter Claesz. Berchem was born in Haarlem in 1620, went to Italy in 1642, returned to Haarlem in 1646, and lived in Amsterdam from 1677 until his death in 1682. Berchem's *Italian Landscape with a Round Tower* (179) is signed and dated 1656. It has an almost rococo freedom and charm. The picturesqueness of the ruins and the dramatic site are matched by the glamour of the countrywomen and the decorative animals that accompany them.

A number of Berchem's pupils became prominent painters, among

178. Jan Both, Rocky Landscape with Oxcart.

them Pieter de Hooch and Jacob Ochtervelt, both of whom are known for their domestic interior scenes, and Karel Dujardin, a painter of idealized Italianate landscapes similar to Berchem's. Dujardin was probably born in Amsterdam in about 1621 or 1622. He visited France as well as Rome. There are dated paintings by him for every year from 1650 on until his death in 1678. A versatile artist, he painted not only many landscapes, but also some portraits, religious subjects, and genre scenes. His landscapes are characterized by a daylight clarity, with long-range visibility that seems to result from exceptionally clean air. His local colors are bright and his forms well defined. The Italian Landscape with Cattle (180), signed and dated 1659, shows the influence of Paulus Potter, with whom Dujardin came into contact when he worked at The Hague from 1656 to 1659. The domestic animals are at least as important as the human figures in this characteristically Dutch pastoral scene. The distant mountain peak, on the other hand, must reflect memories of Italy or of landscape depictions based on Italian views.

Jan Baptist Weenix (1621–c.1660), who was in Italy with Berchem, specialized in paintings of the countryside near Rome and romantic Italian harbor scenes. He also painted still-lifes of game, portraits, and interior scenes. Another member of the second generation of Dutch Italianate

179. Claes Berchem, Italian Landscape with a Round Tower.

180. Karel Dujardin, Italian Landscape with Cattle.

landscape painters, Jan Asselijn (c.1615–52), was in Italy for about a decade, until the mid-1640s. His landscapes and harbor views were gilded with the warm southern light so much appreciated by the Dutch.

SEASCAPES

The sea was significant in a variety of ways to the Dutch. They were constantly warring with it in the struggle to increase and retain their land. On the other hand, the sea was the source of their wealth and their economic stability. The United Provinces was a great maritime trading nation; this was the backbone of its economy. The Dutch relied on the sea for a crucial part of their food supply. The herring, so often represented in still-life paintings, was indeed a national treasure. Salted, it remained edible and provided sustenance during the long sea voyages that promoted Dutch prosperity, and it also enriched the economy as a major item for export. The sea was also the scene of their military successes. Dutch national heroes were admirals rather than generals; the great tomb sculptures in Dutch churches are tombs of admirals. Paintings of seascapes reflected the specific maritime interests of the Dutch people, and there seems to have been a large market for them in the seventeenth century.

A number of Dutch artists whose work consisted mainly of other

Landscape and Seascape

kinds of subjects painted seascapes as well. Jan van Goyen, for example, painted numerous coastal scenes and purely marine subjects. Jacob van Ruisdael and Aelbert Cuyp also painted seascapes. Some artists, however, specialized in seascapes. Most marine painters were experts on ships. Early in the century, such artists as Hendrick Cornelisz. Vroom emphasized ship portraiture and sea battles. Vroom, who was born in Haarlem in 1566 and lived until 1640, was a contemporary of the early realist painters of landscape there. He painted marine subjects in the style of that school, with clearly defined details and strong local colors. He was not particularly interested in the atmosphere, or the sea itself as such, or the sky, but in events that took place at sea. He painted, for instance, to commemorate a Dutch victory over the Spanish fleet in 1607, *The Battle of Gibraltar* (Amsterdam, Rijksmuseum), with ships exploding and the sea full of people, corpses, and debris.

Jan Porcellis represents a long step beyond Vroom and the other early realists in terms of the general line of development of Dutch painting. Instead of becoming involved with minute details and showing them in sharply contrasted colors and values, he tended toward the monochromatic, like the tonal landscapists. He was concerned with the sea itself, the distant view, the effect of the atmosphere on what is seen in the distance, and the changing skies. The ships that sail the seas play a less prominent part. Porcellis' picture Stormy Sea (181), dated 1629 on the cartellino on the ledge at the lower right, shows him as a pioneer in tonal painting. It is predominantly silvery gray. The sawtooth crests of the darker waves in the foreground act as repoussoir, separating us from the boiling waters beyond. The unstable positions of the ships dramatize the effect of the storm. One of the unusual features of this painting is the trompe l'oeil window embrasure through which the seascape is seen. This adds to the impression of realism of the scene. Porcellis, who was born in Ghent, in the southern Netherlands, in 1584, led a restless life, working in Rotterdam, Haarlem, and Amsterdam among other cities. He died in 1632.

Jan van de Cappelle, who lived in Amsterdam from about 1626 to 1679, belonged to the generation of Jacob van Ruisdael and Aelbert Cuyp. He was chiefly influenced by the marine painter Simon de Vlieger (1601–53), who in turn was indebted to Jan Porcellis. Stylistically, developments in seascapes parallel the succession of styles in landscape painting. In the works of van de Cappelle, the greatest of Dutch marine painters, we see, as we do in Ruisdael and Cuyp, tectonic strength and an emphasis on contrasts of color and value, along with structural stability based mainly on horizontal and vertical elements. Van de Cappelle, a wealthy businessman and art collector, painted at most two hundred pictures, of which perhaps fifty are winter landscapes and the remainder sea-

181. Jan Porcellis, Stormy Sea.

scapes. His choice of these two types of subjects indicates his interest in light effects. He fully exploited the luminous possibilities provided by the reflective surfaces of snow, ice, and water. His seas are calm, the better to reflect the light.

The State Barge Saluted by the Home Fleet (182), signed and dated 1650, shows van de Cappelle's extraordinary ability to provide explicit information while at the same time coordinating all elements in a harmonious whole. His touch is fluent and free. The first impression the picture makes is that of unlimited visibility thanks to clear air and brilliant daylight. Water and sky join together in light-flooded splendor. The repeated pattern of vertical masts and shrouds, elongated by their reflections in the still water, is countered by the horizontal lines of hulls. Within this monumental framework, momentary events occur without destroying the firmly based stability of the composition. The large ship to the left of center and the one on the far right are both firing shots in salute to the state barge in the foreground, filled with dignitaries. Prince Frederick Hendrick of Orange can be identified by the blue ribbon of the Order of the Garter that he wears. A number of the figures appear to be recogniz-able portraits. Yet the care for detail does not distract from the effect of the whole painting, so skillfully are the individual elements incorporated in the overall luminosity.

Willem van de Velde the Younger was, like Vroom, a reporter of events at sea and, like van de Cappelle, a pupil of Simon de Vlieger, whose soft late style influenced particularly the early works of van de Velde. Born in Leiden in 1633, he was taught first by his father, Willem van de Velde the Elder (1611-93), a specialist in sea battle depictions. Both father and son were among the seventeenth-century Dutch painters who recorded contemporary events. Willem van de Velde the Elder used black ink on white canvas to make detailed studies of specific ships and battles (183). Both van de Veldes went to sea with the fleet and made sketches that they later used in composing their paintings. The documentary value of their works is great; the design and rigging of the ships and the events of the specific engagements in the sea war between the English and the Dutch, essentially a struggle for the economic benefits of the maritime trade, can be learned from these pictures. In 1672, the year in which the war between the English and the Dutch was resumed, the young Dutch Republic was beset on another front as well, for in that year the French invaded. It was a difficult time for all the Dutch, and doubtless not an easy time for artists to earn a living. At this time the van de

182. Jan van de Cappelle, The State Barge Saluted by the Home Fleet.

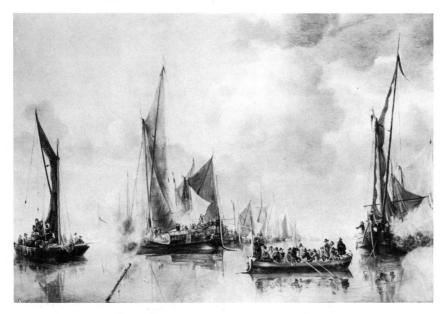

184. Willem van de Velde the Younger, The Harbor of Amsterdam.

Veldes went to England, to settle in Greenwich as court painters to King Charles II and paint the war from the English side.

Later they went back to Holland and continued their careers as marine painters. Apparently it was not held against them that they had served the enemy in a time of war. The paintings of Willem the Younger, which earlier had the luminous quality that we associate with the late works of de Vlieger and even more with van de Cappelle, became colder and drier. The Harbor of Amsterdam (184), which he signed and dated in 1686, was based on a drawing that is now in the British Museum. It shows the "forest of masts" that filled the great port. The featured ship is in itself a naval monument, the Gouden Leeuw (Golden Lion), formerly the flagship of the great admiral Cornelis Tromp, a hero in the Dutch war for independence. Tromp had been the commander of the Dutch fleet that routed the Spanish flotilla in the Downs in the reign of Philip IV, the last attempt that the Spanish had been able to muster to challenge the Dutch rebels on the seas. Though this painting lacks the evocation of wind, weather, and dazzling light on the sea that distinguished the finest works of Willem van de Velde the Younger, it serves a function as a document of history. As such it represents one of the interests that played a part in stimulating the production of Dutch paintings in the seventeenth century, the interest in commemorating historic events and monuments.

183. Willem van de Velde the Elder, Admiral de Ruyter's Flagship, the Seven Provinces, detail from The Council of War Before the Four-Day Naval Battle, 10 June 1666.

185. Frans Post, Brazilian Landscape.

THE EXOTIC COLONIAL WORLD

Dutch leadership in building ships and in producing navigational instruments and charts was put to good use in voyages of exploration and settlement that were essential for the expansion of trade. One such expedition to Brazil, led by Prince Maurits of Nassau, lasted from 1637 to 1644. The Dutch had taken Brazil from the Portuguese in 1630 and retained control until 1654, when they were forced to return this rich and fascinating colony to Portuguese hands. Among the party accompanying Prince Maurits were scientists, who recorded their observations, and the painter Frans Post. Post was the first European to make depictions of Western Hemisphere landscapes. His drawings and paintings were doubtless even more effective than the written reports in making the Dutch people aware of this strange, distant land. Born in Leiden in about 1612, Post retained the innocent eye that is advantageous in absorbing totally new visual experiences, for which too much deference to tradition would be an impediment.

When he returned to Holland and settled in Haarlem in 1644, Post continued to paint landscapes based on his Brazilian studies. The *Brazilian Landscape* (185), signed and dated 166(8?), shows the colors of the

Landscape and Seascape

tropics, so different from northern landscape. There are intense bluegreen hills in the distance, against the glaring sky. A brilliantly colored tropical bird brightens the left foreground, and in the center a group of figures demonstrate Post's impression of the physical types and costumes of the native people. In other paintings he introduced even more prominently the unfamiliar flora and fauna of Brazil. His works remind us that artists, while playing a part in carrying Dutch culture to the far places of the earth, brought back to their own country some knowledge of remote places and different ways of life that contributed to the cosmopolitan outlook of the seventeenth-century Dutch.

11/ Architectural Subjects: Church Interiors and Town Views

CHURCH INTERIORS

MONGTHESUBJECTS that took an honored place in Dutch painting of the seventeenth century, though rare or nonexistent In art elsewhere, were realistic interior views of buildings, especially churches, and town scenes.¹ Such paintings might appear to support the idea, once widely held, that the impetus behind Dutch painting was a wish to record the visible assets of the country. Though the Dutch Republic did not become an outstanding leader in architectural design, there were highly respected architects at work there whose buildings might well have been considered worthy of recording. There were also old buildings of historic interest that might have inspired painters. Casting doubt on the assumption that it was an interest in existing buildings that lay behind these paintings, however, is the fact that the seventeenthcentury development grew out of a tradition of paintings of imagined, not real, church interiors. Fantastic church interiors, as well as courtyards and exterior views of imaginary buildings, were painted by both Dutch and Flemish artists in the early seventeenth century. Pride in existing buildings played no part in these works, which reflected a trend developed in the late Mannerist period. The seminal figure in stimulating the continued interest in purely imaginary architecture in the seventeenth century was Hans Vredeman de Vries. This Dutch painter and architect, born in Leeuwarden in 1527, designed pattern books of architecture and ornament and handbooks on perspective that were widely influential. Many artists used the illustrations in his books in composing their architectural paintings.

Architectural Subjects

Much earlier, by the first quarter of the fifteenth century, church interiors that looked plausible, though they did not depict actual buildings, had appeared in Early Netherlandish paintings. The most famous examples are early works by Jan van Eyck, whose meticulous rendering of architecture and its sculptural ornamentation gives the impression of a substantial reality. Following an existing tradition in manuscript illuminations, van Eyck invented his church interiors as appropriate backgrounds for devotional images. He introduced, by way of his architecture, details of design and figurative sculpture and even apparently naturalistic light effects that were meaningful in terms of Christian symbolism. And Jan van Eyck was by no means the only artist of his time who took the trouble to design elaborate church architecture as the setting for religious scenes. For example, the miniature depicting the Pentecost in the *Book of Hours of Catherine of Cleves*, which dates from about 1435, sets the spiritual event in the realistic apse of a Gothic church.

Architecture understood as the embodiment of number and proportion, representing the Divine Order, may have played a part in the seventeenth-century paintings of church interiors, as well as in the prototypes that preceded them by two centuries. In the later period, however, the artists omitted the religious figures, large in scale in relation to the proportions of the church interiors in which they were placed, that had been the prime subjects of the Early Netherlandish pictures. The church building itself became the theme.

A few views of the interiors of actual churches had been painted as early as the 1570s. Hendrick van Steenwijck the Elder had portrayed churches in Antwerp and Louvain and the Palatine Chapel in Aachen. But most of van Steenwijck's depictions of churches, like those by other artists of his period, were imaginary. This was in keeping with the Mannerist aesthetic, which emphasized respect for the artist's mental conception rather than observation of the real world. Church interiors unrelated to actual buildings continued to be represented well into the seventeenth century by a number of Dutch painters, including Bartholomeus van Bassen, Dirck van Delen, and Gerard Houckgeest. The spreading preference for naturalism, however, led to a dramatic shift, in this as in other types of subject matter.

Outstanding among the specialists in painting church interiors based on the close study of real buildings was Pieter Jansz. Saenredam, who was born in 1597 in Assendelft.² His father, the well-known engraver Jan Saenredam, died when Pieter was only ten years old, after which the widow moved with her child to nearby Haarlem. There Pieter was apprenticed on May 10, 1612, to Frans Pieter de Grebber. He apparently was introduced to the study of perspective by his fellow-student of painting in de Grebber's studio, Jacob van Campen, who was to become a famous architect and the designer of the great new Town Hall of Amsterdam. Remaining in de Grebber's workshop until 1622, Pieter Saenredam became a master in the following year and continued to work in Haarlem, where he died in 1665. This greatly gifted and industrious painter was a hunchback. About fifty paintings by him are known today, and almost one hundred forty drawings, which demonstrate his working methods. He would start with an accurate sketch made at the site, with measurements. When he wished to use such a sketch as the basis for a painting, sometimes many years later, he would make a construction drawing to scale, in the size of the panel to be painted. In this he introduced perspective construction. (Perspective construction is a technical device to give an illusion of depth on the two-dimensional surface; it is not derived from optical experience.)³

Saenredam drew the illustrations for the third edition, published in 1628, of the Reverend Samuel Ampzing's book *Beschrijvinge ende lof der stad Haarlem* (*Description and Praise of the Town of Haarlem*). Included were both interior and exterior views of the Church of St. Bavo. It was apparently this experience that led to his interest in church interiors as subjects for paintings. His earliest dated painting of a church interior is inscribed with the year 1628. From that time on he devoted himself to architectural subjects.

The first depiction Saenredam made of the interior of the Church of St. Bavo in Haarlem, known as the *Grote Kerk* ("Great Church"), was his pen and watercolor drawing after which Jan van de Velde made an etching to be used as an illustration in Ampzing's history of Haarlem. The drawing is inscribed: "*dit geteijckent 1627* inde grote kerck binnen Haerlem, naer t'leeven" ("this drawn in 1627 in the great church in Haarlem, from life"). A ruled line in the drawing indicates eye level, with the vanishing point in the center. The reverse is blackened for transfer to the etching plate. Saenredam habitually inscribed his drawings with dates and descriptive information, and a good many of his paintings are also signed and in some cases dated. Chronological relationships between the original sketch from life, the construction drawing, and the painting are thus made clear.

Saenredam used the drawing showing the interior of the nave and choir of St. Bavo's, viewed from west to east, for a painting (186) some years after the etching was made. In the etching, Jan van de Velde had added a preacher in the pulpit and a large congregation of figures in minute scale, which emphasized the vast spaces of the church. The painting likewise has figures that establish the scale of the building. The figures have been attributed to the architect-painter Pieter Post, with whom Saenredam is known to have worked. As was his usual practice, Saenredam altered the composition from that of the original sketch. He in-

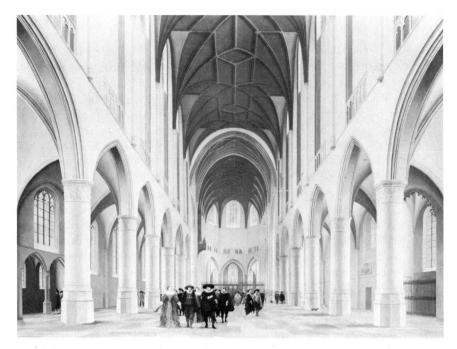

186. Pieter Saenredam, Interior of the Church of St. Bavo in Haarlem.

creased the height in relation to the width, enhancing the soaring lines of the Gothic architecture. He also increased the sense of distance from foreground to rear by exaggerating the height of the nearer columns and arches. The painting, which is signed but not dated, is thought—on stylistic grounds—to have been made in about 1635. Saenrdam made a number of paintings of the interior of the Church of St. Bavo from different viewpoints that entailed complex perspective problems. Throughout his career he took liberties with the observed architectural facts in the interests of pictorial effectiveness. He was, after all, an artist, and not simply an architectural draughtsman.

Besides his painstaking architectural studies in Haarlem, Saenredam made visits to other cities to sketch churches and other notable buildings. In 1631 he stayed for some time in 's Hertogenbosch. His drawings of Utrecht churches and town views are dated from June 1636 to January 1637. He also drew churches "from life" in Rhenen in 1644. The drawings and the paintings that followed them, sometimes after an interval of many years, show his delight in the differences between Romanesque and Gothic features and his ability to devise compositions that make the most of such distinctions. Though he was deeply interested in architectural design and structure, he was not confined to observed reality. Often he

shows more than could really be seen from any one viewpoint. He was the master, not the servant, of proportions and details of ornamentation, just as he was in command of light and color.

The Interior of the Buurkerk at Utrecht (187), signed and dated 1644, was based on a small-scale drawing made in 1636. The oldest parish church in Utrecht, the Buur (neighborhood) Church underwent the last of its many alterations in 1586, and the interior today is as Saenredam saw it. His expressive light and subtle modulations of color transfigure the observed reality. With an infinite range of off-white colors he warmed the stark interior and produced ingratiating textures.

In the distance three small figures in Oriental garb, two men and a boy, all wearing turbans, provide a human measure of the scale of the building. Emphasizing the recession of the left aisle, a man in still smaller scale walks away. A wandering dog in the middle ground is a minute horizontal form beneath the great arch of the ribbed vault. In the immediate foreground, at the right, are two boys and a dog, these surely painted by another artist. Regardless of who painted them, about which there are differences of opinion, their compositional role in leading us into the space makes it clear that they were not mere casual additions. Besides adding human interest and serving as a gauge of the size of the building, the people and dogs draw our eyes into a zigzag course that emcompasses the three-dimensional space that in a sense is the chief subject of the painting.

Moreover, the foreground group may be interpreted as participating in a didactic message. A church is a natural setting for a homily; Saenredam was not the only artist to find ways to include a silent sermon in a painting of a church interior, but he was perhaps the most ingenious. Directly above the two boys in the foreground is a painting of the tablets of the Ten Commandments surmounted by the head and shoulders of Moses. The boy teaching his dog to beg may represent obedience to law, while his companion, who is scribbling on the wall, is guilty of unruly behavior. The childlike drawing to their right is a scene from a thirteenth-century chanson de geste which tells the story of the four sons of Aymon of Dordogne, who escaped on a magic horse, Bayard, after one of them had killed Charlemagne's nephew (or, in the Dutch and German versions, his son). The story was published in Dutch in Amsterdam in 1602 and in Antwerp in 1619. Its continuing popularity is attested by images of the four sons in various media. Saenredam associated it here with his signature, which is directly beneath the drawing. Under the drawing, which is in red, is an inscription, in white, with the signature standing out in black. It reads (in English translation): "the buur church in utrecht/ thus painted in the year 1644/ by/ Pieter Saenredam." On the face of the pier to the right of the drawing there is an equally "naive" white line drawing

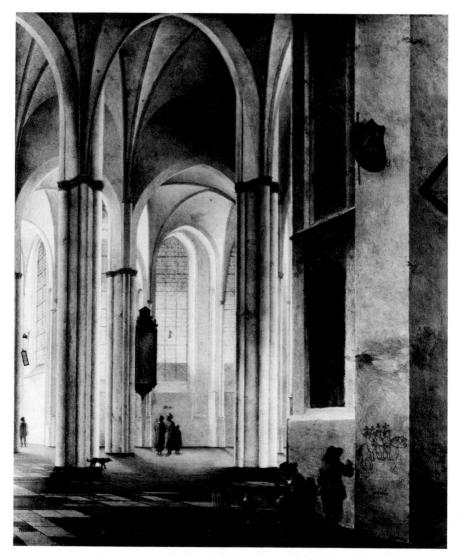

187. Pieter Saenredam, Interior of the Buurkerk at Utrecht.

of a female figure. In other paintings too Saenredam often found amusing ways to include his name as if it were a part of the scene he was painting.

Respectful as he was toward observed reality, Saenredam adapted it in his art to conform with his aesthetic judgment, his moral preoccupations, and his sense of humor. In his church interiors he pays homage to the hand and mind of man as they found expression in the house of God. The town scenes that he began to paint later in his career, in the 1650s, were equally successful combinations of elevated sentiment and human feeling, stimulated by the evident beauty of the world around him.

The painting of church interiors became a specialty of artists working in Delft, and though their connection with the works of Saenredam is not easy to establish, his example must have played a part in inspiring this development. Gerard Houckgeest, who earlier in his career painted only imaginary churches, in 1650 depicted a real church interior for the first time. Houckgeest was born in The Hague in 1600 and became a member of the guild there in 1625. Ten years later he moved to Delft, and he became a member of the Delft guild in 1639. He moved away from Delft in 1652 and lived in other towns for the remaining nine years of his life. In the brief time between his first painting of the interior of the Nieuwe Kerk in Delft, in 1650 (Hamburg, Kunsthalle), and his departure, in 1652, his interest in depicting real church interiors flowered. The Interior of the New Church in Delft (188), monogramed and dated 1651, shows a scene he painted at least four times in 1650 and 1651. The tomb of William the Silent, which is seen in the apse, was erected in 1621 after a design by Hendrick de Keyser. It became a national shrine. Houckgeest shows visitors gathered around the tomb. This could, of course, have been intended to indicate support for the House of Orange, about whom there was considerable controversy during the time of Prince William II, who died suddenly at the age of twenty-four of smallpox and was buried in the family vault beneath this tomb on March 6, 1651.

Houckgeest adhered strictly to perspective construction. He preferred diagonal compositions, in contrast to the horizontal orientation that gave Saenredam's paintings a more stable and peaceful air. Like Saenredam, Houckgeest carefully depicts stick figures drawn on the base of the foremost column, on which his interlaced monogram and the date 1651 appear. (Are we to suppose that children defaced Dutch churches with graffiti in the seventeenth century as they do the walls of American cities in the twentieth? And if this were the case, would artists have displayed these scribbles so prominently? In fact they do lend a human touch to the austere scene.) The tall, narrow format and arched top increase the lofty effect of the composition. Houckgeest's church interiors are, generally speaking, more severe than Saenredam's, with harder edges and colder color. Still, the similarities are such that it is almost inconceivable that

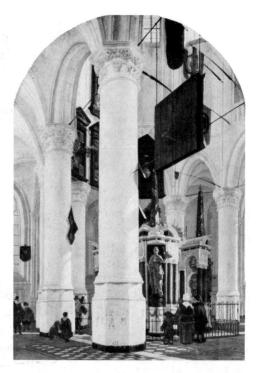

188. Gerard Houckgeest, Interior of the New Church in Delft.

Houckgeest, who earlier had painted only imaginary scenes, would have turned his attention to the interiors of real churches without the inspiration of Saenredam's works. How he came to know these works is not clear. He is not known to have visited Haarlem, and Saenredam's only known visit to Delft took place in March 1651, at which time Houckgeest had already painted architecturally accurate views of the interior of the Nieuwe Kerk.

The brilliant Emanuel de Witte also became a specialist in realistic church interiors during his period in Delft, where he lived for about a decade beginning in 1641.⁴ He became a member of the guild in Delft in 1642. His earliest dated church interior was painted in 1651 (*Interior of the Oude Kerk in Delft*, London, Wallace Collection). His earliest efforts in this field were apparently copies of compositions by Houckgeest. Though clearly influenced by both Saenredam and Houckgeest, by 1651 de Witte had found his own way with this challenging subject matter.

An accomplished painter of figures—which Saenredam and Houckgeest were not—de Witte introduced increased action and social intercourse into the church interior. Human beings play a more prominent part in both composition and meaning in his architectural paintings. His personal color scheme of white, black, and red serves splendidly in these

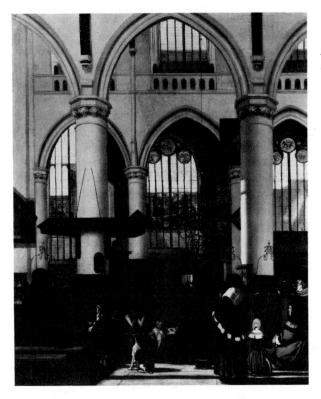

189. Emanuel de Witte, Interior of a Church During a Sermon.

pictures, with the predominantly black costumes punctuated with white accessories adding weight to the lower areas of the compositions, in which the warm colors of wooden church furniture lend a note of visual unity from the foreground to the far distance. Given de Witte's pervasive originality, it is not surprising that his church interiors themselves are usually not as strictly accurate as those of Houckgeest or even those of Saenredam, whose deviations from scrupulous rendering of the architecture were usually a matter of slightly revised proportions. Though they always look as if they could be portraits of a real church—which the fanciful Flemish and Dutch church interiors do not—de Witte's are more often than not free variations on church architecture. Sometimes elements from several churches are combined in one composition; studies of actual churches lie behind his synthetic church architecture. For de Witte, as for most Dutch painters of the seventeenth century, observed reality was only the raw material of art.

De Witte's church interiors could be categorized as representations of contemporary social life rather than as architectural subjects, for the figures are not only given compositional prominence, but they also contribute to the meaning that is intrinsic to the setting. In the *Interior of a*

Architectural Subjects

Church During a Sermon (189) all the people are intent on their devotions. Even the dog is still. The minister's hand, extended in a rhetorical gesture, is silhouetted against the lighted side of the distant column. De Witte carried even farther than Saenredam did the emphasis on the horizontal, so effective in establishing a mood of permanent stability. The strongly rendered pattern of sunshine and shadow on the floor is one of his favorite means of producing an insistent rhythm of horizontal notes. While providing a firm framework on the picture surface, at the same time this device attracts our glance into the depth of the picture space. The contrast in size between the foremost columns and arches and the distant ones bears the brunt of the responsibility for convincing us that we are looking across a considerable distance.

If it is true that architecture aspires to the condition of music, de Witte's *Interior of a Church with a Newly Dug Grave* (190) expresses that aspiration most movingly. The series of elegant brass chandeliers, typically Dutch, are like grace notes accompanying the scale of columns

190. Emanuel de Witte, Interior of a Church with a Newly Dug Grave.

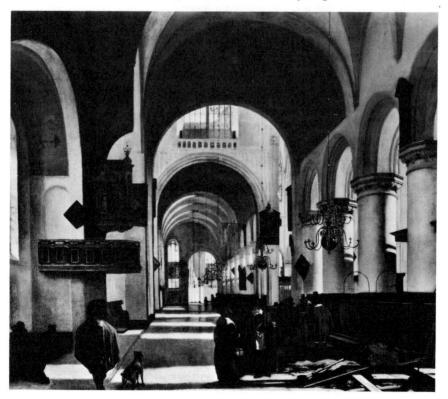

and bays that move forward in steady rhythm. The areas of alternating light and shadow on the floor are syncopations of the dominant accents. Light seems as tangible as matter and even more powerful; it is as strong at the farthest point visible as it is at the nearest. Eloquent in itself, the church is at the same time a setting for human beings and their concerns. In the immediate foreground, at the right, a skull beside an excavation introduces a minor chord into the sunlit harmony. This is the obligatory reminder of mortality, the shadowed side of the Dutch sensibility that enlivened seventeenth-century painting with frank delight in the pleasures of the senses. Perhaps such a homily, appropriate to the setting of a church, was felt to be needed as a warning against the seductive charm of the painting itself. However this may be, it is saddening to recall that de Witte, whose paintings added so much beauty to the world, was a troubled man whose life ended in suicide in 1692.

TOWN VIEWS

Like church interiors, paintings of views of towns were foreshadowed in the works of the great Early Netherlandish painters. Jan van Eyck, the Master of Flémalle (Robert Campin), and Roger van der Weyden painted street scenes with meticulous care in the backgrounds of their religious subjects in the fifteenth century. Their enchanting depictions of town life must have inspired the artists who followed two centuries later. In seventeenth-century Dutch painting, town views as independent subjects reached unprecedented heights of quality and variety. Perhaps the fact that the Dutch Republic was exceptionally urbanized had something to do with this. And the towns were indeed visually attractive. (In the eighteenth century, painters in the beautiful city of Venice became the leaders in townscape painting.)

Views of towns play a subordinate part in many Dutch landscape paintings from all periods of the seventeenth century. The town view proper, however, does not begin to appear before 1650. The earliest dated picture devoted primarily to a scene of streets and buildings in a town is the *View in Delft* (191) of 1652 by Carel Fabritius. This remarkably innovative painter lived from 1622 to 1654.

Fabritius' *View in Delft* is a strange picture that does not lend itself readily to ordinary subject matter categories.⁵ It appears to combine a street scene, at the left foreground, with a town view in eccentric perspective. The scene is identifiable. Viewed from the corner of the Oude Langendijk and Oosteinde approximately toward the northwest, the Nieuwe Kerk of Delft is in the center, with the Town Hall to the left of it in the distance and some typical Delft dwelling houses lining the street on the right in sharp recession. A large tree looms taller than the church or

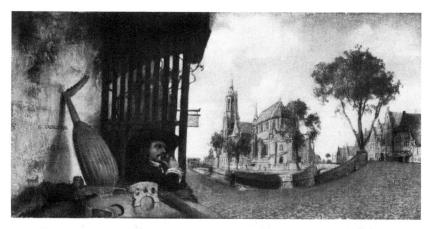

191. Carel Fabritius, A View in Delft.

the houses. In the immediate foreground at the left a viola da gamba in a dramatically foreshortened view is cut off at the bottom of the picture. Beyond it, a lute stands on the same table on which the viola da gamba rests. The lute leans against a wall and casts a strong shadow on it. Partly in this shadow, as if inscribed on the wall, is the signature C. FABRITIVS. and, below it, the date 1652. A seated man wearing a broad-brimmed black hat leans his elbow on the table. He looks preoccupied, perhaps disconsolate. A signboard bearing a picture of a swan projects beyond the vertical lattice that provides a backdrop for the seated man. The picture has been called *A View in Delft with a Musical Instrument Seller's Stall*. More to the point is the observation that has been made that in this unique composition spiritual values, represented by the church, are contrasted with sensuous pleasures, symbolized by the musical instruments. The man is caught between the temporal and the eternal.

The earliest published references to Fabritius praise him for his skill in painting perspective. This small picture, only slightly larger than six by twelve inches, is his only work known to us that gives evidence of the illusionism at which perspective experiments aimed. It has been shown that when mounted on a hemicylindrical backing in a perspective box and seen from a central peephole, the scene achieves a strikingly three-dimensional effect. Other Delft painters were also making experiments with illusionistic space in the early 1650s. Their subjects, however, were interior scenes, as in Samuel van Hoogstraten's famous *Peepshow with Views of a Dutch House*, now in the National Gallery in London. These illusionistic views were responses to the Dutch striving for naturalism in art.

Johannes Vermeer's large townscape, the renowned *View of Delft* (192), was created about ten years later than Fabritius' town view. A strip

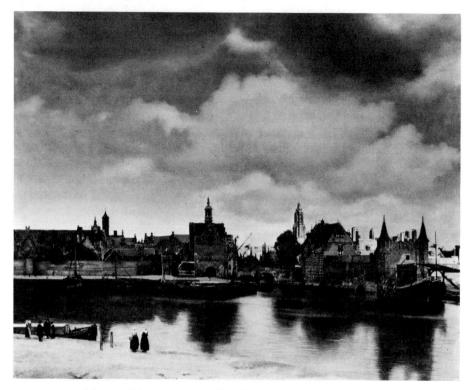

192. Johannes Vermeer, View of Delft.

of land in the foreground, with small, columnar figures grouped on it, and the broad river Schie, rich with boats and reflections, separate us from the warm-toned walls and roofs of Delft. Above, the contrasts of darkness and brilliant light in the sky parallel the alternations of light and dark on the land and water. The freshness of vision embodied in this painting have made it one of the most admired works of art in the world. Proust used it to symbolize the affective power of art,⁶ and numerous other writers have sung its praises. It has been pointed out that this composition in some ways resembles Esaias van de Velde's *View of Zierikzee* (40), painted some forty years earlier, but the differences are even more impressive than the similarities.

In the *View of Delft* Vermeer's *pointillé* works to better effect than in any of his other paintings; the thick dots of highlights add a dance of light to the entire surface, enriching the warm, vibrant colors. The buildings are clustered thickly together as seen from this viewpoint, but the picture is pervaded by air and light.

Vermeer's *Little Street in Delft* (193), which was probably painted slightly earlier than his *View of Delft*, is a scene in a residential area that

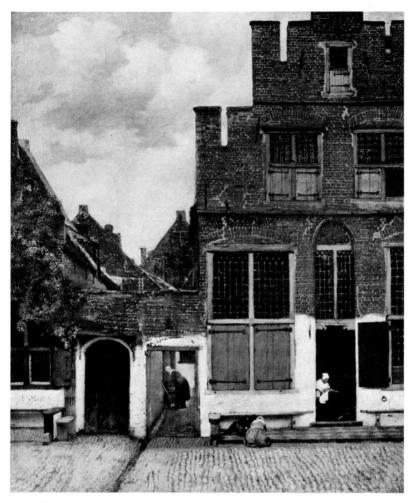

193. Johannes Vermeer, A Little Street in Delft.

includes the added human interest of the domestic tasks of women as well as children at play outside their home. Immersed in their activities, they do not notice us; the street separates them from us. Vermeer's subtle combination of intimacy and restraint enhances this unusual subject. The facades of the buildings close in the view, but our field of vision is extended by the open door, the alleyway, and the outlook over the wall to the roofline and sky beyond. The textures of the old brickwork and the cobbled street make a varied, lively surface sparkling with highlights. In both this picture and the *View of Delft* Vermeer apparently used an unreliable yellow pigment, so that his trees now look blue rather than green.⁷

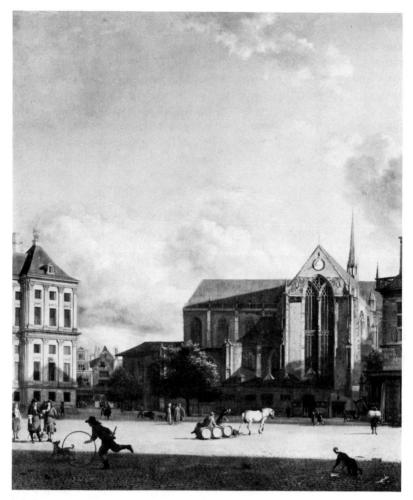

194. Jan van der Heyden, The Dam in Amsterdam.

In any case, it is the soft reds and the brilliance of the whitewashed ground-floor walls that dominate this scene.

Pieter Saenredam's earliest known painting of a town view dates from 1657. It represents *The Old Town Hall of Amsterdam* (5). This building was destroyed by fire in 1651. As the inscription on the painting states, Saenredam based it on a water color he had made in 1641. He wrote that he had worked "diligently from morning to evening for six days" on this drawing. Always an exquisite colorist, Saenredam painted the lost Gothic Town Hall with tender, loving care, to keep it intact in memory.

Jan van der Heyden, who was born in Gorinchem in 1637 and moved to Amsterdam by 1650, traveled in the southern Netherlands and the Rhineland before 1661, making drawings as he went. Mainly between 1666 and 1678, van der Heyden, who lived until 1712, painted town scenes based on his drawings. Most of them are impressions of town squares and imposing buildings on bright, clear days, with every cobblestone and architectural detail accounted for. Some are topographically accurate, while others bring together elements that actually were seen separately. *The Dam in Amsterdam* (194) shows on the right the Nieuwe Kerk, on the left the right wing of the new Town Hall. Various segments of the population are represented by the figures in the sunlit square.

Gerrit Berckheyde of Haarlem painted town views from the 1660s to 1697. Born in 1638, he became a member of the Haarlem guild in 1660 and lived until 1698. *The Market Place and the Grote Kerk at Haarlem* (195) is signed and dated 1674. Berckheyde's compositions and style are similar to those of his contemporary Jan van der Heyden, but he is less involved with the minute details and at the same time more inclined to be faithful to topography. The great church of St. Bavo dominates the square, and the Doric portico of the Town Hall is in the immediate

195. Gerrit Berckheyde, The Market Place and the Grote Kerk in Haarlem.

196. Gerrit Berckheyde, A Street in Haarlem.

foreground at the right. Typical of northern Renaissance architecture is the *vleeshal* (municipal meat market), the building on the right with the high, elaborate gable, just before the church. The part that the square plays in the social life of the town is apparent here. These compositions are perfectly in accord with the dominant stylistic trends of the monumental or structural phase of Dutch painting.

As works of art and as records, the town views of the Dutch painters represent the culture of their time with unfading vitality. Such great masters as Ruisdael (7) and Hobbema participated in this visual chronicle, alongside the specialists in this sort of subject. They pointed with particular pride to their churches and municipal buildings, always with some townspeople present to keep the human touch. They also depicted with evident affection the residential sections of their towns, with the narrow, red brick, high-gabled houses lined up along the tree-bordered canals, scenes of urban felicity still visible today in some Dutch towns much as they were in the seventeenth century. Berckheyde's *Street in Haarlem* (196), painted in about 1680, is an entrancing evocation of a quiet day on a tranquil street in Haarlem—a city whose contributions to art had been substantial—as the Golden Age of Dutch painting drew to its close.

12/ Vermeer and the Delft School

CAREL FABRITUS AND PIETER DE HOOCH

HY ONECENTER rather than another becomes the most fertile field for a new variety of painting at a given moment is one of the impenetrable mysteries of art. We can only conjecture some reasons for the surprising ascendancy of painting in the quiet, small city of Delft almost precisely in the middle of the seventeenth century. By this time Delft was in economic decline in comparison with cosmopolitan Amsterdam and the other great port city, Rotterdam. Delft lacked the intellectual distinction of the university town of Leiden, which had, besides, a thriving textile industry. Haarlem too was a prosperous textile center, where linens from Germany were bleached and finished.

Delft also had developed industries, but one of the major ones, brewing, had declined so sharply that of one hundred breweries functioning at the beginning of the seventeenth century, only fifteen were in operation by about 1670.¹ Pottery factories were established in some of the buildings formerly occupied by breweries. This industry had started by 1600 with the manufacture of simple kitchenware and modestly decorated tiles. The tiles were intended mainly to serve as baseboards facing the lower edges of walls so that water used in washing floors would not be splashed on the whitewashed walls. (Such tile borders are seen in a number of Vermeer's paintings: 206, 219, and 220.) It was considerably later in the century that the Delft pottery industry achieved fame for its elaborate tableware and ornamental pieces. From about 1670 Delft wares were in demand in the countries of western Europe and were even exported to the East Indies, but it was not until the eighteenth century that Delft pottery

Vermeer and the Delft School

reached its zenith both artistically and commercially. Tapestry weaving factories had been established in former convents in Delft as early as 1592. They provided some work for artists in designing tapestries, which were used to embellish rooms in public buildings and also as temporary decorations for festive occasions. Like the pottery trade, however, the tapestry business did not reach its heights until after the great school of Delft painting had already made its presence known.

Though economic conditions in the Delft in the middle of the century would not have provided the wealthy patronage that lured artists to Amsterdam or other more prosperous cities, the quiet serenity of the town might have had its own appeal to painters. Delft was famous for both its physical neatness and its social gentility. A visitor wrote in 1665 that "in many houses, as in the holy places of the heathens, it is not permissible to ascend the stairs or set foot in a room without first removing one's shoes."² Delft housewives were said to be "fanatically clean," and the city itself "not only the cleanest place in all Holland, but, one may rightly assume, in the whole world." The neatness, cleanliness, and decorum of Delft are reflected in paintings of the Delft school and may well have inspired the painters who worked there.

Another asset of Delft that might have attracted artists and stimulated new developments in painting was the presence there of an extraordinary painter: Carel Fabritius. Fabritius was born in 1622 in the small town of Midden-Beemster, a short distance north of Amsterdam. On the basis of Samuel van Hoogstraten's reference to him as a "fellow-pupil," it is generally accepted that he studied with Rembrandt in the early 1640s. By 1650 Fabritius had settled in Delft. He died in the devastating explosion of the powder magazine in 1654 that reduced an area of Delft to rubble, with much loss of life. Very few paintings by him survive, perhaps in part because of the brevity of his career, in part because his works may have perished along with him.

Early references to Fabritius as a painter of illusionistic murals comparable to Giulio Romano suggest the possibility that he may have come to Delft to work with Leonard Bramer (1596–1674), a Delft artist whose extensive travels had included six years in Italy. Though Bramer is known to us mainly for small, dramatically lit night scenes, he was famous in his own day for illusionistic wall paintings in fresco, for which he had important commissions. In the damp Dutch climate, almost all of these have disappeared. Nothing remains of Fabritius' mural paintings. The only surviving visual evidence of his skill in perspective painting is the condensed *View in Delft* (Fig. 191), painted in 1652, the earliest dated town view known to us.

During the short period while Fabritius was active in Delft, Houckgeest and de Witte were also working in that city, painting their realistic church interiors. A marked interest in the depiction of space in interior scenes is also evident in the paintings of two additional outstanding artists. One of them, Pieter de Hooch, was a native of Rotterdam, but his best works originated in the few years that he spent in Delft, from about 1653 to about 1662. The other was Johannes Vermeer, who spent all of his forty-three years in Delft. The degree to which the works of Carel Fabritius influenced these painters cannot be fully documented on the basis of his few known works, but it seems likely that his achievements played some part in their artistic orientation.

Time and chance have brought it about that we know Fabritius mainly not as an experimenter in the depiction of space, but through several bustlength portraits. These show remarkable stylistic independence. His Self-Portrait in Rotterdam (197) would in itself be sufficient to tempt us to recognize Fabritius as a rugged individualist. Not only is his expression intense and unguarded, but his hair is in a naturally tousled state, and his shirt is open, exposing his chest. The brusque quality of the paint surface adds to the impression of direct unpretentiousness. Nothing could have been further from the stylish artist's self-portrait of the period. Other artists generally took pains to depict themselves as gentlemen, conventionally clothed and dignified in demeanor, even in those cases in which they were depicted seated at an easel or holding the palette and brushes of their profession. While consistent with a tendency toward greater elegance in portraiture as in other subjects as the seventeenth century advanced, this reflected more specifically the concern of painters to improve their social and economic status by differentiating themselves from craftsmen.

The one great exception to the polite convention in self-portraiture was Rembrandt. In many of his earlier self-portraits he followed the fashion, posing as a well-to-do young gentleman. After 1650, he renounced such social pretense and adopted a straightforward, realistic approach in most of his images of himself, though there were still some cases of role playing in his later self-portraits. It seems certain that Fabritius would not have seen anything to compare with his defiantly informal self-portrait in Rembrandt's studio in about 1642, when he was presumably a student there. Indeed, Fabritius' only evident reliance on a work by Rembrandt is his earliest known painting, *The Raising of Lazarus*, dated 1642, now in Warsaw, which is a free adaptation of an etching of the same subject that Rembrandt had made ten years earlier. It may not be irrelevant to Fabritius' involvement with this theme to note that it was in the very year of 1642 that Rembrandt made another etching of this subject.

Fabritius' Rotterdam *Self-Portrait* is neither inscribed with a date nor documented, and dates ranging from 1645 to 1650 have been assigned to it by various scholars. On the basis of style, as well as the apparent age

197. Carel Fabritius, Self-Portrait.

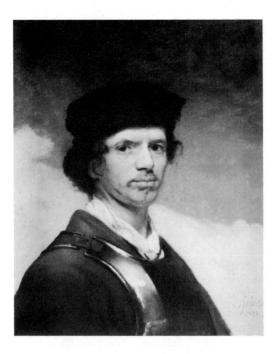

^{198.} Carel Fabritius, *Self-Portrait*, 1654.

of the artist, especially as compared with his dated Self-Portrait of 1654 (198), I consider a date of about 1650 most plausible. Though the earlier Self-Portrait is Fabritius' most Rembrandt-like painting in technique as well as in conception, it is a striking fact that it is in every way unlike Rembrandt's style of the early 1640s. At this time, broad, heavy-laden paint strokes were used by Rembrandt only in a few small, sketchlike biblical subjects. His restrained and delicate portrait style at this time was entirely different. The Fabritius Self-Portrait is in fact similar in style to Rembrandt's Titus at his Desk (106), dated 1655, the year after Fabritius died. There is the same brilliant play of light on the face, accomplished by scumbling the light flesh tones in heavy impasto over translucent darks. The rough, unmodulated edges where light meets dark are the same in both, and there are remarkable similarities in the treatment of the details of the facial features. The Fabritius Self-Portrait also markedly resembles, in color as well as style, Rembrandt's self-portraits of about 1655.³ It may be that this was one of those cases in which a great master learned something from his brilliant student.

In his *Self-Portrait* dated 1654 (198), in London, Fabritius wears a fur cap and steel gorget, a less unconventional costume (though still far from that of a fashionable gentleman); his hair is shorter, and his style of painting is smoother and more restrained. By this time he prefers a light background, which in this case he achieves by way of a vaguely skylike

backdrop. The contrast of the dark form against the light is unlike Rembrandt, who, in his most characteristic vein, preferred to draw his figures out of the darkness. (Rembrandt did, however, paint some portraits in the 1640s against a moderately light background.)

The dynamic contrast of forms seen against sunny daylight tones is even more striking in two other remarkable paintings that bear the date 1654, the last year of Fabritius' life. One of these, The Sentinel (Schwerin, Staatliches Museum), is a strange outdoor scene, with fragmentary architecture and a seated soldier who, if he is indeed on guard, as the title suggests, appears shockingly unvigilant. The Goldfinch (199), with its decisive colors, strong shadows, and background that seems to radiate light, also implies daylight illumination. As in the 1654 Self-Portrait, in The Goldfinch Fabritius boldly stated the differences between various kinds of materials. This little picture, with its vital, accurate portraval of the bird, has the effect of solid reality. It has been suggested that this is in the tradition of trompe l'oeil paintings on doors attached to the frame of a picture, which could be closed to conceal or protect the picture in the frame.⁴ The extraordinary subject of a bird chained to a perch may have emblematic meaning, possibly alluding to the idea of enslavement to love. Birds in seventeenth-century Dutch paintings frequently carry erotic significance. To modern museum visitors, it is its superb pictorial qualities that have made The Goldfinch a great favorite. There is nothing else quite like it from any period.

Carel Fabritius' originality in both conception and execution would surely have attracted the attention of other painters. His preeminence was recognized in his own day, perhaps even more so following his tragic early death. This is clear from the extensive comments devoted to Fabritius by Dirck van Bleyswijck in his *Beschryvinge der Stadt Delft*, a local history published in 1667. Could the fame of Fabritius have played a part in bringing Pieter de Hooch to Delft, for instance? De Hooch shared with Fabritius—and with his contemporary, Johannes Vermeer—an interest in problems of spatial representation and perspective, a specialty of Delft painting spearheaded by Fabritius. An uneven artist, de Hooch was at his best during his years in Delft.

The ways in which de Hooch and Vermeer may have influenced one another cannot be pinned down. The question of which of them should be credited with various innovations is complicated by the fact that few paintings by de Hooch and still fewer by Vermeer are dated. While their works share certain features, there are important differences between them. De Hooch was less interested in people and more in settings than Vermeer was; his furniture and architectural details are useful as historical documents. De Hooch frequently combined interiors with outdoor spaces, while Vermeer stressed enclosed space. Vermeer delved into the

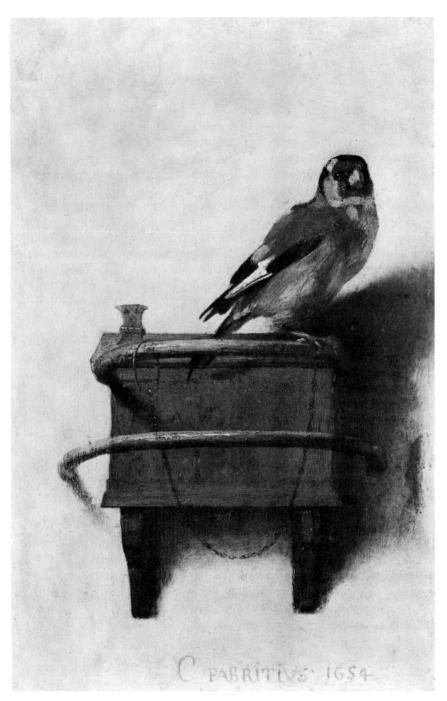

199. Carel Fabritius, The Goldfinch.

essence of things, in contrast to de Hooch's explicit and mundane approach.

Pieter de Hooch was baptized in Rotterdam in 1629 (three years earlier than Vermeer) and is said to have been a student of Nicolaes Berchem, presumably in Haarlem. In 1653 he was employed in Delft. He married there in May 1654 and became a member of the guild in the following year. Sometime between 1660 and 1663 he moved to Amsterdam, where he probably continued to live for the rest of his life, that is, until 1684 or later.

It seems that at the beginning of his career, de Hooch (who later sometimes spelled his name "Hoogh") painted barrack room scenes in a range of silvery gray tones-though of course this would have been long after the heyday of the tonal period. His earliest dated paintings are from 1658, when he was living and working in Delft. In these, space itself, specifically the architectural definition of space, is a prime concern. This is true even when the scene is set outdoors, as in Courtyard of a House in Delft (200), which is inscribed with the monogram P.D.H. and the date 1658. At first glance this might seem a commonplace snapshot of ordinary Dutch life. Indeed, in some ways it does faithfully mirror reality. The tablet above the archway, partially obscured by the vine that clings to the wall, is not an invention of the artist but a likeness of a real tablet that still exists. It was originally placed above the entrance to the Hieronymusdale Cloister in Delft. The inscription in Gothic letters reads, in English translation: "This is Saint Jerome's valley, should you wish to resort to patience and meekness, for we must first descend if we wish to be raised. 1614." (This involves a play on the words daelle, meaning "valley," and daellen, "to descend"-or, in modern orthography, dal and dalen.) This would be an appropriate epigraph not only for this painting but for many of de Hooch's works, which pay reverent tribute to the humble and patient. Mothers busy with their children or their household duties are his most sympathetic subjects. Usually, however, the human beings in his pictures are subordinate to the spatial and architectural elements.

Through the touch of their hands and their glances, the mother (or nurse?) and child in the *Courtyard of a House in Delft* express the reciprocity of their relationship. They are sheltered in an arbor between the indoor and outdoor areas of their home; this provides a dark background against which their flesh tones and costumes glow. A negative counterpart, the figure of another woman is seen through the arch, dark against light, her pose the reverse of the mother's. Her height is three-fifths that of the maternal figure at the right. This difference in scale, even more than the recession of the orthogonals (sight lines perpendicular to the picture plane), establishes the greater distance at which she is placed. Carry-

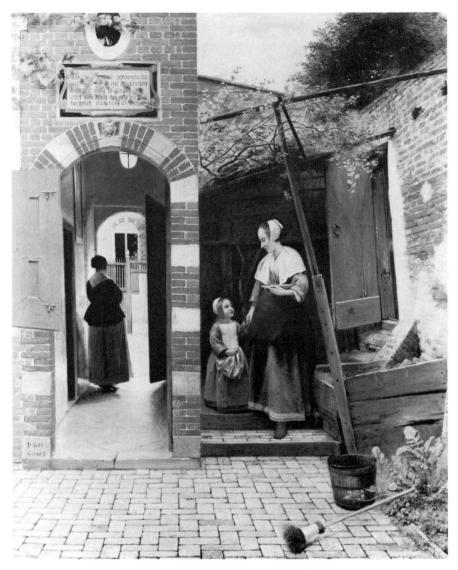

200. Pieter de Hooch, Courtyard of a House in Delft.

Vermeer and the Delft School

ing our eyes even farther with the illusion of depth of space is the red and white arch above the windows of the neighboring house, a miniature replica of the nearer arch. Seen as intermediate between these two is the gray arched opening to the sunlight at the end of the passageway. A light red shutter that overlaps the large archway boldly establishes a foreground plane. Also close to us, on the right, are a broom and pail, emblem of the superclean Delft house.

Patterns, which enrich most of the surface of the picture, also play a part in establishing spatial relations, both through the orthogonals they introduce and through differences in scale, from the neat paving stones in the foreground, to the old timbers of the bin and the weathered brick wall at the right, the brick and stone arch and brick wall with its stone tablet and oval window frame at the left, and on through the passageway to the distant picket fence and the windows beyond it. The patterns of foliage, spaced from the immediate foreground to the far distance, soften the hard architectural edges. In counterpoint to the major horizontal and vertical forms, a series of open doors make diagonal incursions, while at the same time they underline this artist's interest in the accessibility of one area of space from another, an affinity for openness that his compositions demonstrate in various ways. Perhaps related to this feeling for a space beyond is the function of the diagonal post at the right, which directs our attention to the patch of sky above the woman and child.

A Boy Bringing Pomegranates (201), which dates from 1662, again demonstrates Pieter de Hooch's fascination with rectangular forms and with the interplay of blocks of space. It presents a view from a room, across a courtyard, through a vestibule, and all the way across the canal to a house from whose doorway a woman looks out in our direction. To a greater extent even than in *The Courtyard of a House in Delft*, de Hooch relies here on calculated differences in scale more than on lines of recession to create a convincing representation of depth in space. We have seen how such methods were employed in the church interiors of Houckgeest and de Witte (188–190), both of whom worked in Delft for some years, both leaving in about 1652. De Witte's *Interior with a Woman Playing the Virginals* (144), painted at about the same time as de Hooch's *Boy Bringing Pomegranates*, shows a similar enterprise in the depiction of space.

As was often the case with de Hooch, the woman who is receiving the basket of pomegranates at the wide-open doorway is seen from behind. The boy's face is in shadow. De Hooch was apparently not very confident in painting the human face, and with reason. The faces he painted generally lack plasticity and definition, and his depictions of hands also tend to be awkward; he seems to have been more at home with less changeable aspects of the physical world. The best of his figures, how-

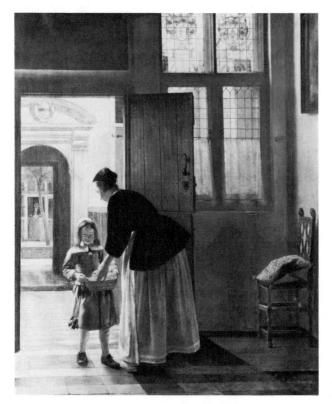

201. Pieter de Hooch, *A Boy Bringing Pomegranates*.

ever, are monumental in their simplicity. His rooms and courtyards are often occupied by women and children engaged in commonplace household activities, but not infrequently he shows groups playing cards, drinking, and otherwise behaving like the frequenters of taverns and brothels familiar to us from paintings by Dutch artists from the beginning to the end of the seventeenth century. The peace and harmony of the modest interiors de Hooch painted in his Delft years were lost in his later works, in which his overinvolvement with details of more elaborate rooms with elegant furnishings detracted from the unity.

JOHANNES VERMEER OF DELFT

The paintings of Johannes Vermeer of Delft are so highly prized today that it is almost impossible for us to understand how it could have happened that to the general public he was virtually nonexistent as an artistic personality for more than a century and a half.⁵ His name was rarely mentioned in print from the end of the seventeenth century until 1858. At that time the French critic Théophile Thoré (who wrote under the name

W. Bürger) began to bring Vermeer's paintings to public notice when he mentioned three of them in his book on the museums of Holland. Bürger-Thoré's chief work on Vermeer consisted of three articles published in 1866 in the *Gazette des Beaux-Arts* and in the same year in book form. Even in Vermeer's own time, some writers on art referred to him only in a cursory way, and others did not mention him at all. The most favorable comment appeared in verses written in Delft at the time when Carel Fabritius was "extinguished at his fame's height," but from the fire of this Phoenix "there rose Vermeer, who trod his paths with mastery."⁶

Johannes (sometimes called Jan) Vermeer was baptized in Delft on October 31, 1632. In the previous year his father had been admitted to the Delft Guild of St. Luke as an art dealer; he was also a silkworker and tavern keeper. In 1653 Johannes married Catharina Bolnes, a member of a well-to-do Catholic family; it is conjectured that Vermeer had become a Catholic. On December 29 of the same year he became a member of the guild. Nothing is known of his training. We can judge only from his paintings what his debts to other artists may have been. That he was respected among his peers is indicated by the fact that he was elected an officer of the guild in 1661–62 and in 1669–70. He died in 1675, having earned little or nothing after 1672, according to his wife's statement, because of the disruption caused by the French invasion in that year. Besides his widow, he left eleven children, eight of whom were minors. In 1672 they had moved from his parents' home, which he had inherited, to a smaller house.

How could it have come about that Vermeer dropped from sight? The fact that his known works are very limited in number may have contributed to his eclipse; only about thirty-five paintings are accepted by most scholars as autograph works by Vermeer. There were perhaps never enough of them to spread his fame widely. Not a single drawing or print exists that might have made his name known outside of Delft. Yet on August 11, 1663, a French traveler, Balthasar de Monconys, visited Vermeer's studio in Delft. He wrote in his diary that Vermeer had no pictures to show, but he did see a painting by him in a baker's shop.⁷ This painting he described as single figure, and he thought the price asked, three hundred florins, was about five times too high.

There are four paintings that everyone agrees originated early in Vermeer's career, though there are some differences of opinion about their precise order. In these four the young artist was exploring diverse possibilities of subject matter and style. One of them was a mythological subject in an outdoor setting, the second a New Testament subject, and the third a Caravaggesque procuress theme. In the fourth, a single female figure in a room setting, representing an elaborate allegory, Vermeer approached the characteristic interests of his maturity. All four of these pictures, however, had much in common with earlier and contemporary works by other painters.

Diana and her Companions (202) probably dates from about 1653, that is, from the time when Vermeer became an independent master, a member of the guild. If this assumption is correct, it would date from about a year earlier than Rembrandt's *Bathsheba* of 1654 (104). The comparison between these two paintings shows how the same motif can be used to depict a legend from classical antiquity, Diana at the bath with her nymphs, and an episode from the Old Testament, the beautiful Bathsheba, whom King David observed while she bathed and summoned to him. Rembrandt chose to depict a nude Bathsheba, and in accordance with tradition, the Diana in Vermeer's painting, and the nymphs as well, could have been nude. On the other hand, a modestly clad Diana appears in some earlier pictures of this subject and is in keeping with the chastity of the moon goddess. Vermeer's version, at the same time, indicates something of the reticence that is characteristic of him. The nymph seen from the rear is the only one who is not fully dressed, and her image is

202. Johannes Vermeer, Diana and Her Companions.

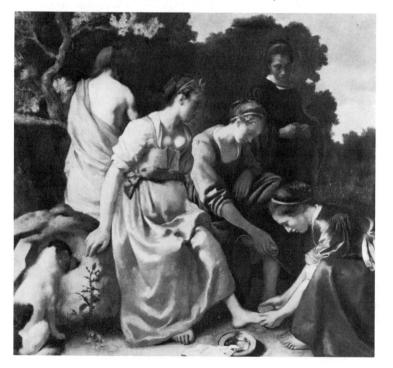

270

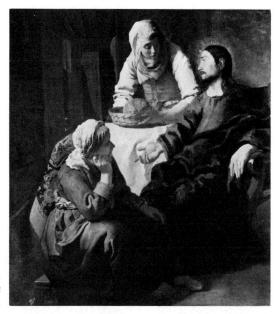

203. Johannes Vermeer, Christ in the House of Martha and Mary.

made thoroughly impersonal. Most of the faces are turned away from us, and others are in shadow, so that there is little sense of confronting individual physiognomies. The women are uncommunicative with each other as well as with us. Even the dog, associated with Diana as huntress, is turned away from us. There is neither a body of water nor a fountain, traditional indications of a scene of bathing. So discreet is the artist that the theme of the picture would not be obvious were it not for the fact that Diana is identified by the crescent moon on her diadem.

The landscape setting is unique for Vermeer in connection with a figural subject, and it seems anything but carefully observed (in part probably the result of abrasion). This is in marked contrast with the treatment Vermeer later gave actual landscape, or rather townscape, subjects (192 and 193). The composition seems more confused spatially than any other picture by Vermeer. This is one indication that it was a very early work. The figures, compactly grouped, are clad in rich, intense colors. The warmth and variety of the colors also point to his early period.

The signed painting *Christ in the House of Martha and Mary* (203) is probably next in the chronological order of Vermeer's surviving works. As in *Diana and her Companions*, the figures more or less fill the picture space, and the colors are warm and saturated. Vermeer's version of Christ's visit to the two sisters in Bethany, the active Martha and the contemplative Mary, has been shown to be related to a tradition of pictures of this subject and of other New Testament subjects. But Vermeer brought the figures together in a compact pyramidal arrangement that dif-

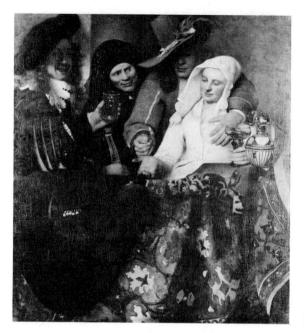

204. Johannes Vermeer, *The Procuress*.

fers from the more open compositions of the Italian and Flemish pictures in which certain parts of this motif were foreshadowed. The pose of Vermeer's Christ is the element that is closest to the proposed antecedents, but it is a motif that was in wide circulation, so that to attribute it to a particular forerunner is not possible. The restless, sinuous fold style is unique for Vermeer.

Christ in the House of Martha and Mary does show, however, that Vermeer had learned from the Utrecht Caravaggists and specifically from Terbrugghen. The compactness of the composition is something that Vermeer could very well have derived from the compositional mode that was typical of Terbrugghen. As with *Diana*, Mary's face, turned away from the light, is Terbrugghen-like in its smooth simplification. Even her striped turban recalls the Utrecht artist. Another similarity is the massive effect of the clothing.

The Procuress (204), which is signed and dated 1656, is one of the two paintings by Vermeer that have inscribed dates that seem to be authentic. This is the earlier of the two. It provides a landmark with which to relate chronologically the undated early paintings. In subject matter and composition it has much in common with paintings by Utrecht Caravaggists. The shallow space is inadequate to accommodate the crowded group of four life-size figures shown in half-length behind a table (or balustrade?) covered with a Turkish carpet, which establishes the foreground

Vermeer and the Delft School

plane. It seems possible that the man wearing black, at the left, was not a part of the composition as Vermeer originally envisaged it. It has been suggested that this figure, looking out at us with a broad smile, is a selfportrait. As no known portrait of Vermeer exists, this supposition cannot be confirmed. In several of his later works Vermeer included female figures seen in side view with head turned to meet our gaze, so the pose of the young man in black, while consistent with self-portraiture, is by no means proof of it. In keeping with the subject of the painting, this man holds a stringed instrument in his right hand and a glass filled with red wine in his left.

He and the procuress, who is also dressed in black, along with the coat thrown over the foreground carpet, comprise a dark half of the painting. In striking contrast is the right side, where a young man wearing a light red jacket offers a coin to a seated young woman wearing brilliant lemon yellow and white. The rug has a pattern of red and yellow on a neutral ground. A line of gold braid on the man's right sleeve leads our eyes to the coin in his hand. The young woman holds out her right hand to receive the money. In her left she holds a wine glass. Perched precariously beside it on the corner of the table is a jug. The young man's left hand is boldly placed on her breast. Pentimenti (indications of revisions) in that area imply that Vermeer had some difficulty in arriving at this motif. The color scheme, ruddy flesh tones, blackness in the shadows, and grainy paint surface are all reminiscent of the style of Rembrandt's pupil Nicolaes Maes.

Aside from *Christ in the House of Martha and Mary*, which has a rather summary indication of a view through a doorway, *A Young Woman Asleep* (205) is the only surviving work in which Vermeer shows an adjoining room. (There is a record in a 1696 inventory of a picture by him of "a gentleman washing his hands with a view through to another room," but we do not know whether the attribution to Vermeer was correct or what the picture looked like.) The open door next to the sleeping young woman gives a view across a corridor and into a room in which both wall and floor are strongly illuminated, so that our attention is drawn in that direction. A black-framed square mirror hangs on the light far wall, a focal point in the pattern of rectangles that provides an abstract scaffolding on which the composition is built.

This is the first appearance of Vermeer's famous light-flooded wall. Another feature that will be characteristic of Vermeer's later works is the stress on an object, in this case a chair, that is very close to the picture plane, which sets up an effect of a dramatic recession in space because the near object is so much larger in scale than the things that are seen as farther from us. This type of perspective illusion was developed by Houckgeest in his church interiors (188). Having experimented with the

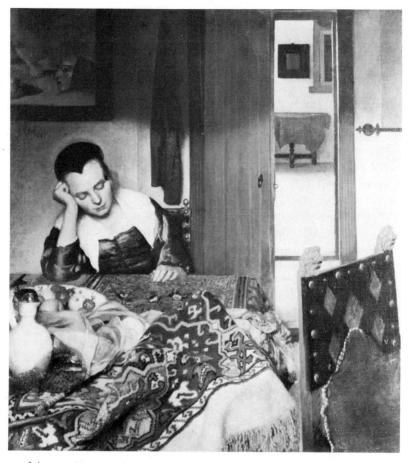

205. Johannes Vermeer, A Young Woman Asleep.

close-up view of the carpet in *The Procuress*, with its limited depth, Vermeer uses it more effectively in the *Young Woman Asleep* and many times thereafter.

The warm colors and grainy surface are again close to the style of Nicolaes Maes, and it has often been noted that there is a strong resemblance between the pose of Vermeer's young woman and figures by Maes, particularly *The Idle Servant* (131). *The Idle Servant*, dated 1655, it has been pointed out, is "the earliest known dated painting of this type with a view into a farther room," a compositional type more often associated with Pieter de Hooch.⁸ Whether lost compositions by Carel Fabritius provided the model for all three of these painters, or, if not, who was the innovator, remain unanswered questions.

A Young Woman Asleep is transitional between Vermeer's early ex-

plorations and his mature style in its subject matter and its composition a single, motionless female figure in a carefully constructed interior space. To a degree, as will increasingly be the case in the works that follow, Vermeer's composition *is* the subject. The young woman is hemmed in by table, chair, wall, and partly open door. Her golden brown satin blouse is the same one as that worn by the woman washing the feet of Vermeer's *Diana*. The chair, carpet, and still-life elements are also studio props that the artist used repeatedly. In *A Young Woman Asleep*, however, even these familiar objects are used with specific intention in relation to the meaning of the whole. The picture is in itself a moral emblem.⁹

The pose of the girl resting her head on her hand reminds us of Vermeer's Mary in Christ in the House of Martha and Mary, but there is a long iconographic tradition that elucidates the image of the woman asleep with head on hand. She represents Sloth, the vice that opens the gate to all the other vices. The objects in the still-life (defaced by abrasions and repainting), the mirror, even the cushion on the chair, are symbols of other vices. All are incorporated in an apparently ordinary household scene, as was the case with the "disguised symbolism" that enriched the religious content of Early Netherlandish paintings. What appears to be a simple reflection of everyday life is in fact a contrived composition in which every element was selected with regard to its contribution to the meaning of the picture. The painting on the wall above the young woman's head also plays its part in the meaning. It is based on an illustration in an emblem book, the Amorum Emblemata of Otho Vaenius (the teacher of Rubens), published in Antwerp in 1608, which castigates falseness and hypocrisy.¹⁰ The message of the painting is a reminder that freedom of will makes each human being responsible for avoiding the snares of sensual indulgence.

A Young Woman Asleep, sometimes called A Girl Asleep at a Table, signals a new stage in Vermeer's art, in which highly evolved content characteristic of seventeenth-century Dutch concerns is embodied in the stylistic mastery for which he was later to become famous.

His series of studies of one, two, or three figures in interior settings was interrupted at some point or points by work on the two town views, *Little Street in Delft* (193) and *View of Delft* (192). It is impossible to be certain of the dates, though it seems likely that both of these pictures were painted before 1660. The brilliant reflections of sunlight on the river in the *View of Delft* may well have been the source of Vermeer's famous *pointillé*. It has been suggested that these points of light represent the "circles of confusion" that are seen in the image in a camera obscura.¹¹ According to this theory, other features of Vermeer's style, including his wide-angle view, dramatic perspective, and extraordinary simplification

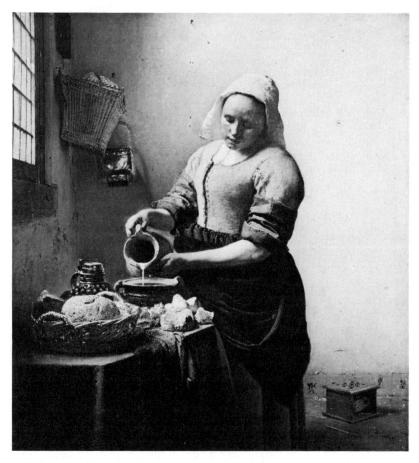

206. Johannes Vermeer, Maidservant Pouring Milk.

of forms may also be ascribed to the use of the camera obscura. While some aspects of Vermeer's style are consistent with the use of the camera obscura, others are not. The proponents of the theory explain these discrepancies by conjecturing that Vermeer saw the effects of the camera obscura, appreciated their aesthetic value, and applied them in paintings for which he did not directly use this or any other optical device. Whether Vermeer used the camera obscura remains debatable. As to the *pointillé*, it is most effective in the *View of Delft*. In some other paintings the peculiar scattering of dots of highlights in thick impasto becomes a mannerism, unrelated to optical experience, but undeniably an enrichment that enlivens the pictures. While it seems appropriate to the glistening brilliance of wind-ruffled water on a sunny day, it seems arbitrary, even

Vermeer and the Delft School

bizarre, when applied to bread or to heavy dark *vant Pouring Milk* (206).

The extravagant distribution of globular high *Pouring Milk* suggests that this is one of the ear great period of Vermeer's mature mastery. Also p is the color scheme, dominated by intense lemon against a wall that reflects an abundance of ligh devoted to the texture of the wall, with its defects or nailhole. The converging lines of window frame

to the effect of perspective recession. Most striking is Vermeer's free hand with the *pointillé*, the little points of light which are spread like sesame seeds over the surface of the bread, as well as on more plausible areas, such as the edge of the pitcher, and on materials that would be even less likely to show such highlights, such as the woman's skirt.

This painting is sometimes called The Milkmaid or simply The Servant. The room and its contents are humble; even the floor is not clean, like the floors in Vermeer's more opulent rooms. Everything in the picture is homely and useful. Even the foodstuffs, the bread and milk, speak of a different aspect of life than that implied by the exotic fruits that appear in some of Vermeer's more elegant settings. In accord with this is the substantiality of the woman, a solid, earthy figure as compared with the delicate female type usual in Vermeer's mature paintings. Such a woman, a provider of food and specifically milk, is the essence of the good mother. Subject, nevertheless, to Vermeer's fundamental reticence. she looks down, unaware of being observed, her attention focused on what she is doing, separated from us both by her attitude and by the table. It seems significant that Vermeer, father of a large family, never painted a child (except for the two tiny figures in the Little Street in Delft), unlike de Hooch and Maes, both of whom dealt warmly with the mother-child relationship.

A Woman Reading a Letter at an Open Window (207) may be considered a work close in date to the Maidservant on the basis of the similar grainy surface and warm flesh tones. That it is somewhat later than the Maidservant is suggested by advances it shows toward Vermeer's propensity for more limited and subtle color schemes and for spatial specificity, both of which characterize his fully mature works. The yellow-green of the silk curtain in the foreground blends with the color of the woman's bodice and with the predominant tones of wall and fruit. The red curtain draped over the open window picks up the main hue of the carpet, whose black and yellow-green pattern echoes the other two chief colors in the painting. Tiny blobs of pointillé highlight the texture of the carpet, the greenish-yellow bodice, and the woman's reddish-gold hair; on the fringe

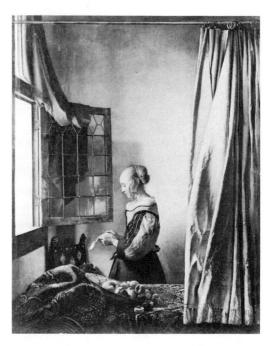

207. Johannes Vermeer, Woman Reading a Letter at an Open Window.

of the foreground curtain they might almost be mistaken for beading.

The single figure, standing still and columnar, was one of Vermeer's favorite motifs. This inaccessible woman, immersed in her reading, is further removed from us by the curtain and the table, which together form a barrier across the entire width of the picture. The curtain pushed to one side on its rod, opening the scene-temporarily, it seems-to our view, had impressive forerunners.¹² One of these was Rembrandt's Holy Family (97) of 1646. Another was Houckgeest's Interior of the Oude Kerk in Delft (Amsterdam, Rijksmuseum), dating from the 1650s. In Vermeer's picture the location and function of the curtain are ambiguous. Is it attached to the frame, so that it can cover the picture? Or is it a part of the room setting that is depicted? In either case, it contributes to the distancing that is basic to Vermeer's art. The curtain is exquisitely clear, so close to us that we can count the threads of the fringe. Thus it appears to be a part of our world, separating us from the scene beyond. Between table and wall, window and curtain, the woman is immobilized in a block of space, her head centered between top and bottom, left and right.

The fact that the woman is seen in profile also in a sense removes her from us. This is a classical mode of showing a relatively unchanging aspect of the human physiognomy. Counteracting this to some degree is the shadowy mirroring of her face in the window. The reflected image is made up of flat patches of light and dark, a forecasting, perhaps, of the direction in which Vermeer will later move, depicting form by way of unmodulated areas of light and shadow.

Women preoccupied with their domestic duties, like the industrious *Maidservant Pouring Milk*, were treated by Vermeer with sympathetic interest. His contemporaries, including Maes, de Hooch, and Metsu, among others, shared his predilection for such subjects. Vermeer, along with these other artists, also dealt with women as sexual objects, sometimes frankly, in other cases guardedly. The Dresden *Procuress* (204) of 1656 follows the outspokenly explicit tradition of scenes of prostitution popularized by the Utrecht Caravaggists earlier in the century. Before very long, he composed scenes in which the coarsely direct approach of the man in *The Procuress* was replaced by methods of persuasion.

In Officer and a Laughing Girl (208), Vermeer repeated what was to

208. Johannes Vermeer, Officer and Laughing Girl.

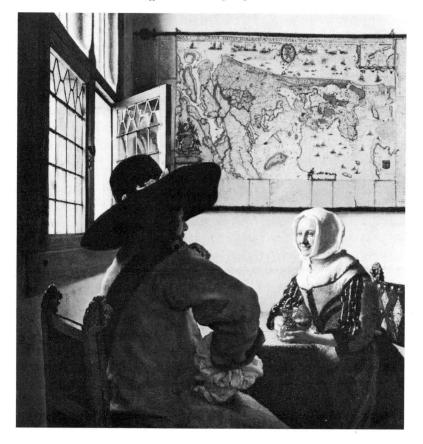

be henceforth his standard architectural setting: a room with windows in the left wall, the far wall parallel to the picture plane, and no right wall visible. In a number of pictures he includes an indication of the floor, more rarely a part of the ceiling. Again there is his characteristic use of a repoussoir, in this case the figure of the soldier, seen very close to us in the foreground, so that everything else takes its place in more distant space. Some observers have been uneasy about this aspect of Vermeer's compositions, thinking that there is something unnatural or unrealistic in these great contrasts in size between the foreground figure or object and those seen at a greater distance. Note, for instance, the difference in scale between the fingers of the soldier and those of the girl. Similarly, the lion's head finial on the girl's chair is half the height of its counterpart placed closest to the painter. It has been pointed out, however, that this in fact is the way that the objects would be related to one another if seen without preconceptions.¹³ To put it simply, if a camera were three feet from the nearest lion's head and six feet from the distant one, the image of the more distant finial would be half the size of that of the nearer one. Vermeer did not exaggerate this relationship. With modern familiarity with the camera, people began to adjust their visual perceptions to these facts of optical experience, and they found it easier to understand that Vermeer's perspective was correct in this respect. This is one of the features that has led some scholars to believe that Vermeer used an optical device, perhaps a camera obcura, that helped him to achieve his unusual objectivity.

Characteristic of Vermeer is the light wall, perhaps a legacy from Carel Fabritius. The brightness of the wall is, however, tempered by the presence of a large map that hangs on it. This is the first of Vermeer's several paintings with identifiable maps hanging on the far wall of the pictured room.14 This particular map, which also appears in two later paintings, was published in 1620. It shows Holland and West Friesland. West is at the top; at that time the convention of placing North at the top of maps had not yet been arrived at. For practical purposes such a map would have been outdated within a few years because it would have failed to show newly reclaimed land, but older maps retained their popularity as wall decorations. It is interesting that with so much evidence in Vermeer's paintings of his interest in maps and globes, no cartographic material is mentioned in the inventory made on February 29, 1676 in connection with his wife's declaration of bankruptcy. It may be that the maps and globes he depicted with such care were part of his stock as an art dealer and that they were sold before his death.

The map on the wall in the painting served a compositional purpose, providing strong horizontal elements. The pattern and color of the map may also have seemed useful to the artist as a means of breaking up what might otherwise be an overwhelmingly large, light area of wall. It is possible that he chose this rather than some other wall decoration because it had emblematic meaning. Maps can represent the idea of the whole world and all worldly things, and thus can refer to a *vanitas* theme, warning that worldly pleasures and concerns should be ignored in favor of thoughts of the eternal.

The window is open, so that the outside world is not wholly shut out, but there is no meaningful view of what lies outside the room. Vermeer's space is typically a closed-off area. Presenting a figure whose face and reaction we do not see is also characteristic of Vermeer. This note of mystery conforms with his reserved temperament. Like the forms, however, the colors are boldly revealed. The soldier wears a red coat and a big black hat, colors that add to the apparent bulk of his angular shape. The girl's skirt is dark blue, her yellow and black bodice is the same one as that worn by the Woman Reading a Letter at an Open Window, and her coif and chemise are luminous white. She holds a wine glass in her right hand and extends her left receptively. So far as the meaning of the picture is concerned, this couple are close relatives of the many Merry Company or tavern scene groups that inhabit Dutch paintings from the early versions of Buytewech to the compositions of Mieris, ter Borch, and de Hooch and other artists through the seventeenth century. Among the pictures of this type most accessible to Vermeer were probably the merrymaking groups of soldiers and women painted by the Delft artist Anthonie Palamedesz. (1601-73).

Three additional paintings by Vermeer represent situations in which a man offers wine to a woman, presumably as a prelude to seduction. These are *A Girl Interrupted at Music* (New York, Frick Collection), *A Couple with a Wine Glass* (Brunswick), and *A Girl Drinking with a Man* (Berlin). In Vermeer's pictorial world, it is generally only the women who drink wine. The role of the men is to urge them to do it. The anecdotal quality of these erotic persuasion pictures is not entirely suited to our expectations of Vermeer, which are better satisfied by the paintings in which the clues to the erotic content are more subtle. Such are *A Lady and Gentleman at the Virginals* (209), known as *The Music Lesson*, and *The Concert* (210).

In both of these superb paintings the space itself becomes a major protagonist. In each of them a table covered with a Turkish rug so intensely real that we can almost feel its texture establishes the foreground plane. Musical instruments help, by means of both their scale and their foreshortening, to convince us of the perspective recession. The figures are in the distance, near the far wall. They are contained within the block of pictorial space whose geometrical nature is stressed by a gamut of rectangular forms. Even the slightest change, one feels, would destroy the

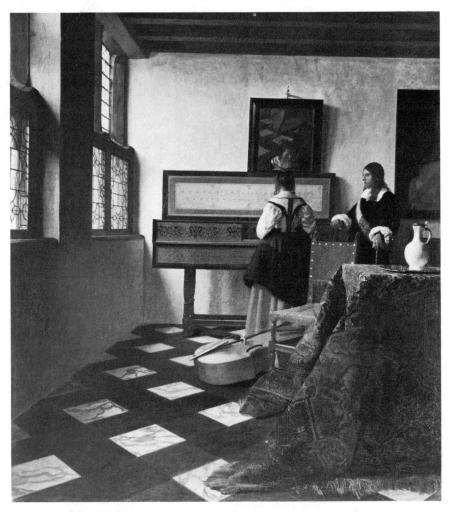

209. Johannes Vermeer, A Lady and Gentleman at the Virginals.

balance and serenity that represent an ideal of life rather than a mirroring of real existence. The perfection of these compositions is what the name Vermeer means to a legion of admirers. These paintings do not demand our attention. They quietly wait for us to discover them. Music is being made, but it emphasizes rather than disturbs the quiet. The figures are fixed in their enveloping space as a fly is fixed in amber. The flawless equilibrium of the space and the figures and objects within it creates an effect of ultimate, eternal immutability.

But these paintings are not exercises in pure form. It would be an anachronism to think of them as such. Each of them was designed, in

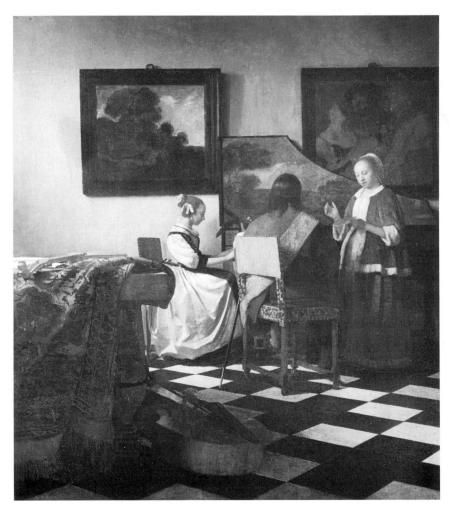

210. Johannes Vermeer, The Concert.

keeping with seventeenth-century standards, to convey a meaning. There is reason to believe that "*The Music Lesson*" represents a meeting of a different kind. Playing a musical instrument can in itself have sexual implications, and a second instrument suggests a sexual partnership, according to an iconographic tradition well understood at the time. The painting on the wall behind the man has been recognized as a depiction of "Roman Charity," a popular subject in the seventeenth century, and one that, in the context of this scene, may refer to the man as a prisoner of love.¹⁵ Like the women in some of Vermeer's other compositions, he is carefully confined in narrow space. Among his symbolic obstacles is the heavy black frame of the painting, which nudges his back. Another is the case of the virginals, on which he rests his right hand, while he holds his left hand immobile on his stick. The inscription on the lid of the elaborately decorated virginals reads: "*Musica Letitiae Comes Medicina Doloris*" ("music, the companion of pleasure, the cure of sorrow"). This could refer to the pleasures and pains of love, a subject popular with emblem writers of the period.¹⁶

Once again Vermeer resorts to a reflection to add to the spatial complexity as well as to the information communicated. The image in the mirror reveals that the woman's face is turned toward the officer. Because of its tilt, the mirror also shows some of the objects in the room and the pattern of the floor in reverse perspective. The topmost part of the reflection seems to show the legs of the painter's easel, along with a box or chest which so far has remained unidentified. The motif of the mirror reflecting the woman's face reappeared a few years later in Emanuel de Witte's *Interior with a Woman Playing the Virginals* (144), in which playing a musical instrument is similarly used as a metaphor for an erotic relationship.

The Concert (210) shows a trio rather than a duet, and in this case all three are engaged in making music. A woman, seen in profile with her face in shadow, plays the harpsichord. The central figure, an officer whose anonymity is guarded by the rear view from which he is seen, plays the lute. A woman at the right stands and sings. Her head overlaps a painting of a procuress with a man and a young woman by the Utrecht Caravaggist Dirck van Baburen (27). The placement of the singer in relation to the picture on the wall, it seems reasonable to suppose, is meaningful. There is a musical instrument on the table in the foreground, and another is on the floor beside it. These clues make it evident that an erotic arrangement binds these elegant and apparently decorous individuals.

During the decade following 1658 or thereabouts, Vermeer painted a series of glowing paintings of single female figures. A solitary person in an enclosed environment is the subject ideally suited to his temperament. Characteristically, he removes her from himself (and from us) by means of intervening objects in the foreground, usually a curtain, a chair, a table, or a combination of these. This serves to establish the three-dimensionality of the picture's space, one of his permanent artistic interests. At the same time, psychologically it provides the seclusion that he found comfortable. The woman is protected, or looking at it another way, she is imprisoned by the objects that hem her in.

A Woman with a Water Jug (211) is an excellent example of the works of this category. This expertly unified picture shows further progress in Vermeer's increasing simplification of form. The right arm is denoted by one long patch of shadow contrasted with the equally simple

211. Johannes Vermeer, Woman with a Water Jug.

area of light. The right hand hardly concerned the artist as a complex, functioning member. The left hand also is greatly simplified, and the foreshortened forearm is treated with bold assurance. The simplification of the features of the face is equally uncompromising. Vermeer is not concerned with the details of the human skeletal structure or with the infinite variations of flesh and skin, which we all know are there, but which are not evident in the purely optical experience on which he based his images. He seems to be concerned only with what is visible, ignoring the conceptual approach to the objects he depicts. This is evident in his treatment of the highly reflective jug and basin. So responsive are they to the colors that surround them that it is impossible to be sure whether the objects represented were silver or brass, though a brassy color seems to prevail. The blue-white coif, so strongly designed and colored, is evidence of Vermeer's ability to simplify even the least prepossessing forms in such a way that monumentality results.

His approach to pattern is quite different. On this he does not skimp or generalize. The rug and the map, at the near and the far extremes of the distance represented, appear as if seen with myopic eyes—or with a magnifying glass—from a viewpoint only a few inches distant from each. The same is true of the elaborate box on the table, from which a string of pearls and blue ribbons emerge. Both the Turkish rug used as a table cover and the map as a wall decoration are realistic features of a Dutch residence of the period.

Maps, which were printed from engraved plates, hand colored, and varnished (which accounts for their warm ocher color), were popular as decoration, but this does not preclude the possibility that their display also reflects pride in the historic struggle of the United Provinces or in its maritime prowess or both. In the many seventeenth-century paintings in which they appear, maps may represent any or all of these interests. The map on the wall behind the Woman with a Water Jug can be dated to before 1612 on the basis of topography; no later areas of reclaimed land (polders) appear on it. The decorative cartouches on the lower left and upper right were added later, but the geography was left unaltered, which indicates that later reissues were intended as decoration. The map in Vermeer's painting is a 1671 edition, which would appear to give a terminus post quem for the painting, with the reservation that the possibility exists that the same state was published earlier in a now unknown edition. The map shows the seventeen provinces, with north to the right. The choice of this particular map could, of course, indicate nostalgia for the days before the independence of the Dutch Republic.

Uncertainty also prevails as to whether there is a specific meaning in the woman's pose. Is there a reason why she is at this window at this moment, holding the handle of the jug and the open window? Or is this simply a general tribute to the woman devoted to her home and household tasks? The composition implies that she is fixed in this position; the precise placement of the pointed end of the map roller emphasizes this. The fact that the table is parallel to the picture plane also contributes to the effect of permanence. Human beings find horizontals and right angles comforting. They help us to have confidence that there is flat ground under our feet. The calculated repetitions of horizontals and rectangles were among Vermeer's most effective means of achieving the stability that many observers have interpreted as implying timelessness.

Also one of the "pearl paintings"—so-called for their color and luster as well as for the pearls depicted in them—is *A Woman in Blue Reading a Letter* (212). This is a reversion, in a more evolved style, to the motif of the Dresden *Woman Reading a Letter at an Open Window* (207). It is characteristic of the quiet, self-contained type of composition and predominantly blue and yellow color harmony that is associated with Vermeer in his maturity. The pearl necklace on the table is a virtual trademark of his paintings of this period. The simplification of forms is typical. Even the cool blue jacket, so effectively contrasted with the yellow-tinged wall and map, is made up of large areas of light and shadow, with minimal details. Along with the foreground table and chair, the woman's immersion in her reading contributes to her remoteness from

212. Johannes Vermeer Woman in Blue Reading a Letter.

the artist and from us. Vermeer's tact in not intruding is one of the aspects of his paintings that seems most revealing of his temperament.

Is the Woman in Blue pregnant? If she is, the singing procuress in The Concert (210) is no less so, and the same is true of the Woman with a Pearl Necklace (213) and Woman Holding Scales (Washington, National Gallery of Art). It seems possible that the effect in question may be ascribed to the kind of costume these women wear, a loose jacket projecting over a full, stiff skirt, rather than to the protuberance of pregnancy.

The Woman with a Pearl Necklace again introduces a mirror, but this time we do not see her reflection. She wears large pearl earrings and a rich yellow ermine-lined jacket, providing an ideal subject for Vermeer's wizardry in building forms with light. The woman adorning herself before a mirror is traditionally related to the theme of *vanitas*, representing the enticing natural world.

One of the very few surviving paintings by Vermeer in which the illumination comes from the right is *The Lacemaker* (214), a tiny, gleaming gem featuring Vermeer's favorite yellow and blue hues. This sitter too is absorbed in her occupation, but in this case she is engaged in a respected womanly task. Lacemaking was a major applied art of the seventeenth century. We see in paintings the part lace played in the elegant costumes of the period. Though *The Lacemaker* may thus be interpreted as simple realism, we know from emblem books that women at work spinning, embroidering, and making lace represent the virtue of domesticity, "the crown that adorns women," as a late seventeenth-century emblem book calls it.

The threads and other accessories are indicated with extreme clarity, as is the light-struck corner of the table cover, while the features of the woman's face are broadly generalized. Contrasts of this kind are among the features that distinguish Vermeer's style from that of other painters. This peculiarity is among the qualities of his paintings that have led some scholars to suspect that the use of an optical device accounts for his different way of looking. Another of Vermeer's idiosyncrasies, the *pointillé*, which has also been attributed to the use of the camera obscura, is here particularly in evidence in the carpet and the collar.

The *Head of a Girl* (215) has been called *The Pearl*, and not solely because of the magnificent pear-shaped pearl at her ear. Seen against a ground so dark that it verges on black, the bust-length figure seems to glow with an inner radiance. This modest, endearing picture epitomizes Vermeer's gift for simplification. There is no distinction between the light side of the nose and the cheek and no indication of the wing of the nostril. The shadowed part of the face joins the shadow on the neck and the dark background. There is no drawing to define the features or to

213. Johannes Vermeer, Woman with a Pearl Necklace.

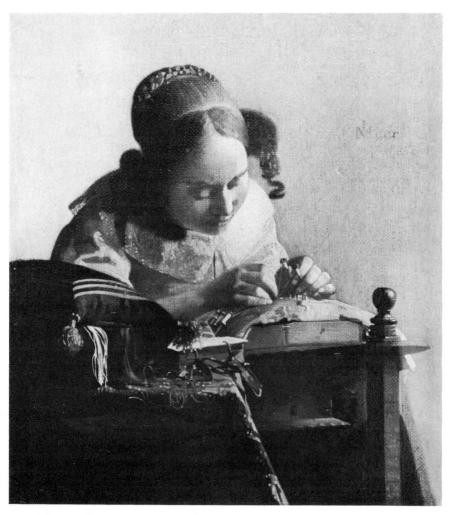

214. Johannes Vermeer, The Lacemaker.

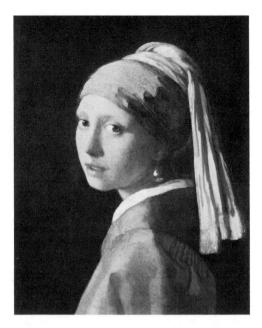

215. Johannes Vermeer, *Head of a Girl.*

delimit figure and ground. It is even more remarkable that the artist was able to proceed with such lack of concern for the differentiated features of the face in a portrait—though the unconventional costume suggests that this was not a commissioned portrait—than in other kinds of subject matter, in which the individuality of the sitter would have been less important. The young woman turns to look out at us over her shoulder, meets our gaze, smiles tentatively—and unforgettably.

In two compositions, Vermeer shows a man alone in an interior. In both cases the man is a scholar, seen at work in his study, a popular subject among seventeenth-century Dutch artists, particularly Rembrandt and his school. Both of these paintings bear dates in Roman numerals. The Astronomer (Paris, Coll. Baroness Edouard de Rothschild) is dated 1668: The Geographer (216), 1669. The inscription on The Geographer is a later addition, which may have been based on an authentic date, perhaps on a discarded frame. Though virtually the same size and related in subject matter, these two pictures are compositionally unsuited for hanging side by side, as in each case the man is shown facing the windows at the left. They could be related to the real scientific interests of the period; the instruments shown are appropriate to the fields of inquiry that are represented. They could also be emblematic of earthly contrasted with heavenly concerns. The astronomer busies himself with a celestial globe and other equipment that would be used by astronomers and astrologers, while the geographer is engaged in cartographic work. Compositional devices similar to those used by Vermeer in his other paintings remove each of these contemplative figures from us.

Another man at work figures in a more complex composition that is indubitably allegorical, *The Art of Painting* (3).¹⁷ Also known as *The Artist in his Studio*, this ambitious picture is third in size of all Vermeer's extant paintings. Only the early works, *Christ in the House of Martha and Mary* (203) and *The Procuress* (204), are larger. This masterpiece probably dates from the later 1660s. It is on record as early as 1676, the year after Vermeer died, when his widow, in a legal document, made over to her mother—as security for a loan the mother had made to Vermeer in the previous year—a painting called *De Schilderkonst* (*The Art of Painting*). There seems every reason to believe, therefore, that in this picture Vermeer intended to produce not a realistic record of a painter in his studio, but an image of an artist at work as a representative of the art of painting.

What a remarkably down-to-earth allegory it is! Compare it, for instance, with grandiloquent high baroque allegories such as Pietro da Cortona's ceiling in the Palazzo Doria-Pamphili, Rubens' Medici cycle, or even Honthorst's painting in Hampton Court. Instead of airborne creatures, Vermeer's allegory employs human figures engaged in a situation

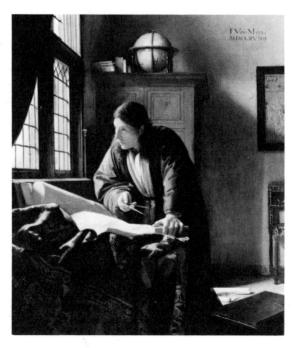

216. Johannes Vermeer, *The Geographer*.

so commonplace, in a setting so realistic, that it has usually been called simply A Painter in His Studio. In the old Netherlandish tradition of disguised symbolism, the objects in the room, which appear to be normal parts of the environment, carry symbolic meanings associated with the allegorical theme. This is a humanized allegory. The young woman who poses, crowned with a wreath of laurel leaves, holding a large book and a trumpet, represents Clio, the Muse of history. The implication is that the art of painting is worthy of fame in history. This is based on the humanistic concept of immortal fame as the reward for the record of one's deeds on earth. The classical associations in this picture are manifold. The trumpet. an attribute of Fame, is also connected with Euterpe. Muse of music and lyric poetry, and with Calliope, Muse of epic poetry. It has been pointed out that the objects on the table may be associated with the other Muses-the mask with Thalia, Muse of comedy, or Melpomene, tragedy. The mask may also represent the art of sculpture. The books may symbolize the Muse Polyhymnia or the Liberal Arts. Any or all of these associations would help to establish the status of painting as above that of the crafts, an issue with which artists had shown deep concern over a period of a century. It still remained a pressing problem in the second half of the seventeenth century.

It is interesting that the painter is not dressed in contemporary fashion; this may be a deliberate indication of timelessness. The map on the wall, which shows the seventeen provinces, may similarly indicate reverence for the historic past. The antiquity of the art of painting and its importance in classical times figured prominently in the arguments advanced by artists and others who wrote in favor of the elevation of painting to the status of a Liberal Art. Cartography itself might well represent the blend of learning and artistic skill that painters claimed as fundamental to their work. The map so conspicuously displayed on the wall is depicted with immense care for its exact appearance, including folds and cracks that testify to its age. Bordering the sides of the map are twenty panoramic views of "the most important towns and courts of the Netherlands."

It might be assumed that the canvas on the easel would give some indication of Vermeer's method of painting. Having sketched the subject, the bust of the young woman, in white on a gray ground, the artist in the picture has started at the top, painting in full color the laurel wreath that Clio wears, the symbol of eternal fame. Radiographic evidence suggests that Vermeer's method was in fact quite different. It appears that he did not start with linear outlines, but with broad areas of light and shadow. It is possible, however, that if he sketched lightly in white on a light gray ground, as in *The Art of Painting*, the underdrawing would be undetectable.¹⁸

Clio's eyes are cast down; she maintains her distance. Even the book

Vermeer and the Delft School

she clasps to her breast may be seen as protecting her from human contact. (Her delicate features have unfortunately been strengthened by later repaint.) The full extent of Vermeer's reliance on observation at this time may be seen in the bulbous, foreshortened hand of the painter, whose identity is so thoroughly masked.

The depth of space is emphasized, first of all by means of the tapestry hanging at the left. This brings us close, while at the same time establishing a boundary between the picture space and the world outside. The *repoussoir* chair in the left foreground is huge in relation to the painter in the middle ground, while he, in turn, is much larger in scale than the distant Clio. The floor pattern also helps to establish the perspective recession. After years of experimentation, Vermeer has brought to perfection his methods of space representation. At this point in his career, probably between 1668 and 1670, the highlights tend to be flattened, the *pointillé* has become unobtrusive, and the surface is smooth.

The Love Letter (217) is a small picture that is unique in compositional format. It lends itself particularly well to appreciation in purely abstract terms, and therefore it has been a great favorite in modern times. A certain dryness associates this picture with Vermeer's late style. The fact that we are outside the doorway removes us even farther from the scene than is the case with other pictures by Vermeer. In the doorway, slippers and a broom are obstacles to our approach to the room within. Letter writing and receiving were favored subjects of Vermeer and his contemporaries. In this picture it seems that the maid has delivered a letter to the seated woman, interrupting her at her music. The theme of interruption is reminiscent of the revelation scenes that were commonplace in early fiction. The sea scene hanging on the wall directly behind the two women may imply that the letter has come from a distance, perhaps from a lover far away. It has also been pointed out that the seascape might be a reference to ideas expressed in Jan Hermansz. Krul's book of love emblems, first published in Amsterdam in 1634: "Love is like a sea, a Lover like a ship . . .'' 19

Another late—and less gratifying—picture is the *Allegory of the Faith* (218), which, like *The Love Letter*, probably dates from after 1670. Less harmonious than Vermeer's best and most characteristic works, this picture is criticized particularly for the awkward and theatrical pose of the woman, whose expression and gesture seem somehow un-Dutch, more appropriate for the ecstatic saints of the Italian baroque. It appears, in fact, to be a composite of figures by the two outstanding sculptors in seventeenth-century Rome, combining the upper part of Alessandro Algardi's *St. Mary Magdalen* of about 1628 and the lower half of Gianlorenzo Bernini's *Truth*, which dates from the period between 1646 and 1652.

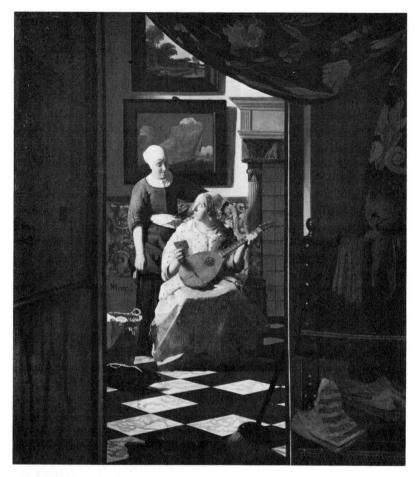

217. Johannes Vermeer, The Love Letter.

In some details, but not in all, the painting carries out the prescriptions for the representation of Faith and Catholic Faith in Dirck Pietersz. Pers's Dutch version of Ripa's *Iconologia*, which was published in Amsterdam in 1644.²⁰ The Catholic Faith should be personified by "a woman dressed in white, who holds her right hand on her breast, and in the left a chalice. . . . The hand that she holds on her breast shows that in her heart the true and living faith resides." Alternative descriptions of Faith in this book account for "the world under her feet," the crown of thorns, the book, the apple, and the snake crushed under the cornerstone. For a picture of Abraham's Offering, Vermeer substituted a painting by Jacob Jordaens of the Crucifixion, which he owned, as we learn from the inventory of his estate. Even though he took some liberties with the requirements of the subject, Vermeer apparently felt under constraint, which shows in the result. Still, there are some brilliant passages that only he could have painted. The magnificent tapestry hanging is one of them, and the crystal globe overhead is another.

Closer to Vermeer's spirit, in the artistic if not in the religious sense, are two more paintings from his final years of work, the *Lady Standing at the Virginals* (219) and the *Lady Seated at the Virginals* (220). The fashion of their costumes would place them after 1670. The painting style would confirm such a dating, especially the interest in decorative pattern such as the marblizing of the virginals and the floors and the play of light and shadow on the satin skirts, which marks Vermeer's latest works. In style, composition, and subject matter the pictures appear to be companion pieces, and they are almost precisely the same size. It appears likely, then, that they have meaning as a pair.

In each case there is a picture within the picture that demands attention both because it takes up a significant portion of the picture area and because it is physically joined with the main figure.²¹ The head of the standing lady overlaps a painting in a simple, heavy black frame, a type that was fashionable early in the century. The picture in the black frame

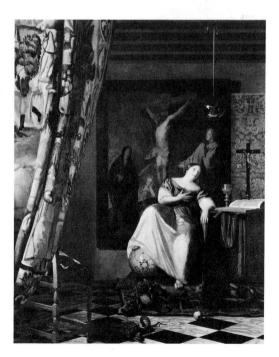

218. Johannes Vermeer, Allegory of the Faith.

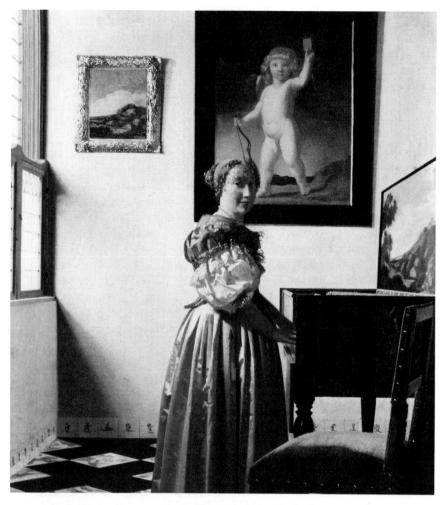

219. Johannes Vermeer, Lady Standing at the Virginals.

depicts a standing Cupid holding his bow in his right hand and with his left displaying a card. The same picture appears in *A Girl Interrupted at Music* (New York, Frick Collection), though there it is less clear. The motif has been traced to an engraving in the *Amorum Emblemata* of Otho Vaenius, first published in Antwerp in 1608, in which the card or plaque upheld by the Cupid bears the numeral I. The emblem it illustrates makes the point that a person should love only one.

On the wall behind the *Lady Seated at the Virginals*, in an elaborate gold frame, is *The Procuress* by Dirck van Baburen (27), the same painting that appears in the background of *The Concert* (210). It cannot have

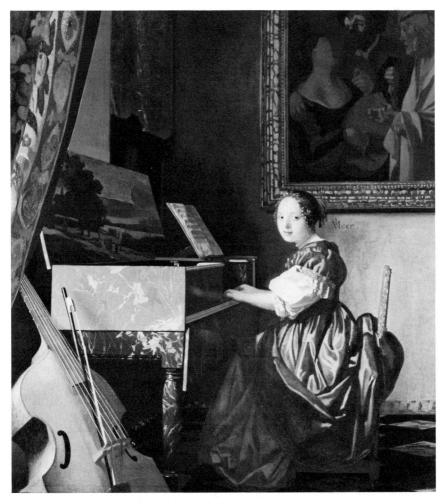

220. Johannes Vermeer, Lady Seated at the Virginals.

been by chance that Vermeer repeated these particular pictures on the walls of works separated by a considerable span of years and that he placed them in visual contact with the protagonist in each of these late paintings. The "picture within the picture" again gives a clue to the meaning of the whole, as would the illustration in an emblem. The very proper-looking young woman who is seated, playing music, is perhaps not so demure as she looks. The beautiful viola da gamba in the immediate foreground, beside her virginals, may indicate the intention of producing a duet—to be understood in the erotic sense. Perhaps together these two paintings represent the contrast between an upright woman who is

faithful to one lover, the *Lady Standing*, and a promiscuous woman, the *Lady Seated*. In both cases Vermeer managed to look into the eyes of the model, though as usual the women did not face him directly, but turned their heads, gently smiling, to meet his gaze. The color schemes harmonize, but the *Lady Seated* is darker and warmer in tone.

The didactic message does not detract from the sensuous appeal of these paintings. The irony of providing such delectable arguments against the pleasures of the senses may indeed have been an added source of enjoyment to the contemporaries of Vermeer who appreciated his paintings. To Vermeer himself the intellectual content was surely not a mere byproduct. It must have been fundamental to his conception. Since we know so little about him from documents, we can only attempt to gain some understanding of the artist's character and temperament from his works. His pictures give the impression that he felt the need for an exceptional degree of control. By means of carefully contrived designs he made things look stable and unchanging. He kept his distance from human beings, while reveling in texture, color, and the magical power of light. No visible brush stroke, no trace of the activity of the artist's hand, was permitted to break the impeccable surface of his pictures. Control of impulses toward sensuality is the leitmotif of both the moral implications and the formal characteristics of his paintings. Not the artist, but the light seems to open the space and caress the figures. The calm and stability he created responded to his inner needs.

With all his individuality, Vermeer was very much an artist of his time and place. Like his contemporaries, he did not hesitate to adapt existing modes and motifs from many sources. Along with other Dutch painters, he scrutinized the world around him and incorporated in his pictures colors, shapes, and textures experienced in the visible world. At the same time, he shared with his fellow-countrymen a profound concern for permanent values, and his works are dignified by the moral stance that permeates them. His command of space representation may be understood as a metaphor for the deeper truth with which he was preoccupied.

Epilogue The End of the Golden Age

HE END of the Golden Age of Dutch painting did not come with the suddenness of a curtain descending to mark the end of a play. It was more like the gradual dimming of the golden sunlight as dusk approaches, extending through the last quarter of the seventeenth century. There was a brilliant afterglow in the works of Aert de Gelder (133, 134), with their warm reminiscences of Rembrandt's late style, as well as some individual sparks of brilliance, such as The Avenue, Middelharnis (169), so surprisingly produced by Meindert Hobbema in 1689. There were also some estimable artists who came to maturity during this period, such as Adriaen Coorte, who painted still-lifes of consummate delicacy between 1685 and 1703, and Rachel Ruysch, a gifted painter of flowers (1664-1750). The polished academic style of Adriaen van der Werff (1659-1722), imbued with fashionable French elegance, brought favor and high prices for his portraits, scenes of social life, and religious subjects. On the whole, however, paintings made in the last decades of the century tended to be dry and derivative. The great creative surge had ended, along with the period of rapid economic expansion.

As early as 1647 the wish for baroque grandeur had moved Amalia van Solms, widow of the Stadholder Frederick Hendrick, to choose the Antwerp style of painting to decorate the Orange Room of her new country house at The Hague, the Huis ten Bosch (House in the Woods). The allegorical program, planned by Constantijn Huygens after the death of Frederick Hendrick, was executed by Jacob Jordaens and other Flemish painters, along with such Dutch artists as the stadholder's old court painter, Honthorst; Jan Lievens, who had effectively adopted the Antwerp style; and Caesar van Everdingen (1606–78), whose classicizing style qualified him for admittance to this select company. The large allegorical paintings in the new Town Hall at Amsterdam were designed by Flinck and Bol, who had abandoned the style of their teacher, Rembrandt, in favor of imitations of the international baroque style that was associated with political power. For the propaganda purposes served by these ensembles of paintings, Dutch realism was not considered appropriate.

Even before the Peace of Münster in 1648, there was evidence of French influence in literature and classical studies in the United Provinces. With the exception of painting, the Dutch had not developed fully independent culture. The French taste in fashion, literature, art, and etiquette, always prominent at the court in The Hague, spread widely through Dutch society during the last quarter of the seventeenth century. Though the French invasion of 1672 was repulsed, French style conquered the Dutch Republic. The native tradition, undervalued by the tastemakers, lost support and prestige. Reflecting French art theory, Samuel van Hoogstraten in his book published in 1678 stressed the importance of fixed rules. His judgment that only the charming and elegant are worthy subjects for painting speaks for the dominant taste of the time. In keeping with this point of view, he criticized Rembrandt's lack of taste and his choice of vulgar subjects.

The striving for a more aristocratic, elaborate style and more pretentious subjects in painting led to arid academicism. The vigor and clarity of earlier Dutch painting were lost. Small, highly finished paintings in the manner of Dou were among the pale reflections of stronger works from the earlier days that continued to be in demand through the eighteenth century and even into the nineteenth, while the general public underesteemed the accomplishments of the great artists and completely forgot some of them.

When it abandoned its intimate contact with the observed world, Dutch art lost its vitality, like Antaeus when his feet lost contact with the earth. The rich diversity of Dutch art of the Golden Age, with its profound expression of human experience, became a treasure of the past, to be rediscovered by future generations.

Notes

The Selected Bibliography that follows these notes gives full references, listed according to authors' names in alphabetical order.

Chapter 1: The Birth of a Nation (pp. 1-7)

For a reliable history of the United Provinces in English (by a Dutch historian), see Geyl.

Chapter 2: Dutch Culture and Art (pp. 8-27)

1. On Dutch life and culture in the seventeenth century, see Boxer, Haley, Huizinga, Parr, Price, Wilson, and Zumthor.

2. On emblem books, see de Jongh, Landwehr, and Praz; also Henkel and Schöne.

- 3. Mundy, p. 70.
- 4. Evelyn, p. 29.
- 5. On the painters' training and the guilds, see W. Martin, 1905-07.
- 6. On academies of art, see Pevsner.
- 7. See Barnouw and Landheer.

8. On Goltzius' drawing, see Reznicek, Cat. No. 419. On the whale's strange, earlike appendages, see Gombrich (1960), pp. 80 f.

9. Jacob Matham (1571–1631) was Goltzius' stepson and was taught by him from childhood. It is very likely that the inscription on his print had the approval of Goltzius; it may even have originated with him.

10. Satirical prints, often containing incisive political comments, were produced inexpensively and plentifully by the Dutch in the seventeenth century. Satirical pamphlets were also popular. The Dutch bent for moral teaching through satire continued the tradition established by the immensely influential *Moriae Encomium (The Praise of Folly)* by Erasmus of Rotterdam, first published in Paris in 1511 and thereafter in many editions and translations. The great forerunners in satirical painting were Hieronymus Bosch and Pieter Bruegel the Elder.

11. On The Hours of Catherine of Cleves, see Plummer.

12. On prints by and after Aertsen and Beuckelaer, see Hollstein.

13. G. fol. 85.

14. On Geertgen tot Sint Jans, see Panofsky (1953).

15. M. p. 52.

Chapter 3: Utrecht (pp. 28-43)

1. On Mannerism, see Shearman. On Dutch Mannerism, Reznicek (1963).

2. On Dutch Caravaggist painters, see A. von Schneider; also Spear.

3. On Terbrugghen, see Nicolson.

4. See Chapters 8 and 12.

Chapter 4: Haarlem (pp. 44-66)

1. Haarlem had produced outstanding artists in the sixteenth century. Drawings and prints by Maerten van Heemskerck (1498–1574) were especially influential in the seven-teenth century.

2. On the Christ Child as the source of light, see Chapter 2, figures 13 and 14.

3. G. P. Lomazzo, *Trattato dell'arte della pittura* . . . Milan, 1584. F. Zuccaro, L'Idea de' scultori, pittori e architetti . . . Turin, 1607.

4. Van Mander, pp. 364 f.

5. Stechow provides an admirable discussion of landscape painting.

6. On Buytewech, see Haverkamp-Begemann (1959).

7. On Goltzius' pupil, the interesting draughtsman Jacques de Gheyn II (1565-1629), who drew intimate genre scenes before the end of the sixteenth century, see Judson (1973).

8. On Judith Leyster, see Harris and Nochlin, pp. 137 ff.

Chapter 5: Frans Hals and the Portrait Tradition (pp. 67-88)

1. On Frans Hals, see Slive (1970-74).

2. See de Jongh and Vinken.

3. Riegl wrote the pioneering work on group portraiture.

4. Difficult to judge because it is abraded and repainted, this is the one of several known versions of the portrait of Descartes that Slive (Cat. No. 175) accepts as the original by Hals, painted probably in about 1649, shortly before Descartes left for Sweden.

5. This is confirmed by Joyce Plesters, in "The Materials and Techniques of Seventeenth Century Dutch Painting," London, National Gallery, Exhibition Catalogue, 1976, *Art in Seventeenth Century Holland*, p. 7: "Hals' most usual technique seems to be to lay in the face solidly on the light ground in a warm mid-tone, apply rather large hard-outlined patches of highlight to forehead or pink to cheeks, then finish the modelling and details of beard, hair, etc., in swift diagonal or criss-cross brush strokes like coarse hatching."

Chapter 6: Rembrandt (pp. 89-154)

1. The latest complete catalogues of Rembrandt's paintings are Gerson (1968) and Bredius (revised by Gerson, 1969); of his drawings, Benesch (2nd ed., 1973); of his etchings, White and Boon. These are all highly recommended, as is White (1969). See them for references to earlier literature.

2. In *The Stoning of St. Stephen*, it has been suggested that the face seen to the right of the man holding a stone over his head with both hands is a self-portrait by Rembrandt and that the one to the right of St. Stephen's upraised hand is a portrait of Lievens. See Bredius-Gerson, No. 531A.

3. The autobiographical notes exist in manuscript in the Royal Library in The Hague. The text was published by J. A. Worp in *Bijdragen en Mededeelingen van het Historisch Genootschap*, 18, 1897. I am indebted to Slive (1953) for the translated passages cited.

4. The painting reproduced in figures 75 and 76 is now accepted by a number of scholars as the original work by Rembrandt's hand, of which several copies are known. Its condition presents problems.

5. The legends of Protogenes, Apelles, and Parrhasius were known through the writings

of Pliny. All three were mentioned by Leon Battista Alberti in his treatise on painting written in 1435.

6. The inscription in a contemporary hand on the drawing representing his father bears marked similarity to Rembrandt's handwriting in his letters (facsimiles in Gerson, 1961). "Van de Rijn" is not his usual spelling of his name, but as he was not consistent in the spelling of his name, this would not rule out the possibility that he inscribed the drawing.

7. On Rembrandt and blindness, see Held (1969), ''Rembrandt and the Book of Tobit.''

8. On *The Anatomy Lesson of Dr. Tulp*, see Heckscher (1958). Cf. Bredius-Gerson, Br. 403.

9. On Flora, see Held (1961).

10. On Rembrandt's correspondence with Huygens, see Gerson (1961). A brief autograph note by Rembrandt concerning his *Aristotle* commission is mentioned by Held (1969, p. 21, note 69).

11. On *The Blinding of Samson*, see Kahr (1973). Old copies show that the painting was originally even larger than it is at present.

12. On Danaë, see Kahr (1978).

13. Sandrart, p. 202. English translation in Goldscheider, p. 20.

14. On Rembrandt's knowledge of Italian art, see Clark.

15. Goltzius' composition dates from thirty-seven years and Seghers' probably from almost twenty years before Rembrandt's etching.

16. On the myth that *The Night Watch* was the crux of Rembrandt's difficulties, see Held (1969), "Rembrandt: Truth and Legend."

17. Clark (pp. 85 ff.) pointed out the Raphaelesque quality of the architectural background and other features of *The Night Watch*.

18. See Haverkamp-Begemann (1973) and Kahr (1965).

19. Held (1969).

20. Maclaren read the date of A Woman Bathing in a Stream as 1655.

21. On *The Polish Rider*, see Held (1969). A different interpretation, which I find unconvincing, is that of Campbell (1970).

22. On Jacob Blessing the Sons of Joseph, see Stechow (1943) and Held (1969, p. 121, note 28).

On the question of judging whether this painting—or any other—is unfinished, we might bear in mind that Houbraken, who criticized Rembrandt for leaving works unfinished, quoted him as declaring "that a picture is completed when the master has achieved his intention by it."

23. The inventory is published in English translation in Clark, pp. 193-209.

24. See Held (1969), "Rembrandt and the Book of Tobit."

25. The agreement is published in English translation in Holt, vol. II, pp. 204 ff.

26. On the new Town Hall, see van de Waal, Fremantle, and, regarding the paintings decorating it, Blankert (1975).

27. Tacitus, Histories, Bk. IV, 13-16.

28. The Sampling Officials of the Cloth-Makers' Guild (Dutch title: De Staalmeesters) bears two dates. The "1662" on the table cover is authentic. The signature and date "1661" on the wall are not. On the meaning of the beacon, see de Jongh (1967, pp. 63 f.).

29. The Mauritshuis *Self-Portrait* of 1669 had been considered Rembrandt's last self-portrait, until a cleaning in 1966 revealed the date of 1669 inscribed on the one in the National Gallery in London, which might be the later of the two.

Chapter 7: The Rembrandt School (pp. 155-169)

1. On Lievens, see H. Schneider.

2. On the interpretation of Dou's Poulterer's Shop, see de Jongh (1968-69).

3. On Rembrandt as a teacher, see Haverkamp-Begemann (Budapest, 1973), who maintains that Rembrandt deviated from the traditional guild system of instruction. He offered life classes to large numbers of students of various ages, some of whom had already been trained as painters, and thus he could be said to have headed an "academy," in seven-teenth-century usage. See also Gerson (1969), pp. 62–70.

4. On Flinck, see Moltke. On Flinck's commission for the new Town Hall, see our pages 145-146.

5. On Bol's paintings for the Town Hall, see Blankert (1975).

6. On the motif of the lazy servant, see Kahr (1972).

7. On Aert de Gelder, see Lilienfeld.

8. Hoogstraten's book, *Inleyding* . . . , includes his theoretical outlook and practical advice on painting, with much information on art and artists.

9. On trompe l'oeil still-life, see Chapter 9, page 189 f. On perspective boxes, see Koslow.

Chapter 8: Scenes of Social Life (pp. 170-188)

1. On Brouwer: Bode (1924); also Knuttel (in English).

2. On Adriaen van Ostade: Traudtscholdt.

3. On Gerard ter Borch: Gudlaugsson. Also Exhibition Catalogue, *Gerard ter Borch:* 1617–1681, The Hague-Münster, 1975.

4. On Jan Steen: Martin (1954). Also Exhibition Catalogue, Jan Steen, Mauritshuis, The Hague, 1958–59.

5. On Emanuel de Witte: Manke.

6. On costume, see Thienen.

Chapter 9: Still-Life (pp. 189-203)

1. On Dutch still-life Bergström is basic.

2. See figure 132.

3. Panofsky (1953), Vol. I, p. 142.

4. On *Vanitas* subjects, see Exhibition Catalogue, *Ijdelheid der Ijdelheden*, Leiden, Museum De Lakenhal, 1970. Also Bergström, Chapter 4.

Chapter 10: Landscape and Seascape (pp. 204-239)

1. See Chapter 4, page 48 ff.

2. On developments in seventeenth-century Dutch landscape painting, see Stechow (1966).

3. Stechow (1966, p. 23).

4. On Jan van Goyen, see Beck (1972).

5. See Chapter 3.

Chapter 11: Architectural Subjects (pp. 240-257)

1. Jantzen is the basic study on the subject of this chapter.

2. On Saenredam, see Exhibition Catalogue, *Pieter Jansz. Saenredam*, Utrecht, Centraal Museum, 1961.

3. On perspective, see John White; also Edgerton.

4. On de Witte: Manke.

5. On Fabritius' *View in Delft*, see Wheelock (1973) and, for a different and in my opinion more convincing opinion, Liedtke (1976). Liedtke (p. 61) noted the "convention of contrast between the church and worldly vanities."

6. Marcel Proust, La Prisonnière. Paris, 1954, pp. 198 ff.

7. On Vermeer's unstable yellow: Houbraken. See also Plesters, in London, National Gallery Exhibition Catalogue, 1976.

Chapter 12: Vermeer and the Delft School (pp. 258-298)

1. On the city of Delft: Eisler.

2. Bleyswijck (1669) quoted these remarks made by a cartographer from Cologne.

304

3. Fabritius' self-portrait of 1654 may be compared, for example, with Rembrandt's self-portraits, Gerson 324 and 329.

4. Boström (p. 81) suggested The Goldfinch's original function as a door.

5. On Johannes (or Jan) Vermeer of Delft, see de Vries, Swillens, Gowing, and Blankert. Swillens made an interesting study of Vermeer's perspective and technique and published the known documents about his life. Gowing is the most perceptive writer on Vermeer; his insights about the individual qualities of Vermeer's works and observations as to their relationships to works by other artists are lastingly valuable. Blankert's book, in Dutch, is useful for the documents (compiled by Rob Ruurs) and the new information as to provenances (in the catalogue by William L. van de Watering). Blankert rejects the attribution of some paintings that other Vermeer specialists accept; he does not make his position clear in every case. Johannes Vermeer of Delft is not to be confused with the landscape painter Jan Vermeer of Haarlem (1656-1705).

6. The verses associating Vermeer with Fabritius were written by the Delft printer, Arnold Bon, and were published by him in Bleyswijck, Vol. II, p. 853.

7. Monconys, p. 149.

8. Maclaren, p. 229.

9. On *A Young Woman Asleep*, see Kahr (1972) and de Jongh (1976, pp. 145 ff.). The indications of a man's head and (perhaps) a dog that X-rays have revealed beneath the surface of the painting seem to me to be so incongruous with the existing composition in both scale and placement that they cannot have had anything to do with *A Young Woman Asleep*. Perhaps they were connected with other ideas that had been tried out on this canvas and discarded.

10. De Jongh (1967, p. 95, note 69).

11. On the question of Vermeer and the camera obscura, see Seymour, Fink, Gowing, and Wheelock (1977).

12. The painted curtain as an illusionistic device goes back to Pliny's story of Parrhasius and Zeuxis (Nat. Hist. XXXV.65).

13. On Vermeer's perspective, see Mayor; also Swillens.

14. On the maps in Vermeer's paintings, see Welu.

15. Gowing, pp. 123 f.

16. Gowing, p. 124.

17. See van Gelder (1958).

18. On Vermeer's method of painting, see Plesters, in London, National Gallery, Exhibition Catalogue, 1976.

19. De Jongh (1967, pp. 50 ff.).

20. Ripa, Iconologia, Amsterdam, 1644, pp. 147 f.

21. On the paintings on the walls, see de Jongh (1967, pp. 47 f.).

Selected Bibliography

- Ampzing, S., Beschrijvinge ende Lof der Stad Haerlem in Holland. Haarlem, 1628.
- Andrews, K., Adam Elsheimer. Oxford, 1977.
- Angel, P., Lof der Schilder-Konst. Leiden, 1642. Facsimile, Utrecht, 1969.
- Antal, F., *Classicism and Romanticism*. London, 1966. Chapter II, "The Problem of Mannerism in the Netherlands."
- Barbour, V., Capitalism in Amsterdam in the Seventeenth Century (The Johns Hopkins University Studies in Historical and Political Science, Series LXVII, No. 1). Baltimore, 1950.
- Barnouw, A. J. and B. Landheer, eds., *The Contribution of Holland to the Sciences*. New York, 1943.
- Bauch, K., *Rembrandt: Gemälde*. Berlin, 1966.
- Beck, H. U., Jan van Goyen: 1596–1656. 2 vols. Amsterdam, 1972–73.
- Benesch, O., The Drawings of Rembrandt. 6 vols. London, 1954–57; enlarged edition, 1973.
- *——, Rembrandt, A Biographical and Critical Study.* New York (1957?).
- York, 1970–73. Vol. I: Rembrandt.
- Bengtsson, A., Studies on the Rise of Realistic Landscape Painting in Holland: 1610-1625 (Figura III). Stockholm, 1952. Review by J. G. van Gelder with Bengtsson's reply, Burlington Magazine, XCV, 1953.
- Bergström, I., Dutch Still-Life Painting in the Seventeenth Century. New York, 1956.
- Bernt, W., Die niederländischen Maler des 17. Jahrhunderts. 3 vols. Munich, 1948. Vol. IV (supplement), 1962. Revised ed., 3 vols.
- Blankert, A., with R. Ruurs and W. L. van de Watering, Johannes Vermeer van Delft 1632–1675. Utrecht/Antwerp, 1975. Eng-

lish transl., Vermeer of Delft, Oxford, 1978.

- ——, Kunst als regeringszaak in Amsterdam in de 17^e eeuw: Rondom schilderijen van Ferdinand Bol, Exh. Cat. Amsterdam, Royal Palace, 1975.
- Bleyswijck, D. van, Beschryvinge der Stad Delft. Delft, 1667.
- Bloch, Vitale, Tutta la Pittura di Vermeer di Delft. Milan, 1954.
- Blunt, A., Artistic Theory in Italy, 1450–1600. Oxford, 1959.
- Bode, W. von, Adriaen Brouwer, sein Leben und seine Werke. Berlin, 1924.
- *—____, Masters of Dutch and Flemish Painting.* New York, 1967.
- Bol, L. J., The Bosschaert Dynasty. Leighon-Sea, 1960.
- Boström, K., ''De oorspronkelijke Bestemming van Carel Fabritius' Putterje,'' *Oud Holland*, LXV, 1950.
- Boxer, C. R., The Dutch Seaborne Empire 1600–1800. New York, 1965.
- Bredero, G. A., Werken, 3 vols. Amsterdam, 1921-1929.
- Bredius, A., Kunstler-Inventare: Urkunden zur Geschichte der holländischen Kunst des XVI., XVII. und XVIII. Jahrhunderts. 8 vols. The Hague, 1915–22.
- Bredius, A. (revised by H. Gerson), *Rembrandt: The Complete Edition of the Paintings*. London, 1969.
- Broulhiet, G., Meindert Hobbema. Paris, 1938.
- Brown, C., *Catel Fabritius*, Oxford and Ithaca, NY, 1981.
- Campbell, C., "Rembrandt's Polish Rider and the Prodigal Son," Journal of the Warburg and Courtauld Institutes, 33, 1970.
- Chicago, Art Institute, Exhibition Catalogue, *Rembrandt after Three Hundred Years*, 1969.
- Clark, K., Kembrandt and the Italian Ren-

aissance. New York, 1966.

- Drost, W., Adam Elsheimer als Zeichner. Stuttgart, 1957.
- Edgerton, S. Y., Jr., The Renaissance Rediscovery of Linear Perspective. New York, 1975.
- Eisler, M., Alt Delft. Kultur und Kunst. Vienna, 1923.
- Emmens, J., Rembrandt en de Regels van de Kunst. Utrecht, 1968.
- Evelyn, J., *The Diary of John Evelyn*, E. S. de Beer, ed. Oxford, 1955, 6 vols.
- Félibien, A., Entretiens sur les vies et sur les ouvrages des plus excellens peintres . . . 5 vols. Paris, 1666–85.
- Fink, D. A., "Vermeer's Use of the Camera Obscura: A Comparative Study," *Art Bulletin* 53, 1971.
- Freise, K., Pieter Lastman, sein Leben und seine Kunst. Leipzig, 1911.
- Fremantle, K., The Baroque Town Hall of Amsterdam. Utrecht, 1959.
- Friedländer, M. J., Landscape, Portrait, Still-Life; Their Origin and Development. Oxford, 1949.
- Fromentin, E., Les Maitres d'autrefois Belgique-Hollande. Paris, 1876.
- , The Masters of Past Time: Dutch and Flemish Painting from van Eyck to Rembrandt. H. Gerson, ed., intro. and notes. London, 1948.
- ——, Appraisal, M. Schapiro, Partisan Review, XVI, 1949.
- Gelder, J. G. van, *De Schilderkunst van Jan Vermeer* (with commentary by J. A. Emmens). Utrecht, 1958.
- Gelder, J. J. de, Bartholemeus van der Helst. Rotterdam, 1921.
- Gerson, H., Philips Koninck. Berlin, 1936. —, Rembrandt Paintings. New York, 1968.

Hague, 1961.

- Geyl, Pieter, *The Netherlands in the 17th Century.* 2 vols. Part I, 1609–1648, London, 1961; Part II, 1648–1715, London, 1964.
- , *Revolt of the Netherlands*. London, 1966.
- Goldscheider, L., Jan Vermeer. London, 1958. 2nd ed., 1967.
 - , Rembrandt: Paintings, Drawings, & Etchings. London, 1960. (Contains English translations of the three earliest biographies, by Sandrart, Baldinucci, and Houbraken.)
- Gombrich, E., Art and Illusion. New York, 1960.

- ——, Meditations on a Hobby Horse, London/New York, 1971.
- , "The Renaissance Theory of Art and the Rise of Landscape," in *Norm* and Form. London, 1966.
- Gowing, L, Vermeer. London, 1952. Revised ed., New York/Evanston, 1970.
- Grisebach, L., Willem Kalf, 1619–1693. Berlin, 1974.
- Gudlaugsson, S. J., The Comedians in the Work of Jan Steen and his Contemporaries. Utrecht, 1974.
- —, Gerard ter Borch. 2 vols. The Hague, 1959–60.
- Haley, K. H. D., The Dutch in the Seventeenth Century. London, 1972.
- Hall, H. van, Repertorium voor de Geschiedenis der Nederlandsche Schilder en Graveerkunst sedert het begin der 12^{de} eeuw tôt het eind van 1932. The Hague, 1935. Vol. II, 1933–1946, The Hague, 1949.
- Harris, Ann Sutherland and Linda Nochlin, Exhibition Catalogue, Los Angeles/New York, 1976. Women Artists, 1550– 1950.
- Hauser, A., The Social History of Art. 2 vols. London, 1951.
- Haverkamp-Begemann, E., Hercules Seghers. Amsterdam, 1968.
- *—____, Hercules Seghers: the Complete Etchings.* Amsterdam, 1973.
- , "Rembrandt as Teacher," in Actes du XXII^e Congress international d'histoire de l'art. Budapest, 1969: Evolution générale et développements régionaux en histoire de l'art. Budapest, 1973.
- , "Rembrandt's Night Watch and the Triumph of Mordecai," in Album Amicorum J. G. van Gelder. The Hague, 1973.
- Heckscher, W. S., Rembrandt's Anatomy of Dr. Nicholaas Tulp: An Iconological Study. New York, 1958.
- Held, J. S., "Flora, Goddess and Courtesan," in M. Meiss, ed., *De Artibus Opuscula XL: Essays in Honor of Erwin Panofsky*. Princeton, 1961.
- , Rembrandt's "Aristotle" and Other Rembrandt Studies. Princeton, 1969.
- , and D. Posner, *17th and 18th Century Art*. Englewood Cliffs, N.J. and New York, n. d.
- Henkel, A., and A. Schöne, Emblemata: Handbuch zur Sinnbildkunst des XVI.

und XVII. Jahrhunderts, Stuttgart (1967).

- Heppner, A., "The Popular Theatre of the Rederijkers in the Work of Jan Steen and his Contemporaries," *Journal of the Warburg and Courtauld Institutes*, 3, 1939–40.
- Hind, A. M., A Catalogue of Rembrandt's Etchings. New York, 1967.
- Hofstede de Groot, G., Beschreibendes und kritisches Verzeichnis der Werke der hervorragendsten holländischen Maler des XVII. Jahrhunderts. 10 vols. Stuttgart/ Paris, 1907–28. English transl., vols. 1–8. London, 1908–27.
- —, Die Urkunden über Rembrandt (1575–1721). The Hague, 1906.
- Hollstein, F. W. H., Dutch and Flemish Etchings, Engravings, and Woodcuts, ca. 1450–1700. 16 vols. Amsterdam, 1949–76.
- Holt, E. G., *A Documentary History of Art*, *Vol. 11.* Princeton, 1947 (paperback ed., Garden City, N.Y., 1958).
- Hoogewerff, G. J., *De Bentvueghels*. The Hague, 1952. (With English summary.)
- Hoogstraten, S., Inleyding tot de Hooge Schoole der Schilder Konst: anders de Zichtbaere Werelt, Rotterdam, 1678.
- Houbraken, A. De Groote Schouburgh der Nederlantsche Konstschilders en Schilderessen. 3 vols. Amsterdam, 1718–21.
 Maastricht, 1943–53, P. T. A. Swillens, ed.
- Huizinga, J., Dutch Civilization in the Seventeenth Century and Other Essays. London, 1968; New York, 1969.
- Iconographic Index, Netherlands Institute for Art History, The Hague, 1959– (Decimal Index, Art of the Low Countries, known as DIAL).
- Jantzen, H., Das niederländische Architekturbild. Leipzig, 1910.
- Jongh, E. de, "Erotica in Vogelperspectief: De dubbelzinnigheid van een reeks 17^{de} eeuwse genrevoorstellungen," *Simiolus*, III, 1968–9.
- —, "Pearls of Virtue and Pearls of Vice," Simiolus, 8, 1975/6.
- —, *Tot Lering en Vermaak*, exh. cat., Rijksmuseum, Amsterdam, 1976.
- , Zinne- en minnebeelden in de schilderkunst van de zeventiende eeuw (in the series: Nederlands en Belgisch kunstbezit uit openbare verzamelingen), 1967.
- , and P. J. Vinken, "Frans Hals als Voortzetter van een emblematische Tra-

ditie," Oud Holland, LXXVI, 1961.

- Judson, J. R., *The Drawings of Jacob de Gheyn II*. New York, 1973.
- *Gerrit van Honthorst.* The Hague, 1959. (Deals with works through the 1620s only.)
- Kahr, M. M., "A Rembrandt Problem: Haman or Uriah?" Journal of the Warburg and Courtauld Institutes, 28, 1965. ——, "Danaë," Art Bulletin, 60, 1978.
- —, "Rembrandt and Delilah," Art Bulletin, 55, 1973.
- —, "Rembrandt's Esther," Oud Holland, 81, 1966.
-, "Vermeer's Girl Asleep: A Moral Emblem," Metropolitan Museum of Art Journal, 6, 1972.
- Kirschenbaum, B., The Religious and Historical Paintings of Jan Steen. New York, 1977.
- Knipping, J. B., De Iconographie van de Contra-Reformatie in de Nederlanden. 2 vols. Hilversum, 1939–40. Reprinted Nieuwkoop, 1974.
- Knuttel, G., Adriaen Brouwer: The Master and his Work. The Hague, 1962.
- Koslow, S., "De wonderlijke Perspectiefkast: An Aspect of Seventeenth-Century Dutch Painting," Oud Holland, 82, 1967.
- Kuznetzov, J. I., Rembrandt's Danaë: The Riddle of its Creation (Russian text). Leningrad, 1970. Also published in Oud Holland, 82, 1967, as "Nieuws over Rembrandt's Danaë."
- Landwehr, J., Emblem Books in the Low Countries 1554–1949. Utrecht, 1970.
- Liedtke, W. A., "The View in Delft by Carel Fabritius," Burlington Magazine, CXVIII, 1976.
- Lilienfeld, K., Arent de Gelder. The Hague, 1914.
- Loewinson-Lessing, V., ed., Rembrandt Harmensz. van Rijn, Paintings from Soviet Museums, Leningrad, 1971.
- London, National Gallery, Exhibition Cat., Art in Seventeenth Century Holland, 1976.
- Maclaren, N., The Dutch School, National Gallery Catalogues. London, 1960.
- Mander, K. van, Het Schilder-Boeck . . . Haarlem, 1604. 2nd ed., 1618. Partial and not wholly accurate English translation by C. van de Wall, Dutch and Flemish Painters. New York, 1936, reprinted New York, 1969. French ed., Le Livre de Peinture, Paris, 1965.

- Manke, I., *Emanuel de Witte 1617–1692*. Amsterdam, 1963.
- Martin, W., De Hollandsche Schilderkunst in de 17^{de} Eeuw. 2 vols. Amsterdam, 1936.
 - , "The Life of a Dutch Artist in the Seventeenth Century," *Burlington Magazine* VII, 1905; VIII, 1905–6; X, 1906–7.

—, Jan Steen. Amsterdam, 1954.

- Mayer-Meintschel, A., "Rembrandt und Saskia im Gleichnis vom vorlorenen Sohn," *Staatl. Kunstsamml. Dresden Jb.*, 1970-71.
- Mayor, A. H., *The Photographic Eye, Bulletin*, Metropolitan Museum of Art, 1946.
- Mirimonde, A. P. de, "Les sujets musicaux chez Vermeer de Delft," Gazette des Beaux-Arts, Series 6, 57, 1961.
- Möhle, H., Die Zeichnungen Adam Elsheimers. Berlin, 1966.
- Moltke, J. W. von, *Govaert Flinck*. Amsterdam, 1965.
- Monconys, B. de, Journal des voyages. 3 vols. Lyon, 1665–6.
- Mundy, P., *The Travels of Peter Mundy in Europe and Asia, 1608–1667, Vol. IV:* Travels in Europe, 1639–1647. Issued by the Hakluyt Society, Second Series, No. LV. Cambridge, 1924, Richard Carnac Temple, ed.
- Münz, L., A Critical Catalogue of Rembrandt's Etchings. 2 vols. London, 1952.
- Netherlands Institute for Art History, *Bibliography*. The Hague, 1943-.
- Neurdenberg, E., "Judith Leyster," Oud Holland, XLVI, 1929.
- Nicolson, B., Hendrick Terbrugghen. London, 1958.
- -----, "Second Thoughts about Terbrugghen," Burlington Magazine, CII, 1960.
- Orlers, J. J., Beschryvinge der Stad Leyden. Leiden, 1642.
- Panofsky, E., Early Netherlandish Painting. 2 vols. Cambridge, Mass., 1953.
- Parr, C. McK., Jan van Linschoten: The Dutch Marco Polo. New York, 1964.
- Pevsner, N., Academies of Art, Past and Present. Cambridge, 1940.
- Pigler, A., Barockthemem. Eine Auswahl von Verzeichnissen zur Ikonographie des 17. und 18. Jahrhunderts. 2 vols. Budapest, 1956.
- Piles, R. de, *Abrégé de la vie des peintres*. Paris, 1699.

- Plummer, J., The Hours of Catherine of Cleves. New York [1966].
- Praz, M., Studies in Seventeenth Century Imagery (Studies of the Warburg Institute, III). 2 vols. London, 1939–47. Revised and enlarged ed. 1 vol. Rome, 1964.
- Preston, L., Sea and River Painters of the Netherlands in the Seventeenth Century. Oxford, 1937.
- Price, J. L., Culture and Society in the Dutch Republic During The Seventeenth Century. London, 1974.
- Reiss, S., Aelbert Cuyp. New York/Boston, 1975.
- Rembrandt After Three Hundred Years: A Symposium—Rembrandt and his Followers. Chicago, 1973.
- Rembrandt after Three Hundred Years, Exhibition Catalogue, 1969, Chicago Art Institute.
- Rembrandt: Experimental Etcher, Exhibition Catalogue, 1969. Boston, Museum of Fine Arts and New York, Pierpont Morgan Library.
- Reznicek, E. K. J., Die Zeichnungen von Hendrick Goltzius. 2 vols. Utrecht, 1961.
- —, "Realism as a 'Side Road or Byway' in Dutch Art," Studies in Western Art, Acts of the Twentieth International Congress of the History of Art, II. Princeton, 1963.
- Riegl, A., Das holländische Gruppenporträt (first published 1902). Reprinted, 2 vols. Vienna, 1931.
- Ripa, Cesare, *Iconologia*. Rome, 1593. First illustrated ed., 1611. Dutch version published by Dirck Pietersz. Pers. Amsterdam, 1644.
- Robinson, F. W., *Gabriel Metsu* (1629–1667). New York, 1974.
- Roethlisberger, M., Bartholomäus Breenbergh, Handzeichnungen. Berlin, 1969.
- —, Bartholomeus Breenbergh, The Paintings. Berlin, 1980.
- Rosenberg, J., *Rembrandt*, *Life and Work*. London, 1964.
- _____, S. Slive, and E. H. ter Kuile, Dutch Art and Architecture 1600–1800 Harmondsworth (Pelican History of Art), 1972.
- Rotermund, H. M., *Rembrandt's Drawings* and Etchings for the Bible. Philadelphia, 1969.
- Rowlands, J., Hercules Segers. London, 1979.
- Sandrart, J. von, Teutsche Academie.

Nuremberg, 1675–9. Munich, 1925, A. R. Peltzer, ed.

- Scheller, R. W., "Rembrandt en de encyclopedische verzameling," Oud Holland, LXXXIV, 1969.
- Schneider, A. von, Caravaggio und die Niederländer, Marburg-Lahn, 1933. Reprinted Amsterdam, 1967.
- Schneider, H., Jan Lievens, sein Leben und seine Werke. Haarlem, 1932. Reprinted with supplement by R. E. O. Ekkart. Amsterdam, 1973.
 Seymour, C., Jr., "Dark Chamber and
- Seymour, C., Jr., "Dark Chamber and Light-Filled Room: Vermeer and the Camera Obscura," Art Bulletin, 46, 1964.
- Shearman, J., Mannerism. Harmondsworth/Baltimore, 1967.
- Simson, A. von, and J. Kelch, eds., *Neue Beiträge* zur *Rembrandt-Forschung*, Berlin, 1973.
- Slatkes, L. J., *Dirck van Baburen*. Utrecht, 1962.
- Slive, S., Drawings of Rembrandt. 2 vols. New York, 1965.
- , Frans Hals. 3 vols. London/N.Y., 1970-4.
- , "Notes on the Relationship of Protestantism to Seventeenth Century Dutch Painting," Art Quarterly, XIX, 1956.
- ------, "Realism and Symbolism in Seventeenth Century Dutch Painting," Daedalus, 1962.
- *——, Rembrandt and his Critics:* 1600–1730. The Hague, 1953.
- Smith, J., A Catalogue Raisonné of the Works of the Most Eminent Dutch, Flemish and French Painters. 9 vols., London, 1829-42.
- Spear, R., Caravaggio and his Followers. Cleveland, Ohio, 1971.
- Stechow, W., Dutch Landscape Painting in the Seventeenth Century. London, 1966.
- Sterling, C., Still-Life Painting from Antiquity to the Present Time. Paris/New York, 1959.
- Sutton, P., Pieter de Hooch. Oxford, 1980.
- Swillens, P. T. A., Johannes Vermeer. Utrecht, 1950.
- dam, 1935.

- Thienen, F. van, Das Kostüm der Blütezeit Hollands: 1600-1660. Berlin, 1930.
- Timmers, J. J. M., A History of Dutch Life and Art. London, 1959.
- Trautscholdt, E., "Notes on Adriaen van Ostade," Burlington Magazine, LIV, 1929.
- Utrecht, Centraal Museum. Exhibition Catalogue, 1961, Pieter Jansz. Saenredam.
- Valentiner, W. R., Nicolaes Maes. Berlin/Leipzig, 1924.
- Vassar College Art Gallery, Poughkeepsie, New York, Exhibition Catalogue, 1970, *Dutch Mannerism: Apogee and Epilogue*, with introduction by W. Stechow.
- Visser 't Hooft, W. A., Rembrandt and the Gospel. New York, 1960.
- Vries, A. B. de, Jan Vermeer van Delft, English ed. London/New York, 1948.
- Waal, H. van de, Drie Eeuwen vaderlandsche Geschieduitbeelding, 1500– 1800, een iconologische Studie. 2 vols. The Hague, 1952.
- Wagner, H., Jan van der Heyden: 1637-1712. Amsterdam/Haarlem, 1971.
- Welu, James A., "Vermeer: His Cartographic Sources," Art Bulletin 57, 1975.
- Wheelock, A. K., Jr., "Carel Fabritius: Perspective and Optics in Delft," Nederlands Kunsthistorisch Jaarboek, XXIV, 1973.
- —, "Zur Technik zweier Bilder, die Vermeer zugeschrieben sind," Maltechnik, 1978.
- White, C., *Rembrandt and his World*. London, 1966.
- ——, *Rembrandt as an Etcher*. 2 vols. London, 1969.
- ——, and K. G. Boon, *Rembrandt's* Etchings. 2 vols. Amsterdam, 1969.
- White, J., The Birth and Rebirth of Pictorial Space. London, 1957.
- Wilson, C., The Dutch Republic. New York, 1968.
- Wurzbach, A. von, Niederländisches Künstler-Lexikon. 3 vols. Vienna/Leipzig, 1906–11. Reprinted in 2 vols., Amsterdam, 1968.
- Zumthor, P., Daily Life in Rembrandt's Holland. London, 1962.

List of Illustrations

Dimensions are given in centimeters, height precedes width. Dates are given only in those cases in which exact dates are known.

- Gerard ter Borch, The Swearing of the Oath of Ratification of the Treaty of Münster, May 15, 1648. London, National Gallery. Oil on copper, 45.4 x 58.5 cm.
- Adriaen van Ostade, A Painter's Studio. Amsterdam, Rijksmuseum. Oil on oak panel, 36 x 35 cm.
- Johannes Vermeer, The Art of Painting. Vienna, Kunsthistorisches Museum. Oil on canvas, 130 x 110 cm.
- Jacob Matham, engraving after Hendrick Goltzius, *The Beached Whale*, 1598. Amsterdam, Rijksprentenkabinet, 31.6 x 42.5 cm.
- Pieter Saenredam, The Old Town Hall of Amsterdam, 1657. Amsterdam, Rijksmuseum. Oil on oak panel, 64.5 x 83 cm.
- 6. Rembrandt, drawing, The Ruins of the Old Town Hall of Amsterdam. Amsterdam, Rembrandthuis. Pen and wash, 15 x 20.1 cm. Inscribed by the artist: "The City Hall of Amsterdam after the conflagration of 9 July, 1652, seen from the Weighing-House."
- Jacob van Ruisdael, *The Quay at Amsterdam*. New York, Frick Collection. Oil on canvas, 51.7 x 65.7 cm.
- Emanuel de Witte, Interior Court of the Amsterdam Exchange, 1653. Rotterdam, Boymans-van Beuningen Museum, Willem van der Vorm Collection. Oil on canvas, 49 x 47.5 cm.
- 9. Frans Hals, Portrait of Descartes. Copenhagen, Statens Museum for Kunst, on loan

from Ny Carlsberg Glyptothek. Oil on panel, 19 x 14 cm.

- Hours of Catherine of Cleves, St. Ambrose with mussel and crab border (Ms. M.917, p. 244). New York, Pierpont Morgan Library.
- 11. Emanuel de Witte, Adriana van Heusden and her Daughter at the New Fish Market in Amsterdam. London, National Gallery. Oil on canvas, 57.1 x 64.1 cm.
- Hours of Catherine of Cleves, The Holy Family at Supper (Ms. M.917, p. 151). New York, Pierpont Morgan Library.
- Geertgen tot Sint Jans, The Nativity at Night. London, National Gallery. Oil on panel, 34 x 25 cm.
- Gerrit van Honthorst, Adoration of the Shepherds. Florence, Uffizi. Oil on canvas, 235 x 195 cm.
- Rembrandt, The Presentation of Jesus in the Temple, 1631. The Hague, Mauritshuis. Oil on panel, 61 x 48.
- Joachim Wttewael, Diana and Actaeon. 1607. Vienna, Kunsthistorisches Museum. Oil on panel, 58 x 79 cm.
- Abraham Bloemaert, Preaching of John the Baptist. Amsterdam, Rijksmuseum. Oil on canvas, 139 x 188 cm.
- Abraham Bloemaert, Flute Player, 1621. Utrecht, Centraalmuseum. Oil on canvas, 69 x 57.5 cm.
- Caravaggio, *The Calling of St. Matthew*. Rome, San Luigi dei Francesi, Contarelli Chapel. Oil on canvas, 338 x 348 cm.

- Hendrick Terbrugghen, The Calling of St. Matthew, 1621. Utrecht, Centraalmuseum. Oil on canvas, 102 x 137.5 cm.
- 21. Hendrick Terbrugghen, *Shepherd Playing a Recorder*. Cassel, Staatliche Kunstsammlungen. Oil on canvas, 70 x 75 cm.
- 22. Hendrick Terbrugghen, *Liberation of St. Peter*. The Hague, Mauritshuis. Oil on canvas, 105 x 85 cm.
- 23. Hendrick Terbrugghen, St. Sebastian Attended by St. Irene, 1625. Oberlin, Ohio, Allen Art Museum, Oberlin College. Oil on canvas, 149.5 x 120 cm.
- Gerrit van Honthorst, Christ Before the High Priest. London, National Gallery. Oil on canvas, 272 x 183 cm.
- 25. Gerrit van Honthorst, *Samson and Delilah*. Cleveland, Museum of Art. Oil on canvas, 125.4 x 94 cm.
- 26. Gerrit van Honthorst, *The Procuress*, 1625. Utrecht, Centraalmuseum. Oil on panel, 71 x 104 cm.
- Dirck van Baburen, *The Procuress*, 1622. Boston, Museum of Fine Arts. Oil on canvas, 101 x 107.3 cm.
- Karel van Mander, Adoration of the Shepherds, 1598. Haarlem, Frans Halsmuseum. Oil on panel, 36 x 46.5 cm.
- Bartholomeus Spranger, Venus and Adonis. Amsterdam, Rijksmuseum. Oil on panel, 135 x 109 cm.
- Hendrick Goltzius, engraving after Bartholomeus Spranger, *The Marriage of Cupid* and Psyche, 1587. Amsterdam, Rijksprentenkabinet. Three plates: 43.5 x 85.5 cm.
- Gillis van Coninxloo, Landscape with Venus and Adonis. Cleveland, Museum of Art. Oil on copper, 37 x 44.5 cm.
- Hercules Seghers, Landscape in the Meuse Valley. Rotterdam, Boymans-van Beuningen Museum. Oil on panel, 29.5 x 45.5 cm.
- Hercules Seghers, View of Amersfoort. Amsterdam, Rijksprentenkabinet. Etching, 8.6 x 30.1 cm.
- Hercules Seghers, Great Landscape with a Wooden Rail. Amsterdam, Rijksprentenkabinet. Etching, 22.5 x 48.9 cm.
- Hercules Seghers, *The Larch*. Amsterdam, Rijksprentenkabinet. Etching, 16.9 x 9.8 cm.
- Hendrick Goltzius, Landscape with a Farmyard, 1603. Rotterdam, Boymans-van Beuningen Museum. Drawing, pen and brown ink, 8.7 x 15.3 cm.
- Claes Jansz. Visscher, Outside Haarlem on the Road to Leiden, 1607. Amsterdam, Rijksprentenkabinet. Drawing, pen, 12.5 x 10.9 cm.
- Esaias van de Velde, Spaerwou. Amsterdam, Rijksprentenkabinet. Drawing, pen and wash, 8.5 x 17.8 cm.
- Esaias van de Velde, Village in Winter, 1614. Raleigh, North Carolina Museum of Art. Oil on panel, 25.3 x 31.3 cm.

- Esaias van de Velde, View of Zierikzee, 1618. Berlin-Dahlem, Staatliche Museen. Oil on canvas, 27 x 40 cm.
- Hendrick Avercamp, Large Winter Scene. Amsterdam, Rijksmuseum. Oil on oak panel, 79.5 x 132 cm.
- Willem Buytewech, Grove at the Pond. Amsterdam, Rijksprentenkabinet. Etching, 8.85 x 12.4 cm.
- Esaias van de Velde, Banquet Outdoors, 1615. Amsterdam, Rijksmuseum. Oil on oak panel, 35 x 61 cm.
- Hendrick Goltzius, *The Musical Trio*, 1607. Vienna, Albertina. Drawing, black and red chalk with wash, heightened with white, 37.8 x 31.2 cm.
- Willem Buytewech, Fashionable Courtship. Amsterdam, Rijksmuseum. Oil on panel, 56 x 70 cm.
- 46. Willem Buytewech, *Interior with a Family by the Hearth*, 1617. Hamburg, Kunsthalle. Drawing, pen and brown ink with brown and grey wash, 18.8 x 29 cm.
- 47. Frans Hals, A Young Man and his Sweetheart ('Jonker Ramp''), 1623. New York, Metropolitan Museum of Art, Benjamin Altman Bequest. Oil on canvas, 103.7 x 77.5 cm.
- Judith Leyster, *The Rejected Offer*, 1631. The Hague, Mauritshuis. Oil on panel, 30.9 x 24.2 cm.
- Frans Hals, Boy with a Flute. Berlin-Dahlem, Staatliche Museen. Oil on canvas, 62 x 54.5 cm.
- Frans Hals, *The Laughing Cavalier*, 1624. London, Wallace Collection. Oil on canvas, 86 x 69 cm.
- Michiel van Miereveld, Jacob van Dalen, 1639. New York, Metropolitan Museum of Art. Oil on panel, 69.4 x 57.5 cm.
- 52. Frans Hals, *Isaac Abrahamsz. Massa and his Wife*. Amsterdam, Rijksmuseum. Oil on canvas, 140 x 166.5 cm.
- Frans Hals, Cornelia Vooght Claesdochter, 1631. Haarlem, Frans Halsmuseum. Oil on panel, 126.5 x 101 cm.
- Frans Hals, Banquet of the Officers of the St. George Militia Company, 1616. Haarlem, Frans Halsmuseum. Oil on canvas, 175 x 324 cm.
- 55. Frans Hals, Banquet of the Officers of the St. George Militia Company, c. 1626/27. Haarlem, Frans Halsmuseum. Oil on canvas, 179 x 257.5 cm.
- Frans Hals, Officers of the St. George Militia Company, c. 1639. Haarlem, Frans Halsmuseum. Oil on canvas, 204.5 x 416.6 cm.
- 57. Frans Hals, *Regents of St. Elizabeth's Hospital*. Haarlem, Frans Halsmuseum. Oil on canvas, 153 x 252 cm.
- Frans Hals, Male Regents of the Old Men's Home. Haarlem, Frans Halsmuseum. Oil on canvas, 172.5 x 256 cm.
- 59. Frans Hals, Female Regents of the Old

Men's Home. Haarlem, Frans Halsmuseum. Oil on canvas, 170.5 x 249.5 cm.

- Thomas de Keyser, Constantijn Huygens and his Clerk, 1627. London, National Gallery. Oil on oak panel, 92.4 x 69.3 cm.
- Bartholomeus van der Helst, The Celebration of the Peace of Münster, June 18, 1648, at the Headquarters of the St. George Civic Guard. Amsterdam, Rijksmuseum. Oil on canvas, 232 x 547 cm.
- Bartholomeus van der Helst, Daniel Bernard, 1669. Rotterdam, Boymans-van Beuningen Museum. Oil on canvas, 124 x 113 cm.
- 64. Gerard ter Borch, *Helena van der Schalcke* as a Child. Amsterdam, Rijksmuseum. Oil on panel, 34 x 28.5 cm.
- Pieter Lastman, Christ and the Woman of Canaan, 1617. Amsterdam, Rijksmuseum. Oil on panel, 78 x 108 cm.
- Rembrandt, *The Stoning of St. Stephen*, 1625. Lyons, Musée des Beaux-Arts. Oil on panel, 89.5 x 123.5 cm.
- Adam Elsheimer, *The Stoning of St. Stephen*, 1625. Edinburgh, National Gallery of Scotland (photo: Annan). Oil on panel, 67 x 45 cm.
- Rembrandt, *The Flight into Egypt*, 1627. Tours, Musée des Beaux-Arts. Oil on panel, 26.5 x 24 cm.
- Adam Elsheimer, The Flight into Egypt. Munich, Alte Pinakothek. Oil on copper, 31 x 41 cm.
- Hendrick Goudt, engraving after Adam Elsheimer, *The Flight into Egypt*. Amsterdam, Rijksprentenkabinet. 36.1 x 40.9 cm.
- Rembrandt, Self-Portrait. London, British Museum. Drawing, pen and bistre, brush and brown ink, with grey wash, 12.7 x 9.5 cm.
- Rembrandt, Self-Portrait. Cassel, Gemäldegalerie. Oil on panel, 23.5 x 17 cm. panel, 23.5 x 17 cm.
- Rembrandt, Samson and Delilah, 1628. Berlin-Dahlem, Staatliche Museen (photo: Walter Steinkopf). Oil on panel, 59.5 x 49.5 cm.
- 74. Jan Lievens, Samson and Delilah. Amsterdam, Rijksmuseum. Oil on canvas, 131 x 111 cm.
- Rembrandt, Judas Returning the Pieces of Silver, 1629. Private Collection. Oil on panel, 76 x 101 cm.
- 76. Detail of 75.
- 77. Rembrandt, "*Rembrandt's Mother*." Windsor Castle. Reproduced by gracious permission of Her Majesty, the Queen. Oil on panel, 58.5 x 45 cm.
- Rembrandt, "Rembrandt's Sister Lysbeth," 1632. Stockholm, National Museum. Oil on canvas, 72 x 54 cm.
- Rembrandt, Portrait of his Father. Oxford University, Ashmolean Museum. Drawing, sanguine, 18.9 x 24 cm.

- Rembrandt, Nicolaes Ruts, 1631. New York, Frick Collection. Oil on panel, 115 x 85.5 cm.
- Rembrandt, *The Anatomy Lesson of Dr. Tulp*, 1632. The Hague, Mauritshuis. Oil on canvas, 169.5 x 216.5 cm.
- Rembrandt, Saskia in a Straw Hat, 1633. Berlin, Kupferstichkabinett. Drawing, silverpoint on white prepared vellum, 18.5 x 10.7 cm.
- Rembrandt, Saskia as Flora, 1634. Leningrad, Hermitage (photo: courtesy of M. Knoedler & Co.) Oil on canvas, 125 x 101 cm.
- Rembrandt, *The Descent from the Cross*, 1633. Amsterdam, Rijksprentenkabinet. Etching and burin, 53 x 41 cm.
- Rembrandt, The Blinding of Samson, 1636. Frankfurt, Städelsches Kunstinstitut. Oil on canvas, 236 x 302 cm.
- Rembrandt, *Danaë*, 1636 (and later). Leningrad, Hermitage. Oil on canvas, 185 x 203 cm.
- Rembrandt, Self-Portrait Leaning on a Stone Sill, 1639. Amsterdam, Rijksprentenkabinet. Etching, 20.5 x 16.4 cm.
- Rembrandt, drawing after Raphael's Portrait of Baldassare Castiglione, 1639. Vienna, Albertina. Pen and bistre, some white body color, 16.3 x 20.7 cm.
- Rembrandt, Self-Portrait, Leaning on a Sill, 1640. London, National Gallery. Oil on canvas, 102 x 80 cm. 80 cm.
- Rembrandt, Landscape with an Obelisk, 1638 (?). Boston, Isabella Stewart Gardner Museum. Oil on panel, 55 x 71.5 cm.
- Rembrandt, View of Amsterdam from the Northwest, c. 1640. Amsterdam, Rijksprentenkabinet. Etching, 11.2 x 5.3 cm.
- Rembrandt, Two Women Teaching a Child to Walk. London, British Museum. Drawing, red chalk, 10.3 x 12.8 cm.
- Rembrandt, The Militia Company of Captain Frans Banning Cocq ("The Night Watch"), 1642. Amsterdam, Rijksmuseum. Oil on canvas, 359 x 438 cm.
- Rembrandt, *The Triumph of Mordecai*. Amsterdam, Rijksprentenkabinet. Etching and drypoint, 17.4 x 21.5 cm.
- Rembrandt, The Parting of David and Jonathan, 1642. Leningrad, Hermitage. Oil on panel, 73 x 61.5 cm.
- Rembrandt, Christ Healing the Sick ("The Hundred Guilder Print"). Amsterdam, Rijksprentenkabinet. Etching, drypoint, and burin, 27.8 x 38.8 cm.
- Rembrandt, The Holy Family with Painted Frame and Curtain, 1646. Cassel, Gemäldegalerie. Oil on panel, 46.5 x 68.5 cm.
- Rembrandt, Winter Landscape, 1646. Cassel, Gemäldegalerie. Oil on panel, 17 x 23 cm.
- 99. Rembrandt, Self-Portrait Drawing at a Win-

^{60.} Detail of 59.

dow, 1648. Amsterdam, Rijksprentenkabinet. Etching, drypoint, and burin, 16 x 13 cm.

- 100. Rembrandt, Winter Landscape. Cambridge, Mass., Fogg Art Museum. Drawing, 6.55 x 15.16 cm.
- Rembrandt, A Young Girl at a Window, 1651. Stockholm, National Museum. Oil on canvas, 78 x 63 cm.
- Rembrandt, Aristotle with the Bust of Homer, 1653. New York, Metropolitan Museum of Art. Oil on canvas, 143.5 x 136.5 cm.
- Rembrandt, A Woman Bathing in a Stream, 1654. London, National Gallery. Oil on panel, 61.5 x 47 cm.
- 104. Rembrandt, *Bathsheba*, 1654. Paris, Louvre. Oil on canvas, 142 x 142 cm.
- Rembrandt, Adoration of the Shepherds (with the Lamp). Amsterdam, Rijksprentenkabinet. Etching, 10.5 x 12.9 cm.
- Rembrandt, *Titus at his Desk*, 1655. Rotterdam, Boymans-van Beuningen Museum. Oil on canvas, 77 x 63 cm.
- Rembrandt, *Hendrickje at an Open Door*. Berlin-Dahlem, Staatliche Museen (photo: Walter Steinkopf). Oil on canvas, 86 x 65 cm.
- Rembrandt, *The Polish Rider*. New York, Frick Collection. Oil on canvas, 117 x 135 cm.
- 109. Rembrandt, Jacob Blessing the Sons of Joseph, 1656. Cassel, Gemaldegalerie. Oil on canvas, 175.5 x 210.5 cm.
- 110. Detail of 109.
- 111. Rembrandt, Self-Portrait at the Age of Fifty-Two, 1658. New York, Frick Collection. Oil on canvas, 131 x 102 cm.
- 112. Rembrandt, Old Tobit and Anna Waiting for their Son, 1659 (?). Rotterdam, Boymans-van Beuningen Museum (Willem van der Vorm Foundation). Oil on panel, 40.5 x 54 cm.
- 113. Rembrandt, The Apostle Peter Denying Christ, 1660. Amsterdam, Rijksmuseum. Oil on canvas, 154 x 169 cm.⁴
- Rembrandt, Jacob Trip. London, National Gallery. Oil on canvas, 130.5 x 97 cm.
- 115. Rembrandt, Margaretha de Geer, Wife of Jacob Trip. London, National Gallery. Oil on canvas, 130.5 x 97.5 cm.
- Rembrandt, A Lion Lying Down. Amsterdam, Rijksprentenkabinet. Drawing, reed pen and bistre, 11.9 x 21.2 cm.
- 117. Rembrandt, *The Oath of the Batavians*, 1661. Stockholm, National Museum. Fragment, oil on canvas, 196 x 309 cm.
- 118. Rembrandt, The Oath of the Batavians, 1661. Munich, Staatliche Graphische Sammlung. Drawing, pen and ink with wash, 19.6 x 18 cm.
- Rembrandt, The Sampling Officials of the Cloth-Makers' Guild (De Staalmeesters), 1662. Amsterdam, Rijksmuseum. Oil on canvas, 191 x 279 cm.

- Rembrandt, The Loving Couple ("The Jewish Bride"). Amsterdam, Rijksmuseum. Oil on canvas, 121.5 x 166.5 cm.
- 121. Rembrandt, *The Downfall of Haman*. Leningrad, Hermitage. Oil on canvas, 127 x 117 cm.
- 122. Detail of 121: King Ahasuerus.
- 123. Rembrandt, Self-Portrait in his Last Year, 1669. The Hague, Mauritshuis (photo: A Dingjan). Oil on canvas, 59 x 51 cm.
- 124. Jan Lievens, Constantijn Huygens. Douai, Musée des Beaux-Arts, on loan to the Rijksmuseum, Amsterdam. Oil on panel, 99 x 84 cm.
- 125. Jan Lievens, Job in Misery, 1631. Ottawa, National Gallery of Canada. Oil on canvas, 171.5 x 148.6 cm.
- 126. Gerrit Dou, Self-Portrait in his Studio, 1647. Dresden, Gemäldegalerie Alte Meister. Oil on panel, 43 x 34.5 cm.
- 127. Gerrit Dou, *A Poulterer's Shop*. London, National Gallery. Oil on panel, 58 x 46 cm.
- Govaert Flinck, *Portrait of a Woman*, 1638.
 Private Collection (photo: Luigi Pellettieri). Oil on canvas, 74.9 x 63.5 cm.
- Govaert Flinck, Isaac Blessing Jacob, 1638. Amsterdam, Rijksmuseum. Oil on canvas, 117 x 141 cm.
- Nicolaes Maes (?), Christ Blessing Children. London, National Gallery. Oil on canvas, 206 x 154 cm.
- 131. Nicolaes Maes, Interior with a Sleeping Maid and her Mistress (The Idle Servant), 1655. London, National Gallery. Oil on panel, 70 x 53.3 cm.
- 132. Samuel van Hoogstraten, Still-Life, 1655. Vienna, Akademie der Bildende Künste. Oil on canvas, 72 x 92.5 cm.
- 133. Aert de Gelder, Hermanus Boerhaave with his Wife and Daughter. Amsterdam, Rijksmuseum. Oil on canvas, 104.5 x 173 cm.
- 134. Aert de Gelder, Jacob's Dream. Dulwich College Picture Gallery. Oil on canvas, 66.7 x 56.9 cm.
- 135. Adriaen Brouwer, *Tavern Scene*. Rotterdam, Boymans-van Beuningen Museum. Oil on panel, 34.8 x 26 cm.
- Adriaen Brouwer, *Peasants Quarreling* Over Cards. The Hague, Mauritshuis. Oil on panel, 19.5 x 26.5 cm.
- 137. Adriaen van Ostade, An Alchemist at Work, 1661. London, National Gallery. Oil on panel, 34 x 45.2 cm.
- 138. Gerard ter Borch, "The Fatherly Warning." Berlin-Dahlem, Staatliche Museen. Oil on canvas, 70 x 60 cm.
- 139. Gerard ter Borch, A Woman Writing a Letter. The Hague, Mauritshuis (photo: A. Dingjan). Oil on panel, 39 x 29.5 cm.
- 140. Frans van Mieris the Elder, *The Brothel*. The Hague, Mauritshuis (photo: A Dingjan). Oil on panel, 43 x 33 cm.
- 141. Jan Steen, The Dissolute Household. Lon-

don, Wellington Museum. Oil on canvas, 76 x 82 cm.

- Ian Steen, *The Physician's Visit*. London, Wellington Museum. Oil on panel, 47.5 x 41.3 cm.
- 143. Jan Steen, *Girl Salting Oysters*. The Hague, Mauritshuis. Oil on panel, arched top, 20.5 x 14.5 cm.
- Emanuel de Witte, Interior with a Woman Playing the Virginals. Rotterdam, Boymans-van Beuningen Museum. Oil on canvas, 77 x 104 cm.
- 145. Gabriel Metsu, Self-Portrait with his Wife in a Moralizing Tavern Scene, 1661. Dresden, Gemäldegalerie Alte Meister. Oil on panel, 35.5 x 30.5 cm.
- 146. Ambrosius Bosschaert, the Elder, Large Bouquet in a Gilt-Mounted Wan Li Vase. Pasadena, Norton Simon Inc. Foundation. Oil on panel, 80 x 54.5 cm.
- 147. Balthasar van der Ast, Fruit and Flowers. Pasadena, Norton Simon Foundation. Oil on panel, 40.6 x 73.8 cm.
- Floris van Dijck, Breakfast Still-Life, 1613. Haarlem, Frans Halsmuseum (photo: A. Dingjan). Oil on panel, 49.5 x 77 cm.
- 149. Willem Claesz. Heda, Breakfast Still-Life, 1629. The Hague, Mauritshuis (photo: A. Dingjan). Oil on panel, 46.2 x 69 cm.
- Pieter Claesz., Still-Life with Skull, 1630. The Hague, Mauritshuis (photo: A. Dingjan). Oil on panel, 45 x 65.5 cm.
- 151. Jan Davidsz. de Heem, Still-Life, 1640. Paris, Louvre. Oil on Canvas, 149 x 203 cm.
- 152. Abraham van Beyeren, Fish Still-Life. Copenhagen, Statens Museum for Kunst. Oil on canvas, 72 x 95 cm.
- 153. Abraham van Beyeren, Still-Life, 1666. San Francisco, De Young Museum. Oil on canvas, 137.5 x 155 cm.
- 154. Willem Kalf, Still-Life, 1663. Cleveland, Museum of Art, Leonard C. Hanna Jr. Coll. Oil on canvas, 59.4 x 49.4 cm.
- 155. Pieter de Molijn, Sandy Road, 1626. Brunswick, Herzog Anton Ulrich Museum. Oil on panel, 26 x 36.5 cm.
- 156. Jan van Goyen, Landscape with Two Oaks, 1641. Amsterdam, Rijksmuseum. Oil on canvas, 88.5 x 110.5 cm.
- 157. Jan van Goyen, River Scene Near a Village, 1645. Amsterdam, Rijksmuseum. Oil on canvas, 131 x 166 cm.
- 158. Jan van Goyen, *River Landscape*, 1649. Haarlem, Frans Halsmuseum. Oil on canvas, 39.5 x 65 cm.
- Salomon van Ruysdael, *The Ferry* 1653. Haarlem, Frans Halsmuseum. Oil on panel, 52.5 x 80 cm.
- Aert van der Neer, Canal Scene by Moonlight. London, Wallace Collection. Oil on canvas, 57.5 x 61.25 cm.
- 161. Philips Koninck, Panoramic Landscape, 1649. New York, Metropolitan Museum

of Art. Oil on canvas, 143.2 x 173.4 cm.

- Jacob van Ruisdael, Rocky Landscape. London, Wallace Collection. Oil on canvas, 100 x 122.5 cm.
- 163. Jacob van Ruisdael, *The Jewish Cemetery*. Detroit, Art Institute, Julius Haass in memory of his brother Dr. E. W. Haass. Oil on canvas, 140 x 186.25 cm.
- Jacob van Ruisdael, *The Mill at Wijk bij* Duurstede. Amsterdam, Rijksmuseum. Oil on canvas, 83 x 101 cm.
- 165. Jacob van Ruisdael, Extensive Landscape with a Ruined Castle and a Village Church. London, National Gallery. Oil on canvas, 34 x 40 cm.
- Jacob van Ruisdael, Wheatfields. New York, Metropolitan Museum of Art. Oil on canvas, 98.5 x 108 cm.
- 167. Meindert Hobbema, A Stormy Landscape. London, Wallace Collection, 1663. Oil on canvas, 92.5 x 125 cm.
- Meindert Hobbema, Ruins of Brederode Castle, 1671. London, National Gallery. Oil on canvas, 82 x 106 cm.
- Meindert Hobbema, *The Avenue, Middelharnis*, 1689. London, National Gallery. Oil on canvas, 103.5 x 141 cm.
- 170. Aelbert Cuyp, A Herdsman with Five Cows by a River. London, National Gallery. Oil on panel, 38.1 x 50.8 cm.
- 171. Aelbert Cuyp, Dordrecht: Sunrise. New York, Frick Collection. Oil on panel, 102 x 161 cm.
- Paulus Potter, Cows in a Meadow Near a Farm, 1653. Amsterdam, Rijksmuseum. Oil on panel, 58 x 66.5 cm.
- 173. Philips Wouwerman, The White Horse. Amsterdam, Rijksmuseum. Oil on panel, 43.5 x 38 cm.
- 174. Jan Wijnants, Dune Landscape with a Horse Drinking. Amsterdam, Rijksmuseum. Oil on panel, 23.5 x 30.5 cm.
- 175. Adriaen van de Velde, *The Beach at Scheveningen*. Cassel, Gemäldegalerie. Oil on canvas, 50.8 x 72.4 cm.
- Cornelis Poelenburgh, Rest on the Flight into Egypt. Poughkeepsie, NY, Vassar College Art Gallery. Oil on copper, 23.7 x 25.9 cm.
- 177. Bartholomeus Breenbergh, Moses and Aaron Changing the Waters of Egypt into Blood, 1631. Malibu, CA, J. Paul Getty Museum. Oil on panel, 60 x 83.5 cm.
- 178. Jan Both, Rocky Landscape with Oxcart. London, National Gallery. Oil on canvas, 120.5 x 160.5 cm.
- 179. Claes Berchem, Italian Landscape with a Round Tower, 1656. Amsterdam, Rijksmuseum. Oil on canvas, 88.5 x 70 cm.
- Karel Dujardin, Italian Landscape with Cattle, 1659. Amsterdam, Rijksmuseum. Oil on panel, 37 x 50 cm.
- I81. Jan Porcellis, Stormy Sea, 1629. Munich, Alte Pinakothek. Oil on panel, 18.5 x 24 cm.
- 182. Jan van de Cappelle, The State Barge Sa-

luted by the Home Fleet, 1650. Amsterdam, Rijksmuseum. Oil on panel, 64 x 92.5 cm.

- 183. Willem van de Velde the Elder, Admiral de Ruyter's Flagship, the Seven Provinces, detail from The Council of War Before the Four-Day Naval Battle, 10 June 1666. Amsterdam, Rijksmuseum. Pen painting on canvas.
- Willem van de Velde the Younger, *The Harbor of Amsterdam*, 1686. Amsterdam, Rijksmuseum. Oil on canvas, 179.5 x 316 cm.
- 185. Frans Post, Brazilian Landscape, 166(8?) The Hague, Mauritshuis (photo: A. Dingjan). Oil on panel, 50 x 69 cm.
- 186. Pieter Saenredam, Interior of the Church of St. Bavo in Haarlem. Philadelphia, Museum of Art, John G. Johnson Collection. Oil on panel, 81.3 x 108.8 cm.
- 187. Pieter Saenredam, Interior of the Buurkerk at Utrecht, 1644. London, National Gallery. Oil on panel, 60.1 x 50.1 cm.
- Gerard Houckgeest, Interior of the New Church in Delft, 1651. The Hague, Mauritshuis (photo: A. Dingjan). Oil on panel, 65.5 x 77.5 cm.
- 189. Emanuel de Witte, Interior of a Church During a Sermon. London, National Gallery. Oil on canvas, 51.1 x 56.2 cm.
- 190. Emanuel de Witte, Interior of a Church with a Newly-Dug Grave. Rotterdam, Boymans-van Beuningen Museum. Oil on canvas, 98.5 x 111.5 cm.
- 191. Carel Fabritius, A View in Delft, 1652. London, National Gallery. Oil on canvas, 15.4 x 31.6 cm.
 - 192. Johannes Vermeer, View of Delft. The Hague, Mauritshuis. Oil on canvas, 98.5 x 117.5 cm.
 - 193. Johannes Vermeer, A Little Street in Delft. Amsterdam, Rijksmuseum. Oil on canvas, 59.3 x 44 cm.
 - Jan van der Heyden, The Dam in Amsterdam. Amsterdam, Rijksmuseum. Oil on panel, 68 x 55 cm.
 - 195. Gerrit Berckheyde, The Market Place and the Grote Kerk in Haarlem, 1674. London, National Gallery. Oil on canvas, 51.8 x 67 cm.
 - 196. Gerrit Berkcheyde, A Street in Haarlem. Dresden, Gemäldegalerie. Oil on panel, 42.5 x 37.5 cm.
 - Carel Fabritius, Self-Portrait. Rotterdam, Boymans-van Beuningen Museum. Oil on panel, 65 x 49 cm.
 - Carel Fabritius, Self-Portrait, 1654. London, National Gallery. Oil on canvas, 70.5 x 61.5 cm.
 - Carel Fabritius, *The Goldfinch*, 1654. The Hague, Mauritshuis. Oil on panel, 33.5 x 22.8 cm.
 - Pieter de Hooch, Courtyard of a House in Delft, 1658. London, National Gallery. Oil on canvas, 73.5 x 60 cm.

- 201. Pieter de Hooch, *A Boy Bringing Pomegranates*, 1662. London, Wallace Collection. Oil on canvas, 74 x 60 cm.
- 202. Johannes Vermeer, *Diana and her Companions*. The Hague, Mauritshuis. Oil on canvas, 98.5 x 105 cm.
- 203. Johannes Vermeer, Christ in the House of Martha and Mary. Edinburgh, National Gallery of Scotland. Oil on canvas, 155 x 139 cm.
- 204. Johannes Vermeer, The Procuress, 1656. Dresden, Gemäldegalerie Alte Meister. Oil on canvas, 140.6 x 128 cm.
- 205. Johannes Vermeer, A Young Woman Asleep. New York, Metropolitan Museum of Art. Oil on canvas, 85.3 x 75.3 cm.
- Johannes Vermeer, Maidservant Pouring Milk. Amsterdam, Rijksmuseum. Oil on canvas, 45.5 x 41 cm.
- 207. Johannes Vermeer, Woman Reading a Letter at an Open Window. Dresden, Gemäldegalerie Alte Meister. Oil on canvas, 83 x 64.5 cm.
- Johannes Vermeer, Officer and Laughing Girl. New York, Frick Collection. Oil on canvas, 47.5 x 42.5 cm.
- 209. Johannes Vermeer, A Lady and Gentleman at the Virginals. London, Buckingham Palace. (Reproduced by gracious permission of Her Majesty the Queen). Oil on canvas, 71.3 x 61.5 cm.
- 210. Johannes Vermeer, *The Concert*. Boston, Isabella Stewart Gardner Museum. Oil on canvas, 70 x 61.9 cm.
- Johannes Vermeer, Woman with a Water Jug. New York, Metropolitan Museum of Art. Oil on canvas, 45.7 x 40.6 cm.
- 212. Johannes Vermeer, *Woman in Blue Reading a Letter*. Amsterdam, Rijksmuseum. Oil on canvas, 45.6 x 38.8 cm.
- 213. Johannes Vermeer, Woman with a Pearl Necklace. Berlin-Dahlem, Gemäldegalerie. Oil on canvas, 52.6 x 44.4 cm.
- 214. Johannes Vermeer, *The Lacemaker*. Paris, Louvre. Oil on canvas, 24 x 21 cm.
- 215. Johannes Vermeer, *Head of a Girl*. The Hague, Mauritshuis. Oil on canvas, 46.5 x 40 cm.
- Johannes Vermeer, The Geographer. Frankfurt, Städelsches Kunstinstitut. Oil on canvas, 52 x 45.6 cm.
- 217. Johannes Vermeer, *The Love Letter*. Amsterdam, Rijksmuseum. Oil on canvas, 44 x 38.5 cm.
- Johannes Vermeer, Allegory of the Faith. New York, Metropolitan Museum of Art. Oil on canvas, 111.3 x 86.9 cm.
- 219. Johannes Vermeer, Lady Standing at the Virginals. London, National Gallery. Oil on canvas, 50 x 45 cm.
- 220. Johannes Vermeer, Lady Seated at the Virginals. London, National Gallery. Oil on canvas, 50.5 x 45 cm.

Index

Page numbers in italics refer to illustrations.

Academies, first, 12 Aertsen, Pieter, 23, 187 Alba, Duke of, 2 Albert, Archduke of Austria, 3 Alberti, Leon Battista, 71 Algardi, Alessandro, 293 Ampzing, Samuel, 242 Amsterdam, 4, 5, 18, 53, 58, 170-171, 191, 202, 258, 259; Bourse, 17, 186-187; Old Town Hall, 16, 254; Surgeons' Guild, 106, 107; Town Hall (new), 145-146, 148, 162, 163, 242, 300 Antwerp, 1, 3, 4, 17, 30, 48, 49, 191, 299, 300 Apocrypha, 140 Aquinas, St. Thomas, 190 Architecture, 240-241 Asselijn, Jan, 232 Ast, Balthasar van der, 193-194; Fruit and Flowers, 22, 193-194, 194 Avercamp, Hendrick, 56-57; Large Winter Scene, 57, 57 Baburen, Dirck (Theodor) van, 42; The Entombment, 42; The Procuress, 42, 43, 284, 296-297 Backer, Adriaen, 121 Backer, Jacob, 161 Bailly, David, 197 Bandinelli, Baccio, 46 Banquet pieces, 201-202 Baroque style, 148, 299, 300; of Rembrandt, 112-113, 117, 120 Bassen, Bartholomeus van, 241

Beer, Joos de, 30

Berchem, Claes (Nicolaes), 229-230, 265; Italian Landscape with a Round Tower, 229, 231

- Berckheyde, Gerrit, 255; The Market Place and The Grote Kerk at Haarlem, 255, 255, 257; A
- Street in Haarlem, 256, 257
- Bergström, Ingvar, 190
- Bernini, Gian Lorenzo, 293
- Beuckelaer, Joachim, 23
- Beyeren, Abraham van, 200-202; Fish Still-Life, 22, 200, 201; Still-Life, 201, 201
- Bible, 8, 140; illustrations, 15-16
- Biblical scenes, 92, 94; in landscapes, 53
- Bijlert, Jan van, 30
- Bleyswijck, Dirck van, 263
- Bloemaert, Abraham, 30-31, 38, 42, 227-229; Flute Player, 31, 31; Preaching of John the Baptist, 30, 31
- Bol, Ferdinand, 162-163, 300
- Book of Hours of Catherine of Cleves, 22, 23, 241; The Holy Family at Supper, 24, 24; The Pentecost, 24; St. Ambrose with Mussel and Crab Border, 21, 21
- Borghese, Scipione, Cardinal, 38
- Bosschaert, Ambrosius, the Elder, 191-193; Large Bouquet, 191-192, 192
- Both, Jan, 30, 220, 229; Rocky Landscape with Oxcart, 229, 230
- Bramer, Leonard, 259
- Brazil, landscapes from, 238-239
- Breakfast pieces, 194-197
- Bredero, Gerbrand Adriaansz., 9, 62
- Breen, Adam van, 59
- Breenbergh, Bartholomaeus, 228-229 Landscape with Ruins, 228, 228

Bronzino, Agnolo, 46

- Brothel scenes, 42-43, 60, 171, 178, 180
- Brouwer, Adriaen, 66, 172-175; The Dentist, 175; Peasants Quarreling over Cards, 174, 174;

- Brouwer, Adriaen (cont'd)
 - The Surgeon, 175; Tavern Scene, 172-174, 173
- Bruegel, Pieter, the Elder, 48-49, 57, 172
- Bruegel, Pieter, the Younger, 172
- Bruges, 3
- Brussels, I
- Buckingham, George Villiers, First Duke of, 42
- Bürger-Thoré, Théophile, 268-269
- Burgundy, Duchy of, 1
- Buytewech, Willem, 57-63, 68, 281; Fashionable Courtship, 61-62, 62; Grove at the Pond, 58, 58; Interior with a Family by the Hearth, 63, 63: Merry Company in an Interior, 62
- Calvin, John, 15, 94
- Calvinism, 4, 5, 9, 16, 197, 202, 203
- Camera obscura, 275-276
- Campen, Jacob van, 241-242
- Campin, Robert (Master of Flémalle), 27, 250
- Cappelle, Jan van de, 233-235, 237; The State
- Barge Saluted by the Home Fleet, 234, 235 Caravaggio, Michelangelo Merisi da, 31-32, 42, 45, 61, 229; The Calling of St. Matthew, 32, 32: Crucifixion of St. Peter, drawing by Honthorst, 38-39
- Caravaggist style, 26, 60-61, 65, 99, 116, 227, 229, 272, 279; in Haarlem, 45-46, 68; in Utrecht, 30-43, 68, 171, 227
- Catholic painting, 6, 8, 16
- Catholics, 5, 18, 181, 227
- Cats, Jacob, 8, 197
- Chardin, Jean-Baptiste-Siméon, 197
- Charles I, King of England, 41-42, 227
- Charles II, King of England, 237 Charles V, Holy Roman Emperor, 1, 2
- Christus, Petrus, 27
- Church interiors, 240-250
- Claesz., Pieter, 196-198, 229; Still-Life with Skull, 197, 197-198
- Claude. See Lorrain, Claude
- Codde, Pieter, 77-78, 171
- Coninxloo, Gillis van, 49, 51, 53; Landscape with Venus and Adonis, 50
- Coornhert, Dirck Volkertsz., 47
- Coorte, Adriaen, 299
- Cornelis Cornelisz. van Haarlem, 30, 45, 47, 57, 75, 91
- Correggio, 48, 112
- Council of Trent, 16
- Cuyp, Aelbert, 220-221, 223, 233; Dordrecht: Sunrise, 221, 222; A Herdsman with Five Cows by a River, 221, 222
- Cuyp, Jacob Gerritsz., 220
- Delen, Dirck van, 241
- Delft, 5, 258-259; church interiors, 246-247; Nieuwe Kerk, 246-247; town views and street scenes, 250-253
- Descartes, René, 18; portrait by Frans Hals, 19, 79 Devotio moderna, 21
- Dijk, Floris van, Breakfast Still-Life, 194, 195
- Dircx, Geertje, 123
- Dou, Gerrit, 156-159, 164, 184, 300; A Poulterers's Shop, 159, 160; Self-Portrait in His Studio, 158, 159
- Duck, Jacob, 171
- Dujardin, Karel, 230; Italian Landscape with Cattle, 230, 232

- Dutch East India Company, 4
- Dutch Reformed Church, 9
- Dutch Republic, origin of, 4, 6
- Dutch West India Company, 4
- Duyster, Willem, A Man and a Woman Playing Trick-Track, and Three Other Men, 171 Dyck, Anthony van, 131
- Eeckhout, Gerbrandt van den, 163
- Eliasz., Nicolaes (Pickenoy), 107, 121
- Elsheimer, Adam, 91, 92, 116, 227, 228; The Flight into Egypt, 94-95, 95, engraving by Goudt after, 95, 96; The Stoning of St. Stephen, 92, 93
- Emblems, 8-9, 60-62, 69, 72-73, 96, 149, 159, 183, 263; in still-life, 190, 197-198, 202, 203; Vermeer's use of, 275, 281, 283-284, 287-288, 292-294, 296-297
- England: Dutch artists in, 41-42, 227, 237; Dutch relations with, 3, 7, 235, 237
- Evelyn, John, 9
- Everdingen, Allaert van, 211-212
- Everdingen, Caesar van, 300
- Eyck, Jan van, 25, 27, 241, 250; Arnolfini Wedding Portrait, 73
- Fabritius, Barent, 163
- Fabritius, Carel, 34, 163, 166, 259, 269, 274, 280; The Goldfinch, 263, 264; The Raising of Lazarus, 260; Self-Portrait, 260, 261, 262; Self-Portrait (1654), 262, 262-264; The Sentinel, 263; View in Delft, 250-251, 251, 259
- Fish as subjects, 22-23, 187, 200-201
- Five Senses as subject, 69, 173, 175, 181-182, 199
- Flemish art: church interiors, 240, 248; landscapes,
- 49, 51, 204; scenes of social life, 172 Flinck, Govaert, 121, 146, 161-162, 300; Isaac
- Blessing Jacob, 161, 162; Portrait of a Woman, 161
- Flower paintings, 191-194
- Fontainebleau, School of, 29, 30
- France: alliance with Dutch, 3; influence on Dutch taste, 300; war with Dutch, 7
- Francken, Hieronymus, 30
- Frankfurt-am-Main, 194
- Frederick Hendrick, Stadholder, 42, 110, 111, 113, 234, 299
- Friesland, 3
- Geertjen tot Sint Jans; The Holy Kinship, 25; The Nativity at Night, 25, 25-26; Saint John the Baptist Meditating in the Wilderness, 24; The Story of the Remains of John the Baptist, 27
- Gelder, Aert (Arent) de, 166, 169, 299; Hermanus Boerhaave with His Wife and Daughter, 166, 167, 169; Jacob's Dream, 168, 169
- Gelderland, 3
- Genre art, 20, 58, 170; in Rome, 229; scenes of social life, 59-66, 170-188, 268
- Ghent, 3
- Giustiniani, Marchese Vicenzo, 38, 39
- Goltzius, Hendrick, 45, 47-48, 53, 57, 58, 75, 91, 118; Beached Whale, 14, 15, 48; Landscape with a Farmyard, 52; The Marriage of Cupid and Psyche, engraving after Spranger, 47, 47; The Musical Trio, 60-61, 61
- Goudt, Hendrick, engraving after Elsheimer, The Flight into Egypt, 95, 96

- Goyen, Jan van, 181, 205–208, 210, 220, 233; Landscape with Two Oaks, 206, 206–208; River Landscape, 207, 208; River Scene Near a Village, 207, 207; Windmill by a River, 216
- Grebber, Frans Pieter de, 241–242

Groningen, 3

Guercino, 40

- Guild of St. Luke, 10-11, 40
- Haarlem, 2, 5, 67, 75, 258; Caravaggist style in, 45-46; landscapes, 48-59, 205; Mannerism in, 44-47; St. Bavo Church, 242-243; scenes of social life, 59-66, 171; town views, 255-257
- Hague, The, 9, 58, 59, 300 Hals, Dirck, 67, 68; Children with a Cat, 65; A Lunch in the Country, 65; Party Scene, 65
- Hals, Frans, 57, 64-65, 67-85, 172, 175; Banquet of the Officers of the St. George Militia Company (1616), 75, 75-76; Banquet of the Officers of the St. George Militia Company (1626), 76, 76-77; The Boy with a Flute, 68. 69; Cornelia Vooght Claesdochter, 74, 74; Female Regents of the Old Men's Home, 79, 80; Isaac Abrahamsz. Massa and His Wife, 72-74, 73; The Laughing Cavalier, 69, 70; Male Regents of the Old Men's Home, 79, 80-81; Malle Babbe, 71; The Meagre Company (The Corporalship of Captain Revnier Reael and Lieutenant Cornelis Michielsz. Blaeuw), 77; Officers of the Civic Guard Company of St. George, 78, 78; Portrait of Descartes, 19, 79; Portrait of Jacobus Zaffius, 67, 75; Regents of St. Elizabeth's Hospital in Haarlem, 78, 79; Shrovetide Revellers, 64, 68; A Young Man ("Jonker
- Ramp'') and His Sweetheart, 64, 65, 68 Heda, Willem Claesz., 195–196; Breakfast Still-Life, 22, 195, 195–196
- Heem, Jan Davidsz. de, 198–200; Still-Life, 199, 199
- Held, Julius S., 131
- Helst, Bartholomeus van der, 84–85, 121; The Celebration of the Peace of Münster, 84–85, 85, 87; Daniel Bernard, 85, 86
- Henrietta Maria, Queen of England, 42
- Heyden, Jan van der, 254–255; The Dam in Amsterdam, 254, 255
- Hobbema, Meindert, 218–220; The Avenue, Middelharnis, 219–220, 221, 299; Ruins of Brederode Castle, 219, 220; A Stormy Landscape, 218, 219
- Holbein, Hans, the Younger, 84, 85
- Holland (province), 3, 5
- Honselaersdijck castle, 42
- Honthorst, Gerrit van, 30, 31, 38–42, 65, 116, 300; The Adoration of the Shepherds, 26, 26; 39; Christ Before the High Priest, 39, 39; drawing after Caravaggio's Crucifixion of St. Peter, 38–39; Mercury Presenting the Liberal Arts to Apollo and Diana, 41–42, 291; Merry Company, 41; The Procuress, 41, 41; Samson and Delilah, 40, 40
- Hooch (Hoogh), Pieter de, 63, 166, 230, 260, 263, 265, 274, 277, 279, 281; A Boy Bringing Pomegranates, 267, 268; Courtyard of a House in Delft, 265, 266, 267
- Hoogstraten, Samuel van, 166, 259, 300; Peepshow with Views of the Interior of a Dutch House, 166, 251; Still-Life, 166, 167

- Houbraken, Arnold, 83, 85, 91, 161, 166, 211; De Groote Schouburgh, 31
- Houckgeest, Gerard, 241, 246–248, 259–260, 267, 273: Interior of the New Church in Delft, 246–247, 247; Interior of the Old Church in Delft, 278
- Huis ten Bosch, 42, 299-300
- Huygens, Constantijn, 84, 110–111, 116, 155, 299; portrait by de Keyser, 82, 83–84; portrait by Lievens, 155, 156; praises Rembrandt, 98–100, 103
- Isabella Clara Eugenia, wife of Albert, Archduke of Austria, 3
- Italian art, 12, 26; Rembrandt influenced by, 116-117; Irompe l'oeil, wood inlays, 189-190; see also Caravaggist style; Mannerism
- Italianate (Romanist) landscape painters, 30, 226
- Jacobsz., Lambert, 161
- Jews, 5, 18
- Jordaens, Jacob, 294, 299
- Kalf, Willem, 202-203; Still Life, 202, 203
- Kampen, 56
 - Keyser, Hendrick de, 186
 - Keyser, Thomas de, 79, 83, 107; Constantijn Huygens and His Clerk, 82, 83-84
 - Knupfer, Nicolaus, 181
 - Koninck, Jacob, 211
 - Koninck, Philips, 211; Panoramic Landscape, 211, 212
 - Krul, Jan Hermansz., 293
 - Laer, Pieter van (Bamboccio), 229
 - Landscapes, 20, 23–24, 48–49, 204–232, 238–239; animals in, 223–224, 230; from Brazil, 238–239; in Haarlem, 48–59, 205; Italianate (Romanist) painters, 30, 226; monumental or structural phase, 211–224; by Rembrandt, 117–118, 128–129, 204
 - Lastman, Pieter, 91–92, 96, 155; Christ and the Woman of Canaan, 91 92
 - Leiden, 2, 5, 58, 90, 258; plague in, 196–197; University of, 14, 90, 197
 - Letter writing as subject, 178
 - Leyden, Lucas van, 175; The Prodigal Son in a Tavern, 65
 - Leyster, Judith, 65–66; The Rejected Offer, 65, 66 Lievens, Jan, 116, 155–156, 300; Constantijn Huygens, 155, 156; Job in Misery, 156, 157; Samson and Delilah, 98–99, 99, 100, 155
 - Lingelbach, Johannes, 224
 - Locke, John, 18
 - Lomazzo, G. P., 45
 - López, Alfonso, 115
 - Lorrain, Claude, 228, 229
 - Love Garden as subject, 62, 73
 - Luther, Martin, 15, 94
 - Maes, Nicolaes, 163–166, 277, 279; Christ Blessing Children, 163, 164; Interior with a Sleeping Maid and Her Mistress (The Idle Servant), 163–164, 165, 166, 274; Mother Looking at Her Child in a Cradle, 163–164
 - Mander, Karel van, 44–45, 47–48, 61, 67–68; Adoration of the Shepherds, 44; Het Schilder-Boeck, 44–45, 67

Mannerism, 91, 190, 240, 241; in Haarlem, 44-47; landscapes, 204, 205; in Utrecht, 28-30, 44 Maps in paintings, 280-281, 286, 292 Marie de' Medici, Queen of France, 6 Mary, Dowager Queen of Hungary, 2 Mary, Queen of England (wife of William III), 7 Mary of Burgundy, I Master of Flémalle (Robert Campin), 27, 250 Matham, Jacob, 14 Maurice (Maurits), Prince of Nassau, 3, 4, 14, 238 Merry Company as subject, 41, 60, 62, 64-65, 171, 281 Metsu, Gabriel, 63, 158, 187-188, 279; Self-Portrait with His Wife in a Moralizing Tavern Scene, 187-188, 188 Michelangelo, 28; David, 159; Samson Killing Philistines, 159 Middelburg, 5, 191 Miereveld, Michiel van, 71–72; Jacob van Dalen, 72, 72 Mieris, Frans van, the Elder, 158, 184, 281; The Brothel, 178, 180 Military subjects, 171 Moeyaert, Claes, 91 Molenaer, Jan Miense, 65-66 Molijn, Pieter de, Sandy Road, 205, 205 Momper, Joos de, the Younger, 49 Monconys, Balthasar, 269 Moreelse, Paulus, 42 Mundy, Peter, 9 Musical instruments represented, 41, 60, 281, 283-284

Naples, 31

Naval battles, 171, 233, 235 Neer, Aert van der, 209–210; Canal Scene by Moonlight, 210, 210

Ochtervelt, Jacob, 230

- Oldenbarnevelt, Johan, 4, 5
- Orlers, J. J., 156-157
- Ostade, Adriaen van, 175–176, 181; An Alchemist at Work, 175, 176; A Painter's Studio, 11, 12, 176

Ostade, Isaack van, 176

- Ovens, Juriaen, 146, 163
- Overijssel, 3
- Paintings: sale of, 9–10; within paintings, 42, 182–183, 275, 283, 284, 293, 295–297
- Palamedesz., Anthonie, 171
- Panofsky, Erwin, 190
- Patinir, Joachim, 48; Landscape with Cliffs and Bay, 48
- Peace of Münster (1648), 6, 87, 300
- Peasants as subjects, 172-174
- Pers, Dirck Pietersz., 294
- Philip II, King of Spain, 2, 3
- Philip IV, King of Spain, 86, 237
- Pickenoy, see Eliasz., Nicolaes
- Pictura (academy), 12
- Pietro da Cortona, 291
- Plague, 196
- Plays, scenes from, 61-62, 68
- Poelenburgh, Cornelis, 30, 224, 227–229; Landscape with an Italian Hill Town, 227, 227–228 Porcellis, Jan, 233; Stormy Sea, 233, 234
- Portraiture, 20, 27, 71–74, 83–88; group portraits, 75–79, 106–107, 120–122, 148–149; by Hals,

- Portraiture (cont'd) 68, 69, 71-79; by Rembrandt, 97-98, 103-104, 106-108, 114-115, 120-123, 140, 145, 148-149; self-portraits, style of, 260
- Post, Frans, 238–239; *Brazilian Landscape*, 238, 238–239
- Post, Pieter, 242
- Potter, Paulus, 223, 230; Cows in a Meadow Near a Farm, 223, 223
- Primaticcio, Francesco, 29
- Prodigal Son as subject, 41, 60, 65
- Protestantism, 5, 8, 15, 18, 92, 94 Pynas, Jacob, 91
- Pynas, Jan, 91
- Quesnoy, François du, 159
- Raphael, 28, 48, 116, 117; Portrait of Baldassare Castiglione, Rembrandt's drawing after, 114, 114-115
- Ravestyn, Jan Anthonisz. van, 71
- Rederijkers, see Rhetoricians' Societies
- Religious art, 15-16, 92, 94, 190
- Rembrandt, 15, 18, 26, 49, 84, 89–154, 172, 175, 203, 211, 259, 299, 300; Dou as pupil, 156–159; Fabritius influenced by, 260, 262–263; Flinck as pupil, 161–162; landscapes, 117–118, 128–129, 204; and Lievens, 155–156; life, 90–91, 104, 106–108,
 - 113-114, 123-124, 139-140, 143-144, 153-154; Maes influenced by, 163-164; stu-
 - dents working with, 159–163, 166
 - The Adoration of the Shepherds (with the Lamp) (etching), 133, 135; The Anatomy Lesson of Dr. Deyman, 140; The Anatomy Lesson of Dr. Tulp, 106, 106-107; The Apostle Peter Denying Christ, 144, 144-145; Aristotle with the Bust of Homer, 131, 132, 133; Bathsheba, 133, 135, 270; The Blinding of Samson, 111-112, 112; Christ Healing the Sick (The Hundred-Guilder Print) (etching), 125, 125-126, 163; Danaë, 112-113, 113; The Descent from the Cross, 110; The Descent from the Cross (etching), 110, 111; The Dordrecht Merchant Jacob Trip, 145, 145; The Downfall of Haman, 150-151, 151-152, 153, 166; The Flight into Egypt (1627), 94, 94-96; Hendrickje at an Open Door, 137, 137-138; The Holy Family with Angels, 163; The Holy Family with Painted Frame and Curtain, 24, 126-128, 127, 278; Jacob Blessing the Sons of Joseph, 138–39, 140–141; Judas Returning the Pieces of Silver, 100–101, 100, 102; Landscape with an Obelisk, 117, 117-118; A Lion Lying Down (drawing), 145, 146; The Loving Couple ("The Jewish Bride"), 149-150, 150; Margaretha de Geer, 145, 145; The Militia Company of Captain Frans Banning Cocq ("The Night Watch"), 120, 120-123, 126; Nicolaes Ruts, 104, 105; The Oath of the Batavians (The Conspiracy of Julius Civilis), 146, 147, 148; Old Tobit and Anna Waiting for Their Son, 143, 143; The Parting of David and Jonathan, 124, 124; The Polish Rider, 138, 138; Portrait of His Father, 103, 103-104; The Presentation of Jesus in the Temple, 26, 27, 102; The Raising of the Cross, 110; Raphael's Portrait of Baldassare Castiglione, drawing after, 114, 114-115; "Rembrandt's Brother Adriaen," 103;

- Rembrandt (cont'd)

 - "Rembrandt's Mother," 102, 103; "Rembrandt's Sister Lysbeth," 102, 103; The Return of the Prodigal Son, 153; The Ruins of the Old Town Hall of Amsterdam (drawing), 16, 17; The Sampling Officials of the Cloth-Makers' Guild, 148-149, 149; Samson and Delilah, 98, 98-99, 155; Saskia as Flora, 108, 109, 110; Saskia in a Straw Hat (drawing), 107-108, 108; Self-Portrait (drawing), 97, 97; Self-Portrait at the Age of Twenty-one, 97,97; Self-Portrait at the Age of Thirty-four, Leaning on a Sill (1640), 115, 115–117, 129; Self-Portrait at the Age of Fifty-two, 140, 142; Self-Portrait Drawing at a Window (etching, 1648), 129, 129-130; Self-Portrait in His Last Year, 153, 154; Self-Portrait Leaning on a Stone Sill (etching, 1639), 114, 114-115, 117; Self-Portrait with Saskia in a Moralizing Tavern Scene, 188; The Stoning of St. Stephen, 92, 93, 117; Titus at His Desk, 133, 136, 137, 262; The Triumph of Mordecai (etching), 122, 122-123, 126; Two Women Teaching a Child to Walk (drawing), 118, 119, 120; View of Amsterdam from the Northwest (etching) 118. 119; Winter Landscape, 128, 128-129; Winter Landscape (drawing), 130, 130; A Woman Bathing in a Stream, 133, 134; A Young Girl at a Window, 130, 131
- Rembrandt school, 155-169
- Rhetoricians' Societies, 20, 83, 181
- Romanist (Italianate) landscape painters, 30,
- 224-232 Romano, Giulio, 259
- Rome, Dutch artists in, 30, 31, 38, 42, 45, 47, 91, 224, 227-230
- Rosso Fiorentino (Il Rosso), 29
- Rotterdam, 5, 58, 258
- Rubens, Peter Paul, 41, 62, 112, 117, 131, 172, 291; Conclusion of the Peace, 6; The Descent from the Cross, 111; self-portrait with Isabella Brant, 73
- Rudolph II, Holy Roman Emperor, 46
- Ruffo, Antonio, 131
- Ruisdael, Jacob Isaacksz. van, 211-219, 233; Extensive Landscape with a Ruined Castle and a Village Church, 216, 216-217; The Jewish Cemetery, 213-214, 214, 219; The Mill at Wijk bij Duurstede, 214-216, 215; The Quay at Amsterdam, 17, 18, 18; Rocky Landscape, 212-213, 213; Wheatfields, 217, 217
- Ruysch, Rachel, 299
- Ruysdael, Salomon van, 208-212; The Ferry, 209, 200

Ruyter, Admiral Michiel de, 7

- Saenredam, Pieter Jansz., 25, 241-248; Interior of the Buurkerk at Utrecht, 244, 245, 246; Interior of the Church of St. Bavo in Haarlem, 242-243, 243; The Old Town Hall of Amsterdam, 16, 16, 254;
- Salviati, Francesco, 46
- Sandrart, Joachim von, 38, 116, 117, 121, 159, 229; Teutsche Academie, 116
- Schalcken, Godfried, 158
- Science, 14, 22
- Seascapes, 232-237; naval battles, 171, 233, 235
- Seghers, Hercules, 49, 51, 53, 57, 118, 204, 211; Great Landscape with a Wooden Rail (etching), 51, 51; Landscape in the Meuse Valley,

- Seghers, Hercules (cont'd)
 - 49, 50, 51; The Larch (etching), 52, 53; View of Amersfoort (etching), 51, 51
- Shells as subjects, 21-22, 192-193
- Skating scenes, 56-57
- Social life, scenes of, 59-66, 170-188, 268
- Soldiers as subjects, 170-171, 178, 180
- Solms, Amalia van, 42, 299
- Spain: Netherlands ruled by, 2-3, 5-6; peace with, 6, 7
- Spanish Armada, 3
- Spinoza, Baruch, 18
- Spranger, Bartholomeus, 45-47; The Marriage of Cupid and Psyche, engraving by Goltzius after Spranger, 47, 47; Venus and Adonis, 45-46, 46
- Steen, Jan, 180-185; The Dissolute Household, 181-182, 182; Girl Salting Oysters, 22, 183-184, 184; The Physician's Visit (The Lovesick Young Woman), 182-183, 183
- Steenwijk, Hendrick van, the Elder, 241
- Sterling, Charles, 189
- Stevin, Simon, De Havenvinding, 14
- Still-life, 22, 189-203; banquet pieces, 201-202; breakfast pieces, 194-197; flower paintings, 191-194; fruit and flowers, 191, 193-194; pronk, 202; symbolism and emblems in, 190, 191, 194, 197-198, 202, 203; Vanitas, 196-199
- Stimmer, Tobias, 153
- Stoffels, Hendrickje, 108, 110, 123, 133, 139, 143, 149; in painting by Rembrandt, 137, 137-138 Street scenes, 250-257
- Students of painting, 11
- Swanenburgh, Jacob Isaacsz. van, 90-91 Symbolism. See Emblems
- Tavern scenes, 170-174, 188
- ter Borch, Gerard, 43, 85-88, 177-178, 187, 281; "The Fatherly Warning," 177, 177; Helena van der Schalcke as a Child, 86, 87; The Swearing of the Oath of the Treaty of Münster: May 15, 1648, 6, 6, 86-88; A Woman Writing a Letter, 177-178, 179
- Terbrugghen, Hendrick, 30, 42, 272; The Calling of St. Matthew, 32-33, 33; The Liberation of St. Peter, 35-36, 36; St. Sebastian Cared for *by St. Irene*, 36, 37, 38; *A Shepherd Playing a Recorder*, 34, 35, 68 Thoré, Théophile (W. Bürger), 268–269
- Titian, 48, 108, 112, 117, 131, 133; Portrait of a Man (Portrait of Ariosto), 115
- Titus, 108, 123, 138, 139, 143, 153; in painting by Rembrandt, 133, 136, 137, 262
- Town views, 250-257
- Treaty of Arras (1579), 3
- Tromp, Admiral Cornelis, 237
- Trompe l'oeil, 166, 189-190, 233, 263
- Tulip mania, 191
- Twelve-Years Truce, 196
- Uffelen, Lucas van, 116
- United Provinces, 3-5, 8, 232
- Utrecht, 5, 28, 191, 227; Buurkerk, 244, 245;
 - Caravaggist style in, 31-43, 171, 227; Mannerism in, 28-30, 44
- Utrecht (province), 3, 5, 28
- Utrecht school, 16, 21, 26
- Uyl, Jan Jansz. den, 196

BOWMAN LIBRARY MENLO SCHOOL AND COLLEG

759,9492 K12

INDEX

Uylenburgh, Hendrick van, 104, 107 Uylenburgh, Saskia van, wife of Rembrandt, 107-108, 111, 123-124

- Vaenius, Otho, 296
- Vaga, Perino del, 46
- Vanitas, 214, 287; still-lifes, 196-199
- Velázquez, Diego Rodríguez de Silva y, 86 Velde, Adriaen van de, 217; The Beach at
- Scheveningen, 224, 225
- Velde, Esaias van de, 53, 55-57, 60, 68, 204-206; Banquet Outdoors, 59, 59-60; Feast in the Open Air, 59; Spaerwou, 53, 54; View of Zierikzee, 55, 56, 252; Village in Winter, 53, 55; Winter Landscape, 56
- Velde, Jan van de, 57; St. Bavo Church, Haarlem, etching after Saenredam, 242
- Velde, Willem van de, the Elder, 235, 237; Admiral de Ruyter's Flagship, the Seven Provinces, 235, 236 Velde, Willem van de, the Younger, 235, 237; The
- Harbor of Amsterdam, 237, 237

Venice, 250

Vermeer, Johannes, 26, 34, 43, 187, 258, 260, 263, 265, 268-298; Allegory of the Faith, 293-295, 295: The Art of Painting (The Painter's Studio), 12, 13, 291-293; The Astronomer, 290; Christ in the House of Martha and Mary, 271, 271-273, 291; The Concert, 42, 281, 283, 284, 287; A Couple with a Wine Glass, 281; Diana and Her Companions, 270, 270-271, 275; The Geographer, 290-291, 291; A Girl Drinking with a Man, 281; A Girl Interrupted at Music, 281, 296; Head of a Girl (The Pearl), 288, 290, 290; The Lacemaker, 287-288, 289; A Lady and Gentleman at the Virginals ("The Music Lesson"), 281, 282, 283-284; Lady Seated at the Virginals, 42, 295-298, 297; Lady Standing at the Virginals, 295-298, 296; Little Street in Delft, 252-254, 253, 275, 277; The Love Letter, 293, 294; A Maidservant Pouring Milk (The Milkmaid, The Servant), 276, 277, 279; Officer and a Laughing Girl, 279, 279-281; The Procuress, 272, 272-274, 279, 291; View of Delft, 55, 251-252, 252, 275, 276; A Woman in Blue

- Vermeer, Johannes (cont'd)
 - Reading a Letter, 286-287, 287; A Woman Reading a Letter at an Open Window, 277-278, 278, 281, 286; A Woman with a Pearl Necklace, 287, 288; A Woman with a Water Jug, 284-286, 285; Woman with Scales, 287; A Young Woman Asleep: A Moral Em-
- *blem*, 273–275, 274 Veronese, Paolo, 48
- Vices and Virtues as subjects, 172, 275
- Visscher, Claes Jansz., Outside Haarlem on the Road to Leiden, 54
- Vlieger, Simon de, 233, 235, 237
- Vondel, Joost van den, 181
- Vorsterman, Lucas, III
- Vries, Hans Vredeman de, 240
- Vroom, Hendrick Cornelisz., 233, 235; The Battle of Gibraltar, 233
- Weenix, Jan Baptist, 30, 230
- Werff, Adriaen van der, 299
- Weyden, Roger van der, 27, 250
- Wijnants, Jan, 224; Dune Landscape with a Horse Drinking, 224, 225
- William II, Prince of Orange, 246
- William III (of Orange), King of England, 7
- William the Silent (William of Nassau, Prince of Orange), 2, 3, 14, 246
- Witt, Cornelis de, 7
- Witt, Johan de, 7
- Witte, Emanuel de, 185-187, 247-250, 259-260; Adriana van Heusden and Her Daughter at the New Fishmarket in Amsterdam, 22, 23, 187; The Interior Court of the Amsterdam Exchange, 17, 19, 186-187; Interior of a Church During a Sermon, 248, 248-249; Interior of a Church with a Newly Dug Grave, 249, 249-250; Interior of the Oude Kerk in Delft, 247; Interior with a Woman Playing the Virginals, 185-186, 186, 267, 284
- Wouwerman, Philips, 176-177, 224; The White Horse, 224, 224
- Wttewael, Joachim, 28-30; Diana and Actaeon, 29
- Zeeland, 3, 5
- Zuccaro, Federigo, 45